LIKE LOVE

Also by Maggie Nelson

On Freedom: Four Songs of Care and Constraint

The Argonauts

The Art of Cruelty: A Reckoning

Bluets

The Red Parts: Autobiography of a Trial

Women, the New York School, and Other True Abstractions

Something Bright, Then Holes

Jane: A Murder

The Latest Winter

Shiner

LIKE LOVE

ESSAYS AND CONVERSATIONS

MAGGIE NELSON

GRAYWOLF PRESS

This publication is made possible, in part, by the voters of Minnesota through a Minnesota State Arts Board Operating Support grant, thanks to a legislative appropriation from the arts and cultural heritage fund. Significant support has also been provided by other generous contributions from foundations, corporations, and individuals. To these organizations and individuals we offer our heartfelt thanks.

MINNESOTA
STATE ARTS BOARD

CLEAN
WATER
LAND &
LEGACY
AMENDMENT

Published by Graywolf Press
212 Third Avenue North, Suite 485
Minneapolis, Minnesota 55401

www.graywolfpress.org

Published in the United States of America
Printed in Canada

ISBN 978-1-64445-281-3 (cloth)
ISBN 978-1-64445-282-0 (ebook)

2 4 6 8 9 7 5 3 1
First Graywolf Printing, 2024

Library of Congress Control Number: 2023940200

Jacket design: Alban Fischer

For Wayne
and for Eileen

CONTENTS

LIGHTS UP

A Preface

The credits have started to roll, the theater is still dark. A mother—my mother—leans over to whisper: "Well, what did you think?" What did I think? How could anyone be composed enough to be thinking, talking? My job is clear: I must protect the transmission, smuggle it out of the theater, to examine it later in my room, see if it still glows. If it does, I might start to think in sentences about it. If the sentences get bossy enough, I might start to write them down. This much I've learned—you put enough in, and eventually, if unpredictably, something will come out. (James Baldwin: "All artists, if they are to survive, are forced, at last, to tell the whole story, to vomit the anguish up.")

My mother took me to much of the first art I ever saw, from John Waters to Jeff Koons. A lot of it was beyond me; some of it freaked me the fuck out; some of it moved me. In response, I acted like a sullen and bored child. Now I am that mother. And I can much more easily imagine the hope—the thrill, even—she must've felt in bringing me around, in having an after-show companion. I'm afraid I wasn't much good for it—I was too busy being born—and I'm not much good for it now, either. And yet. By fending off her inquiries, I grew to understand what I was trying to protect; by beholding her desire to engage, I learned something about the craving for connection that art conjures, frustrates, and possibly exists to

satisfy. I learned that finding out what you think or feel about something can take time, and that that time is always worth taking. I learned that art is one way we live together in this world, even as it relates and separates us, like Hannah Arendt's famous table.

A table suggests that nourishment might ensue. But this is a possibility, not a promise. Maybe the table will become a theater for our deprivation; maybe something else will happen there entirely. I think often of Hilton Als's assertion that "every mouth needs filling: with something wet or dry, like love, or unfamiliar and savory, like love." I think about it a lot because I don't quite understand it. Does he mean that love is an example of something that *could* fill a mouth, or does he mean that something "like love" could do the trick? What is something "like love," but not love? Would such a thing be a cruel—perhaps the cruelest—of substitutes? Or can something that's like love, but not love, offer its own form of sustenance? How would one know the difference?

How can the attention one pays to art be an act of love, or something like it, if and when the love object (words, sounds, paint, pixels) cannot love you back? Or is this simply semantics—we feel love, after all, all the time for things and people who don't love us back, or at least not in any provably reciprocal fashion. (Who's to say whether or how these trees, or this God, loves us, anyway?)

I started getting asked to write about art by friends as soon as I landed in New York City, when I was twenty-one. I knew virtually nothing about it, so the requests flummoxed me, but I quickly gleaned that there was a long history—in New York and beyond—of poets writing about art, and if I wanted to take part, I'd better start looking and learning. My first invitation to contribute to a catalog came from the inaugural *Greater New York* show at PS1, in 2000; all we had to do, the invitation said, was pick one piece of art that compelled us, and write something about it in any form or style. I arrived at the museum quaking, dinky notebook in hand, wordless—until I stumbled upon the work of Nicola Tyson, which in-

stantly demanded my attention. I gave it, and words followed. Over the next twenty-odd years, this cycle recurred, each time teaching me more about how the act of bestowing attention serves as its own reward. And how such engagement attaches and reattaches me to curiosity, to others, to life, especially when my own spirits have dimmed.

"I don't want to talk about this show too much but I've been asked to, and in order to survive in a culture of explanation, one must explain," Als says in an essay about *James Baldwin/Jim Brown and the Children*, a show he put together for the Artist's Institute in 2016. "But how to explain the heart? A sensibility? Love? I love all the artists in this show. . . . I am looking at the artists in this show and introducing them to you through words because it is all that is left to me here." I don't want to talk too much about this collection, either. In fact, I resisted writing a preface to it for some time, and could start only by conjuring a first, fraught memory of resisting the call to explicate, of that juvenile self who fears language might ruin aesthetic experience. "Language is forced on art," says Rachel Harrison. "Is that really best for art? Is that really good for art? Does that make art happy?" Probably not. Probably, language does not make art happy. Language doesn't always make me happy. But sometimes, you must explain. And not just because someone asked, or because we live in a culture of explanation, but because one wants to. Needs to. The language rises up, an upchuck. Words aren't just what's left; they're what we have to offer.

And so, offering in hand, we join the party. We put ourselves in range of something that is neither a cruel substitute nor a consolation prize, but that has all of love's energy—its excitation, its devotion to detail, its flushed conviction of meaning, its sense that it's worth it to stay in it, no matter the repulsion or boredom or misunderstanding or suffering. At which point it doesn't really matter if the energy is love or like love; what matters is that we're turned on, we're in the game. ("I don't really see the work as a vehicle for expressing an idea about my sexuality. I see it as another form of practicing my sexuality"—Nayland Blake.)

I love all the artists in this show, and I thank them for risking making their art unhappy by inviting me into their worlds, and giving me the honor of writing about their work. Thanks, too, to all the conversation partners—within this book and otherwise—who have taken the time to think out loud with me. Such conversations purport to be a trade—you know, "an exchange"—but I think of them more like clouds we made together, floating now on loose tethers. And, of course, I thank my mother, for taking me to all those dark theaters—my reticence, my protectiveness, was just a sign of how much I cared.

And to you, reader—let us here recall together William Carlos Williams's famous lines—"It is difficult / to get the news from poems / yet men die miserably every day / for lack / of what is found there." Let us embrace the good news, which is that we do not have to be like these miserable men. There is so much crazy shit we can stuff into our mouths, with or without the simile.

(2023)

LIKE LOVE

SAY AFTER ME

Conversation with Wayne Koestenbaum

WAYNE KOESTENBAUM: When asked to think about poetry, I can only think about prose, or Déodat de Séverac, or *Pet Sounds*.

MAGGIE NELSON: That seems right and just. It reminds me of the opening of Anne Carson's *Economy of the Unlost*, where she talks about having to write on Celan and Simonides at the same time, because if she picked just one, she'd end up "settling": the worst thing. Or bored: equally bad.

WK: Now I'm writing an essay about artist Amy Sillman and using this assignment to understand why poetic lines are often so claustrophobic for me. Odd, that while writing an essay I'm more inventive with "poetic lines" than when I'm writing a poem . . .

MN: I've been reading Schopenhauer, who is completely hilarious and, for some reason, more heartening to me than anybody even vaguely uplifting. He postulates suffering as one surefire way to avoid boredom. Unless suffering gets boring—then I guess you're sunk.

This conversation with writer and artist Wayne Koestenbaum was conducted by email, then edited for publication in the *Poetry Project Newsletter*.

WK: Can't believe you're actually reading Schopenhauer. I've never cracked the spine of that one. Today I threw out an old unread Aristophanes paperback.

MN: The Schopenhauer is all aphorisms—not very hard to crack. That's about the only kind of philosophy I can read, anyway.

WK: Joseph Joubert never actually wrote a book, only aphorisms and fragments that were his warm-up for a book he never arrived at . . .

MN: Lately I've been trying to stay focused on this prose "sequel" to *Jane*, which I've modeled (loosely) on Peter Handke's *A Sorrow Beyond Dreams*. Although whereas his language is flat, exacting, and excruciating, I worry that mine's just flat.

WK: I never dug Peter Handke's *Sorrow*. Maybe I wasn't sorrowful enough when I read it. I'm finding it hard to finish my Sillman essay, mostly because, I realize, I'm APPROVAL ADDICTED. (A self-help book I saw advertised on the F train: *Approval Addiction*—and how to get over it.)

MN: This AA seems like a group I could really dig.

WK: How's your shoulder? Mine hurts. Say something about how writing damages the body. (Somehow Plath's "the blood jet is poetry" fits in here.)

MN: Thanks for asking—mine hurts too. I've just moved to California, where they're much more concerned with bodily well-being than in NYC, and the computer keyboard that CalArts has bought me has a sticker under the space bar that reads NOTE: SOME EXPERTS BELIEVE THAT THE USE OF ANY KEYBOARD MAY CAUSE SERIOUS INJURY. As if the keyboard were a rock of crack instead of a keyboard.

Poetry has never injured me, bodily, but prose has. My process of writing poems has so much more BODY in it: I write on napkins, in notepads,

on receipts, etc., and then put it all down in one place and tote the pages with me to different locales. But prose makes me feel like my ass is waxed to the chair. Instead of marking time, prose makes it disappear. Whole days, lost to the wormhole of work. Perhaps you and I have this in common: rhetorically we privilege indolence, but we both really like to work.

WK: We're both weirdly giddy. Nervous, afraid to offend, jumpy, a combination of focused and scattered . . . I'm fascinated by what you said long ago about the poetics of fast-talking. Do you speak more quickly than I? I think I've slowed down with age, I used to be a mile-a-minute guy . . . When very young, I stuttered; I still tend to hesitate. Self-interruption is why I love Robert Walser. His voice—at once grandiose and shattered, nervously observing itself crawl through syntax—helped me write *Moira Orfei in Aigues-Mortes*.

MN: The necessary and sheer rush of energy I get from talking to you has much to do with our mutual speediness. It's a drug, really—sometimes I can get to talking so fast with you that I feel like I'm about to skid off the planet. I probably do talk faster than you, but only because I've yet to master the art of talking very fast while remaining understandable. You pause for effect, you enunciate clearly.

WK: If I pause, as you say, for effect, that's a teacherly affectation, or fatigue, or a consciousness that what I'm about to say might be offensive—a wish to gain mileage from indecision, via the pause. Plus I love commas, semicolons, colons, periods, paragraph breaks, line breaks, any chance to stop *in medias res*.

MN: We have never talked about our mutual history in speech therapy.

WK: I remember going into some trailer? I've "blocked" the memory (how melodramatic!). My first-grade teacher told me I stuttered. I remember being caught inside the stutter; it seemed not a stigma but a decorative peculiarity, an embroidery.

MN: I'm remembering that great part of your essay on James Schuyler where you compare the stutter in his untitled villanelle with Bishop's stutter in the final line of "One Art," and talk about them as "two great postmodern statements of the poetics of the closet." Coming out/staying in: seems like we both have the desire to offend while also being afraid of offending *fatally*, as it were: a recipe for shame if I ever heard one!

I too have "blocked" speech therapy. What I haven't blocked is the metal device once affixed to the roof of my mouth with a little spike on it that pricked me every time I tried to put my tongue against my front teeth to make a lispy "s." My speech took on a totally weird rhythm: "s," then "ouch."

WK: Recently in a fit of closure I gave my friend Matthew Stadler my *Hotel Theory* manuscript (at the moment it's in two columns: a nonfiction "meditation" in the left column, a novel in the right column). *Hotel Theory*'s not poetry (maybe it isn't even literature, just turd-arranging), but the fact that it runs in twin skinny columns helps me see it as poetry. Or at least vertical language.

Is it too late to be "experimental"? Now I'm reading Joan Retallack and thinking, "Can I play, too?"

MN: Weirdly, part of the experiment of *Jane* was to let some poems fall flat, which felt sinful: Can I really publish a poem this "bad"? But the project wasn't about delivering lyric flourish at every turn. It had other goals.

WK: Your avoidance of embroidery is refreshing. I love Marie Redonnet's novels because they, too, give up on "lyric flourish." Someone once called my poems "flat," and the adjective hurt. I'm reminded of the time some psycho girlfriend of mine (decades ago!) answered a long rhapsodic letter I'd written her with this terse, humiliating rebuff: "Next time, write to me." One command, on a tiny slip of paper, tucked into an envelope. Derrida hadn't yet written *The Post Card*, so I had no context for my failure as a letter writer, as a sociable human being.

MN: It's so unspeakably painful to feel the thrill of thinking you've found someone who might want to house or hear the excitation, and send back his/her own "too-muchness," and then to receive any rebuff that leaves you suddenly alone with your own reams of rhetorical flourish. Maybe that's why the drug-addled dialogue—or monologue—between Warhol's "A" and the "B" on the other end of the phone line feels more reassuring—"A" may eventually have to hang up, but it isn't punitive.

WK: Your *Jane* gloriously refuses to package itself as poem, novel, or memoir. I respect its unwillingness to dress up grief or placelessness; its ruminations and circlings have a sustaining austerity. A memoirist's or poet's vulnerability, as you've suggested, can be a form of packaging, a hard sell.

MN: And what a perverse form of the "hard sell" it is, in a country meanly obsessed with "protecting itself," from terrorists, from identity theft, from whatever. True bravery, which, I think, involves failure, and loneliness, is harder to come by. Fanny Howe says she avoids titling her poems because titles "put a lid on the loneliness." I think that's brave.

WK: Antipackaging stance number one: I'm trying to move away from writing that too clearly aims at a reader. Reader-friendly = reader-molesting. Give the reader some privacy! Claudia Rankine's newest book, which I admire, is *Don't Let Me Be Lonely*, but I'm equally drawn to Schoenberg's insistence (in his essay "How One Becomes Lonely") on becoming-lonely (like becoming-animal!) as interminable and desirable. Certain reading experiences are touchstones of this loneliness: Benjamin's *The Arcades Project*, Stein's *A Novel of Thank You*, or Sade's *120 Days of Sodom*. As Artaud put it, "But at any given moment, I can do nothing without this culture of the void inside me."

MN: I wonder if the market panic that someone won't pick up a book and read it without knowing what it is has something to do with the culture's panic about loneliness: God forbid we're left alone with something, especially ourselves. Recently I was in an airport bookstore and saw a best

seller with the title *Never Eat Alone*. I didn't know, before being interpellated by this book (a self-help guide to becoming a better "networker"), that eating alone was something one was supposed to avoid.

In what I've been working on lately, I've felt—or it's felt—voiceless. It's been very painful to *not* know what I sound like for the first time in my life, although, I suppose, important—a reversal along the lines of what psychologists like Adam Phillips are always harping on about psychoanalysis: that its point is to become a stranger to oneself, not to bask in some golden halo of "self-knowledge."

wk: The quest to "become a stranger to oneself": that's the "hit" (as Avital Ronell would put it) of writing: seeing a strange face in the mirror, hearing one's voice as strange, like the strange face that psychologist Silvan Tomkins suggests inspires shame in the child—you turn to seek the parent and instead see a strange unloving face. One of my first memories is of my mother's face seeming a stranger's: I wondered, who is that stranger hanging out in my backyard? Too often in my work I give place to the familiar rather than to the strange—I tend to cut odd passages and retain comprehensible ones.

mn: Me too. But partly because to go headlong into the "strange" can court breakdown. Since working on this "sequel," which literally returns to the scene of the crime, has occasioned, or at least come on the heels of, some form of nervous breakdown, many friends have sagely counseled me to leave it alone, or to come back to it when I feel stronger. All I can say is that I wouldn't be doing it if it didn't feel like something I have to do. I admit this may be a little childish—petulance, or masochism, masquerading as adult inquiry.

wk: I doubt I've ever had a proper "nervous breakdown," though I often feel I'm in the midst of a slow-motion, barely detectable dissolution of the threads of sociability and normalcy, a process of becoming-strange to friends, becoming-strange to my own language. A migration in my read-

ing life—toward writers who violate the pact of sociability (Blanchot, Bernhard, Genet, Jelinek, Lezama Lima, Sarduy, Ponge, Huidobro, Celan, Guyotat)—comes from a wish not to repair the slow-motion breakdown but to nourish it, find a mirror for it in equivalently difficult literature, even as my own writing seems, sometimes, so woefully transparent and legible.

MN: I don't know if the term "breakdown" applies unless you're chasing after a rock of crack in the carpet of a hotel room or being involuntarily shipped off to Bellevue, but perhaps there are gradations, and if so, I think it fair to call them breakdowns. The reopening of my aunt's case was contemporaneous with a terrible accident suffered by a dear friend of mine, and tending to her near-fatal injuries while being reimmersed (by the state, by the media, by my own compulsions) in my aunt's fatal injuries has sometimes not felt psychically tolerable. Judith Butler's *Precarious Life: The Powers of Mourning and Violence* has helped: "To be injured means that one has the chance to reflect upon injury, to find out the mechanisms of its distribution, to find out who else suffers from permeable borders, unexpected violence, dispossession, fear, and in what ways." A useful project, especially during these horrible and pointless wars [in Iraq and Afghanistan].

WK: Talking with you gives me so much energy! I want to belong to the School of Maggie, to reinsert myself (post facto) into whatever tradition or ecosystem you're participating in, even if I don't belong . . .

MN: Wayne, you have to be kidding. The School of Maggie? There is no such thing!

WK: And yet I'm inspired by your statement "I write on napkins, in notepads, on receipts, etc., and then put it all down in one place and tote the pages with me to different locales . . ." I want to be in those different locales! I want those napkins, those receipts! I want your speed and mobility and flexibility! I deplore my dependence on filters (as in mentholated

cigarettes): genre is a filter, publication is a filter, the "poetic line" is a filter, plot is a filter, fact is a filter, research is a filter, "I" is a filter, rhetoric is a filter . . .

MN: If it makes you feel any better, I seem to have lost the "different locales" School of Writing for the moment—I've been doing all my writing in my office at CalArts, a round, navy-blue asylum, California '70s motel style, which, as David Antin notes, has no windows, so a huge storm could be raging outside and you'd never know it. Often I emerge to find huge strips of eucalyptus peeling off the trees and flying through the air like clubs.

WK: A dear friend recently expressed surprise when I told him that I considered myself indebted to the so-called New York School of poetry. And then I wondered: are the traces of my indebtedness so difficult to parse? I don't demand that New York School(s) be cohesive—on this subject I've learned so much from your forthcoming book on women and abstraction in the New York School—and yet appearing in the Poetry Project's pages feels like a homecoming. Maybe poetic identifications should remain fugitive or exiled—but without the foster parentage of Schuyler, O'Hara, Brainard, Ashbery, Cage, Feldman, Ginsberg, Myles, Notley, and Warhol, I'd be voiceless. This NYS affiliation means more to me than the old-school "gay" badge.

MN: Yes—whatever the "NYS" was or is, I think of it as a rubric, a practice, a place, in which aesthetics can occupy the foreground rather than gay identity politics, but without the customary downgrading or erasure of being queer that that preeminence usually (unnecessarily, homophobically) entails.

WK: I love the picture of you chasing after a "rock of crack in the carpet of a hotel room"—like a photo of Liza Minnelli (by Chris Makos?) . . . I'm enamored of the phrase "rock of crack," like Artaud's "claque-dents" (which Anne Carson borrows in her poem "TV Men: Artaud"). Do we call the phrase ("rock of crack," "claque-dents") a fricative? If only you

could have recited to your speech therapist Artaud's last words (as translated by Clayton Eshleman and Bernard Bador):

> *And they have pushed me over*
> *Into death,*
> *where I ceaselessly eat*
> *cock*
> *anus*
> *and caca*
> *at all my meals,*
> *all those of THE CROSS.*

Say after me: caca. I believe in spells. And so, I think, do you: I turn to your first book, *Shiner,* and find "Ka-boom, ka-boom," I find "chunky snow," I find "Well I want jack pie," not to mention "pet rock" and "The plung-/ing wall"—signs of the claque-dent aesthetic. We needn't have undergone electroshock to understand that when we write we sometimes reapply the voltage we once passively accepted. In "The Burn" (from *Jane*) you address this hyperaesthesia: "As a child I had so much energy I'd lie awake and feel my organs smolder." This smoldering of the organs is inspiration, but it's also the death sentence shock of overexcitation.

MN: I don't know if I love the image of myself searching for a rock of crack in a hotel room carpet. But "when we write we sometimes reapply the voltage we once passively accepted"—this I love. Maybe it's precisely here that writing becomes cruel—not cruel as in sadistic, but cruel as in Artaud's theater of cruelty: the manifestation of an implacable, irreversible intent, a kind of wild spitting back at the world that begot you without your choosing to be begotten into it. You can hear this spit and crackle, this rock of crack, in Artaud's voice on those final recordings. The earth moves.

WK: In those recordings, Artaud sometimes sounds like Shirley Temple.

MN: Amen.

WK: Being-about-to-burst: my primal scene of writing: sixth grade: teacher gave us fifteen minutes to write a story: the noon lunch bell rang: I hadn't finished my story: that sensation of wanting to crowd everything at the last minute into my story (not enough time!) has never left me.

MN: That's how I feel almost every day in my writing life. I don't think it's necessarily a "healthy" way to write, or to live—a poetics of the rush may be interesting, but is a poetics of the cram? But when the blood-jet is on, that's how it feels. I don't know if I would get anything done otherwise, though I am realizing that always writing and/or living with an undercurrent of desperation can be exhausting. So maybe I'm moving away from "The Burn"—first toward the controlled burn, then I don't know where. It would be good to stay alive.

(2006)

ALMOST THERE

On Eve Sedgwick's *The Weather in Proust*

When I first heard that Duke University Press would be putting out a collection of the final writings of Eve Kosofsky Sedgwick—one of the primary founders of the field known as queer theory, who died of breast cancer in 2009—I first imagined a scrapbook-like volume of wild stray thoughts and posthumous revelations. Then, when I heard the collection was titled *The Weather in Proust*, and that it included all the unfinished writing Sedgwick had done in service of a critical study of Marcel Proust, I imagined it might be a swirling, dense, epic literary analysis, à la Walter Benjamin's 1,088-page *The Arcades Project*, the likes of which the world had never seen.

The slimmish, 215-page collection, edited by Jonathan Goldberg, is neither of the above. It is decidedly *not* a hodgepodge of odds and ends that Sedgwick left behind, but rather nine solid, finished-feeling essays on topics that preoccupied Sedgwick throughout her prolific career. These topics—which include webs of relation in Proust, affect theory, non-Oedipal models of psychology (especially those offered by Melanie Klein, Sándor Ferenczi, Michael Balint, Silvan Tomkins, and Buddhism), non-dualistic thinking and antiseparatisms of all kinds, and itinerant, idiosyncratic, profound meditations on depression, illness, textiles, queerness, and mortality—will be familiar to anyone who has spent time with

Sedgwick's previous work, which includes the groundbreaking *Between Men: English Literature and Male Homosocial Desire* (1985), *Epistemology of the Closet* (1990), *Tendencies* (1993), and *Touching Feeling: Affect, Pedagogy, Performativity* (2003).

But while a great deal here is familiar—indeed, many passages from these books resurface, verbatim, throughout these pages—there is nothing re-hashed about the project itself. To the contrary: for a writer whose prose (and thought) could often be astoundingly dense, circuitous, and lovingly (if sometimes frustratingly) devoted to articulating the farthest reaches of complexity, the overall effect of *The Weather in Proust* is one of clarification and distillation. For those unfamiliar with Sedgwick's work, I would actually recommend starting with *The Weather in Proust* and moving backward from there, as the volume offers an enjoyably compressed, coherent, and retrospective portrait of Sedgwick's principal preoccupations.

In his brief introduction, Goldberg tells us that the first five chapters of *The Weather in Proust* comprise the writing Sedgwick had done toward a book on Proust in the last few years of her life. It is good of him to let us know, for the range of these chapters is wide enough that one might never have guessed that they were all intended to be part of the same project. One can only imagine that Sedgwick's book on Proust, had it come to full fruition, would have profoundly challenged and expanded the notion of a monograph—not to mention raised the bar quite a bit higher for the "how Proust can change your life/my year spent reading Proust" genre.

With the exception of the opening chapter, which bears the title of the collection at large and remains focused on models of relationality and subjectivity in Proust (albeit via forays into the scientific notions of chaos and complexity theory, ancient Greek mysticism, and psychoanalysis), these first five chapters traverse an extremely wide plain, with Proust's novel but a flickering touchstone. "Cavafy, Proust, and the Queer Little Gods" discusses the "saturating and promiscuous" sense of divinity that Sedgwick found in both Proust and the early-twentieth-century,

gay, Greek-language poet C. P. Cavafy. "Making Things, Practicing Emptiness" gives a moving account of Sedgwick's own visual and textile art, which she describes as "a meditative practice of possibilities of emptiness and even of nonbeing." While Sedgwick's observations about her art practice demanding "second-by-second negotiations with the material properties of whatever [she's] working on" are not likely to sound revelatory to many practicing artists, it is fascinating for those of us who knew her primarily as a hyperverbal, hyperarticulate academic superstar to find her describing the distance between this identity and her deepening engagement with a nonverbal, material practice that must, by definition, defy one's hopes (or fears) of omnipotence.

"Melanie Klein and the Difference Affect Makes" explores the importance of Klein's "putting the objects in object relations," as well as her elaboration of the depressive position, which Sedgwick calls "a uniquely spacious rubric." The essay also lays out Klein's notion of "reparation," which became crucial to Sedgwick in her later years, as evidenced by her commitment to something she called "reparative reading" in *Touching Feeling*. Last of these five essays is "Affect Theory and Theory of Mind," which twirls the reader through various controversies and complexities pertaining to the international "neurodiversity movement," in which the voices and perceptual experiences of people who have been diagnosed with various mental disorders—autism chief among them—speak back to truisms about the mind offered by "NTs," or "neurotypicals."

I wish I could say that Sedgwick's close readings of Proust and other literary authors sustained my interest as much as do her inquiries into the wild and woolly terrains just described. At times they do—especially if I surrender to them, and have a strong caffeinated beverage in hand. I say *I wish I could* because I know how important such close readings were to Sedgwick (she was trained, after all, as a literary theorist at Yale in the heyday of deconstruction). I've always been somewhat haunted by the passage in *Tendencies* in which Sedgwick describes one of her not-so-cheery amazements as a professor:

It doesn't surprise me when straight and gay students, or women and men students, or religious and nonreligious students have bones to pick with each other or with me. What surprised me more is how . . . the single most controversial thing in several undergraduate classes has been *that they were literature classes*, that the path to every issue we discussed simply had to take the arduous defile through textual interpretation.

As a devout reader, lover, teacher, and creator of literature, I completely understand Sedgwick's frustration with those who would regard the hard, engaged work of paying close attention to a text's workings as simply a drag, or with those who would treat works of literature as annoying obstacles or detours standing woefully in the way of "the dessert": the ostensibly more desirable, ostensibly more direct insights afforded by critical theory, philosophical tract, or political treatise.

And yet. I must admit that I have always found myself, while reading Sedgwick, skimming or skipping over her close readings of *Recherche* or a Cavafy poem to get to her more overarching inquiries and conclusions, if only because the latter feel so vital, so sustaining, that I feel hungry—even greedy—to arrive at them, even if I know (intellectually) that there should be no way out but through. Her preternatural capacity to pay close attention to the finer points of literary texts (including those she has written herself!), to "pluralize and specify" their meanings, to expand and articulate their nuances, is utterly admirable, and often relentless. I don't mean that as a criticism. Really, I mean to offer up my own exhaustion, my own willingness to skim, skip, pick and choose, as an encouragement to others to read Sedgwick with a similar sense of agency and disobedience. For it would be a shame if any thoughtful reader missed out on Sedgwick's fantastically rich politically, psychologically, philosophically, spiritually, and even scientifically probing essays, on account of feeling turned off here and there by her intense analysis of books or authors one may not have read. Take the full ride with her, feeling free to take what you need and leave the rest; you won't be sorry.

The latter four essays here collected offer more on the "dessert" front, and provide overviews of the kind of antihomophobic inquiries for which Sedgwick is justly famous. In "Anality: News from the Front," Sedgwick uses recent essays on gay male sex by Jeffrey R. Guss and Steven Botticelli to argue—as she always has—against straight, gay, or lesbian thought that is reactionary, normative, and/or separatist. Such an insistence leads her to pose questions crucial to contemporary debates about the interplay between equality and difference in GLBTQ+ rights, as well as about the ever-changing nature of the notion of queerness itself, especially as it conflicts with more mainstream gay/lesbian definitions and even self-definitions. "Can masculinity expand to contain women and femininity as well?" she asks. "And if so, how does it and why should it? Does one want to say about Thomas Beatie, the F-to-M who became briefly famous as the tabloids' 'pregnant man,' 'He must be so secure in his masculinity!'? Maybe it's something else besides masculinity in which, giving birth, he seems secure; but since he is a man, it seems disrespectful to call him secure in his femininity. Can his visible self-possession reside in some broader ontological status—in his human self-knowledge, maybe?"

If, from this passage, you think that Sedgwick means to appeal to this "broader ontological status" as a way of bypassing sticky questions about specific gender identifications and/or desires, or that her goal is to launch us into some postgender utopia in which queers are simply and finally allowed to share in the treasures of universalism, think again. "Making Gay Meanings," a mostly recycled but admirably cogent talk on the meaning of "queer" that Sedgwick delivered in Paris in 1997, and "Thinking Through Queer Theory," a 2000 talk given in Japan in which Sedgwick offers an invaluable retrospective of her twenty years of involvement with feminist and queer issues, crystallize her basic stance with grace and lucidity. In the latter, Sedgwick offers a forceful and still timely critique of the direction of mainstream gay/lesbian politics, which she criticizes as being paradoxically "both separatist and assimilationist": "separatist in terms of its identity, but at the same time all its goals involve the uncritical assimilation of gay people into the institutions of a very conservative

culture." Queer politics, on the other hand, she describes as "both anti-separatist and antiassimilationist"—"antiseparatist in that we don't take it for granted that the world is neatly divided between homosexuals and heterosexuals, and antiassimilationist in the sense that we are not eager to share in the privileges and presumptions of normality."

Unlike some queer theorists and activists, however, who have expressed exasperation and even hostility toward their more mainstream peers (understandably so, as the prioritization of certain issues can mean the neglect, even the worsening, of others), Sedgwick's profound commitment to any antihomophobic activity imbues her writing with compassion, along with an unwillingness to throw the baby out with the bathwater. "Certainly the conservative mainstream of the gay/lesbian movement is achieving some successes," she writes, "and I do not want to diminish the importance of any success in any antihomophobic undertaking. Such successes are all too rare." Nonetheless, she takes the time to describe why a queer politics—especially one unmoored from electoral politics, or even from the subjects of gender and sexuality themselves—remains, to her mind, the most viable and elastic mode by which one might address "the ways that race, ethnicity, and postcolonial nationality crisscross with these and other identity-constituting, identity-fracturing discourses . . . and do a new kind of justice to the intersecting intricacies of language, skin color, migration, state, and culture." At a moment when the Occupy Wall Street movement—with its infamous "lack of legislative demands"—has finally brought some mainstream attention to the spectacle of how such "intersecting intricacies" might take form off the electoral stage, Sedgwick's elucidations feel especially salutary.

The final essay in *The Weather in Proust*, the seven-page "Reality and Realization," is, perhaps, the most moving, insofar as it directly takes up the question of Sedgwick's impending death and her experience of living in "the bardo of dying," which Sedgwick inhabited for a large portion of her adult life (she was first diagnosed with breast cancer in 1991). Sedgwick here uses the example of the gap between knowing one is going to die and realizing one is going to die as a paradigm case of the gap between *know-*

ing and *realizing* more generally—an epistemological, and even spiritual conundrum that has fascinated her at least since *Epistemology of the Closet*. Looking back on what she calls a paranoid theoretical tradition in the West, which has included much deconstructive and queer theory (including some of her own), as well as any "antiessentialist hypervigilance" or "moralizing Marxist insistence that someone else is evading a true recognition of materiality," it becomes clear to her that this tradition can be read as "a hallucinatorily elaborated, long-term refusal to enter into realization as a complex practice." This short final essay is a stunning performance of what assenting to this complex practice might entail—even if, or especially if, it means coming to terms with our own mortality.

Getting curious about the gap between *knowing* and *realizing*—and being willing to hang out there for an indeterminate amount of time—was one of the principal activities of Sedgwick's later years. As she explains in *Touching Feeling*, she wanted to move past the rather fixated questions "Is a particular piece of knowledge true, and how can we know?" to the question "What does knowledge *do*—the pursuit of it, the having and exposing of it, the receiving again of knowledge of what one already knows?" It will likely not come as news to any of us that we can be quick to apprehend something intellectually, but that *realizing* it—whatever that might mean—is often a much more involved, perhaps limitless affair. In a 1999 interview, Sedgwick put it this way: "It's hard to recognize that your whole being, your soul doesn't move at the speed of your cognition. That it could take you a year to really know something that you intellectually believe in a second." Sedgwick explains that she eventually learned "how not to feel ashamed of the amount of time things take, or the recalcitrance of emotional or personal change." Indeed, as she puts it in "Reality and Realization": "Perhaps the most change can happen when that contempt changes to respect, a respect for the very ordinariness of the opacities between knowing and realizing."

Sedgwick never denied the difficulty of such a process—especially for intellectuals, who often pride themselves on their own quicksilver capacity to absorb knowledge (which may have nothing to do with their capacity

for realization). That's why she says "It's hard." It *is* hard, often quite. But Sedgwick's native capacity for tenacity and jubilance in the face of difficulty, as well as her sustained engagement with Buddhism, allowed her to cast this difficulty as a privilege. "In Buddhist pedagogical thought," she writes in *Touching Feeling*, "the apparent tautology of learning what you already know does not seem to constitute a paradox, nor an impasse, nor a scandal. It is not even a problem. If anything, it is a deliberate and defining practice." Sedgwick wrote often about pedagogy in her final years—not so much about specific classroom instances per se, but about pedagogy as a site of relation, a sort of laboratory, in which a list of *things to know* might shift into a manifestation of *ways of knowing*, not to mention doing or being.

This seems as good a moment as any to mention that Sedgwick was once my teacher, back when I was a doctoral student at the Graduate Center of the City University of New York. During this time, I felt very acutely the distance I had yet to travel to become a person who could appreciate such gaps between knowing and realizing. As often happens with a figure whom many treat as a guru, or with someone you perceive as "having what you want," the idolization/idealization produced a kind of melancholia: the melancholia of inferiority, of distance, of longing, of feared impossibility, of shame about where you are, or who you are, right now. The desire to move quickly into enlightenment, liberation, knowledge, sobriety, shamelessness—into a freer self, a happier self, a queerer self, or what have you—can be fierce, and fiercely privatizing.

This melancholia or shame can exist throughout a life in a variety of arenas (Sedgwick also describes its workings in the therapeutic setting). But it's also a constitutive element of being a student. Being a student is—perhaps structurally—an incredibly rich, contradictory, and volatile place to be. Once you've flipped into being a professor, it can be astonishingly easy to forget this fact. I'm reminded of it, however, every time I see the familiar red crawl of a blush creeping up the neck of one of my students while she is giving an oral presentation, or when I run into a student in a public place and quizzically observe his discomfort (or when I

take the plunge, and enroll somewhere as a student myself!). As Sedgwick has taught us elsewhere about blushing in particular, and about shame more generally:

> The pulsations of cathexis around shame . . . are what either enable or disenable so basic a function as the ability to be interested in the world. . . . Without positive affect, there can be no shame: only a scene that offers you enjoyment or engages your interest can make you blush.

Sedgwick's work on shame—inspired by psychologist Silvan Tomkins—teaches us that that rush of blood signals our interest, our investment, our care. If we're lucky, we care a lot.

About twelve years ago, I heard Sedgwick give a talk at the Graduate Center called "In the Bardo," which contained much of the material that appears in *The Weather in Proust*. She talked that day about her recent travels to Tibet, about her textile art, about the gap between knowing and realizing, and about her cancer. She spoke about the importance of "coming to loving terms with what's transitory, mutable, even quite exposed and ruined, while growing better attuned to continuities of energy, idiom, and soul."

Though Sedgwick would live for nine more years, it was clear that afternoon that she would not be around forever. (Neither, of course, will we.) The air in the room hummed with this discomfiting fact, and her bravery in the face of it—even though I knew then, as I know now, that "bravery" is the wrong word, insofar as it connotes a triumph over or denial of fear, rather than the complex brew of curiosity, vulnerability, and ceaseless intellectual shrewdness that Sedgwick put on display that afternoon, and that permeates all her writing.

Perhaps the better word is *generous*. In her talk, Sedgwick reminded us that in Buddhism, being a human being is a privilege, in that it is a good place from which to make spiritual progress. Listening to her then, I was

overwhelmed by the generosity of her example of what making use of this privilege might sound like, or feel like. Reading *The Weather in Proust* brings me the same feeling, over and over again. I hope and trust that its publication will give new and old readers of her work a fresh opportunity to feel it too, for as long as the privilege lasts.

(2012)

BEYOND ALL CHANGE

On Ben Lerner's *10:04*

But of course every generation has its own version, its own smoldering apprehension of end times, of the foreclosure of human history, the cessation of our capacity to inhabit this beautiful earth. But who (besides the increasingly obdurate and immoral climate deniers) can truly ignore the strange pocket of space-time we currently inhabit, in which a grievous threat to our habitat is not only assured but underway? Who knows what to do when that demise is underway, but not necessarily imminent? As philosopher Paul Preciado puts it: "The problem resides precisely in the fact that no one will come to save us and that we are still some distance from our inevitable disappearance. It will thus be necessary to think about doing something while we are on the way out."

One of the things we can do, for better or worse, is make art. Whether or not this art takes this predicament as its principal subject may not, in the long run, matter; in retrospect (should we be so lucky), almost all the art we are creating now will likely appear suffused—if not to say gaslit—by the slow-burning anxiety created by the deepening climate crisis, and the wealth gap that is its intimate companion. Ben Lerner's *10:04* sets up shop in the eye of this anxiety. At 240 pages, his new novel does not announce itself as a magnum opus. But given Lerner's considerable humor, rigorous intelligence, and shrewd breed of conscience—his bighearted

spirit and formal achievement—it is. A generous, provocative, ambitious Chinese box of a novel, *10:04* is affirmative of both life and art, and written with the full force of Lerner's intellectual, aesthetic, and empathetic powers, which are as considerable as they are vitalizing.

Like Lerner's first novel, *Leaving the Atocha Station*, *10:04* is a conceptual novel of sorts, by which I mean that it takes what it wants from any number of genres (fiction, poetry, art criticism, autobiography) and corrals the results under the roof of "novel." Readers and critics less familiar with this approach may spend time wondering about the novel's taxonomy; those who regularly read and love writers such as Édouard Levé, Hervé Guibert, Violette Leduc, Eileen Myles, Marguerite Duras, W. G. Sebald, Lydia Davis, Fernando Pessoa, Karl Ove Knausgaard, and Roberto Bolaño will likely take *10:04* on its own terms, and appreciate its autofictions, its elegant structure (its action is bracketed by two superstorms, 2011's Irene and 2012's Sandy), its meticulously constructed sentences, its deployment of poetic tropes (parataxis, refrain, dialogue that floats and rushes, semantic and syntactical leaps that treat the reader like a grown-up), and its facility in analyzing a wide range of political, cultural, and aesthetic artifacts, from Ronald Reagan's speeches to artist Christian Marclay's *The Clock* to Donald Judd's sculptures to the '80s hit comedy *Back to the Future* (from which the novel's title derives).

Much should and will be said about Lerner's spectacular prose, on display in the novel's opening sentence, which introduces the reader both to Lerner's style and to the decadence to which his novel bears witness:

> The city had converted an elevated length of abandoned railway spur into an aerial greenway and the agent and I were walking south along it in unseasonable warmth after an outrageously expensive celebratory meal in Chelsea that included baby octopuses the chef had literally massaged to death.

The decadence of this opening lunch—whose purpose is to celebrate the sale of the book we are now holding in our hands for "a strong six-figure

advance" ($270,000, the narrator later tell us, after taxes and the agent's cut)—is both exuberant and horrifying. As the perverse fate of the baby octopuses suggests, the pleasures of this decadence are inextricably linked to the suffering and/or deaths of others, be they near or distant, human or non-.

Our narrator vibrates with this knowledge. Indeed, one of his principal gifts is apprehending, in a vertiginous, somatosensory, unrelenting fashion, the vast network of relationships set into motion by global capitalism, along with his implication in them. As he says some pages later, recalling his ingestion of the octopuses:

> I swallowed and the majesty and murderous stupidity of it was all about me, coursing through me: the rhythm of artisanal Portuguese octopus fisheries coordinated with the rhythm of laborers' migration and the rise and fall of art commodities and tradable futures in the dark galleries outside the restaurant and the mercury and radiation levels of the sashimi and the chests of the beautiful people in the restaurant— coordinated, or so it appeared, by money. One big joke cycle. One big totaled prosody.

At the opening lunch, the agent—while calculating tip—asks the author how he plans to expand his book proposal into a full-length novel; he imagines giving her this response: "I'll project myself into several futures simultaneously, a minor tremor in my hand; I'll work my way from irony to sincerity in the sinking city, a would-be Whitman of the vulnerable grid." This is, in fact, a fair outline of *10:04*. One might even say it is its plot. (There is another, more surface plot, involving the narrator's best friend Alex, who has asked him to donate his sperm to her so that she might bear a child; there is also a light romantic drama with a smart artist named Alena, and a darker medical one involving a rare, potentially grave condition—a dilated aortic root—with which the narrator is diagnosed on page two.) But the main narrative tension lies coiled in the author's imagined précis: How does one—indeed, how can one—work

one's way from irony to sincerity, from cephalod-eating literary highflier to Whitmanic vessel for empathy and collectivity, when such a goal is announced in an opening scene ostentatiously contaminated by privilege and capital, and rendered with an exacting wit that some might mistake for cynicism?

It might bear noting here that a novel written by a young, white, Ivy League–educated American male that foregrounds the bidding war and monumental advance that brought his novel into being, reproduces verbatim the short story published in the *New Yorker* that led to the book's sale, and discusses the likelihood of the present novel's symbolic capital (to be bestowed by glowing reviews in major publications, such as the one I am now writing), may rub some people the wrong way. From the outside, it rubs me the wrong way. But to understand what Lerner is up to and capable of, you have to take the ride. Once I did, I came to see his approach as bolder and more politically incisive than that of any number of heavily promoted works of art whose material conditions remain shrouded in mystery.

The narrator of *10:04* is on the winning end of an unjustifiable system and he knows it. (An early scene in which he and Alex shop for storm supplies at the colossal vitrine of Whole Foods on Union Square underscores the point, even if the class status of our main characters remains wobbly: Alex is living on unemployment after having attended NYU's School of Public Service; the narrator's success as a fiction writer marks a change in fortune from his previous life as a precarious poet-academic. Further, however monumental and rare his advance, such one-time payouts pale quickly compared to the excesses of Wall Street, whose darkened buildings appear on the book's jacket.) To stop there, however—to perform some lightweight mea culpa and then pretend such conditions have no bearing on the work at hand—would be the easy way out. For when it comes to reckoning with markets of varying kinds, privilege, inequity, whiteness, unevenly experienced environmental disasters, and all the messy guilt, denial, injustice, confusion, paradox, mourning, and despair such phenomena produce, there's no truer way out than through. By

naming numbers, by exhaustively bringing our attention to the ways in which we collectively, if distinctly, participate in the contradictions, hypocrisies, and exhilarations of our time, *10:04* lays bare the challenges of our conjoined predicament with an audacity that borders on recklessness. The book's "meta" strategy is a high-wire act that could easily fall, in less savvy, stringent, or searching hands, into tinny satire or obnoxious spectacle. Instead, *10:04* is a captivating, moving tour de force that earns its connection to Whitman (whose words merge with the narrator's in the novel's final line).

One way Lerner accomplishes this is by pushing hard on—indeed, pushing through—the concept of contamination. Take, for example, an important scene set in the Park Slope Food Coop—ground zero for mocking a certain demographic's self-righteous liberalism. But Lerner is not after low-hanging fruit. "Complaining [about the co-op] indicated you weren't foolish enough to believe that belonging to the co-op made you meaningfully less of a node in a capitalist network, that you understood the co-op's population was largely made up of gentrifiers of one sort or another, and so on," he writes, before swiftly adding:

> Though I insulted it constantly . . . I didn't think the co-op was morally trivial. I liked having the money I spent on food and household goods go to an institution that made labor shared and visible and that you could usually trust to carry products that weren't the issue of openly evil conglomerates. The produce was largely free of poison. When a homeless shelter in the neighborhood burned down, "we"—at orientation they taught you to utilize the first-person plural while talking about the co-op—donated the money to rebuild it.

The first-person plural taught by the co-op may belie profound obstacles to human solidarity; we may be so awash in the hypocritical and the trivial that it's hard to recognize that which is not. But, Lerner quietly reminds us, we abandon the pursuit of solidarity and integrity at our collective peril.

A headier example of a similar point arrives in an address our narrator delivers at Columbia's School of the Arts, reproduced midnovel in quotation marks. The talk gives an account of the narrator's coming to poetry (Lerner is also the author of several poetry collections, and poetry plays an important role throughout *10:04*, both literally and figuratively): "In the story I've been telling myself lately, I became a poet, or became interested in becoming a poet, on January 28th, 1986, at the age of seven"—that is, the day the space shuttle *Challenger* disintegrated seventy-three seconds into its flight. The narrator recalls the power that Ronald Reagan's subsequent speech—written by Peggy Noonan—had on him that night:

> The ending—one of the most famous conclusions of any presidential speech—entered my body as much as my mind: *We will never forget them, nor the last time we saw them, this morning, as they prepared for the journey and waved goodbye and* "slipped the surly bonds of earth" to "touch the face of God." . . . Let me allow the preposterousness of what I'm saying to sink in: I think I became a poet because of Ronald Reagan and Peggy Noonan. The way they used poetic language to integrate a terrible event and its image back into a framework of meaning, the way the transpersonality of prosody constituted a community. . . . But I wonder if we can think of them as bad forms of collectivity that can serve as negative figures of its real possibility: prosody and grammar as the stuff out of which we build a social world, a way of organizing meaning and time that belongs to nobody in particular but courses through us all. Thank you.

Can the words of Peggy Noonan and Ronald Reagan really be reimagined as bad forms of collectivity that can serve as negative figures of its real possibility? Can art offer something other than stylized despair? Why reproduce if you believe the world is ending? These are *10:04*'s abiding questions. As befits a poet, Lerner doesn't answer them directly, but rather lets his own prosody, his own novelistic devices, comprise a response that is "proved upon our pulses," as Keats had it.

Crucial among these devices is making space for long monologues by other speakers. Lerner used a similar device in *Leaving the Atocha Station*, but there the stories of others tended to highlight the narrator's sense that everyone around him was having "real" experiences, while his remained somehow fraudulent. Here our narrator is an engaged, even breathless, listener. His eagerness to listen to other people from varying walks of life—including Roberto Ortiz, a third grader he unofficially tutors; a protester from Occupy Wall Street to whom he opens his home; a fellow worker at the Park Slope Food Coop named Noor; his own father; a gregarious "distinguished female author" with whom he has dinner after the Columbia talk; an unhinged graduate student named Calvin; an intern at an arts organization who is freaking out on ketamine—stands in sharp contrast to the kind of pompous, self-centered male author exemplified here by one at the same Columbia dinner, about whom the narrator says:

> After two quick glasses of Sancerre, the distinguished male author started holding forth, periodically tugging at his salt-and-pepper beard, moving from one anecdote about a famous friend or triumphant experience to another without pausing for the possibility of response, and it was clear to everyone at the table who had any experience with men and alcohol—especially men who had won international literary prizes—that he was not going to stop talking at any point in the meal.

Of course, one could say this is sleight of hand—the book is of course all Lerner, all the time—but this is literature, not anthropology, which means that the novel's accomplishment lies in its offering of an experience of a certain kind of openness and curiosity, not in literally providing a platform for other voices. As the narrator vacillates between his own commentary and its suspension, we too learn something about the enjoyable, even ethical rhythm to be found in allowing ourselves our loquacity, then holding ourselves in a state of negative capability while we allow others theirs. Noor's monologue, delivered to the narrator as they work side by side in the co-op basement, is exemplary here, in part because of its subject matter—Noor tells a complicated, surprising story about her

Lebanese roots, in which she undergoes a life-altering experience of mis-recognition, or disidentification—and in part because of our narrator's intent interest in it (after he is called upstairs to deliver the dried mangoes he's been bagging, he rushes back, elbowing others out of the way so he can return to Noor's side; eventually he works "as slowly as possible," so as not to interrupt the rest of her tale).

Many of the novel's "guest speakers" are Cassandras of sorts, giving voice to paranoias that seem both insane and reasonable. Young Roberto relays a dream that links Joseph Kony, global warming, and the plight of being undocumented; the unhinged graduate student Calvin charges our professor-narrator:

> You represent the institution. The institution speaks through you. But let me ask you something. . . . You deny there's poison coming at us from a million points? Do you want to tell me these storms aren't man-made, even if they're now out of the government's control? You don't think the FBI is fucking with our phones? . . . Or are you on drugs? Are you letting them regulate you?

In response, our narrator promises Roberto (in two languages) "the only thing I could: he had nothing to fear from Joseph Kony." As for Calvin, our narrator emails him after their meeting to say he's sorry if he upset him and that he wishes to be of help. But to the reader, he confides:

> I did not say that our society could not, in its present form, go on, or that I believed the storms were in part man-made, or that poison was coming at us from a million points, or that the FBI fucks with citizens' phones, although all of that to my mind was plainly true. And that my mood was regulated by drugs.

At times the narrator does seem to represent the voice of the institution, just as at times he seems as inclined to take pleasure in the magisterial ex-

cesses of the system as to protest actively its murderousness. Nonetheless, he too is another Cassandra, pondering the future with a paranoia that is warranted, if unuseful in maintaining one's daily equilibrium.

Futurity is *10:04*'s principal concern, be it the future of the sinking metropolis of New York, the future of art, the future of capitalism, the future of the planet, or the future embodied by unborn human children, such as the one that Alex is carrying in the novel's final scene. I mention this pregnancy not to be a spoiler (I trust that the relative plotlessness of the novel obviates this possibility), but because Alex's pregnancy, and the uncertain role that our narrator will play in it, brings *10:04* into conversation with any number of meditations on the relationship between fertility, technology, and the future of the human species, from the dystopic sci-fi of writers such as Octavia Butler, Margaret Atwood, and P. D. James, to philosopher Jean Baudrillard's apocalyptic "The Final Solution," to Lee Edelman's polemic *No Future*, in which Edelman argues against something he calls "reproductive futurism," which casts all politics as taking place on behalf of the innocent child. In keeping with his appetite for paradox, Lerner shapes *10:04* around a conception narrative, but he does not fully indulge the happily-ever-after logic that so often attends it. As the narrator contemplates the prospect of becoming either a donor or a father (or, most likely here, something in between), his ambivalence is acute, though not paralyzing. After letting an Occupy protester come to his apartment to take a shower, the narrator prepares the protester a meal, and is filled with a rushing desire to have a child, followed by a fit of self-disgust:

> So this is how it works, I thought to myself, as if I'd caught an ideological mechanism *in flagrante delicto*: you let a young man committed to anti-capitalist struggle shower in the overpriced apartment that you rent and, while making a meal you prepare to eat in common, your thoughts lead you inexorably to the desire to reproduce your own genetic material within some version of a bourgeois household, that almost caricatural transvaluation of values lubricated by wine and song. Your

gesture of briefly placing a tiny part of the domestic—your bathroom—into the commons leads you to re-describe the possibility of collective politics as the private drama of the family. All of this in the time it took to prepare an Andean chenopod. What you need to do is harness the self-love you are hypostasizing as offspring, as the next generation of you, and let it branch out horizontally into the possibility of a trans-personal revolutionary subject in the present and co-construct a world in which moments can be something other than the elements of profit.

I suppose there are some who will stubbornly hear sarcasm in such passages, signaled, perhaps, by language that rides the line between precise articulation and jargon. But I take such questions, and the language in which they are formulated, seriously. How does one develop a horizontal, collective politics while living in a system seemingly hell-bent on privatizing everything, including that capitalist bastion of Oedipal privacy, the domestic family? Can one refuse the hard edges of such distinctions, or would that simply be fooling oneself, a form of false consciousness? Our narrator offers no answers, but in the book's final pages, he gives a virtuosic performance of what such blurring might feel like: past, present, and future tenses merge; the tight trio of the narrator, Alex, and developing fetus zooms in and out of focus, set against a metropolis teeming with other lives; the narrator's first-person narration expands out to address the reader directly ("maybe you saw me"), and eventually encompasses the words of Whitman, testifying to a nearly incredible empathy with the multitudinous.

Many poets benevolently haunt *10:04* (most literally, Robert Creeley), but Whitman is foremost among them, due to his relationship to New York City (and Brooklyn in particular), as well as his poetry's capacity to summon the feeling of euphoric collectivity. But as the narrator smartly notes:

> Whitman, because he wants to stand for everyone, because he wants to be less a historical person than a marker for demo-

cratic personhood, can't really write a memoir full of a life's particularities. If he were to reveal the specific genesis and texture of his personality, if he presented a picture of irreducible individuality, he would lose his ability to be "Walt Whitman, a cosmos"—his "I" would belong to an empirical person rather than constituting a pronoun in which the readers of the future could participate.

Our narrator takes the opposite route: he relishes the documentation of particularities, be they of objects, ideas, or psychological structures, and he steadily reveals the specific genesis and texture of his personality, be it via literal examinations of critical moments in his development, or simply via the rhythm of his attention, the scaffolding and cadence of his prose. Often he explicitly compares his situation to that of Whitman, noting the (degraded) difference between, say, our narrator's role in talking an intern through a bad trip at an art party in Marfa and Whitman's deathbed ministrations to soldiers in the Civil War. "The smell of his buttondown shirt was repulsive," our narrator says of the intern, who has vomited from alcohol and drugs. "I helped him get out of it, and then threw the sodden thing in the pool. With his arm around my shoulder and mine around his waist, I walked him slowly inside, a parody of Whitman, the poet-nurse, and his wounded charge." The scene is indeed parodic—it's like *Boogie Nights*, but in a desert town laced with high art. Yet when the intern, in a state of abject terror, begs the narrator, "Don't leave me. I still don't feel like I'm here," the parody vanishes. No matter the circumstance, human suffering matters. Our attending to it matters. Acts of tenderness are not morally trivial. Which is why our narrator stays with the intern until he is asleep, then kisses him on the forehead before taking leave.

Sounds sweet, right? But, as Preciado reminds us, nothing is going to come save us from a climate crisis of our own making, not even acts of interpersonal tenderness. As we begin to absorb this news—which by all rights shouldn't be news—it is tempting to feel nihilistic, as if all that remains for us to do is give in to "an alienation that has reached such a degree that [mankind] can experience its own destruction as an aesthetic

pleasure of the first order," as Walter Benjamin (another important figure in *10:04*) wrote in 1936, facing down Fascism. *10:04* is not afraid to touch this nihilism, this alienation, nor the compromised aesthetic pleasures to be found there. But to its credit, it does not succumb to their temptations. Its rigors and pleasures remain in service of nuance, of negotiation, of continuance. For as Naomi Klein has reminded us, our demise isn't all or nothing, at least not for the next few centuries. "There are degrees to how bad this thing can get," Klein says. "Literally, there are degrees." As we struggle to figure out how to notch back the degrees, so as to mitigate the suffering that a warming planet is going to bring, we also need to figure out forms of relationality—both to ourselves and to each other—that won't make things worse.

By the time I finished *10:04*, I felt like I understood some options: not being ashamed of the desire to make a living doing what we love, while also daring to imagine "art before or after capital"; paying as intense attention to our collectivity as to our individuality; demanding a politics based on more than reproductive futurism, without belittling the daily miracle of conception, nor the labor and mysterious promise of childbearing and -rearing; attempting to listen seriously to others, especially those who differ profoundly from ourselves, no matter how precontaminated the attempts; spending time reading and writing poetry; and more. Far from despair, I felt flooded with the sense that everything mattered, from meticulous descriptions of individual works of art to kissing the forehead of a passed-out intern to analyzing our political language to documenting the sensual details of our daily lives to bagging dried mangoes to the creation of the book I was holding in my hand to my deciding to spend time writing a review of it. "The earth is beautiful beyond all change," Lerner repeats in *10:04*, quoting the poet William Bronk. The inspired and inspiring accomplishment of his novel makes me want to say that sometimes, art is too. And maybe—if incredibly—so might we be, ourselves.

(2012)

FROM IMPORTUNATE TO MERETRICIOUS, WITH LOVE

Conversation with Brian Blanchfield

BRIAN BLANCHFIELD: It feels appropriate to treat this topic (a rich one for both of us) in a written dialogue, since the taproot of our friendship was an exchange of letters, a blind correspondence—between Manhattan and Brooklyn, in early 2001. Right?

MAGGIE NELSON: Yes—we met because I had sent my manuscript *Jane: A Murder* to Farrar, Straus and Giroux, where you were then working. At the time it felt like a big, weird, gutsy move for me—I mean, who was I, a young poet writing in her little Brooklyn room, suddenly convinced her book should have a more formidable home? Nonetheless, I sent it to FSG, as well as to other houses. The book was roundly rejected, but you subsequently wrote me—off the record—a fan letter, saying it was one of the best manuscripts you'd read in your time at FSG.

Not knowing, as I do now, that NYC publishing is full of women, and that the whole business has an increasingly "precariat" vibe, I then imagined

This conversation with poet and essayist Brian Blanchfield was originally conducted by email for an anthology titled *Among Friends: Engendering the Social Site of Poetry*; its topic was to be "gender and poetic friendship." The exchange appeared instead in the online poetics journal *Evening Will Come*.

every publishing house as being The Man, run by white men in suits, chucking around their immense cultural power. (This may have been an impression garnered after working at age nineteen, for a single day, for Gordon Lish; shortly thereafter I sequestered myself in New York bars and basements and Kinko's back rooms, with a more punk, DIY crowd.)

At any rate, the point is that when I received your letter, I felt sure it came from a bastion of power, and that you, "Mr. Blanchfield," were its emissary. (The patrician vibe of your name worked into this fantasy quite well!) And it was meaningful to me, because *Jane* was a story about girlhood, about being female, about proposing femaleness as the center of a human story. And my letter from Mr. Blanchfield of FSG said to me that all this was worthwhile, that it was good, and that it had almost made it through, even in its freaky form.

BB: I can remember well reading *Jane* in manuscript at FSG. I knew who you were because we already had a friend or two in common, but I wasn't prepared for the transformative reading experience there in my cramped little Union Square office. A clear-eyed and structurally innovative book that sought to be a new sort of—a subversion of—investigation into sexually violent crime, objectively dismissive of criminal psychology, riveting in the way rivet removal might be, *Jane* turns out to have as its central subject girlhood. It became clear in the book's uniqueness just how rare that is or was in literature. I had never read anything like it before, certainly not in my capacity at FSG. I still have an almost diagrammatic understanding of its relations: symmetrical pairs of girls and women—Maggie and her sister, their mother who was Jane's sister, and even their dolls Stacey and Tracey—tightly wound in their relationality, where the dark companion of bright ambition was recrimination, often self-punitive, and where open generosity was shadowed by privation. The horrible murder and vanished life of one in the configuration had made all the mirrorings skew and distort and glare and ricochet. What a prism.

I think I was bold enough to write some of that to you, then; I remember troubling over whether to use the FSG letterhead. Jonathan Galassi's

letter had gone out to you already (I had written it), conceding its bril-
liance and concluding, if I recall, that the company did not have experi-
ence publishing and promoting so peculiar a book. A line. It was one of
the several times I couldn't let my dissenting opinion rest. I was the office
I held, I decided, and sort of trusted that you might want to hear a fellow
writer's high opinion of you. To sidestep the imprimatur, always a good
idea, if you want to be real. There was sort of a delicious freedom in that.

MN: What a surprise it was, then, to meet you at a party in Carroll
Gardens a few months later, and to find that you were young, almost ex-
actly my age (born in 1973), dating a writer I knew (Douglas A. Martin),
queer, brilliant, interested in all kinds of on-the-grid and off-the-grid lit-
erature, a true intellectual, an omnivorous roamer, a southerner, son of a
truck driver and a Primitive Baptist, a gentle giant, and a fascinating, ter-
rific poet who wanted to be my friend, too.

BB: Over books and manuscript pages: that's certainly one setting of our
friendship. But when I flash on our formative times together, I often
think of us in driver and passenger seats, really all over the country. Do
you? Driving out of New York, while it was quite literally still burning, in
your rental car, to Eileen Myles's Scout festival in Buffalo, October 2001,
a profound and anxiously giddy (and somewhat perilous) epic drive with
Douglas and with Bruce Benderson. Also, driving a Ryder truck of your
furniture to a storage place in Connecticut when you were living in gray,
cold Middletown, Connecticut, with its piped-in Vivaldi parking struc-
tures. A ludicrously expensive minor accident in an otherwise innocuous-
seeming wooded parking lot somewhere on Cape Cod visiting your
friend, the inimical Annie Dillard. Reading Peter Handke's remorseless
prose to you in a traffic jam on the Cross Bronx Expressway, to make you
forget there would be no restroom for miles. Crossing a perplexing and le-
gitimate wrinkle in the time-space continuum involving a giant roadside
turkey buzzard, my keys on the car roof, and a narrow causeway in south
Florida. Numerous wending trips on the Pacific Coast Highway, when we
were both living in Los Angeles, on days off from CalArts, looking for the
biker clam bar or a reading cove, depending on our mood.

You became, rather soon after I met you, the person in my life who was patient, empathic, sound and even sage, in a very difficult stretch for me. Loss and grief were catching up with me, not to mention anger and some relived trauma, and I had been the sort of bottled up one imagines at the time as self-possessed. Whenever I consider the sort of friend I relish *being*, I think of you: a deeply understanding, permissive, even fiery advocate with advanced capacity to listen, whose intellect is a joy, who can surrender happily to the absurd, and who can share the playground of language.

MN: And you, to me, quickly became an inspiration, a brother, a support in times of seriously dark waters, an editor, a lender of excellent and pivotal books, a cheerleader, a colleague, a couch sleeper (and couch mover), a fellow swimmer, an excellent and well-dressed date, a road tripper, a canal sitter, a reference, a beneficiary, a comrade in the world of modern dance, a corrupting gambler, (queer) family.

BB: Well, so, Agent Nelson, about gender and friendship and poetry, I have a couple of questions I have wanted to ask, both related to *Jane*, and to much of the rest of your work. Relationships among girls and women are central to *Jane*, and when I think of your aunt's excerpted journal entries in the book, I think of her poignant accounts of feeling shame at having appeared selfish in her friendships. In essence she was an adolescent who used the diary's meditative space to encourage herself to be more self-effacing, more qualified in her ambition, and more generous with her sister and friends. Her struggle for what was appropriate in self-expression, and her temperance, are, it seems to me, gendered. I wonder if you would speak a bit about the relationship between gender and pleasing others.

MN: Whoa, this is a big one. Because in writing, one is usually attempting to please someone—one's own ear, of course, but also a listener, or an addressee, and often a specific one. Of course, one is also attempting to speak things one needs to say, however abstract, however ugly, however frightening—the results of which aren't always pleasing, either to

oneself or to others. I've found this difficult territory to negotiate: how to violate the gendered taboos that have made it so difficult for women to speak things the culture would rather not hear (à la Adrienne Rich's "On Women and Lying") but how to understand, simultaneously, that one's bravery or audacity doesn't come without consequences. That people react, and you have to abide the reactions. Somehow it never seems to get any easier.

Jane's worries about appearing selfish, as expressed in her diary entries, are a good example of the bind. In some ways, they make me think that if one is worrying over appearing selfish, one might already be heading down the wrong path altogether, insofar as for women—not exclusively, but perhaps especially—setting boundaries around what one can and cannot give to others has always been a difficult point, a subject of much internal consternation. I have become an avid reader in the occasionally linked spheres of Buddhism and feminism, and one subject that appears often in this overlap is how women need to be especially cautious in avoiding "idiot generosity," that is, giving that which will make you resentful or depleted, while also pursuing the kind of radical generosity that Buddhism encourages. But this generosity has to be commensurate with your capacities—you can't just become a doormat, which doesn't help anyone. But nor does being paranoid about becoming one. It's a bit of a pickle.

As far as pleasing others goes, at least I don't care half as much as I used to about reviews and whatnot; after my book *The Red Parts* was called "meretricious" by *Kirkus* or *Publishers Weekly* or some such, I really stepped off that flag. I remember that there was a word you also hated, once applied to your work—what was it?

BB: How interesting that your word was *meretricious*. I'd forgotten. Mine was *importunate*. I remember we both admitted to looking the word up, after reading our reviews. Which I have done again. They are interestingly similar and interestingly gendered. Both words can mean distasteful, and both in all of their usages bespeak the greater (literary) cultural value of

caution or moderation or, certainly, humility. It is sloppy and clambering for me, a man, to ask or attract attention to a need, and it is vulgar or speciously insincere for you, a woman, to do so. Isn't there a way, if you were really going to investigate the inferential semantics here, that in my poems I was said to behave and comport my speech too little "like a man" and you in your account did not show the gentility or earnestness "befitting a woman"? Mine came at the tag end of a diminishing comparison: I think it was "But Ashbery would never have been as importunate." "You're embarrassing yourself" *does* seem to be one of the twenty irrepressible outcomes in the average critic's eightball. Which is why John Ashbery (the one who loves Marianne Moore) might write a poem so titled. My sources say no.

MN: Given that *The Red Parts* was the first book in my life that I'd made any money on—not to mention how much the money helped me at that particular juncture, or how proud and relieved I was to have wrested a meaningful piece of writing out of the horror of my aunt's 2005 murder trial—the whole "meretricious" invocation (i.e., "of or relating to a prostitute") felt like a perverse sort of welcome mat: this is how it is, then. This is the welcome for a woman joining this sphere. Okay, I thought, so be it.

That's partly why I adore Eileen Myles's proposal, in her* *Inferno*, of being invited to become a prostitute in New York as a parallel for becoming a poet. I mean, why not? I just finished Virginie Despentes's *King Kong Theory*, which has a great chapter on her sex work (I'm rooming here in Mexico for the week with the amazing Annie Sprinkle, who lent me Virginie's book—so at the moment I'm in a real reclamatory mood). I love how, whenever Virginie hits upon some kind of misogynistic deadend or supremely irritating or unjust moment, she just says, literally, "Well, fuck you." I'm not a person who can say such things very easily—nor, I think, are you—so it's a real pleasure for me sometimes to hear

* Eileen Myles respects the history of pronoun usage when a speaker or writer uses she/her in reference to them in the past (see also pages 69 and 93), but Myles identifies today as trans and uses the pronouns they/them.

others doing so. Just like it's a real pleasure for me to read the writing of others for whom the charge "You're embarrassing yourself" has no truck.

As for "importunate": according to my *OED*, it means "burdensome; troublesome; persistent or pressing in solicitation." You're right—it's a kind of begging—clambering, as you say—that's at issue, that disrupts the-man-who-doesn't-need-anything, or, conversely, the man for whom longing is annoyingly sacrosanct, poetically alchemized into the dignity of "yearning." (Barthes: "We are always being told about Desire, never about Pleasure; Desire has an epistemic dignity, Pleasure does not.") There's a lot of pleasure in your poems—the pleasure of the language, the pleasure of syntax, of unusual vocabulary, unusual collisions; the pleasure of "discovery rather than receipt," as you say. I think that's what makes your poetry difficult and generous at the same time—you have to submit to its tightly coiled syntactical mazes in order to discover their twists and turns of meaning, of emotion—but they always deliver, should one take the time. Should one go with the encounter being proposed, as you say.

BB: *Solicitous* and *whorish*, is that then the literary beat officer's read on us? It is interesting—and, sure, a bit unfair, teleological—to boil the two reviews down to judgment about open and mercenary lust on the public square. "A walking way of standing still," I believe that's what Joe D'Alessandro claims to have in *Heat*, when interviewed by the street cop who suggests his idle lamppost leaning is suggestive. He orders him to keep it moving, anyway. Which reminds me of *Standing Still and Walking in New York*, the O'Hara book of essay prose, with him and Larry Rivers on the cover in folded arms taking the avenue in.

My other question to you has to do with assessments of your work like the ones I made when I said I loved realizing that *Jane* was about girlhood or sisterhood, or ones such as Eileen Myles's formulation on the book's cover, "a deep, dark female masterpiece." Considering some response to *Bluets*, are you comfortable with such assessments that determine your work is where one might "learn" about female experience?

MN: Honestly I'm pretty comfortable with such assessments, even though I know a lot of people wouldn't be. I mean, it's preposterous to think that there's something called "female experience" or "femaleness" in which all women share. But I'm not one of those people who thinks "I want to be an artist, goddamn it, not a female artist!" This is likely a result of the fact that I've been lucky enough to come up in a time and place in which being called a female artist did not assign you to any ghetto; or, maybe more to the point, if it did, I was proud of the ghetto, and unafraid of its grouping. I mean, if Eileen Myles wants to call *Jane* a "deep, dark female masterpiece," I'll take it. (I also knew that she was layering it up by placing "female" and "masterpiece" side by side, so there's an interesting political wager already embedded in the frame.)

I have also always felt strongly that girlhood and femaleness, as well as transgender identifications of all stripes, are as fundamental to the human experience as the so-called straight white male subject and all his trappings. So when I hear the word "female" applied to my work, I almost hear it as "human," even though I know for others the word works in an opposite fashion. I think this stance is likely the result of a long habit of reclamation, some of which I performed in my New York School book, which celebrates what Alice Notley once called her "girl theory of poets," but also keeps a lively ambivalence about the word "women" throughout, as in its title: *Women, the New York School, and Other True Abstractions*.

Would my feelings on the matter change if I felt these gendered remarks were hindering my work's capacity to be taken seriously, or if such designations landed my work on the "women's studies" shelf instead of on that of poetry or literature? Absolutely! For God's sake, let's all be human already! But in a sense I'm done with gaping after the human, and after those who presume to have privileged access to it. I already know we belong, so fuck it.

BB: I'm interested in what you are reading, in what is foremost in your reader's mind (I know you are finishing a book about art and cruelty) that you might consult soonest in thinking about our topic. What five

books are on your desk or in your midst right now that relate to the topic at hand—sociality, friendship, gender and poetry and poetics? And how have they organized or disorganized your thinking about the question?

MN:
Félix Guattari, *Chaosophy*
Adam Phillips, *Winnicott*
Judith Butler, *Precarious Life*
Barbara Hammer, *Hammer! Making Movies Out of Sex and Life*
Eve Sedgwick, *Touching Feeling*

Barbara Hammer I just saw in conversation with Silas Howard at the Hammer Museum in LA the other night, and it was so moving, for so many different reasons. One is that Barbara and Silas, as stage presences, represented such different moments in feminism and queer life: Barbara, as a true hero of sexual liberation from back in the day, filming Super 8 movies with her shirt off in a field full of naked women, jerking off at the Macy's counter with her core of "super dykes," exploring sexuality that was hot but not based in power play or S/M—and most of her writing about sex in her book is excited by the sameness she feels about other women's bodies, not the difference. By contrast, Silas comes from a subsequent generation more devoted to punk rock/queercore (as performed with his band Tribe 8), trans representation, and bold interventions into Hollywood and/or narrative cinema (as with *By Hook or By Crook*, which Silas made with my Harry [Dodge]) rather than in experimental, non-narrative film like Barbara's. But that night at the Hammer, due to their deep mutual respect, broadness of vision, openness, lightheartedness, and real sense of solidarity, these differences were exactly what differences can be, at their best: fascinating points for conversation, overlap, and observation, rather than occasions for rift, competition, or nonunderstanding. This was a tent in which everyone could party, and it gave me hope for all of our futures.

The Phillips on Winnicott and the Butler have been useful to me together in thinking about our radical dependency on others, a dependency that

nearly every theory of subjectivity has tried to obliterate or at least down-play. (I've been reading Kristeva lately, on the matricide she proposes at the heart of subjectivity—compelling, but foul.) It is so heartening to hear someone say—as Adam Phillips says in his little book written with Barbara Taylor, *On Kindness*—that to deny or discount as pathological the dependency that grows between intimates really makes no sense at all. The ways in which we come to depend upon each other—and, as cited here, the ways in which we may or may not always be able to deliver unto each other what we need or want—is *the* human struggle, sometimes per-formed on the most dire, basic levels (can an infant get the sustenance it needs to survive?), and sometimes on the more psychologically complex (as in the grief described by Butler, in which we must grapple with losing a part of ourselves when we lose a beloved other).

BB: Two of the books you mention are books I've recently read, *Touching Feeling* and *Precarious Life*; in fact they are the two most transformative nonfiction books I've read this year. I am moved by the searching ex-ploration of both books, by their uniqueness in "the field" (as discourse not fastidiously mounted on other discourse) but maybe even more fas-cinated by their similarities. First, they share a means and an end: both writers propose our commonality, our physical or eidetic or haptic or af-fective commonality, as humans, in the course of arguing for, at least, more intentionality and agency in the humanities. Sedgwick's critique is that reading and interpreting any text from a "paranoid" paradigm is merely to make *exposure* the objective (aha, we were *right* about the policy influence of Cheney's oil friends: now what?) and reifies humiliation as a kind of annihilation. Reifies, too, *time*, as the measure of anxiety: antici-pation and retrospection are the active elements of proving oneself right about something. (Why is her substitutive aspiration for a reader of signs, of texts, disappointingly diffuse: to accrete and to organize and to heal? Maybe I don't understand what she calls "reparative reading.")

In Butler's case, she wishes for a new discipline that can study the struc-ture of address, in an era and technological/ethical situation in which speakers are routinely permitted passive or relativist or inferential or con-

cessional (or, to use Sedgwick's term, "periperformative") assertions, a *study* that would locate responsibility in speech back to the speaker function, one speaker at a time. Is it a corollary perhaps to the saw about poetry (which I believe): I don't know that poetry can be taught, but I know it can be learned. Likewise, I know from my experience (the call I feel to answer) that I am being addressed and therefore I know that someone has addressed me. Indirection should not be an *obviation* in political discourse, she determines, which kind of nails it.

Both positions are stimulating and it seems to me both thinkers are at pains not to distance or discredit the work they and others have done to defamiliarize and denaturalize the author-subject (and sexual binarism) in the appeal for responsive and empowered critical speech. Isn't it as though they really (I'm tempted to say "finally") were addressing squarely the freshman student or indeed the freshman provost who asks, "But what does theory do?"

MN: *Precarious Life* and *Touching Feeling* are two of the most transformative nonfiction books I've read in the past few years, too. Both were great the first time; both have significantly opened up in subsequent readings. Harry and I have been returning to Sedgwick's "Shame in the Cybernetic Fold" for some time now, trying to decode it. It's like Eve's speaking ten languages at once, and depending on which one you are ready or able to hear, you will hear that one; but if, say, you suddenly read a lot of chaos theory, or affect theory, or systems theory, or Buddhist writing, a different reading bobs up and becomes suddenly available to you. In that late work, she seems to have come up with a way to manifest her deep love and understanding of the embroidered—the texts have so many threads. Complexity is all—but not, as she makes clear, an excuse for any fuzzy invocation of multiplicity, or worse, of the infinite.

Gender and sexuality certainly bring the questions of which lives count, which lives are visible/readable as lives, and which are grievable, to the fore. But it's no accident that Butler—who posed some of those questions most eloquently as a queer theorist—has now taken those questions to other

lives, such as those of the Iraqis and Afghanis killed in the United States' ongoing wars on those countries. Such is the focus of *Precarious Life*.

BB: I wonder what you mean by "it's no accident." What, for you, is the connection between Butler's (and Sedgwick's) early work on the performance and construction of gender and queerness and the more recent engagements both writers have (had) in reparative and "new humanist" reading and analysis? What is the threadthrough? I can imagine you have given it some thought in your current book project on art and cruelty. Is the connection in the negation or illegibility of lives, in the threat or contrastive "normativity" alterity produces?

MN: In part I just mean that it would have been very hard, in the Bush II years, *not* to shift one's attention toward the atrocities being committed so egregiously in our name, and in the name of the War on Terror. The other threadthrough, as you say, seems apropos to current discussions about gay rights, civil rights, and human rights—that is, the difficulties that have attended casting the fight for, say, gay marriage as a human rights issue, and all the controversy (within the gay community, as well as without) that has attended it. For it isn't just "whose lives count," but also "what counts as a life?"—what rights attend or should attend a life in order to make it "count," or make it livable. (Hence all the renewed interest in Arendt, and the prevalence of Agamben, etc.)

The argument for gay rights—or for the recognizability, visibility, and dignity of the queer subject—is inextricably linked to humanist discourse, the discourse of human rights. The more radical among us think the whole discourse needs to be hauled up and reconfigured. I'm totally on board for this. At the same time, I'm also a pragmatist, and a romantic—I married my Harry, even as I believe just about everything the beyond-marriage queers say—and I'm glad that I did. Personally, I tend to think of all rights as an invention, rather than as "inalienable"— what use is it to yell "I was born with a right!" in the face of someone who is lawfully discriminating against you? Better to address the behavior head-on, I think. Work from contingency rather than essence.

As for normativity, I have to say that I'm not sure what it is anymore, and so I certainly don't know how alterity produces it, or how it produces alterity. I've lost sight of, or maybe patience with, claims about the heteronormative, or the homonormative, as they say. To me these terms have begun to take on something of a policing vibe, but perhaps that's just a reflection of my own life, some of the folks I know. I mean, certainly the normative is in full swing out there; I just try to keep my distance, surround myself with those who think otherwise, but who aren't cops about it.

To my mind, the right-wing, family-values version of normativity is really and truly freaky, in all its claustrophobia, all its mean, provincial sentimentality. Conversely, or relatedly, I've also become steadily less likely to believe there is anything necessarily radical about choosing sexual partners or life partners of the same sex—save the reaction-formation that ensues when heteronormative culture pushes on you, threatens you, tries to "cure" or shame you, won't let you into a loved one's emergency room or an adoption office, beats you up, or kills you.

We got into a really heated debate with our good friend Jack Halberstam the other night, in which Jack—who had been reading Christina Hanhardt's work—was asserting that gays (or at least white gays) were absolutely not second-class citizens anymore, that they were as or more guilty than others of benefiting from gentrifying neighborhoods, and they feared being gay-bashed far more than the statistics suggest they should, indicating that some queers now use this fear as an outdated means of thinking of themselves as victims, which conveniently obscures their class sins or status.

There's some truth here, and I don't have the facts to dispute statistics. But even if Jack has the numbers right about gay bashing (and I'm not totally sure he does), an internalized fear of being discriminated against or beat up or what have you seems to me a real force, not one that can easily be discounted as phantasmagorical. Or, perhaps more to the point: the phantasmagorical still bears important information, perhaps even powerful truths, that one cannot wish away. Not yet, anyway.

BB: I want to go back and retrieve something from *Precarious Life* that has been meaningful to me. If it is not affect and the availability to touch that Butler founds (like Sedgwick) for our commonality, it is something close: our bodies and our common development as subjects who have first been related to others by our bodies. This is (most of) the paragraph that levels me:

> Although we struggle for rights over our own bodies, the very bodies for which we struggle are not quite ever only our own. The body has its invariably public dimension. Constituted as a social phenomenon in the public sphere, my body is and is not mine. Given over from the start to the world of others, it bears their imprint, is formed within the crucible of social life; only later, and with some uncertainty, do I lay claim to my body as my own, if, in fact, I ever do. Indeed, if I deny that prior to the formation of my "will," my body related me to others whom I did not choose to have in proximity to myself, if I build a notion of "autonomy" on the basis of the denial of this sphere of a primary and unwilled physical proximity with others, then am I denying the social conditions of my embodiment in the name of autonomy?

What she does with this articulation is profound, to me. Conceding the equally bracing extrapolation that I certainly found myself making, that it is *humiliating* as an adult who "exercises judgment in matters of love" to reflect on the uncritical and boundless love and surrender one had as an infant or a child for one's parents, she goes on to suggest the autonomous huff we get ourselves in, as avengers of some preconscious betrayal (the "child is father of the man" in the *shitty dad* way too), is actually a construction. (Stay with me, she says, and I do. I listen close, I sit up on the therapist's couch—am I alone, he must have gone to the restroom or canceled our appointment.) She says to consider the common status we all share then, as selves with bodies that began with and are imprinted with dependency on others and, more to the point, vulnerability toward others. "Is this not another way of imagining community, one in which we

are alike only in having this condition separately and so having in common a condition that cannot be thought without difference?" Beautiful, elegant, reassuring, and yet worrisomely inexact.

I'm reminded of Whitman's most gently paratactic poem, "The Sleepers" (and maybe a little bit of the children's book—did your stepson read it?—*Everyone Poops*), which blesses all the nightly retiring bodies, underway in various predicaments and identities and partnerships, equivalent in their need for sleep, and conjoined by equivalence—but wait! *Conjoined* in their *equivalence*, is it a dream? A *community* of separate dependents reckoning separately their immersion in and immanence from dependency—is it too fantastic? Just as I don't think Whitman's poem is actually, performatively *democratizing*, as many are quick to claim, I don't think our common experience of vulnerability assures anything close to interdependence or family-of-man humanism. (And this from someone whose practice of poetry is pervaded with "conjoined in their equivalence" sleights and other principles of sympathetic magic.)

But/and/so I am humbled and provoked by sitting with the real truth that my body related me to others whom I did not choose (and, as it turns out, would not have chosen!), and my latecomer's (paranoid?) relationship with the outward-public and here-before-me (heraldic?) body that needed others to make it their own is made richer by Butler's characterization. It seems important in the extreme not to build a notion of autonomy on the dismissal or disregard of that phenomenon. And that's where I am at the moment with that. *Here*, with my cursor hovering a possible transposition: Needed others. Others needed.

MN: Indeed. I wonder, though, why you say that Butler's proposition about community (i.e., formed from the common condition of each person's vulnerability toward others—a condition that cannot be thought without difference) is "worrisomely inexact"? It seems related to your calling Sedgwick's notion of reparative reading "disappointingly diffuse." I guess, for me, if something is "beautiful, elegant, and reassuring," as you say Butler's proposition is, I feel it has done its (affective, not necessarily

political) job. But maybe I am a pushover? I read their books to see things anew, to let different seeds be planted within me; I don't look to them for plans of political action. But I suspect you don't either.

I wonder, too, why commonality rushes, in your equation, into equivalence, as they don't seem to me the same thing at all. I mean, everyone needs to poop, but not always *equally*, right? I guess what I'm saying is that it seems to me that there could be, should be, likely is, more difference within commonality than "equivalence" implies.

But maybe this is hair splitting. I agree with your more troublesome point: that the common experience of our vulnerability doesn't necessarily assure us anything close to interdependence or family-of-man humanism. I guess the point here—and it is one with which I think Butler would heartily agree—is that there is no guarantee. In fact, much/most of *Precarious Life* is concerned with what happens when our reaction to our shared vulnerability goes haywire, when we displace it onto others, when we smear our wounds around in an attempt not to suffer from them ourselves, and the disastrous consequences therein. I devote much time in my *Art of Cruelty* book to such dynamics, which I call (after certain Buddhist writings) "styles of imprisonments."

As per Sedgwick's writing on paranoia, sketching out these styles, or "knots," to use R. D. Laing's term, sadly does not guarantee anything about their undoing or redirection, no matter how clearly executed by the sketch artist (and I do always hope to be clear!). But I decided, in *The Art of Cruelty*, that the sketching was a worthwhile task anyway. I don't have too grand a theory behind it, so far as pragmatism or the reduction of suffering goes—whatever theory there is, hopefully the book itself enacts it, by the simple performance of playing close attention to the knots, and then, when necessary, demonstrating that it's okay to turn away from them. That one doesn't necessarily need to *unravel* them in order to see them clearly, give them their due respect, then devote one's attention elsewhere—to what I call in my book "rarer and better things" (a phrase lifted from Ivy Compton-Burnett, of all people!).

BB: Agreed. A little chime sounds in what you have said here. I'm afraid I read as a poet often, not as a foot soldier in the cause. Which is to say I am transformed a bit by the formulations of both Butler and Sedgwick, and the way I can metabolize that change is to isolate and lift and re-treat and repurpose to my present circumstance the locutions that have embedded in me, fuss with them, with their interrelationship to other elements that are impacting me at the contemporary moment.

I wrote a short poem last month that takes its title from *Touching Feeling*:

Paranoia Places Its Faith in Exposure

Some touch is received and the sensation is entire
at contact, and some touch there is a rising into. Lucky
the lover who is encouraged to fit or press
into the hand presented, lucky to have a hand, gloves off.
The hard jar against eyetooth and black jowl the tom
engineers if a fist presents, the kitten in the brick cinders
beneath the broken road, her dusty body knowledgeable.
Pick me up can also be as frequency and antennae do.

I'm still a little bit "in love" with this formulation of Sedgwick's, in the title, with the wisdom of it as an urge to move past or move aside *proving* how all along someone has slighted or abused or deceived or desired you. I find in her aphorism and her personal paradigm shift a beautiful emblem hard won from the years of stunned citizenry under the Bush administration. Again and again the nightmarish fears of we who suspected deep corruption and abuse of power were proven correct, or very nearly so, and "broad daylight" turned out not to be much of a dissuasion and hardly a disinfectant. (That still floors us; I think of Rachel Maddow's segment about congressional Republicans, "They're Not Embarrassed.") But here, I put the formulation in play in a small arena with a remark I made to someone who is very attractive to me and the observation similar to something Sedgwick investigates, that being touched is mysteriously constitutively different from touch. So I make a sort of oblique and

even ambivalent love poem out of it, through which I answer or mean to please someone rather specific, and, I guess, wager the poem holds that energy for others. Partly I wonder whether it is "wrong" to use her episteme in this grammar. Do you also suffer from this, or am I particularly weak-willed?

MN: I, like you, read primarily as a poet, rather than a foot soldier, as you say, in any cause. I too have a long and deeply ingrained habit of taking what I need and leaving the rest. You ask if I think it's wrong to do so, to drag Sedgwick's, or anyone's, episteme into a different grammar—and I say, of course not! It is, to my mind, THE action (or at least one main action) of poetry, of art. After working in academia a bit, and then moving to an art school environment, I would say that's the biggest difference: academia privileges being scrupulous, because whole careers depend on poking holes in—exposing—weak or undeveloped points in other people's arguments. Art doesn't function on the level of argument—or, at least, not all art, or most art—so the exposure model doesn't hold. One loses a degree of rigor in the change, but one also gains.

Your concern about wrongness here reminds me of one of my favorite passages in Barthes's *The Neutral*, which I'm currently deep into. The passage arrives in Barthes's weekly response to the questions and comments his students have handed in to him re: the previous week's lecture. Here a student has taken issue with Barthes's use of Buddhism in the previous week's session, and the "seemingly uninformed way [Barthes] uses mysticism." He responds:

> I thank her, but this observation reveals a misunderstanding about the way I proceed when I "cite" (I call) a knowledge. . . . It's obvious that knowledge enters the course by means of very fragmented bits, which can seem offhand: this knowledge is never cohesive. It is never mobilized as doctrinal knowledge: I know nothing and do not pretend to know anything about Buddhism, about Taoism, about negative theology, about Skepticism . . . when I cite from Buddhism or

from Skepticism, you must not believe me: I am outside mas-
tery, I have no mastery whatsoever, I have no other choice
than (Nietzsche) to "lose respect for the whole": for the master
is one who teaches the whole (the whole according to him-
self): and I don't teach the whole (about Buddhism, about
Skepticism). My aim = to be neither master or disciple, but in
the Nietzschean sense (thus with no need for a good grade),
"artist."

I think about such issues quite a bit, perhaps because—unlike Barthes,
who was teaching highly sophisticated and curious graduate students at
the Collège de France—I teach undergraduate art students in California,
who not only aren't in need of a good grade (they are in a low-stakes,
pass/fail situation), but who also don't often strike me as needing to be
disabused of the notion of the whole, or of mastery, or of knowledge. In
fact, often I feel as though my job is the opposite—that is, to let them
know that such notions even exist! This all relates to larger questions I
have about pedagogy: Is "experimental pedagogy," or a pedagogy that
disavows mastery, a one-size-fits-all approach? Or is truly experimental
pedagogy that which—like good therapy, perhaps—adapts itself to the
particular humans at hand? How does the task of the teacher change in
a culture in which reading, writing, and thinking themselves—radical
tools, it seems to me—have become whipping posts, tagged as poten-
tially dispensable in whatever wacko phase of capitalism we're now in?
The Neutral is so great on this account because it is literally a pedagogical
text: it's Barthes's *lecture notes*, for God's sake.

But back to poetry, which is our ostensible subject here: I'm all for drag-
ging epistemes into poetry; my only demand is that they be metabolized,
embodied, or inhabited in some way—don't toss in the word "Hegel" just
because you want to sound smart but don't really give a hoot about the
referent; don't mock critical theory or terms for sport, especially with the
aim of demonstrating that poetry doesn't need those things, doesn't need
to be "thinky" in order to have value. Of course it doesn't! Poetry doesn't
need to be thinky, or intellectual, in any proper sense! It can be, but it can

also be a shimmer of mood scribbled on a cocktail napkin. And, as our mutual friend Aaron Kunin has recently demonstrated, in his brilliant and moving book *The Sore Throat*, a poetry with an intensely limited and accessible vocabulary can be extremely challenging and smart.

Perhaps I will here trot out a favorite phrase, one I relied upon a great deal while writing *Women, the New York School, and Other True Abstractions*: *"Each narrowing of what contemporary poetry is supposed to do bears with it an equivalent narrowing in the definition of a human being"* (Douglas Oliver). Like Sedgwick's axiom "People are different from each other," it's so sage, so simple, and, I think, so true—yet it's also so unbelievably hard to remember, or to learn how to live by.

BB: On that note, now for something about truth and poetry and love. And some of this may be off the record; we'll see as we go. You've said elsewhere that adding the Buddhist concept of "right speech" (that which minimizes harm and confusion) to the consideration of honesty and dishonesty in potentially cruel situations is to "make the pike of honesty into something more like a three-legged stool," which is the choicest thing either of us is likely to come up with for the duration of this dialogue. The last two years for me have indeed been about clearing away a lot of psychological static and a lot of impasse in my life and the key has been as you suggest the base fact that all you owe anyone is your emotional truth. You cannot be an accurate mirror, or in "right relation," to someone otherwise. I am a rescuer and a protector and a redeemer and an accommodator from way back, and most of my relationships have sprung from those dynamics and most have clashed then with my need for private or secret, languaged, liberated and permissive, dark-tinted, dreamy/brooding space, a home base of sorts, a reset. The obligation I would grow to make of the former endorsed the surreptitious elective delicacy of the latter. I would often come to pit friendship or fantasy or, indeed, poetry against the love and care of a partner. There are some pretty extreme conditioning reasons for this pattern, which I won't get into here. You know them, anyway. Well, suffice it to say in the last couple of years, more con-

sciously clear about this dynamic and others, my writing or relationship to writing *has* changed somewhat.

For one thing, and in much admiration for your *Bluets* and *Red Parts*, I have been writing these (now that I think of it, scientistic, objective, structuralist) essays that have vulnerability (shame and guilt) built in as perforce components. *Onesheets*. They are another room on the house. Part of the fun of the monograph essay project is to speak and reason and wander authentically but to appreciate my one-among-many subjectivity. What and how does the topic of Owls or Br'er Rabbit or Man Roulette or Foot Washing mean to a poet and teacher in his midthirties who grew up white and gay and male in Piedmont, North Carolina, the son of a Primitive Baptist and a truck driver and, later, a tax attorney? That is, my difference is very particular, but no more particular than anyone's, touchingly. You know, it turns out candor can also be a practice of displacing one's self-centrality.

It was Eileen [Myles] who asked me recently, Is there just less shame of giving it up in prose than poetry? Further, I like her question as a reader of poetry, My pleasure doesn't matter? (a gendered question classically). And I think the two provocations are linked but not concentric; there are pleasures outside of being leveled with. I do think that a reader's pleasure is one of discovery rather than receipt so one of the particular ways a poet needs to be obliging is to be revelatory moment to moment, which demands, for me, a release of control, to write, in short, like a reader, to encounter. (As Beckett puts it: "What folly for to need to seem to glimpse afaint afar away over there, what, what is the word—") When I think of poetry's categorical difference from prose, I primarily think of pleasure, the pleasure of reading poetry that happens *as* you read it, that uses—I suppose—parallels, resets, likenesses, echoes, suspensiveness, aoristic time, associations, and breakages as a means to advance (and follow) meaning or engagement. So, you know the bareness of feeling or truth-telling is for poetry an important tool but, really, a device among many devices.

One of the interesting things about interviewing Eileen was to learn that Hart Crane was for her an important poet. (Oddly, our interview returned repeatedly to gay male poets and queer tutelage and queer structures of caregiving and family.) I think, in fact, no one has put it so succinctly that it is "the love of things irreconcilable" that one finds in Crane, an "architecture of contradictions" he brought to the poetry and filled it with, concerned about resolution but devoted to irresolution. As she says, "that was being gay for me" and "the queer piece was the ill-fitting piece and poetry was the place where you accommodated that ill-fitting perspective into its own kind of interfaces." It seems to have been for her, and it was for me, a young ego's understanding of what poetry is for, but an incredibly important one that if one grows out of, it shouldn't be thought of as surpassing but sprouting. What else or what eventually the living practice of feeling makes of the practice of poetry, the practice at poetry, is something I continue to learn.

I wonder, is there something in poetry that you have "grown out of," and if so, how so? What do you make of Eileen's claim that being a poet involves the performance of the job of poet, mostly outside of the writing of a poem? She has perhaps been a poet more pervasively in her two novels and book of essays, performed it more there. What do you think?

MN: I feel awkward talking about this for an anthology centered on poets and poetry—almost like going to an AA meeting and saying the program isn't working for you, that you've learned you can in fact remain sober another way. But, since you asked, I will speak to it, since it is something I have actually been thinking a lot about, in closed quarters.

I had a lot of energy and love for the "performance of the job of being a poet," as you/Eileen say—energy that flew me through my twenties in New York, where I moved, as so many people do, to live the life of a poet (and, at that time, as a dancer), without having any idea what all that would entail. I just went on my nerve, all the way through, which served me well. I never thought I was solely a poet, but poetry was almost a metaphor, or a consolation, a crystallization, of what it meant to be a

language-maker—to care, inordinately, about words. And certainly I was that, aspired to be that. Falling in with Eileen was instructive; it kept the mythos well fed for many years, so much so that I dispensed with other forms of writing almost entirely.

Your recent interview with Eileen in *OR* magazine filled my heart with the reminder of the electricity, the sanctity, the *perversity* of the poet's job, the poet's life—the perverse beauty of wasting your life, as she says, being a poet: What could be better? I love and agree with everything she says about fieldwork, and about the work of poetry: about essentially making yourself into a lens, a recorder, a sieve, a receiver, so that all the world becomes your field, and poetry, the field notes, the record of your thought, spirit, and metabolism as one moves through it.

Alas, since moving to LA in 2005, I've written few to no poems. The urge simply fell away from me, though it has returned in bouts of crisis, beauty, or great feeling (falling in love with Harry, the death of loved ones, visits to impressive places, and so on). I have, however, written three books of nonfiction prose since moving to LA six years ago (*The Red Parts*, *Bluets*, and *The Art of Cruelty*—actually four, if you count *Women, the New York School, and Other True Abstractions*, which I edited here). These projects have been totally consuming, and totally satisfying. Each one has felt like it contained the information I needed, the writing journey I needed to be on. The feeling reminds me a lot of when I quit dancing: I had always identified as "a poet and a dancer," so it was strange for me to realize that a strong yoga practice could easily subsume my need to go to class or the studio, even to perform. Now I haven't danced in years, which is fine by me. At this very moment, so far as body and mind go, I would say I identify mostly as a swimmer and writer of prose, albeit one who is a poet first and always.

Since poetry is such a joke in the culture—theatrically revered and reviled at the same time—it needs a lot of apparatus to make it worth joining, worth sticking with. It needs a sense of nobility and worth, because God knows it isn't going to come from without. I will freely admit that

it has been empowering for me write books that have traveled in other spheres, not because those spheres are better or more important, but because they have expanded my sense of what writing is, in the world. But as the publishing world implodes, as I believe it is now doing, it's the poets who are going to know how to keep on keeping on. It's the poets who know how to get worth from their work for its own sake, to have dialogue with others (as opposed to the expectation or reality of $), to be a sustaining force, to press books into people's hands out of love, to return to books over and over again rather than toss out thousands in a pulp. It's poets who know that a DIY spirit is key not only to the future of books, but also to diminishing the ever-increasing stranglehold that corporations have on our lives.

And yet, at the moment, I feel as though there is more artistic and intellectual discovery for me in prose. I feel that I know certain tricks in poetry that make a poem "work," how to make fresh images and good beginnings and endings, but that a single good poem doesn't satisfy me as it used to, it no longer seems quite enough. (This feeling began when I was writing *Jane*.) UNLESS, as you say, one feels the urge to please someone rather specific, and one wants to test the wager, as you say, that the poem holds that energy for others. I often try to express myself to Harry in poems, for example, but whereas I used to think that the urge to express myself to a beloved was the same engine that made a good poem, now I'm not so sure. I feel distrust when I'm making poetic decisions that take the poem out of the realm of a communication and into "literature." Often I give poems to Harry with the caveat that I'm not trying to make it a perfect poem; I'm trying to communicate something to him.

In return for your poem, here is my favorite of these love poems, the first I ever wrote to Harry:

> I wake each dawn
> with a new idea
>
> The idea is you

You

Walking through
the boneyard of names

A windmill of sparks
I see you

Person

It had been Thanksgiving
Everyone was drunk

It had snowed
Where would you park

How would you find me
Your gait made of fire

in the boneyard of names

It's a very stripped-down poem, with two basic feelings: one, amazement at finding and beholding a novel, astonishing other; and two, wanting to tell that other, *I see you*. In your most stripped-down form, *Person*. I see you. And you are astonishing.

BB: Paul Celan holds hands with Robert Creeley: fire, bones, snow, thanks, names. I love that its question, "how would it (we) come together," is answered by the inevitability of that togetherness, in each day's "new idea," "you" again (and again).

I have been thinking about your smart gloss, earlier, of the argument for gay rights: "for the recognizability, visibility, and dignity of the queer subject." That compound noun is one I feel rather differently about since living these last two years in Missoula, Montana's most progressive city.

Here, I understand as a threatened minority, and am not likely to forget, the real reasons to organize, to stand in solidarity—and the purposes of being both recognizable and visible as queer. In the polarizing national media climate, a place with small or discreet gay population can produce some shocking public behavior; the local Tea Party organizer recently and reluctantly stepped down from his post after blogging, in reference to Matthew Shepard, "Where can I get that Wyoming instruction manual" about how to "hang . . . decorative fruits . . . where they can be admired." The stairwell down to the city's one gay bar, whose owner denies and rejects the designation, in a busy and boozy downtown scene is routinely the site of harassment. An antidiscrimination ordinance was passed by the city council earlier this year (because the state legislature has refused to do so several times), over the protests and hysteria and shocking propaganda by a group gathered in the cause "Not My Bathroom," an alarmingly well organized campaign that suggested that if Missoula required accommodation for transgender and transsexual people, young girls in public bathrooms are at great risk of being molested by "female-identified men."

It was a proud night as well as a *relief* that so many civic leaders, until well after 2:00 a.m., in three-minute speeches, spoke in favor of the ordinance before the mayor and the council, which passed the mostly toothless but—in my opinion—greatly significant measure. The lesbian population is larger than the number of out gay men, but you'd be hard pressed to call it a community. And most gay men who stay here are quiet and rather removed, "disinterested" in "politics," and many consciously pass as straight. Off the record maybe: An older man hit on me the other day and when I wasn't interested he told me that in his "old-goat" ways he's getting less anxious about humiliation and figures "one in ten" guys he offers a blow job at the post office will take him up on it. Then again, one in ten, he admitted, tend to spit on him or tell him he ought to have his ass kicked. So, you know, fine and great, anonymous sex, I suppose, *if* you feel there is an alternative, if it is a choice. He asked me if occasionally I need someone to help get me off. And I've been thinking about how and when and why "want" became "need" in that sentence of his, or when

"someone" came to describe himself as a sex partner. I've mostly chosen to live in places that have a deep and broad context for my sexuality, and it is fascinating, confusing, and a little exhausting to live in so spotty a community, where fear produces invisibility, and invisibility produces fear.

I suppose that is why I take umbrage with Jack Halberstam's provocation. It's different out here in America's middle. Rights are inventions, no doubt, constructs, sure; but equality under the law, eventually, has real social effects.

"The beyond marriage queers," *c'est moi*. I happen to think if civil unions were given the same exact partnership rights as marriage, the distortion that will accompany this national "debate" for at least another generation, and with increasingly harmful vilification, would be disinteresting to most. I think ultimately same-sex marriage is a religious issue, and like all religious issues, small and mean. It would be kind of reasonable if religious people got married and nonreligious people had civil unions. It's a nomenclature thing.

"Work from contingency rather than essence" is also a tricky proposition, in this matter. I love the sentence, and who wouldn't rather step into contingency than be essentializing. I take you to mean "don't consider a right inalienable, innate; engage the social conflict around discriminatory ideology as it arises." But it is awfully close to another familiar dynamic. Every queer person living probably has had some curiosity about life before Stonewall, before, even, the trials of Oscar Wilde, when arguably "homosexual" transitioned in popular understanding from a behavior or an act to an identity. Homosexual has not always been something to *be*. It was homosexual, what we did; not: I am now homosexual. Right? And it can be enticing to wish again that it were not understood as essence, that as a minority in a culture, you didn't have to *be* queer all day long.

Most people who have a difficult coming-out struggle recite and repeat all the other ways they identify (a writer, a son, a vegetarian, a friend) so as to not feel boxed by this one. A person's identities, all of them, should

be fluid and subject to change and flourish together, with great contra-diction even; but for a culture, homosexual identities themselves, beyond homosexual behavior in contingent contexts, are more useful. I've given some thought to and love the new direction in queer studies (José Muñoz, Michael Snediker) devoted to exploring or reviving "forward-dawning" queerness, utopian not univocal, queerness not "here and now" as, for in-stance, the incremental progress of "gay marriage" politics demands. But just as I don't think my freedom damages or depletes or discredits your freedom (it's not a zero-sum game, of course), I want to be one of a group that as a group secures the chance for happiness and self-expression for its most marginalized members. I know some of them here in western Montana.

(2012)

CHANGING THE FORMS IN DREAMS

On Alice Notley's *The Descent of Alette*

When I picked up *The Descent of Alette* a few weeks ago to try to find something to say about it that I hadn't already said in *Women, the New York School, and Other True Abstractions*, I was surprised to find its pages yellowed. Granted, the book isn't in the most protected spot in my house, and maybe Penguin used cheap paper. But more to the point: no matter how much Alice has written since *Alette*—and God knows she has written A LOT—I always think of *Alette* as having been written yesterday. It remains, in my mind, a kind of warm, beating heart (maybe I'm free-associating from an image from *Alette* itself, as in: "he was gone" "I still" "held his heart" "My hands were // red with" "its blood" "'What do I do now?'"*).

And yet, here are the facts. Alice published *Alette* in 1992, which is twenty-two years ago. When she published it, she was forty-seven; next year she turns seventy. Maybe more to the point—when *Alette* came out, I was *nineteen*; I wrote about it in my twenties. It seemed to me then the work of someone inestimably wise, shamanistic, as people often say of

* *The Descent of Alette* uses a poetic measure invented by Notley that consists of rhythmic units marked off by quotation marks. It takes a moment to get used to, and it makes reproducing lines from the book visually complex, but once you acclimate, you're rolling.

Alice—someone with a depth and reach of vision so original and nec-essary and impressive, I could stand only in youthful awe before it. It is humbling to realize that I am about the same age today that Alice was when she wrote *Alette*. It turns out that such vision and profundity don't necessarily come with age; they are Alice's singular gift.

So, why bother with this recitation of dates? Because it points toward something of greater interest to me, which is the nature of *Alette*'s contin-ued power. I wanted, still want, to know more about why *Alette* feels so fresh, why it abides, and why I believe it always will.

It's easy enough to say: it abides because it's written in a genre meant to abide, that is, it's an epic poem containing an archetypal journey to the underworld, in which our hero Alette must move through various stations of witness and transformation and eventually slay the Tyrant, thereby quote unquote healing the world. It's easy enough to say: it abides because we're still enslaved by the Tyrant, or whatever you want to call it—as Alice once put it in an email to me (during an interview in which I was pressing her, no doubt to her irritation, to discuss the New York School's cheery relation to "dailiness"): "I can't abide what the world has become, the frozen-ness of our product this evil thing that we kiss the ass of every hour. I want a dailiness that is free and beautiful." But there's more.

There was a time when I thought *Alette*'s most astonishing achievement was its weird denouement. I mean, how was Alice going to handle this meeting of Alette and the Tyrant, when she'd put so much pressure on the question of "what do women DO" in an epic poem (or in life), when so often woman's role was "essentially passive: sufferer, survivor." How would Alette's slaying of the Tyrant differ from all the other heroic sto-ries that revolve around acts of regenerative violence, that is, the blood of the villain gets shed, and with the felling of this single node of power, the bells of liberation (the end of the patriarchy, the death of capitalism, the end of our excavatory, ruinous treatment of the planet, and so on) suddenly toll. Back then I was preoccupied with questions of violence

and representation, so I ruminated for a long while on the terms of the Tyrant's slaying: that bizarre climax in which Alette comes across a bush that is somehow also the Tyrant's body (how weird and funny is it that, at the moment of his slaying, the Tyrant takes the form of a bush?). Alette must dig up this bush with her owl's talon, then sit back, blood-spattered, like a final girl in a horror movie, and tell him, "'I'm killing no one" "You are not real" "You said so" "yourself' (. . . .) "'Forms in dreams . . ." "forms in dreams . . ." (. . .) "'I will change the" "forms in dreams.'" I was fascinated by Alice's propositions re: dreams and reality, her contention that our actual, material lives change by changing the forms in dreams. As she wrote to me then, she thinks that "life is a dream; that we construct reality in a dreamlike way; that we agree to be in the same dream; and that the only way to change reality is to recognize its dreamlike qualities and act as if it is malleable." I wasn't sure if I bought it, but the power of *Alette*—the change I felt within me while taking its ride and after—gave me pause. For I can't think of another book that changed me—or that makes me feel that radical change is possible—the way *Alette* did and does. And I know a lot of people who feel the same way.

Reading *Alette* twenty-odd years later (I've read it in the intervening years, but I'm talking about the experience of reading it, like, this week), I'm find myself newly fascinated by how its mood, or attitude, interacts with its plot points and spatter.

I have to admit that I am feeling a lot of despair these days. Who isn't? I put on a good face, and I'm with Fred Moten when he talks about refusing the "academy of misery," when he talks about the importance of focusing on what we already have that we want to keep, rather than only on what "this evil thing that we kiss the ass of every hour" keeps from us, or keeps from being—or even seeming—possible. But the truth is that on many days I feel that the energy I project is really a version of what painter Francis Bacon called "exhilarated despair." This has its charms and drive, but it isn't really good enough. I have come to realize that, in addition to whatever Fred is saying, the thing I treasure most in his work is the *feeling* I get while and after reading it—a tone, a modality, a posture, maybe

even a form of body, that I can inhabit, that isn't despair, that isn't naive, that isn't hectoring, that has humor, that is fundamentally weird, that has kaleidoscopic knowledge and conviction, that has anger, that has joy, that flickers with agency informed by its dispossession, and vice versa.

Reading *Alette* now, its arc and its denouement seem less important; its mood, its posture, feel like everything. And I don't necessarily mean its epic mood—for the truth is that I've always kind of hated epic, hated archetype, hated anything Jungian, hated any notion of WINNOWING DOWN to basic, or "primal," forms, as if we might best understand ourselves as loose, all-purpose forms, amputated blobs, rather than luxuriating in orgies of specificity rich with indeterminacy and irony. *Alette* allows for archetype and radical particularity, both. Mood-wise, it gives the feeling of going for broke, while also reserving the option to disengage, to peace out. It offers a space to postulate the most indefensible, clichéd thoughts, to poke fun at archetypes while also granting them all their big power. (Some of the clichés Notley pokes fun at while also embracing: that there is a [male] locus of power that "owns form" that has interpenetrated us all, a Tyrant whom we need to "kill & change the world"; that our fundamental problem is that the "first mother of us all" [who was, of course, a brown woman, here imagined by a white woman] has been silenced, suppressed, and forgotten, her head severed from her body; that when her Cartesian split is healed and her speech restored, the blood will rush back to her kind, brown eyes, and the demise of the Tyrant will become possible; after his death, all the oppressed souls will rise up from the underworld and build something better together.)

Part of *Alette*'s genius is that it puts all of this on the table, and treats it with Alice's inimitable tone, which makes words like "funny" or "ironic" or "multifaceted" seem lame. So let me just give you a few examples. In Book One, which takes place in the subway, we meet a crazed woman crouching naked in the corner of a car, insisting that everyone has been "made by" "men, made out of man-thought"; she hides under her "ugly shawl," as she believes it is the only place where she can be "a woman's world," uncorrupted by the male (a position Alice has described in inter-

views as sharing in, but that is here portrayed with all its pitfalls: ideo-
logical purity, isolation to the point of psychosis, etc.). There's the fact
that, within this subway of horrors (as in *The Shining*, some subway cars
open to washes of blood), there is also pure comedy, as in the bit about
the eyeball rolling around on the floor ("This eyeball's funny" "on the
gray floor" . . . "What's it looking for?" "I guess, whatever."). There's the
subway car full of revolutionaries, whose macho revolution is purchased
at the price of a woman who is attached by a collar to a man's belt. There
are various fantasies of matriarchal power, which are seductive, but often
produce in the character Alette a certain disavowal, as when one potential
matriarch tells her, "'I was" "a queen . . .' / " "'before they banished me"
"beneath the earth" "made me" / "a serpent . . ." and Alette says, "I'm not
looking for" "a queen'" (. . .) / "Our mother would not" "be a mother" /
"of others' poverty." There's the fantasy of becoming liberated by becom-
ing "unsexed," which is complicated by the scene in which a man and a
woman detach their genitals and push them into a fleshy cave wall, then
become seized with panic, their minds lost. There's a discourse on our
animal nature, on the necessity of killing and eating and surviving and
protecting, which coexists with a disgust for unjust forms of such (and
who's to tell the difference? Who decides whose "weapons are moral"?).
There's her canny discourse on the roles of beauty and empathy—the
ways in which we need them, and the ways in which they can get repur-
posed and used against us—as when the Tyrant responds to Alette's grief
and rage: "'But it's all" "so beautiful," "so moving.'" ("'It is not *beautiful*,"
Alette screams at him. "It is what was!'") There's even an invocation—
intentional or not?—of the *Story of O*, in which O chooses an owl mask
for her final meeting with Sir Stephen, tyrant of Roissy, and asks for per-
mission to die (which he grants): What the hell is O doing here?

Alette holds all these questions in the bowl in their undiminished wild-
ness, in a varied and capacious tone that makes me feel able to keep going,
keep fighting, keep shape-shifting, keep seeking. Today I especially love
not just its grand gestures, but also its many moments of deflation, as
when Alette finally meets the Tyrant and finds that she has no impulse to
kill him, or to take any "drastic action" whatsoever. "'You didn't" "really

think" "you could kill me," "just // kill me?" "Kill me & change the world?'" he says before inviting her on a tour of his abode, to which she assents. Or as when, after the deed is done, a recently ascended woman nonchalantly picks up and folds the Tyrant's "clothlike body" into a "small square shape" and lays it to the side. Alette sits down "to rest & watch awhile" as a discussion picks up around her: "'Must we continue" "to live in" "this corpse of him?'" someone asks. "'But can't we make" / "something new now . . .'" another wonders. I wonder, too. I, too, fold up my little black rag of exhilarated despair and rest awhile, as the conversation begins to swarm around me.

(2014)

A GIRL WALKS INTO A BAR ...

On Peggy Ahwesh and Keith Sanborn's *The Deadman*

I'm so glad that Adam [Marnie] and Rebecca [Matalon] invited me to say a little about Peggy and Keith's 1989 film *The Deadman*. I've never introduced a movie before, so I feel a little nervous, as it seems a prime occasion to ruin an audience's fresh perception of a film before it begins. I don't want to do that, especially not to a film I love very much, not to mention one I love in part for its sense of surprise. So don't worry, I won't go on too long.

Any female viewer—or fuck it, any viewer, at this point—has a pretty good idea of how to finish the story line that begins, "A wasted, nearly naked chick walks into a bar." This is how Bataille has it in his short story "The Dead Man": "Marie broke loose, bit the dwarf on the dick and he screeched. Pierrot knocked her to the ground. He spread out her arms to form a cross: the others held her legs. Marie wailed: —Leave me alone. Then she fell silent. By the end she was panting, her eyes closed. . . . The scene in its slowness evoked the slaughter of a pig, or the burial of a god." Having been raised on indelible images of Jodie Foster's character being gang-raped in *The Accused*, Jennifer Jason Leigh's character being gang-raped in *Last Exit to Brooklyn*, Hilary Swank's character being gang-raped in *Boys Don't Cry*—I could go on and on—I find this particular cul-de-sac of cinematic history exhausting and potentially irredeemable.

Peggy and Keith's adaptation of Bataille's "The Dead Man" is one of the best inoculations, or *détournements*, or fuck-yous, to this history that I've ever seen. It's a funny, radical, stand-alone reclamation of realms in which so many of us have too often had to hold our noses and practice a robust disidentification in order to play. Not here. Peggy and Keith have made a party full of raunch and risk where I feel right at home. I'm stunned by its innovation and frenzy, in all the best ways.

As far as I understand it, Peggy got turned on to "The Dead Man"—first published posthumously in 1964—through Keith, who read Bataille in the '70s, translated "The Dead Man" into English, and published his translation of the story in 1989. Here is Peggy's account, in a 2001 interview, of how their adaptation came about:

> Yvonne Rainer had made *The Man Who Envied Women* [1985], where at the beginning of the film the woman packs up her bags and leaves the movie. I remember seeing that and thinking, "As a Lacanian response, that's really smart." It's a really knowledgeable, thought-through Lacanian position about women and sexuality in this culture—the woman can't even be *in* the movie because she's *so* misunderstood and misrepresented by language and imagery. I understood that gesture as an end point in a kind of logic about women and sexuality. First, you make the woman into text, and then you remove her from the movie.
>
> Keith and I had many discussions about this, and we were interested in somehow reinserting woman as a sexual agent into the movies. A sexed being, female, gendered, who was the *agent* of the action. In a nutshell, that's what we tried to do; that was the game that we were playing. Could you have a woman be the main character and have movie sex, and confront the audience in a material way? The film was basically about that, and about what you can discover in relation to

that. So in that way *The Deadman* was a response to *The Man Who Envied Women*.

And also, we thought the original Bataille story was fantastic.

As my life goes on and reveals its finitude, this strategy of barreling straight into the impossible idea (woman as sexual agent in a movie) rather than turning away from it (as in Rainer's walkout) only gains in appeal. And Peggy and Keith were just the people to do it.

Peggy comes out of the anti-art sensibility of punk, out of feminism, and out of lowbrow horror—she even once worked for filmmaker George Romero, of *Night of the Living Dead* fame. From Romero, as well as from hanging out in punk clubs, Peggy says she picked up the ethos "Have fun, make a movie, make friends, and mess around." That's the vibe of *The Deadman*. It was the first of her movies to have a script, which, she says, was read once then thrown out. Much of the film's wit and artistry got applied later—in the text cards, in the editing, in the sound collage (listen for the eerie, comical laugh tracks, such as the one that celebrates Marie vomiting on top of her shit). But the sense of an improvised mosh pit holds strong. It's art, and it's also hot, in that we get to watch real bodies doing real sexual things to each other, with all the mess and stakes. This is important, in that it refuses the idea that, as Peggy wrote in her working notes for the film, "there's no sex in feminist films," even as they remain "obsessed with issues of sexual difference and sexuality." Here, we get the sex, and the novelty of a "female, gendered, who [is] the *agent* of the action."

One of the difficulties of being a feminist who adores transgressive pornographic writers is that you can love the freshness of the writing while dreading being sucked back into a whirlpool of gender norms that threaten to kill off that freshness. Bataille is a fascinating writer in that this happens in his work quite rarely. As "Lord Ouch" puts it in his short introduction to Keith's translation of "The Dead Man" ("Lord Ouch" being

a play on Bataille's "Lord Auch" pseudonym): "What gender is Bataille's excess? What sex? . . . Bataille replaces the strictures of gender, sexuality and hierarchy, with the orgy of metaphoric chains and their inexorable combinations: eye/egg/testicle." That's one of the great pleasures of Bataille—that "the erotic theme . . . is never directly phallic," as Barthes put it. Combine this aspect of Bataille with Peggy's feminist sensibility and anarchic drive, and you get an exploration of perversity that nods to misogynstic tradition and feminist corrective while also devoting itself to nongendered erotics—the erotics of chaos, of self-abandon, of wrestling, of scatology, of necrophilia, of ugliness, of aggression, of suicidality, and so on. You also get something hilarious. For *The Deadman* is laugh-out-loud funny, from its opening shots of Jennifer Montgomery staggering around wearing nothing but a raincoat, eyeglasses, and combat boots, to her drunken wrestling-waltzing in the bar, to her body flailing off a bar stool as someone tries to give her head, and so on.

I have no idea how Peggy and Keith worked together on the film, but I'm still chuckling at a preshoot letter written to them by performance artist and drag king pioneer Diane Torr (who eventually plays the barmaid). In this letter—which is collected in the "Deadman Sourcebook," a collage of research and correspondence illuminating the film's process—Torr writes: "It's obvious to me that you are both talented, gifted, skilled, intelligent and have extraordinary insight in terms of contemporary thought. But you are skilled in different areas. Keith worked hard on the translation and the script in preparation for the shoot. . . . Peggy has a remarkable talent at getting people to do things in front of a camera that take guts and lack of inhibition. . . . I don't mean to downgrade you Keith, in saying this, but I simply feel that you don't have the 'way with people' or whatever you want to call it, that Peggy has. . . . You have different aesthetics. There seemed to be no coalescence." I don't know whether Keith ended up on set or not, nor do I know by what dialectical process they eventually got their aesthetics and skill sets to coalesce. But coalesce they did, producing a short, wild film crackling with disturbance and pleasure.

(2015)

POROUSNESS, PERVERSITY, PHARMACOPORNOGRAPHIA

On Matthew Barney's *OTTO* Trilogy

The camera pans down a tunnel—maybe one of those interminable pedestrian tunnels under Fourteenth Street in New York—before landing on a bearded male figure in football regalia (Jim Otto's 00 jersey, to be exact), his body affixed to a sculptural form recalling a pillory. By "affixed," I mean arms above the shoulders and restrained; legs spread; a huge white shaft, maybe about three feet long, penetrating his mouth; a speculum on the shaft's opposite end threatening a further widening. A greasy facsimile of Al Davis shows up (played by the artist's mother, in prostheses), to stalk around the motionless, mouth-stuffed figure, seemingly appraising the body, lecturing it, lightly threatening it, before giving a kick that magically sets the figure free, running, perhaps, into an unseen game.

The body impaled, the body restrained, the body for hire, appraised, encased in apparatus, penetrated. By some logics, this doesn't typically describe the white male body. But why not? What is penetrability, anyway? In Angela Carter's terrific book *The Sadeian Woman and the Ideology of Pornography* (1978), Carter describes how pornography typically involves "an abstraction of human intercourse in which the self is reduced to its

formal element"—or, rather, two formal elements: "the probe and the fringed hole," which represent "the simplest expression of stark and ineradicable sexual differentiation." Under this ubiquitous symbolic regime, "the male is positive, an exclamation mark," whereas "woman is negative. Between her legs lies nothing but zero, the sign for nothing." In the universe of Matthew Barney's *OTTO* trilogy, however, it's Jim Otto who wears the 00, symbolizing, for Barney, a "twin roving rectum"; there's also the Character of Positive Restraint, who uses vaginal specula to open up the orifices of his body, which are eventually penetrated with bagpipe drones, ice screws, and large-pearl tapioca.

Rather than confirm the structural clichés about penetration described by Carter, these images offer novel ways of conceptualizing or perceiving porousness. Sometimes, as with the tapioca, it's about a soft filling; sometimes, as with the bagpipes, it's the injection of an element; sometimes, as with the ice screws, it's the construction of a circuit. Whatever the proposition, the action of the *OTTO* trilogy takes place in a world unloosed from "our current configuration of gender dimorphism"—a configuration that, as Paul Preciado has it in *Testo Junkie* (2008), "only the bodies of cis-females, trans-females, and gays are considered to be *potentially penetrable bodies*, in the same way that only the bodies of cis-males present themselves and are represented as natural and universal penetrators."

One reason for this unloosing is that Barney's avowed interest—on display here and developed further in the *CREMASTER Cycle*—lies in the space prior to sexual differentiation. But were that unequivocally the case, the visual signifiers on offer would presumably be gender neutral, as in predifferentiation, whereas part of the pleasure of this work is that it feels like a staged resistance to a differentiation that has already occurred or is always occurring, but has proven itself to be plastic. Hence the pleasure of *RADIAL DRILL*, in which Barney appears in drag—or in disguise, to use the piece's logic—as an Audrey Hepburn figure, impossibly beautiful and graceful, muscled back rippling out of black evening dress, or the

pleasure of watching Barney's mother performing as Davis, who is, ironically, the first of what Barney calls "the paternal characters in the work."

Barney says these paternal characters are not so much father figures as they are "paternal phalluses, a phallus constructed by the child out of his own excrement." And indeed, any interest in the suspended state before sexual differentiation is going to bring us, sooner or later, to the anus. As Preciado writes, the anus "has no gender. Neither male nor female, it creates a short circuit in the division of the sexes. As a center of primordial passivity and a perfect locale for the abject, positioned close to waste and shit, it serves as the universal black hole into which rush genders, sexes, identities, and capital. The West has designed a tube with two orifices: a mouth that emits public signs and an impenetrable anus around which it winds a male, heterosexual subject, which acquires the status of a socially privileged body." Note how, once again, the notion of the unpenetrated body quickly aligns with that of the "male, heterosexual subject." Even queer theorists such as Leo Bersani, whose classic essay "Is the Rectum a Grave?," first published in *October* magazine in 1987, seems like required reading here, insisted on the equation "*To be penetrated is to abdicate power.*"

Written in response to the AIDS crisis, Bersani's (in)famous essay provocatively underscores the link between the US government's murderous policies toward AIDS patients, the culture's rabid hostility toward male penetrability, and the supposedly porous, masochistic state of being female. Bersani sums up this link in his comment about homophobes' paranoid response to so-called innocent victims of AIDS: "In looking at three hemophiliac children, they may have seen—that is, unconsciously represented—the infinitely more seductive and intolerable image of a grown man, legs high in the air, unable to refuse the suicidal ecstasy of being a woman." Given the *OTTO* trilogy's appearance in the early '90s, at the height of the AIDS epidemic, it makes sense to me that whatever alternate propositions Barney may have been exploring might have been hard to absorb or discern. In fact, I believe one of the great innovations of this early work lies precisely in its disinterest in the aforementioned

models of penetrability, and in its construction of alternate visual and narrative systems by which the porous body might differently mean.

Another term for such alternative systems might be "polymorphous perversity," which was Freud's amoral description of the relatively omnivorous, unfocused sexuality of children prior to their "graduation" to genitally focused, reproductive sexuality. Indeed, as I first began to contemplate this early work, Barney sent me in the direction of French Freudian Janine Chasseguet-Smirgel's 1984 book *Creativity and Perversion*, which Barney recalls being an inspiration. "I was walking through the Yale Co-op picking up my course books for a psychology class and I noticed it on the shelf," he told me. "I can't remember if the course was abnormal psychology or child psychology. I believe it was 1987. This was around the same time I was exposed to J. G. Ballard. In my memory I connect the interest with Chasseguet-Smirgel to Ballard and other things I was starting to explore outside of my coursework at that time." Like so many encounters with texts (or ideas, or objects, or people) that end up shaping our work in fundamental ways, Barney's discovery of *Creativity and Perversion* seems part chance, part overdetermined. Either way, the book is a revealing source, both for what it argues, and for the role Chasseguet-Smirgel's work has occupied in the world.

The basic argument of *Creativity and Perversion* is that regression to the anal-sadistic phase erodes differences between sexes and generations. The pervert who regresses (or, as Freud had it, simply remains) in the anal-sadistic phase of development aims to annihilate the universe of differences (the genital universe) and remain instead in an anal universe, in which the (male) subject believes he can compete with his father for his mother's attention with an immature phallus, that is, one made out of shit. In this sense, the pervert is trying to free himself from, or at least resist, the paternal universe and the constraints of its law, by thoroughly believing that pregenitality is as good as or better than genitality.

Back in the 1960s, Chasseguet-Smirgel and her husband, psychoanalyst Béla Grunberger, wrote critiques of the May '68 protesters under the com-

bined pseudonym "André Stéphane." These critiques were subsequently lambasted by figures such as Deleuze and Guattari; in *Anti-Oedipus*, they call Stéphane part of a group of conservative reactionaries—cop-like analysts who consider all those who "do not bow to the imperialism of Oedipus as dangerous deviants, leftists who ought to be handed over to social and police repression." Experienced apart from this context, however, *Creativity and Perversion* comes off as more happily descriptive than disciplinary. Undoubtedly, Chasseguet-Smirgel considers perversion a problem—it is, she argues, essentially based on a delusion, as it denies the "fundamental fact of sexual difference" (which her husband calls the "bedrock of reality," sigh); she also regularly connects perversion with extreme political ideologies, such as Nazism. But her contention (echoing Freud) that there is a "'perverse core' latent within each one of us that is capable of being activated under circumstances" reads to me—and, I imagine, to Barney—as more of a goad to set up shop than a warning against alleged perils.

This is especially so considering how generative Chasseguet-Smirgel considers the perverse state to be, even if its particular creativity generates (according to her) primarily false gods, delusions, fetishes, and aestheticism. (She uses Oscar Wilde as a prime example.) In Chasseguet-Smirgel's view, this creativity derives from the pervert's attempts to "disavow his father's (genital) capacities and to accomplish a (magic) transmutation of reality by delving into the undifferentiated anal-sadistic dimension." (Magic) transmutation seems to me a very apt description of Barney's early videos, sculptures, and actions. The work does not propose anything as concrete as an alternate reality (we are still in recognizable places—elevator shafts, white-box gallery, underground parking lot, and so on), but it most certainly enacts a transmutation of those spaces (e.g., a gallery is now a place one has to climb across while suspended from the ceiling, a ramp in an underground parking lot is now a place for teams in kilts to push a football blocking sled, and so on).

Even the most cursory reading of *Creativity and Perversion* provides a loose key to titles or concepts in the *OTTO* trilogy that may otherwise

strike some as arcane. I'm thinking not only of Chasseguet-Smirgel's elaboration of the anal-sadistic world as a world of serious play (e.g., the Anal Sadistic Warrior, who must cross the gallery ceiling using a harness, carabiners, and ice screws) but also of her focus on hubris, especially as it relates to notions of excess, extremity, outrageousness, and hybridity. (*Hubris*, Chasseguet-Smirgel argues, shares a root with the Greek word for *hybrid*.) This latter discussion sheds light on—though by no means makes plain—the presence of the "Hubris Pill" in the trilogy, especially its mutation into other forms (glucose-sucrose hard candy, petroleum jelly, large-pearl tapioca, pound cake).

As if in testimony to the power of startling images over rote analysis, *Creativity and Perversion* is at its most compelling when Chasseguet-Smirgel forgoes the standard Oedipal script and instead transcribes images from the dreams of her "'pervert' patients." One patient dreams of being required to meticulously coat "a huge pile of logs, all alike" with silver paint ("masking the excremental world with a surface of shining paint" is a recurrent favorite image/activity for both Chasseguet-Smirgel and her patients). Another dreams that her lover's penis is "very like some kind of dog's shit that litters the pavement" (this image ends the book, in a rare moment of literary flourish). Add these together with Barney's notion of his paternal characters as phalluses "constructed by the child out of his own excrement" (and, much later, the repeated image of turds or penises enfoiled in gold in 2014's *River of Fundament*), and you have the blossomed expression of a classically perverse universe.

Given that Barney plucked *Creativity and Perversion* off a shelf and took what he needed from it (as artists do and must), it's likely he may not have known or cared much about the political position Chasseguet-Smirgel and Grunberger occupied in French intellectual circles. Their orientation matters, however, insofar as it sheds light on the differences between subversion, transgression, and perversion—words that customarily get tossed together when talking about art, as if being in the same ballpark made them near synonyms. *Subversion*—which derives from the Latin for "overthrow"—refers to an attempt to transform an established order.

Transgression—which derives from the Latin for "going over or across"—implies the crossing, typically intentional, of a line or a law. But as we have seen, *perversion*—which derives from the Latin for "turning around or away"—has to do with "an alteration of something from its original course, meaning, or state." In other words, as per the excrement painted in silver or gold, perversion enacts a sort of alchemy. On the one hand, its ambitions are smaller than those of subversion: perversion has no serious designs on upending the power structures that be. On the other—as Chasseguet-Smirgel makes clear via her discussion of hubris—the pervert's alchemical aspirations and activities have a special largesse, insofar as they threaten to become godlike: "The man who does not respect the law of differentiation challenges God. He creates new combinations of new shapes and new kinds. He takes the place of the Creator and becomes a demiurge." Barney has long been interested in this role, or this space, which he has elsewhere described as "the threshold between hubris and some kind of real but repressed omnipotence."

Deleuze and Guattari wisely point out that the whole notion of a pregenital state defined by sexual undifferentiation is but a reversal of the differentiation posited by Oedipus. Therefore, the whole notion of regressions to and progressions from undifferentiation "are made only within the artificially closed vessel of Oedipus"; outside this vessel, they cease to mean. For the pervert, however, this "artificially closed vessel" acts not so much as a conceptual prison, but as a field of play. And the more elaborate and dedicated the play, the more the closed vessel begins to involute and reveal a certain spaciousness. Barney's work—which circulates obsessively around evocations of closed circuits and the possibility/threat of release (see also his *Drawing Restraint* series)—knows the paradoxes and possibilities of this terrain exceedingly well. Unlike Chasseguet-Smirgel and her Freudian peers, however, who so often seem to skim the realm of the bodily for psychic concepts—such as "drives"—only to shepherd them around abstractly or allegorically, Barney remains devoted to physicality. He remains especially devoted to what I would call, after Preciado, the body's pharmacopornographic dimensions.

Preciado argues that, in the latter half of the twentieth century, the economy of the automobile (Fordism) was superseded by a new economy—"pharmacopornism"—which is dominated "by the industry of the pill, the masturbatory logic of pornography, and the chain of excitation-frustration on which it is based." This economy—aka our economy, and certainly that of the '90s, when Barney was making the *OTTO* trilogy—runs on something Preciado calls "potential gaundendi"—"the (real or virtual) strength of a body's total excitation." This excitation "is of indeterminate capacity; it has no gender; it is neither male nor female, neither human nor animal, neither animated nor inanimate. Its orientation emphasizes neither the feminine nor the masculine and creates no boundary between heterosexuality and homosexuality or between object and subject; neither does it know the difference between being excited, being exciting, or being-excited-with. It favors no organ over any other, so that the penis possesses no more orgasmic force than the vagina, the eye, or the toe." Unlike a Freudian schema, in which the subject marches teleologically through oral, anal, and genital stations, in a pharmacopornographic system, all bodily systems—endrocrinal, digestive, sexual, molecular, and so on—play a part, and simultaneously. In such a system, it doesn't really matter who's fucking or getting fucked, or if the substance at issue is antacids or antidepressants or Viagra or testosterone or birth control pills or steroids or human chorionic gonadotropin. What matters is that your excitation, what you take in and excrete out, is the circulating currency.

In this economy, sexuality is not a disruptive or liberatory force in the face of pharmacy or capital, but rather a crucial node in its operation. Perhaps for this reason, Preciado's theory has been exciting to some and a downer for others. (Or both, in turns.) It has the virtue of sidestepping Oedipus—or, rather, of treating it, à la Foucault, as but a chapter in the greater machinery of the biopolitical/pharmacopornographic era. But the theory also refrains from treating polymorphous perversity as an inarguably heroic, subversive, or redemptive force, as some queer theory has tended to do. Instead, the polymorphic nature of our perversities allows for them to enter the marketplace—or be penetrated by it—via that many more orifices. No accident that *Testo Junkie*—the book that

lays out Preciado's pharmacopornographic thesis—opens with a section titled "Videopenetration," in which Preciado sets up a video camera to film an auto–double penetration in drag. Which brings us back to the *OTTO* trilogy, and its particular, relentless conjoining of athletic, medical, pharmacological, and pornographic registers: the autopenetrations; the football regalia; the coveted, mutating pills; the vial of human chorionic gonadotropin in the chilly sculpture *Transexualis*; the repeated use of specula; the invocation of pornographic tropes (as in one person filming another's anus as it descends on his face).

Perhaps it's here that Barney meets Bersani, insofar as Bersani insists, at the end of "Is the Rectum a Grave?," that instead of attempting to redeem particular aspects of sexuality and celebrate them as emancipatory, democratic, and subversive, we might instead believe that *"the value of sexuality itself is to demean the seriousness of efforts to redeem it."* I find this a liberating thought, especially in regard to Barney's work. Not only does this approach relieve art of the whole redemption/emancipation burden so often placed on it, but it also clears away a certain demand for seriousness. In other words, it makes space to play, and to take that play extremely seriously (as in, say, football, or the Anal Sadistic Warrior's travail across the gallery ceiling). Barney's idiosyncratic dilations in the *OTTO* trilogy and beyond demonstrate over and over again that there is no *one* expression of "polymorphous perversity"—a fact that should be made obvious by the very word *polymorphous*, but that can be strangely hard to remember, especially in the face of any schema, Freudian or queer or other, that would aim to make use of perversity in an instrumental, homogenizing, or redemptive way.

—

Barney's work has long been characterized by its combination of detailed, somewhat abstruse backstory (manifested in titles, explanations, accompanying drawings, and a wide array of iconographic references) and the visceral impact of the work itself, whose import deepens with explanatory context, but that definitively holds its own without it. The *OTTO*

trilogy is no exception. Barney has explained, for instance, that there is a chase going on here between an antagonist faction (Jim Otto/Al Davis) and protagonist (the Character of Positive Restraint/Houdini), and an essential narrative conflict at stake (i.e., the antagonist faction wants the Houdini faction to expel energy—often figured as air from bagpipes on the cusp of playing "Amazing Grace"—whereas the Houdini faction wants to keep holes sealed, suspended in a state of unexpressed potential). But not much, if any, of this narrative is obvious to the viewer, certainly not on initial exposure, and perhaps not even with repeated viewings. (Indeed, since the videos are silent, there is no way of knowing that the song "Amazing Grace" is even at issue, though the drama around expelling the air from the bagpipes is acutely legible.)

Although he's happy to offer a detailed explanation of the action at hand, I suspect Barney intends the relationship between such explanation and the immediate, visual experience to be loose. In fact, he says he was preoccupied at the time of this work's making with the action being "suggestion, not concrete, and for the narrative to be nonlinear but looping." He says he wanted the monitors "to feel ambient in the space, like those in an airport or Off Track Betting parlor," and that the videos could "function like a proposal rather than a fact." In other words, a chase might be going on, and one with a central conflict, but "chase" and "conflict" are here repurposed into dynamics or moods more than narrative unspoolings.

The difference matters, especially as it lends insight into Barney's particular way of working with images, bodies, and ideas. Choreographer William Forsythe has said (in a 2006 *BOMB* interview) that Barney is himself "an absolutely superior choreographer in every sense. Really one of the best in our field. No one moves ideas around like he does." In a 1995 piece in *Parkett*, Keith Seward compares Barney's work to Artaud's desire to stage "events" or "emanations of forces" rather than "men," aka psychologized individuals. But Barney never vanishes particular bodies in order to shepherd ideas, events, or forces through space and time. Instead, he works *through* them—often literally, by exploring the body's capacity to absorb, infiltrate, or expel. And while he has evi-

denced a long-standing interest in mythologies of different kinds, his use of them does not reflect the problem, articulated by Carter, that "myths deal in false universals, to dull the pain of particular circumstances." Bodies, no matter how strange, are always particular circumstances. Jim Otto may be the "porous, perforated" antagonist (aka the Hypothermal Penetrator) who "seeks to open more orifices in others," and Houdini the "self-contained, sealed-off, hermetic" protagonist, but these figures are not archetypes. Their universe and activities are too surprising and strange simply to "represent." Instead, via their idiosyncrasy, they make a new thing—something suspended between myth, event, forces, characters, and individual bodies.

This suspension is critical for Barney. In the *OTTO* trilogy, it's also literal. Though they constitute some of the longest video pieces here and have the least variability of image, I continue to find the two cross-ceiling climbs—*MILE HIGH Threshold* and *BLIND PERINEUM*— among the most compelling. The obvious difficulty of the physical feat being attempted, combined with the ridiculousness of the image (Barney dangling naked, save silicone swim cap, harness, socks and shoes, and a tail fan of ice screws), sets the viewer rocking between seriousness (will he complete the next move without falling?!) and inanity (this is art?! etc.). Over the course of watching, however, one gets enjoyably lost in the daft, mesmerizing momentum of simple physical effort. This momentum seems skimmed off any operative plot about Houdini and Jim Otto rather than constitutive of it—a feeling key to Barney's approach to narrative and abstraction. *Abstraction* derives from the Latin "to draw away"; the abstraction here arrives via Barney's separation of the propulsive force of each scene from the more elaborate narrative that may have generated it, a method reminiscent of Gertrude Stein's activation of the power of the declarative while leaving sense-making behind (as in insistences such as "Sugar is not a vegetable").

As with Stein, a certain confidence of gesture and pacing is critical. Consider the perfect, three-minute skit of *Delay of Game*, in which the Character of Positive Restraint (played by Barney) appears in a retro

one-piece white swimsuit, white sunglasses, white pumps, white turban, and white robe, à la Lana Turner. She removes a pearl from her glove, deposits the pearl into an orifice on the ground, crouches for a snap from center that never arrives, and then exits while pushing a sculpture (the *PACE CAR FOR THE HUBRIS PILL*) and offering a First Lady–style wave and smile. The scene is remarkable for the physical grace of its character— Barney is as strong and beautiful cross-dressed as he is as Houdini—and for the sheer pleasure that this grace offers, a grace augmented by the scene's narrative mystery.

That final smile seems to crack something in this work open. I'm not sure whether it's just the glimpse, however theatrical, of someone enjoying herself in what can sometimes feel a grim, grayscale, sedulous landscape, or if it's my projection of the pleasure Barney might be taking in this work, in making and inhabiting this world, these character zones. Whatever it is, it feels like a portal to the linked subjects of humor, physical grace, and the startling image in Barney's work, all of which come together to suggest that something else is possible within the pharmacopornographic regime—a new game, or at least a novel way to play the field.

The use of the startling image in the *OTTO* trilogy strikes me as all the more intriguing when compared with the *CREMASTER*s that followed. Despite obvious abiding interests (in athleticism, in suspension, in phar-macopornographia), the opening shots of *CREMASTER 1* (1995)—a large cast of chorus girls in opulent pink and orange stands on royal-blue Astroturf, a bright brassy soundtrack playing behind—it's clear that the palette, the aesthetic stakes, have changed. Perhaps because of the lush-ness, the extravagance, the chromophilia of the high-quality images to come, the dingy, lo-fi footage of, say, figures in Black Watch tartan push-ing a dank pink sled through an underground garage, or of Barney's Houdini character struggling, in grainy, close-up footage, to thread to-gether ice-climbing screws that have been inserted into his rectum and mouth, feel like distilled, punk experiments with pacing, surprise, and absorption.

One of my favorite startling images from the *OTTO* trilogy is that of two sets of hands wrapped in athletic tape and sodden with petroleum jelly doggedly sewing together the hems of two kilts, presumably to construct a new monstrous body. The image brings to mind the sculptures of Meret Oppenheim, especially her *Das Paar* (1936), in which two brown women's boots are weirdly attached at the toe, and *Ma Gouvernante* (1936), in which two women's white pumps have been trussed together with tight brown string and placed on a silver platter. Like most Surrealist or Surrealist-influenced artists, Barney and Oppenheim would seem to have a stake in "the image" as theorized by French poet Pierre Reverdy, who, in his miniessay "The Image" (1918), wrote "[The image] is not born from a comparison but from bringing together two or more less distant realities. . . . An image is not strong because it is BRUTAL or FANTASTIC—but because the association of ideas is distant and fitting [*juste*]." Barney and Oppenheim perfect but also pervert this process, insofar as both not only bring together "distant realities" but also create images that double back on themselves, invoking the specters of self-cannibalism, autoeroticism, and the discomfiting twin fantasies of interpenetration and impermeability.

For while penetration bears its own species of pleasure and threat, so, too, does closed circuitry. I'm thinking of the great sequence in the *OTTO* trilogy in which several naked bodies lie with their backs to one another, a bagpipe drone inserted into each of their anuses, the full bag of the instrument lying in the space between. The Jim Otto figure, now dressed in full tartan regalia, comes running at the bag, presumably to jump on it and expel the air into the waiting bodies. We never see him land—as in a horror movie, we're left to imagine the wind enema to come. Instead, Barney cuts to the Black Watch tartan team sticking their heads into three floppy pink orifice-vats as if at a no-hands pie-eating contest; their faces come up dripping with strands of alien-like goop, punctuated by huge tapioca pearls. The disruption of momentum here, coupled with the surprise of the juxtaposition, is pure absurdist comedy. Its satisfactions derive from Barney's skill exploring how far or how long the abstract or

unresolved can hold one's attention, and how juxtaposition and interruption can reroute the foreboding of action.

Given the depth of Barney's commitment to this mode, the concluding remarks of Calvin Tomkins's 2003 *New Yorker* profile of Barney would seem to seriously miss the point: "A lot of people are wondering what's next for Matthew Barney. If we consider that the prevailing metaphor of the *CREMASTER Cycle* was pre-genital, there's no telling what he'll bring us when the creative organs fully descend." O how difficult it is, to give up the Oedipal dream! Barney is no stranger to this conundrum. In fact, if there's one thing his work has played out over the past twenty years, it's the pathos of what it might mean—for himself, for the culture, for grandiose white males like Norman Mailer (and for those anxiously awaiting their demise)—to keep alive the dream of making epic, "mature" works of genius when the cultural appetite for such figures and works has (finally, understandably) shriveled, and when one also has a rich knowledge of (and appreciation for) the expansive possibilities of the perverse, which is, by definition, "immature." Barney's work since the *OTTO* trilogy has derived much of its energy and controversy from its devotion to this paradox. From this vantage point, the *OTTO* trilogy seems to me not so much like a first act, and more of an eerie, quietly hilarious, pleasure-giving node in the ongoing loop of Barney's singular, propulsive, essentially irresolvable form of narrative sculpture.

(2016)

THE GRIND

On Prince

In 1984, when I was ten, my father died. He was a small man, five-five tops, jammed with energy. I understood. Energy felt to me then, as it does to so many kids, like an unstoppable force run through a kaleidoscope of affect—at times electric, then liquid, popping, burning. Above all, it felt uncontainable. The miracle is that our skin contains it, for the most part. Was I sexual at ten? I don't know. I know my father died, and then, suddenly, there was Prince.

1984 was also the year of *Purple Rain*. We saw it in the theaters and then my sister and I watched it innumerable times downstairs in our TV room. Our lair. I had already watched and would watch a lot of rock musicals—*Sgt. Pepper's Lonely Hearts Club Band*, *The Song Remains the Same*, *Tommy*, *The Wall*. I liked parts of these movies and had moments of cathexis, but nothing really stuck. Maybe because they were full of white British men whose angst was fundamentally inscrutable to me, and seemingly tethered to Margaret Thatcher, whoever that was, or grossly thefted from American blues. Maybe it was because the girls in the movies were sticks—who wanted to be Strawberry Fields, chained up while Aerosmith sings "Come Together" at you menacingly? And while God knows I wanted to be the hippie chick conjured in Led Zeppelin's "Going to California," I already sensed that was just some guy's dream, because

the hippie girls I knew who fit the part either had to go along with their hippie-fascist boyfriends in a haze of suppressed agency or they spoke up and the dudes lost interest "pronto." Anyway, that girl was pretty and probably liked to get fucked in a field of flowers, blond ringlets spread out on a velvet blanket strewn with empty goblets, but she wasn't seething with electric energy, she didn't talk, she didn't grind.

Then there was *Purple Rain*. Did I want to be Prince or be with Prince? I think the beauty is, neither. He made it okay to feel what he was feeling, what I was feeling. I wanted to be a diminutive, profuse, electric ribbon of horniness and divine grace. I bought a white shirt with ruffles down the front and wore it with skintight crushed-velvet hot pants, laid a full-length mirror on the floor and slithered atop it, imitating Prince's closing slither on the elevated amp in "Darling Nikki." Yeah, he's telling Apollonia to come back, but you can tell he doesn't really give a shit about Apollonia. He's possessed by something else, his life force onstage. Half-naked, wearing only black bolero pants and a black kerchief tied over the top part of his face, his torso slick with sweat, Prince is telling us a story. An important one.

The story is of a woman whom he meets while she's masturbating. I guess you could say she was a sex fiend. Not a slut, mind you. A sex fiend. Yes, that's it. No word in high school for that, because to be a fiend is to be beyond shame. You can make fun of someone whom you think has been humiliated by sucking dick on the playground, but what can you do with a sex fiend? A sex fiend who knows how to pleasure herself. A sex fiend who wants to, knows how to, grind.

I wanted to grind. I didn't want to be dominated or to dominate; maybe that would come later. In 1984, 1985, 1986, I wanted to grind.

And so I slithered on my mirror and told my sister to call me Princess. She understood. She was into Wendy and Lisa, the first dykes either of us had ever seen. And the brilliant part was that no one had to tell you they were dykes. You just knew, because they were always together, be-

cause they played their instruments without self-consciousness, and be-
cause Lisa says, "Wendy?" and Wendy answers, "Yes, Lisa." And then
they grind. And so my sister became a dyke and I became a sex fiend. Or
maybe I became a dyke and she became a sex fiend. Or we both became
both and neither, or, as "I Would Die 4 U" had it, we became "something
that you'll never comprehend."

I cannot overemphasize the importance of Wendy and Lisa. That they
were just there, the first women I'd ever seen as fundamental parts of
a band, a band that shredded. They were the stoic dudes keeping it to-
gether to Prince's histrionic grace. But even that's not right. I never saw
Prince as womanly or manly or even androgynous. He was just beauty,
grace, energy, sex, light. He came undone and left it all on the floor, and
also moved in tight formation, choreographed chic. The opening chords
of "Purple Rain" are the opening of a conversation. A plaintive, resigned,
questing conversation. (In the movie, they're played by Lisa.)

He was a hot little guy, the kind of guy whose profound sex appeal none
of the other guys, certainly not Morris Day, can understand. Day and his
macho buddy roll their eyes and shake their heads as Prince starts in on
"Darling Nikki." Prince is doing that weird thing with one of his hands
that we all imitated, where you make one hand look like it's the hand of
an other, creeping down the side of your face. It's Nikki's hand, it's one's
own self-pleasuring hand, it's creepy, one's own body made other. It's self-
seduction, a magic trick. It's the masturbatory dream, that one's hand
could feel the way the hand of an other feels on you. I think this was
another of Prince's gifts—to keep self-seduction and alloseduction on a
rollicking continuum, like those rectangular boxes that contain a bright-
blue wave rolling back and forth. Why decide between onanism and ob-
session, when you can just celebrate the root energy of each?

No accident, then, that by 1986, when I started to want to be touched
and touch someone besides myself, I picked out an incredibly small guy
who wore eyeliner and lipstick and most definitively was an unrepentant
sex fiend. Not in the way that so many teenage boys are, with their gross

language about "boning"—you know, all the Brock Turners or medium-grade Brock Turners of the world. A sex fiend is someone who actually likes sex, not just the getting-off part but also the dirty parts, the salty mess of it. And so my androgyne boyfriend liked the mess, and so did I. Grinding that's good enough you don't need to tell anyone about it. And I sincerely doubt he told anyone about it, because, being small and femme and freakish, he wasn't "in" with the other eighth-grade boys. But I bet he was the only one getting it. I'm telling you this now because I hate the way this possibility of experience for boys and girls and everyone in between gets drowned out in moralistic crap about power and consent, all of which is necessary but too often eclipses the real divine electric dirtiness that is possible between excited young bodies who have accepted that they have desire and somehow manage to find each other. I want people, especially girls, to know that that's possible. It's possible even when you're thirteen, fifteen, and it can be great.

I recited "Darling Nikki" for two years like a prayer. Then, there was high school. The *Purple Rain* moment had passed, but I am here going to credit any good sex that happened over the next few years to Prince. He was so many things besides a sex symbol for suburban white girls like myself, so please forgive me my momentary narrowness. I'm just struggling to give my thanks. I imbibed it then without naming it, but I can see now how important it was that his feminism and queerness and blackness all blazed together, implicit, a streak of insistence on what's possible, a rejection of the paltry ways of being that pretend to be all that's on offer.

It may bear interjecting here that friends of mine who've watched the movie more recently—I haven't seen it for more than thirty years—have told me that it isn't nearly as female-friendly as I remember. Indeed, as one friend told me this, the image of a jabbering woman being thrown into a dumpster came to mind. I asked, grimacing, "Oh shit, does a woman get thrown into a dumpster?" "Oh, yeah," she said. "And that's just the start." Other images then flickered back: the humiliation of low-to-no-talent Apollonia, with Day's dog collar around her neck, The Kid's mother cowering from her husband's blows, and so on. So I guess the

more complex question is, How does a girl figure out, amid the crushing misogyny all around her, how to pick out the avenues that will prove most emancipatory, pleasure-giving, and life-sustaining? I'm sorry to say that this skill remains as urgent now as it ever was, so maybe I have *Purple Rain* to thank for that, too.

In any event, Tipper Gore had it so wrong. Of all the music, all the forms of sexuality that were on offer to the youth in 1984, "Darling Nikki" was first rate. Female autonomy, mind-blowing, consensual, victimless perversion, and a dirty little Prince who wants to grind grind grind grind grind grind grind grind grind grind. Did Tipper ever listen to that strange hymn at the end of "Darling Nikki"? You have to play it backward— hallmark, in other realms, of the satanic. My sister and I played it. We knew what it said. Do you know? It says, The Lord's coming, Prince is coming. And somehow, with his help, we learned how to come, too.

(2016)

IF I DIDN'T TELL IT

On Zackary Drucker and Rhys Ernst's *Relationship*

"There was something about my particular life," Eileen Myles once said in an interview, "as a female, as a person prone to drug and alcohol abuse, as a lesbian—that I sensed was endangered. I had a feeling nobody would know what it was like if I didn't tell it." I keep thinking of this remark while looking at the photos of *Relationship*. Not the drugs or the endangered part per se, more the "I had a feeling nobody would know what it was like if I didn't tell it." Indeed, in talking about the trans/trans aspect of their coupling, Drucker and Ernst say that when they were together, they at times found themselves wondering whether there had ever been a relationship like theirs before. It felt that new, that without precedent or company. They've since realized that of course their relationship has both predecessors and contemporaries (not to mention futures), but that sense of bewildered singularity permeates the project, was in fact one of the forces propelling them to document, and later, to exhibit (along with the usual forces one might imagine animating two lovers riveted both by each other and by the camera).

Myles's "it" became a tale told by a single teller; here, the "it" signifies "a visual diary" (as Nan Goldin had it) constructed by two, about two. But that's not quite right. Because in many ways, the photos don't tell us anything about this particular relationship, nor is the relationship depicted

here precisely a one-to-one affair. The title alone, *Relationship*, with its baggy genericness, seems to want to point to all kinds of relation in addition to that between lovers: the relationship of oneself to oneself (which may include one's relation to one's body, one's desire, one's gender, one's representation, and so on); the relationship between life and art, between the microbodily and the macropharmacopornographical, the romantic and the mundane, lyric moment and narrative unfolding, relatively straightforward autoethnography and bona fide aesthetic intent, privacy and performativity, and more.

It's become something of a commonplace that gender is best understood as a relation we have with ourselves, whereas sexuality is essentially relational, angled toward other bodies. This may be a useful formulation for some or in some senses, but it fails on several counts, insofar as it misses both the ways in which sexuality can have its own inner, private aspect, and the ways in which our genders rub against each other, form and deform in response to one another and the world. As Judith Butler has it:

> All of us, as bodies, are in the active position of figuring out how to live with and against the constructions—or norms—that help to form us. We form ourselves within the vocabularies that we did not choose, and sometimes we have to reject those vocabularies, or actively develop new ones. . . . My sense is that we may not need the language of innateness or genetics to understand that we are all ethically bound to recognize another person's declared or enacted sense of sex and/or gender. We do not have to agree upon the "origins" of that sense of self to agree that it is ethically obligatory to support and recognize sexed and gendered modes of being that are crucial to a person's well-being.

Another way of putting this might be: that which we feel to be innate, and that which we feel to be constructed (whether in relation to an other, to language, to norms, and so on) might be constructively reimagined as *one flow* rather than as colliding realities.

This flow is what *Relationship* brings into focus. It does so in part via its combination of the seemingly unstaged, smeary-faced snapshot aesthetic of Goldin and the highly staged, film-still aesthetic of Cindy Sherman (not to mention touches of the hall-of-mirrors, corridor-rich choreography of Fassbinder). But whereas that work is often characterized by grief, grotesquerie, or alienation, the photos of *Relationship* give the felt sense of two people committed to—and turned on by—the project of supporting and recognizing each other (which doesn't mean they don't also fight, cry, and sometimes end up sleeping on the couch). Drucker and Ernst have noted that most of the photos here were taken in domestic settings, including in the artists' childhood homes, which both artists testify were supportive ones. So one of the new things pictured here is queer experience relatively unmarked by enforced exile to an urban subculture (Los Angeles never looks very much like a city, anyway). But while the subjects may be "at home" in multiple ways, there's not a lot of overt comfort or cheer. Neither Drucker nor Ernst ever offers the camera (or each other) a smile proper; a certain deadpanness, sometimes glumness, permeates the work, even though the artists testify that the time in question (2008–2014) was one of childlike play. Some of that play is explicit, as in the food play with half-eaten hot dogs, testicularly posed eggs, and citrus glory holes, but the humor in these shots feels intentionally flat in its knowingness. It may be that the play at hand is less the unselfconscious, zany sport of the toddler, and more the thoughtful, moody tragicomedy of puberty, which would befit a period of hormonal rearrangement.

Indeed, one of the most memorable photos in the series depicts the naked butts of Drucker and Ernst, each bearing its own Band-Aid, presumably marking the spot of an injection. On the one hand, the twinned nature of the Band-Aids is adorable, and marks a certain solidarity and shared experience. On the other, the distinctness of their butts, their underpants, and the specific physiological effects of the hormones all point toward the separate nature of their journeys, even if those journeys are being undertaken together and placed side by side. Which is, of course, just another description of a relationship: a shared journey in

which deep identifications, immersions, attractions, and entanglements must work together with radical specificity, moments of divergence, and the specter of separation.

For Drucker and Ernst, that specter eventually became a reality; the two broke up in 2014. *Relationship* now stands as a retrospect of—perhaps even a memorial to—a meaningful but past period in both artists' lives. The retrospective angle underscores the various forms of youthfulness here on display: there's the literal youth of Drucker and Ernst, whose bodies retain the kind of baby-faced credulity that sometimes lingers into one's second decade, no matter how world-weary the posturing (every time I see Drucker in that wide-brimmed sun hat I think Tatum O'Neal in *Bad News Bears*, or Brooke Shields in *Pretty Baby*); there's the youth of their gender transitions, a process that brings about a kind of second puberty no matter when it's undertaken; and there's the relative youth of trans representation itself, which certainly has a long history, but not one that features the specific biotechnologies or terminologies of our day. (As Drucker and Ernst note, their self-documentation preceded or coincided with the phenomenon of folks uploading selfies to the internet in documentation of their transitions, a now-exploded genre.)

There's also the puberty of their careers, in that *Relationship* ended up marking a sort of turning point for both artists. As they tell it, the photos were picked out by a curator from the Whitney at the end of a studio visit in a kind of "Hmm, what's in that file?" moment—the photos weren't put forward by the artists themselves as their "real," or "realest," work. The amount of positive attention the photos subsequently received at the 2014 Whitney Biennial reawakened questions each artist has long had about where best to focus one's energies, if and when the goal is to create better representations of and for existing and nascent trans communities. Since that time, while continuing to ponder questions about the relationship between art, entertainment, and social and political change, Drucker and Ernst have turned to the world of television, devoting themselves to their roles as coproducers on the Amazon series *Transparent*.

Whatever the artists focus on next, either separately or together, the interest generated by these photos at the Whitney, and later at Luis De Jesus Los Angeles gallery, remains a testament to the ways in which the art of our lives may not always be exactly where we presume it to be, that we ourselves may not always be in complete control of what images or offerings will travel, or what they'll do once they hit the road. For viewers outside certain communities, these photos may end up performing the relatively simple task of introducing bodies or forms of relation unfamiliar to them. For others, the photos may offer the relief of recognition, the excitement that attends seeing familiar but oft-elided experiences appear on a gallery wall or in a book. For others—and I guess I'd put myself mostly in this category—the photos derive power from the part they play in the history of visual diary and poetic documentary, a tradition in which, as Goldin put it, the pictures "come out of relationships, not observation." In her introduction to *The Ballad of Sexual Dependency*, Goldin explains further: "There is a popular notion that the photographer is by nature a voyeur, the last one invited to the party. But I'm not crashing; this is my party. This is my family, my history." I'm glad to be living in the moment of this party. No one will know what it's like if we don't tell it, even, or especially, when we ourselves don't know exactly what it is we're telling, only what we're seeing, feeling, wanting, loving.

(2016)

THE REENCHANTMENT OF CAROLEE SCHNEEMANN

My introduction to the work of Carolee Schneemann came via an ironic rehash of her iconic 1975 work, *Interior Scroll*. ("That dreadful *Interior Scroll*," Carolee says in her 2009 Smithsonian oral history interview—dreadful because of how she feels it has come to dominate her reputation at the expense of her other work.) Even in ironic rehash, it was thrilling. It came as part of a Ms. Lower East Side contest in the early 1990s, at a time when I was immersed in Judson Church performance culture just as Carolee had been thirty years prior, when she marshaled "raw fish, chickens, sausages, wet paint, plastic, rope and paper scrap" and a host of orgiastic naked bodies around the Judson Church stage in 1964's *Meat Joy*. I think the Ms. Lower East Side contest took place at Fez, in the basement of the Time Café on Lafayette Street, but I can't quite recall, and the internet apparently hadn't been invented yet. I can, however, clearly remember the enjoyably stocky, naked body of the young white dyke who announced that she was going to redo *Interior Scroll* for the talent portion of the evening. When the time came, she stood under the stage lights with her legs spread and attempted to pull the folded-up scroll from her pussy. But she had a hard time—the integrity of the paper's pulp was challenged, and she struggled to read the text, eventually giving up. "I'm sorry," she told the crowd and judges, laughing. "It's too smeary to read. I guess this is a lot harder than I thought."

Indeed.

Twenty years later, Carolee picks me up from the Trailways bus station in New Paltz in her old purple-blue Subaru. She has been having a hard time walking since breaking a hip in October 2014, on her way to the podium at NYU (she didn't go to the hospital until after her event had finished, then didn't return to her home upstate for months). But she still drives these country roads, which she has driven for fifty years now and count-ing, like a demon. En route to her stone house, built by Huguenots in 1750 and featured in much of her work, including the films *Fuses* (1965) and *Kitch's Last Meal* (1973–76), we stop at a Stewart's. Carolee hands me a fifty-dollar bill, says we're here to feed her addiction. Diet Coke? I guess. The *New York Times*, she winks. Later, at her beautiful, dark home, I no-tice articles cut out from the *New York Times* everywhere: an article about an Animal Planet show devoted to rescuing cats from trees ("Cats in Trees, and Their Secret Agenda"), a review of Edward Baptist's *The Half Has Never Been Told: Slavery and the Making of American Capitalism.* She says she likes reading the weddings section, seeing all the different com-binations of people. I do, too.

Carolee can't physically access the upstairs of her house right now, which is where one of her home studios is located (her main studio is out back by the pond, and was built with funds from the 1994 sale of *Infinity Kisses* to the SF MOMA—her first sale, incredibly, to a US museum, over three decades into her career). But she encourages me to go upstairs and look around. The staircase landing is dark, cobwebby, and dominated by sev-eral bookcases. One contains an enviably well organized wall of publi-cations in which Carolee's work is featured or mentioned, with dividers beginning in the year 1962 and moving up to the present. Another is filled with fiction and nonfiction classics, loosely divvied up into the-matic cul-de-sacs: recent and contemporary fiction (Dana Spiotta's *Eat the Document*, Sigrid Nunez's *The Last of Her Kind*, Don DeLillo's *White Noise*); true crime/violence (James Ellroy's *My Dark Places*, Bret Easton Ellis's *American Psycho*, Ann Rule's *The Stranger Beside Me*); a cluster of weathered Virginia Woolf paperbacks; feminist theory (Luce Irigaray's

Speculum of the Other Woman, Mary Daly's *Gyn/Ecology*); a kind of "masculinity studies" area (Barbara Ehrenreich's *The Hearts of Men*, Klaus Theweleit's *Male Fantasies*, a book I've never seen before called *Why Men Exist*); and more.

Past the bookshelves, in the abandoned-for-now studio, a large Mac desktop computer sits on the floor humming loudly, as if running through what's left of its fan, or finishing a forty-year download. On one wall there are about a dozen or so Ziploc baggies tacked up with fat silver thumbtacks, each containing a decaying carcass of some kind. One is discernibly a grasshopper; another, a mouse. One is labeled "Lilly Grey, September 2014." (Miss Lilly Grey is one of Carolee's two cats, the other being the kitten La Niña. Carolee has deemed La Niña psychic, in the mold of her predecessors Kitch, Cluny, and Vesper; Miss Lilly Grey she calls "completely ordinary—not psychic at all." She appears to love both animals equally.) One mouse carcass, which looks like a piece of fried black seaweed, forgoes the plastic bag, and is tacked directly to the wall.

The display brings to mind Carolee's 2001 work, *More Wrong Things*, which featured, among other things, vivid, close-up photos of Carolee's cat Treasure after he was hit and killed by a car. Carolee chose an image of Treasure titled *Photograph of Treasure after death, 2001* for the postcard announcing her show. In the photo, Treasure lies on his side, one eye open and normalish save for a distended, parallelogram-shaped pupil. His other eye is squashed out, and so engorged it would seem to belong to a much larger animal. Blood smutches up Treasure's dainty nose and mouth, streaks his expelled eyeball. The image bears a relation to the bulging eyeball slit by a straight razor that begins Luis Buñuel and Salvador Dalí's *Un Chien Andalou* (1929)—that notorious act of violence that announced both the Surrealists' love of the startling image and their dedication to the mutilation or fragmentation of women's bodies in order to achieve it. But here Carolee isn't performing, or pretending to perform, an act of violence (as in *Chien*, wherein the slit eyeball was actually a cow's eye procured for that purpose). Carolee is recording something that happened. Something sad and wrong that happened to something

she loved. (*More Wrong Things* also includes photographs of her injecting an alternative cancer treatment into her thigh.)

I don't really know what Carolee was thinking when she chose this image of Treasure for the postcard—were it another artist, I might attribute it to some unconscious sadism. But Carolee seems not to house an iota of such a thing. In fact, one of the most striking aspects of her sensibility may be the way in which she has consistently reoriented the energies of certain avant-garde influences (Surrealism, the Actionists, Artaud), demonstrating how shock is not always mobilized for similar reasons or to similar effect. Carolee's love of Artaud, for example, is remarkable for its introjection of Artaud's manic, shamanistic energy, his insistence on the fusion of "thought and life," and his desire to produce an altering, sensory experience for the audience, all the while leaving behind Artaud's desire—taken up by so many in his wake—to terrorize or bully the spectator. When Carolee showed the slide of Treasure at a 2015 talk, she told the audibly discomfited audience, "That's part of my need to look at things that we don't want to see. You all can close your eyes, but I can't." Other artists might insist the audience look; Carolee gives others permission to close their eyes, while acknowledging that she can't, won't. The ghost of her father, a country doctor, is in the house.

Also upstairs—a scrapbook I'd heard tell of, a binder with the label "Influence/Plagerism [*sic*]/I Forgot." I'd heard that Carolee kept a scrapbook full of clippings of work by artists she thinks have derived images, ideas, or impulses from her. When I poke around in it, however, it's clear that this is no litany of woes. Quite the opposite—it is an expansive elaboration of the morphological correspondence theory that has driven Carolee for so long: *This looks like this. This stems from this.* As Carolee asked at a 2011 slide talk at Portland Community College: What does this building under construction in Liverpool with rebar sticking out of it remind me of? Of course—my childhood drawing of a cat emerging from a mystery clutch of wires! Let's now put the slide of my childhood drawing next to the Liverpool building, and behold the mystery! Carolee's unapologetic fascination with her childhood drawings makes me think of

Jill Johnston's line about Agnes Martin, that "a great woman may be a woman more interested in herself than in anything else."

The intensity of Carolee's interest in morphological and symbolic correspondences (which, of course, bloom into visibility only under the artist's powers of attention) brings her into the analogic realm described by Emerson: "It is easily seen that there is nothing lucky or capricious in these analogies, but that they are constant, and pervade nature. . . . Man is an analogist. He is placed in the centre of beings, and a ray of relation passes through from every other being to him." As with Johnston's line about Martin, Carolee's wager has been to put herself at the center, and to insist that the rays of relation passing through her, a female human being, matter just as much as they might if passed through Emerson's self-reliant man.

Carolee no longer has to insist alone, via scrapbook or otherwise, on the "rays of relation" passing through her early work and work done by others—a team of academics and art historians and artists has thankfully risen to the task. But the conversation around her often still turns on the underrecognition of her influence on other, more commercially successful artists. Listen, for example, to this bit from a 1997 interview with artist Odili Donald Odita:

> ODILI DONALD ODITA: I'll add, when in fact, after seeing your piece, *Up to and Including Her Limits*, a piece I was not aware about when I was standing in that gallery looking at Mr. Barney's work [*Drawing Restraint*]. Basically, it's an extension of that piece. It comes from that piece.

> CAROLEE SCHNEEMANN: I'm always happy when people see extensions of my work where I might see it as well. This is one piece that many people see, and so Matthew Barney must have heard at some point that so many people are being reminded of this precedence. And of course, the book, *More Than Meat Joy* was published in 1977, and hit a whole generation of

art students who found ideas, inspirations, permissions in it, and certainly Matthew Barney is only one of many kinds and forms of actions that I see coming and going that make me think, "Didn't I do that? Is it mine? Can I use this?"

ODO: And is that a question you still have, think about, or are you at a point where you are beyond that? I don't like getting into this negative space but at the same time, it's something that annoys me greatly. Especially when there's an irrational fascination or preoccupation, in this case in Matthew Barney, when the people who go about describing his value lose all reason discussing it. I wanted to talk with you a little bit about this absurdity. I want to know if you think the same, especially of an artist like Barney when it really speaks about the promotion machine.

CS: Well I can't speak to it except to have my usual wonder as to why I'm so unattractive to any promotion machines. I'm some part of nature that just keeps pouring and pouring and pouring.

Lured as she may be, Carolee doesn't talk trash. (Whenever I mention someone or something Carolee doesn't like, she offers only a "meow.") Instead she turns the question around, to ask (rhetorically? honestly?) why she's so "unattractive to any promotion machines"—the implication being that she'd be glad to participate in them, but senses there's something about her or her work that intrinsically repels them. Elsewhere she speculates: "Is it because my body of work explores a self-contained, self-defined, pleasured, female-identified erotic integration? Is that what the culture can't stand? It is interested. It gets tremendous courage, vitality, and feeds itself off this material I provide. But it will not come back and help me. It's almost as if it's saying, 'If you've got all that, go feed yourself!'"

The narrative of the underrecognized, underrated, underbought female artist is a difficult one to get off Carolee, in part because pointing out gen-

dered inequity and injustice in the art world and beyond has been one of the most vital services she has performed in art, writing, and personhood for six decades and counting. So, on one level, trying to separate it from her is a fool's errand. As far back as 1959, Carolee was on a "desperate search" for what she calls the "missing precedents," that is, women artists unaccounted for by art history. While a student at Bard, she worked at the Cloisters; one of her jobs was to polish the plaques under the paintings at the Metropolitan Museum of Art. She explains: "They came in a cigar box. And you know I had a cloth and some oil. And I had a rather large one that said, 'Marie Joseph Charpentier' in tiny little letters. And in big letters 'Attributed to [Jacques-Louis] David.' So I took it to the top curator, and I said, 'This doesn't make sense.' This is a beautiful portrait of the woman painting; it used to be at the top of the Met stairs for years. I said, 'What does this mean? Is this by a woman or by David?' And they said, 'If it's by Charpentier, it's worthless. It's in the School of David, and it's valuable.'" Carolee has never let up on this eagle-eyed analysis of systems of value in the art world, be the focus Charpentier's valuation or her own.

Another entertaining example of this analysis: the blunt 1999 letter Carolee wrote to Daniel Socolow at the MacArthur Foundation, in response to his request that she nominate a candidate for the hefty MacArthur "genius" award:

> I myself am a failure at raising funds and sustaining my work. As a visiting artist I can hardly support basic functions. I do not have health insurance, life insurance, storage, or insurance for art works; I do not have savings, retirement funds, medical plan, investments, bonds, etc. It is impossible to produce the new works I envision. . . . In 1995, I was unexpectedly diagnosed with non-Hodgkins Lymphoma and Breast Cancer. I am alive because a Pollock-Krasner Grant enabled me to undertake alternative therapy in Mexico. . . . People find it unbelievable that in thirty years I have sold only two works to museums in the U.S.A. I am not the only woman

artist with a distinguished history who has no way to sustain
her work, nor provide for her future. I'm enclosing a bibliogra-
phy as well as an exhibition and lecture sheet to clarify this ex-
tremely paradoxical history, the punishing facts of this mythic
"career." Perhaps you will understand that being in dire straits
while enduring a fantasy of success and achievement makes it
impossible to fulfill your request.

As delighted (and troubled) as this response makes me feel, I can't help
but notice how to consistently deem someone an underrated living leg-
end is also to practice a certain repetitive distortion, whereby all praise
or estimation begins to register more as corrective than insight. Similarly
complicated is the question of censorship, which nearly always accom-
panies discussions of Carolee's work. On the one hand, if one forgets
or represses the real risks and obstacles Carolee has faced, one fails to
apprehend the particular taboos of our culture, and the differences be-
tween making work in a "nothing's shocking" environment versus an en-
vironment in which the safety of one's work, not to mention of one's
own body, is regularly imperiled. (A man once attempted to strangle
Carolee during the 1964 Paris performance of *Meat Joy*; in 1968, French
men ripped up the seats of a movie theater with razor blades in response
to a screening of *Fuses* at Cannes; at a 1985 screening of *Fuses* in El Paso,
Texas, the police arrested the projectionist and seized the print; and so
on.) As Carolee explains: "The influence of my bodywork on younger
artists—both women and men—is replete with contradictions. There has
been a 'phylogeny recapitulates ontology' aspect, as if my performative
works have provided an imagistic bridge for another generation of artists.
Since it is easily forgotten that my early events were often considered out-
rageous, marginalized, often demonized and censored in their original
time, this subsequent appreciation and appropriation has been both dis-
maying and confirming."

On the other hand, while demonization and censorship may establish
one's reputation as a taboo buster or outlaw, they come at a cost, both to
the artist herself and to the work, as the lowest-common-denominator

conversation preferred by moralists has a squashing effect on the art's (and the artist's) multivalence. As C. Carr reports in her biography of David Wojnarowicz, who battled heavily with right-wing censors in his final years before dying of AIDS in 1992, Wojnarowicz repeatedly complained that "his work had been turned into 'banal pornography,' stripped of its artistic and political content. And these bowdlerized images had reached way more people than his real art ever had. He began to have trouble sleeping."

These effects are, however, not my principal points of interest here. What interests me more vis-à-vis Carolee is the question of how what we may wish to be known for most (in Carolee's case, being a painter and a formalist) inevitably washes up on the shores of actuality, that is, the given, crippled, molten world in which certain image makers can never appear neutrally in the images they create. To put it bluntly, how the female, queer, colored, or otherwise nonnormative body remains a contaminant, a disruption—or, more cheerily, an occasion for invention, revolt, *détournement* (as in artist Glenn Ligon's repurposing of the Zora Neale Hurston line: "I feel most colored when I am thrown against a sharp white background"). Carolee came up in the big AbEx moment, but, like most restless, ambitious artists, she wanted, needed, to ask the next big questions about painting. The question she came up with—"Could a nude woman artist be both image and image maker?"—was simultaneously formal, art historical, metaphysical, and revolutionary. When Carolee took her clothes off and put her body into her painting (starting with 1963's *Eye Body*), she thought "it would be seen as an integrated, powerful event." It wasn't. "They said, 'If you want to paint, put your clothes back on.' It's always been like that." In this same interview, Carolee says, "I never thought I was shocking. I say this all the time and it sounds disingenuous, but I always thought, 'This is something they need. My culture is going to recognize it's missing something.'" I don't think this sounds disingenuous at all; to my ear, it sounds like sane amazement.

Faced with such a situation, the most immediate options would seem to be hoping to assimilate (usually against hope, but with the possibility of

moderate gain), or rushing headlong into the unjust mess, à la Adrian Piper's Mythic Being: "I embody everything you most hate and fear," or Carolee's Vulva from 1995's *Vulva's Morphia*: "Vulva strips naked, fills her mouth and cunt with paint brushes, and runs into the Cedar Bar at midnight to frighten the ghosts of de Kooning, Pollock, Kline." Note that, in both of these cases, it's invented characters that do the headlong rushing; part of each artist's formalism is to hold something back, to allow something to remain fugitive, even as their bodies and words get in your face.

While the conditions that generate these options are, without a doubt, deplorable, the dogged, surprising, and shifting ways in which artists such as Piper and Schneemann have navigated them also constitute the propulsive force of their careers. And as the background behind their work keeps changing, the import of the work keeps shape-shifting. Carolee could have gone the way of, for example, Elaine de Kooning, twenty years Carolee's senior, who had this to say in response to Linda Nochlin's famous 1971 essay "Why Have There Been No Great Women Artists?": "To be put in any category not defined by one's work is to be falsified. We're artists who happen to be women or men among other things we happen to be—tall, short, blonde, dark, mesomorph, ectomorph, black, Spanish, German, Irish, hot-tempered, easy-going—that are in no way relevant to our being artists. . . . There are no obstacles in the way of a woman becoming a painter or sculptor, other than the usual obstacles that any artist has to face." I don't know many people who enjoy being put into categories, especially ones that feel falsifying, but it still seems to me that the idea of an artistic work to which all physical, gendered, racialized, national, temperamental, or geographical contingencies are "in no way relevant" can only be an impoverished and impoverishing fantasy—one Carolee has never tired of revealing, exploring, and dissolving.

For these reasons and more, I would be very pleased if this essay were to serve as the final resting place for the by now stale critiques of Carolee and other female performance artists in the 1960s and '70s—that they were just using their naked bodies in their art because they had beautiful bodies, and, no matter their intent as artists, the voyeurism and vanity as-

sociated with the naked female body will always override any experiment with it, and you're a naive fool if you think otherwise. Sure, there are moments in *Fuses* when I think, Wow, she's really young and lovely, and mugging a bit for the camera. It's also true that an artist's intent to leap over the cultural baggage we bring to certain images can only go so far. I'm thinking, for example, of Carolee's long-standing insistence that the act of swinging naked from a harness in *Up to and Including Her Limits* (1976) was all about "anti-gravitational delight," not bondage or repression or pain. Carolee's letters from 1956–99—collected by Kristine Stiles in 2010's *Correspondence Course*—contain a fascinating exchange about this piece between Carolee and her friend, the poet Clayton Eshleman. Eshleman tells her that he interprets the piece as saying, "Look at me I have been wounded." Carolee responds, "You DID NOT ACTUALLY SEE [it]," and accuses him of being blinded by "perceptual systems" that limit his understanding of what's actually in front of him. Eshleman replies: "You have your sense of what it is to mean to someone and seem irked when I do not realize what you intend. I see what I see. Sometimes we connect." I'm with Carolee, but I understand both their points, the convergence of which brings us into the heart of art, which takes place (tragically, excitingly, inexorably) in the mash-up between authorial intent and viewers who must "see what [they] see."

In the case of feminist performance art, we now have the advantage of looking back as much as *fifty years* on the work, and noticing how "what we see" is subject to change over time. Time has shown us how the impulse to use the body in fearless ways in the work of artists such as Carolee, Hannah Wilke, and Annie Sprinkle has persisted beyond their youth, and into all kinds of physical adventures, including illness, aging, and death. Time has given us Wilke's harrowing *Intra-Venus* photos (1991–93), taken throughout her fatal cancer (Wilke: "People give me this bullshit of, What would you have done if you weren't so gorgeous? What difference does it make? Gorgeous people die as do the stereotypical 'ugly.' Everybody dies"). It has given us Annie Sprinkle and Beth Stephens's *Breast Cancer Ballet Collages*, (2005), which depict Annie's very famous DDs being subjected to all sorts of oncological interventions. And

it has given us Carolee's very great, very strange *Infinity Kisses* (1981–87), a series of photographs showcasing Carolee "deep kissing" with her cats each morning over a number of years.

The question behind *Infinity Kisses* was the same as it was for *Fuses*—does this act of physical intimacy look like I experience it from the inside? Or, as Carolee says: "I knew what the action felt like but I wanted to see what it looked like. And that's unpredictable—I don't know what kind of discrepancy between sensation and visualization will evolve." My guess is that the discrepancy in *Fuses* is much smaller—that is, *Fuses* tends to produce a sense of euphoria, liberation, and excitation in many of its viewers, whereas *Infinity Kisses* has a more disconcerting effect. Not only is the act of intimacy portrayed likely more foreign, but the aesthetic of the photos is alarmingly ghoulish. I'm not sure if this was intentional; none of the descriptions of the work I've seen mention it. (SF MOMA, which bought the piece for its collection, says the work serves to "renew our hope and belief in regeneration," and references the Egyptian symbology of cats that Carolee was working with. Okay, but.) There's a stunning lack of vanity: Carolee's eyes are nearly always closed, her mouth open and sometimes actively drooling; at times it seems there's a contusion of some sort on her upper cheek. The cat often seems ravenous, almost vampiric. The colors are washed out, greenish and bluish; the camera POV is extremely close to Carolee's face, the flash often blowing out portions of it. The soundtrack to the slideshow version is eerie, like that of an avant-garde horror film. Many of the photos have the vibe of a crime scene more than that of an early-morning snuggle.

When the museum bought this piece, Carolee at first said, Great, now I can print it in Kodachrome. She was surprised when the acquirers said No, we want it as is, as these grainy color Xeroxes. But I understand. The work is punk and unnerving even as it's about affection or regeneration. It's unnerving not because of any taboo between animal and human per se (at least from my perspective; I know there are others who are horrified or riveted or both by the interspecies aspect), but because of the gulf between how the encounter looks on the outside as compared to how

Carolee purports to experience it internally. What I love about this gulf is that it reveals Carolee's driving question—"Is there a sensory and conceptual correspondence between what I live and what can be viewed or seen?"—as one that can be answered in the negative without it meaning that the art need be less compelling. The gap is—as Carolee says—unpredictable: her job is to decide what to make of that unpredictability. Her long-standing commitment to this process is what makes her, in the words of her former partner Bruce McPherson, "a visual thinker, a philosopher of the actual."

Infinity Kisses stands, for me, in the gray area between what Carolee has called her "works of pleasure" (*Fuses, Meat Joy*, etc.) and her "atrocity collection" (*Viet-Flakes, Snows, Terminal Velocity*, etc.). In dividing up her work this way, Carolee doesn't labor overtime to hammer out a specific or causal relationship between the two modes (i.e., "because there is pleasure, there also is pain"). It's more like both veins stream from her wide, nearly credulous embrace of *what is*, and a voraciousness to get that down. "I don't think of [*Fuses*] as documentary," she once said, "[but rather as] a desperate desire to capture the passionate things of life." This feeling has persisted throughout the years, but it's particularly feverish in Carolee's early letters, some of which record harrowing experiences with a lushness and liveliness melding pain, risk, curiosity, and rapture.

One such letter, to her friend Naomi Levinson, offers an account of Carolee's 1959 abortion in Cuba:

> Following [the doctor] into his office where he belligerently repeats, "voy a ver," not believing I am not more than twelve weeks pregnant. . . . Still stirruped he begins to explain that he has no sodium pentothal: "Tiene que hacer un Sacrificio." He might have said he would crucify me . . . such terror. All right, it must be. "And no, cries," he squeezes his lips together, "not a sound." . . . From a glass cistern over the table he pours an orange douche of local anesthetic. Silvery clamps and pinchers, the sensation of being meat or wood held for

chopping. And the "inside" pain for which I find no correlatives. He punches a hole in me, he pulls me apart, I am splitting, twisting, pulled apart, mysterious islands of flesh scream in my head, suddenly singular with pain, blood, scrapings and pullings over and over. And I have turned my head, eyes filled black, becoming held by some intense consciousness which retreats from bodily agony. . . . Finally he has stopped and the pain continues of itself, marching, tramping, so raw. The nurse brings me an aspirin which seems like a pathetic irony—what can that do. "Do you want to see it?" he asked. ("Look," he said, "does it have a soul?") I barely understand and dazedly look at the basin of beautiful purple red colors, thinking why yes that is my own blood, that is its colors . . . Jim's is orangey. They tell me to get up and put on my shoes. I can get up, wonderous! Then my feet walk in the shoes to a dark room, a dark red couch which lifts in the air and there I rest. My head flooding with wonderful power; its body is altogether, the head says we can go on together. The body writhes and crumples and twists, the head is filled with joy, exaltant, is free.

Back at Carolee's house, sitting on her porch and attempting to amuse her cats with feather toys, I ask her whether it's true that her former partner, composer James Tenney, felt hurt by her publishing accounts of abortions that occurred while they were together. She says, "I think he was a lot more upset that I made them public at the time by having a party after each one! I just had to celebrate getting that thing out of me." Carolee has always spoken about pregnancy in this way—as a life-sucking, invasive force deadly to the ambitions of a female artist, "a social usurpation of the private products and processes of [her] body—even the ecstatic fucking." In a written piece entitled "Anti-Demeter: The More I Give the More You Steal," published in 1994 in *Mother Journeys: Feminists Write about Mothering*, she writes: "You are not invited into my body. I did not invite an alien being, a 'child,' into my future. I had a mountainside to climb, my back pushing against a heavy rucksack filled with paints, turpentine, oils, brushes, the roll of canvas."

The formula that holds being a mother as fundamentally incompatible with being an artist at times strikes me as a sensical (if execrable) holdover from an earlier era, and at others like a conviction idiosyncratic to Carolee and her particular body. (Obviously, it's some combination of the two.) And though I've personally spent time and trouble trying to unravel this formula, I'm not bothered by Carolee's pronouncements on the subject. They seem, characteristically, to speak for Carolee alone, or mostly for her alone, and also to provide a bold, needed example for other women repulsed by the prospect of an "alien being" taking up residence inside their bodies and, later, requiring their care. In fact, Carolee's defiant rejection of how "the umbilicus unfurled" might necessitate "years of eternal distractions, demands, needs to be fed, washed, dried, clothed, walked, spoken to, taught everything!" can feel fresh and urgent in a political climate in which "reproductive freedom" often seems to swirl dankly around the holy trinity of "rape, incest, or life of the mother" as the only plausible reasons why a woman shouldn't be forced to bear a child she does not want to bear.

Before making the pilgrimage to her larger studio, I use her bathroom. Since she is recovering from hip surgery, her toilet has one of those mounted elements so that you don't have to bend down as far to sit. I'm relieved—it's an easier height to manage, no matter one's age. I'm forty-two. While resting, I contemplate her bathtub, which has a row of chipped dark-blue mosaic tiles along its base. There's a tortoiseshell hair comb in the middle of the tiles, as if flung there; at the end of the tiles lies an open box of dark-gray, fine-grain kitty litter. In the bathroom as elsewhere, there are clumps of jewelry, clusters of essential oils and lotions, and fistfuls of turkey feathers, which Carolee believes to be sacred messengers.

As we head out to her studio by the pond, Carolee explains that it's going to be in disarray, as she's in the middle of unearthing work to ship to a retrospective in Austria, at the Museum der Moderne Salzburg, which will open in a couple of months. She tells me that she recently found the original ropes that were used in 1994–95's *Mortal Coils*, a piece that pays

homage to fifteen friends lost the year prior. The ropes had been languishing in some decaying cardboard boxes, which she now notices are scattered messily out by her garbage containers. We shift course, walk over to clean them up. I attempt to break down some of the boxes and fit them into the recycling—a fool's errand, it turns out, as the cans are too full. As I'm doing this, I notice that the boxes are full of mouse droppings, which makes me think of another comment Carolee made in her Smithsonian interview. When asked about the 1996–97 retrospective of her work at the New Museum in New York, she agreed that it was indeed an important show for her, but added, "Again, it led to no sales, no commissions. Everything came back home here to the shed, to the waiting raccoons. And if you really want to know how to dissolve epoxy resin, have a mouse pee on it. It's magic."

The fine line between garbage and art is something of a well-kept secret among most object makers. Through her willingness to talk openly about the material effects of not having enough money to take care of her work over the years, Carolee performs the same double trick that she is so brilliant at: calling attention to the difficulty of staying devoted to making work that isn't financially supported, while also drawing attention to something fascinating and repressed about art itself—its precarity, its relationship to the elements, and the weird, strobing intimacy between the revered object meticulously cared for by an institution and the object slowly disintegrating via mouse urine in one's backyard.

On our way back from the cans, I ask her about the line she's often proffered, about having a body that is "not conflicted about its pleasures." (Yvonne Rainer used to tell her, "You make sexuality too easy." To which Carolee would respond, "You make it too hard.") Yes, that is true, Carolee says, but adds that whenever she says that now, she's careful to add that she was never abused, which allowed her positive relationship with her sexual body to flourish. As she puts it in her interview with Odita: "The transposition of the body as a source of knowledge and ecstatic pleasure—this is not a useful example for everybody because if your pleasure and your experience of the body has been damaged, or interfered with, or hurt, then

you're not going to be able to assume the position that I assume." When Odita responds, "Right. But one has to learn how to get to that liberation," Carolee says: "Maybe, but maybe not." Odita: "You say maybe, maybe not. That's interesting to me because before you said that we all should try to get to a place where we can understand ourselves." Carolee: "Where you might understand yourself by realizing that you have to put pins all over your body because that's the only correlative to the violence that was done to you when you were four years old."

This "maybe, maybe not" in the face of "one must"s or "we all should"s brings us into the heart of Carolee's unusually generous and unbossy approach to the aesthetics of liberation. It also corresponds to the way that she often appears, in interviews and in person, to be willing to restate, with unfailing articulation, the same feminist and aesthetic principles she's been called upon to defend or embody for decades now (see her exceedingly patient definition of feminist art for the Brooklyn Museum in a 2008 YouTube video), while simultaneously evidencing a penchant for thinking anew on the spot. She fiercely proclaims, then swiftly proffers scenarios (as per the traumatized four-year-old later coming to pins) that would complicate, contradict, or otherwise expand her positions. Case in point: after reiterating to me that her untroubled ecstatic relation to her body was made possible only by her not having been abused, she pauses and says, "You know, I've been saying that for years, and then one day it occurred to me, I *was* raped." She seems almost surprised. "I remember thinking afterward, well, at least that's over with now, my first time."

Eventually we make it to her studio, which is lovely and busy and hot. On the far wall is *Flange 6rpm* (2011–13), a series of hand-molded aluminum shapes revolving on motors, with a video of the fire that forged the shapes playing behind them. I can't help but think of the extravagant, awe-inducing forge scene in Matthew Barney's *River of Fundament* (2014), and how the scale and feeling here are almost the opposite—Carolee's feels handmade, a kind of mini- or antiapocalypse. Carolee apologizes that one can't really get the full effect of the flames projected on the wall during daylight hours, but I like the look of the pale orange flickering in

the midday heat, the weird flanges creaking in the foreground. On a long table lies an ensemble she recently unearthed from *Noise Bodies* (1965), a piece that will also be traveling to Salzburg. The ensemble is akin to, or actually is, a bicycle wheel strung with pots and pans, designed for a performer to wear and shake. She tells me to put it on and move around. I feel silly doing so, but so instructed, I submit, I shake.

We sit and watch the projected flames, as if at an ersatz campfire, and Carolee repeats to me the line that so many straight women have spoken before her: "I wish I could just be gay; it would be so much easier." From others, this faux lament can be irksome; from Carolee, I take it as true musing. "I just love cock too much," she sighs. When I say something to the effect of, You might be surprised at the possibilities for cock in so-called lesbian relationships, she narrows her eyes in a cheery way and says, "Maggie, I'm literal-minded." She tells me that her most recent relationship, with a mechanically inclined local guy who assisted her with the motorized elements of some of the pieces in her studio, ended not long ago. ("That guy," she says, pointing to a photograph on the wall of a cock entering a cunt.) I ask her what it's like not to have that source of inspiration at present after having made so much art in explicit, generative relationship to sex over the years. "It's melancholy," she says. She says it feels like such a waste, since she's still tremendously horny. "I'm still tight and wet!" she marvels, before explaining to me that she never really went through menopause—she stopped menstruating, yes, but she never had hot flashes or mood swings or other symptoms of "the change."

Aging may not be Carolee's favorite subject, but she has been quite brilliant on it. Listen, for example, to her response to Danish choreographer Mette Ingvartsen, who had suggested that Carolee restage *Meat Joy* using the original cast:

> Somehow, it is never made very clear that by the time you're in your sixties or seventies, people have lost flexibility, mobility, and the sort of ecstatic sensuality that is best communicated by young bodies. Men typically lose their hair, usually

women's hair will thin, and if you look closely you will see there is often almost a bald spot at the top of their heads. Women's breasts have moved down toward their waists and are wrinkled; men's breasts usually acquire a layer of fat, as does their stomach. Female upper arms almost always have a flabby layer. Many men's do as well. Viagra is very popular. If women in their sixties and seventies remain genitally viable—desiring, lubricating, and muscular—the Venus mound has nevertheless put on a layer of fat. For both sexes, their knees will be intensely wrinkled, and unless they exercise consistently, ankles weaken, and their feet are invaded by arthritic disturbances. . . . The exquisite ballerina who is eighty, the irrepressible mountain climber who is ninety, the sixty-five-year-old Hollywood star surrounded by lovers. . . . What do they represent? An exceptional displacement of reality, a fantasy of younger people who can never imagine they will become old, and the kind of physical adventure that process will entail. Popular culture only introduces subjects of aging or old age as anomalous, sorrowful, or ridiculously optimistic. Mette, do not try to re-create *Meat Joy!*

I can imagine someone might feel let down that Carolee—ecstatic sensualist par excellence—would deem ecstatic sensuality "best communicated" by young bodies. But I suspect Carolee would file such a response under "ridiculous optimism." Why go in for faux optimism or sorrow when one could instead join Carolee in admitting the "real physical adventure of aging," complete with layers of fat atop men's breasts and the Venus mound?

Carolee also has a lot to say about heterosexuality. So far as I can tell, most of what she knows hasn't seeped very far into heterosexual culture. Carolee calls *Fuses* a "heterosexual classic." Who, these days, would characterize their work that way? Not that the world isn't teeming with work that might fit under that rubric (perhaps minus the "classic" part), but most often its creators aren't self-aware enough to employ the adjective.

Carolee may have been given a hard time by dykes back in the day—she often tells the story of literally crawling out of a New York screening of *Plumb Line* (1968–71) to avoid being booed by a "lesbian contingent"— but by classifying *Fuses* in this way, she denaturalizes heterosexuality even while focusing on "the fuck," which she calls "the core of heterosexual connection." One of Carolee's credos is "touch tenderly, fuck fiercely." She knows how to access the ferocity of the fuck without insisting, à la Camille Paglia or Leo Bersani or so many others, that there's an inherent destructiveness in that ferocity—or more to the point, that there's an inherent self-destructiveness in that ferocity for the female or feminized subject. Rejecting the revisionist, or at least myopic, history that would cast the "free love" of the 1960s as a good time solely for men preying on LSD-addled hippie chicks, Carolee testifies: "We were young women taking tremendous freedoms, maintaining self-definition and an erotic confidence in choosing partners spontaneously in the firm expectation of great times to be won together." Carolee insisted then, and insists now, on female heterosexual self-knowledge, in a world that continues to treat self-knowledgeable heterosexual women as a kind of oxymoron, as if there's always something self-compromising or self-denigrating about their desire.

A lot of artists, including many male artists, have used art to deconstruct masculinity or reveal its pathetic nature, most often using tropes of abjection or self-destruction. But, as Carolee has noted, talking about men in Hollywood films, "[men's] diminishment or their self-destruction is more tolerable than participating in equity, in which they lose power." Carolee, in contrast, has long been interested in equity. She doesn't find anything degrading about heterosexuality because she remains—as she was out of the gate, incredibly, back in the '50s—devoted to "the firm expectation of great times to be won together." Her formative relationship with Tenney seems to have laid the groundwork for this expectation. She suspects—as do I—that her 1957 portrait of Tenney, *Personae*, caused the stir at Bard that it did not for its obscenity, but because she was able to get a guy to be vulnerable enough to pose nude for her, and to support his girlfriend, the artist, in her desire to publicly exhibit the result. As Carolee puts it,

"[James] was my model, and that was considered really outrageous, be-cause to include and depict the genitals of a male student who everybody knew was to deny him his authority and his proper respect." Eight years later, she will film Tenney's penis aglisten with her menstrual blood in *Fuses*. Indeed, while watching *Fuses*, I'm filled with respect for Carolee, but also for Tenney. (Reading his impassioned, compassionate correspon-dence with Carolee from those years only deepens this feeling.) One of *Fuses*'s less heralded but utterly moving, innovative achievements is its in-vention of a new subject position and manner of respect for a heterosexual male subject—a new, and still underexplored, possibility.

Carolee's unwavering belief in the possibility (and sometimes lived real-ity) of equity has never led her to repress the difficulty of finding or sus-taining it, however. As she told Andrea Juno in the iconic 1991 *Angry Women* anthology, "In my experience men would rather tear a relation-ship apart than adjust, adapt and change what needs to be changed in their psyche. . . . It's difficult to find a really intelligent man who shares a commitment to feminist issues and practice, who reads the same mate-rial I read . . . someone who knows what's happening with this reinvesti-gation of 'inherited culture.'" Difficult, maybe, but the search goes on. In her work, in her life, and in her letters, Carolee repeatedly shows herself to be the kind of radical feminist who does not shy away from difficult conversations with men. In this she reminds me of poet Alice Notley, who has devoted many volumes of poetry to conversations with men, many of them invented or dead: her father, her brother, Surrealist poet Robert Desnos, the characters the Tyrant or Mitch-ham, her first husband Ted Berrigan, and so on. ("The dead in my life are men," Notley once told me, "and I need to talk to them.") In a poem from her autobiographical book *Mysteries of Small Houses*, Notley tries to explain to Berrigan's ghost the gendered complexities of their time together, saying: "'Men were a prob-lem then—I see that better / in the future, but you, sometimes you were 'men,' / usually not.'" To which Berrigan replies, "Then were men men?"

Carolee's record of letters to male interlocutors in her collected corre-spondence offers a voluminous collision of "you"s who veer in and out of

being "men men." Here is Eshleman again, in a 1975 letter to Carolee: "I haven't answered because there seemed not much to say in a letter to your letter: you do not write directly to ME, but to me AS A MAN; since I am constantly in the process of removing myself from that 'wall of huge men' it is frustrating to be put back into it when addressed." To which Carolee replies: "Yes indeed I fall into treating/writing you as if you are the enemy-man rather than the individual man who has done so much to separate himself from the wall of men I describe. My exasperation is this: you have opened, unraveled, aided, opened, unraveled, aided, and used every knot and knife in your male psyche to open, unravel, and aid and within I find old wall of man—stubborn, autocratic, severe, humorless, punishing. . . . You tear me apart in your viscera mythic stew of English anal/rancid Bacon, stoked-off Velazquez, Japanese Ukiyo-e cock strut, Soutine's blood and grub, *I BELONG TO NATURE NOT TO THESE ARTIFACTS YOU CHOOSE. I AM ELECTRICAL VULVIC BOLT IN TIME.*"

Reading these inflamed exchanges (with Eshleman, Stan Brakhage, and others), I am repeatedly astonished by the doggedness, indeed the courage—often of both parties—in sticking with conversations that would have likely sent me straight to the nearest exit. After each rough letter, I think, Well, there goes that friendship. And then there's another. Eshleman: "Your reaction is so simplistic I can barely deal with it. . . . I am really getting fed up with your deliberate confusion of issues. If you have a bone to pick with Stan Brakhage for God's sake do it—you do not respond to my poem by dragging in your 20 year rancor with the way he treated you and the way you yourself allowed him to treat you. . . . Such is the death of response, and, ultimately, of relationship." Carolee: "I mention brakhage because for many years I wanted to make him understand the situation of the woman artist—from his antagonisms and prejudices I was learning much of what the man struggled with and from towards his art. As with you." And so on, and so on. Carolee's fundamental optimism lies in her unceasing drive to make others understand while also attempting to learn from their "antagonisms and prejudices," be they those of friends, cultural gatekeepers, or serial killers. Indeed, when I

mention the true crime cul-de-sac on her bookshelf, Carolee says she al-
ways has found it comforting and illuminating to read about Ted Bundy
after meetings with male gallerists who have crappy things to say about
her work. After describing my own experience in researching and writing
about the gruesome murder of my aunt Jane, long thought to be part of
an infamous serial killing spree, I ask Carolee if she has ever grown tired
of the question, Why do men hate women. I ask because while work-
ing on my two books about my aunt, I sometimes felt like the question
was becoming so tautological that I couldn't maintain my interest in it.
Without the slightest pause, Carolee says, "Never. I will never grow tired
of that question."

For those who think such a project is retro, Carolee might insist, as she
does in *Angry Women*: "my work is addressing issues involving 3000 years
of Western patriarchal imposition. So if I'm fighting with some younger
artist about the past 15 years—I'm already suspicious: those are not the
right stakes!" At a moment when the media seems anxious to highlight
disagreements between trans women and cisgendered women, or trans
guys and cisgendered women, or the radical queer and the assimilation-
ist gay, and so on (just as, in the past, conflicts between fags and dykes,
or straight women and dykes, or dykes and bisexuals, got a lot of airtime),
the one party missing from all this conversation and conflict remains cis-
gendered straight men. Given that one thing most all of the foregoing
parties could probably agree upon is the oppressive force of cisgendered,
straight male patriarchy, the exclusion of such folks from the conversation
could be seen as a big fucking problem. Clearly there are all kinds of rea-
sons one might not want to participate in conversations that may range
from fruitless to damaging, and not everyone shares Carolee's motiva-
tion and capacity for such dogged engagement. Still, there is much to be
learned from her relentless will to expose and stare down the very worst
that men have done, and her desire to understand it, change it.

Perhaps because of this doggedness over time, Carolee's work has a re-
markable ability to stay relevant when placed beside different gender
emergencies. One such emergency is how to navigate a moment in which,

through the hard work of queer, feminist, and trans folks and activists, the culture is finally beginning to understand that particular bodily morphologies need not determine or correspond to a person's gender identity, while at the same time, there still exists the need to account for the three thousand years of patriarchy Carolee has in mind, which has systematically obscured, ignored, misunderstood, maligned, demonized, and punished the female and the feminized.

If one believes, à la Irigaray, that the so-called feminine has not yet begun to speak—that the long-repressed feminine, being that which cannot be named, and neither a particular nor a universal, contains the power, via its specific morphology and function, to topple Western patriarchy, binary thinking, and a metaphysics based on nominatives as opposed to fluidity—it can be difficult to imagine skipping ahead, as it were, to a discourse that untethers gender from anatomy. (I'm thinking, for example, of the hope for a present and future in which "we can talk about uteruses, ovaries, penises, vulvas, etc. with specificity without assigning these parts a gender," as activist Dean Spade has put it. "Rather than saying things like 'male body parts,' 'female bodies' or 'male bodies' we can say the thing we are probably trying to say more directly, such as 'bodies with penises,' 'bodies with uteruses,' 'people with ovaries' and skip the assumption that those body parts correlate with a gender.")

I can't imagine that Carolee would let go too swiftly of the concept of the "female body," but what's interesting about her focus on genitality is that it's so concentrated, so tenaciously material, that it actually links up fairly easily with meditations on the mysteries and possibilities of morphology as much as or more than it does with a regime of fixed gender assignations. It is true that much queer theory and trans activism has labored hard to move us AWAY from genitality—or more specifically, away from treating the genital as the exclusive, constitutive focus of sexuality or gender. At the same time, there's also been a renewed interest from within genderqueer and trans communities in the morphology and materiality of the body, as biomedicine has made their malleability more salient and possible.

After one has gone through the looking glass of detaching gender from anatomy, looking at genitals of whatever kind can become a fresh occupation. "As a child I thought the genital was where God lived," Carolee says, and there is indeed a kind of genital worship throughout her work, as well as a deep openness to whatever is to be found down there. For example, while sitting in her studio, I ask her about a photograph on the wall that appears to depict stringy white mushrooms illuminated by orange light. "Oh," she says, "that's just inside me. As far up as the lens would go."

The photo makes me wonder, How many vaginas or vulvas have we really seen in representation, apart from those homogenous hairless slits of contemporary pornography? Probably, not so many (which partly explains the thrill of Eileen Myles's piece "Tapestry," in which Myles catalogs the vicissitudes of vulvas they have known. There's "a small woman who had a lacy-looking pussy that she hated. There was like this frottage over her clit. Instead of a hood it had a large mantilla." "Clits were all different. Hers was larger. All rubbery, more like porn. I had seen a pussy like hers before but not so close. It was like a lip going vertical. I mean, if you had your head right there. It was kind of a lippy trail, actually this is not her clit, it's her labia I'm describing, what I used to describe as a little girl my gum. Outer gum. Hers was a very uncomplicated female and large, a red road to a small swollen button." "One woman was told by a lover that she had a fat cooch. It was true—her outer lips were pillowy and fat. Full. Her inner lips were regulation healthy and her clit—it was a small red little spud. It was however guardian of one of the most avid pussies I've ever known." It's hard not to go on.)

For Carolee and Myles both, there is materiality—the lens in as far as it will go—and there is also always performativity and humor (that mantilla!). In Carolee's *Vulva's Morphia*, rows of vulvic images are interspersed with lines from a written piece titled "Vulva's School," in which Carolee indicates that Vulva has heard it all, and is no one's fool: "Vulva deciphers Lacan and Baudrillard and discovers she is only a sign, a signification of the void, of absence, of what is not male (she is given a pen for taking notes). . . . Vulva decodes feminist constructivist semiotics and

realizes she has no authentic feelings at all; even her erotic sensations are constructed by patriarchal projections, impositions, conditioning." Notably, Vulva neither accepts nor rejects the charge of false consciousness; the text's disobedience derives from its wryness, its suggestion that a first challenge to Vulva's "authentic feelings and erotic sensations" is not going to intimidate her, throw her off her game.

The game, for Carolee, always comes back to liberation. She identifies as an unrepentant Reichian, sharing Wilhelm Reich's belief that "complete and repeated genital gratification" is critical to our individual and social health. She does not agree with the characterization of the "dream of sexual and material liberation" as being "long ago dashed," as her friend Wayne Koestenbaum once put it. Indeed, spending time with Carolee makes me wonder how much I really know about this dream, how and why I—along with so many others—feel able to dismiss it so glibly. In Carolee's world, "Vulva learns that the dream of sexual and material liberation was dashed long ago" would be just another stifling lesson, ripe for our refusal.

Earlier in the day, while driving from the Trailways station to her house, Carolee and I had passed by the local movie theater, which was playing *Love and Mercy*, the biopic about Beach Boy Brian Wilson. Carolee was excited—she had seen the movie before and loved it. She tells me she'd see it again, if I want to. "Most movies are mind pollution," she says, "but this one was good." It seems interesting, as a prospect—to spend my final hours with Carolee at a movie about a tortured, synesthetic male genius. But as the show time nears, she says, "You know, I think I'd just like to go somewhere lovely and have some oysters instead." And so we do.

At the restaurant, Carolee and the young, clean-cut waiter greet each other warmly by name. "The birds are chirping in the back, Carolee," he tells her; she's delighted. It's empty in the back, the tables aren't set for dinner yet, it's just empty tables overlooking a lovely stretch of lawn and giant trees. Carolee orders the drink special, a tiki thing. "It has an umbrella!" she enthuses when it arrives, and offers me a sip. I sincerely wish

I still drank so that I could partake. Instead I agree to an oyster, also not on my usual roster. I tell her I have always wanted to like oysters more than I actually do. "People have different relationships to viscera," she shrugs, diplomatically.

In one of my favorite books of recent times, Fred Moten and Stefano Harney's *The Undercommons: Fugitive Planning and Black Study* (2013), the authors emphasize the importance of asking ourselves two questions (derived from the curriculum of the Mississippi Freedom School): "What do we not have that we need?" (a question of struggle, aspiration, demand) and "What do we have that we want to keep?" (a question of self-knowledge, appreciation, preservation). The first question may contain more urgency, even of the life or death variety, but the second question is more primary, Moten and Harney explain, because it presumes that we are, at least at times, already living and loving and thinking and fucking and caring and studying and making in ways worth continuing, enjoying, deepening, and defending. Further, our self-knowledge on this account need not be delusional, rigid, nor friable, but rather a real if mercurial source of wisdom, "some part of nature that just keeps pouring and pouring and pouring." Carolee's long-standing devotion to pleasure and atrocity, ecstasy and rage, protest and preservation, provides a lavish example of what it might mean to meditate on these two crucial questions over the course of a life. In the face of "the long ago dashed dream of sexual and material liberation," Carolee continues to offer the possibility of reenchantment. As she wrote in a letter to a friend when she was all of eighteen, about going back to the country: "Then when the city exhausts me I will be, may be, re-enchanted by here. That is all, (all?!) I want— re-enchantment. . . . It is something I must do myself." So she did, and so she invites us to do for ourselves.

(2016)

BY SOCIALITY, TO SOCIALITY

On Fred Moten's *Black and Blur*

I'm going to try to write something plain about poet/critic/theorist Fred Moten's new collection of essays, *Black and Blur*, which feels hard, because *Black and Blur*, like all of Moten's work, isn't written plainly, and I've always felt a little foolish coming at his writing in the (idiot) idiom of lucidity; what's the point in shooting a straight arrow into a field defined by incessant motion, escape. Even if I admit that such an approach is a fool's errand wholly inadequate to what makes Moten's work so worthwhile and sustaining (albeit an approach socialized by my own maternal; my mother teaches business writing), it still feels, well, foolish. But as Fred once said to me in his irreducibly generous, space-making, permission-giving way, "Let's just agree to be stupid for one another!" Okay, then, Fred—here goes stupid.

Because I know Moten in a world that opposes entanglement and clear-sightedness, this essay must technically be a "response" rather than a "review" of *Black and Blur*. (The book is the first of three to be published as the *consent not to be a single being* series, a phrase borrowed from Édouard Glissant; two companion volumes, *Stolen Life* and *The Universal Machine*, are blessedly, impossibly, soon to follow.) And thank God this isn't a review, really, because how preposterous and off the cake it would feel, at least for me, to drag *Black and Blur* into the world of appraisal or

evaluation of argument. Others can do that, and do it well. It's not that I'm not interested in Moten's contributions and interventions into ongoing, crucial discussions about the relation between, say, as he puts it, "the critical analysis of anti-blackness to the celebratory analysis of blackness." I am, and deeply. As Moten intimates in *Black and Blur*'s preface, that relationship is, in some sense, what it's all about: "It hurts so much that we have to celebrate. That we have to celebrate is what hurts so much. Exhaustive celebration of and in and through our suffering, which is neither distant nor sutured, is black study." (Moten's 2003 book *In the Break: The Aesthetics of the Black Radical Tradition* begins by locating this foundational interdependence in the work of Saidiya Hartman; *Black and Blur* begins the same way: "*In the Break* also began with an attempt to engage Hartman; as you can see, I can't get started any other way." Indeed, it's Hartman's theorization of "the diffusion of terror" in Black expression that summons and undergirds Moten's inquiry into the nature of that diffusion, its multiple ontological possibilities.)

It's more that so many debates between, say, something we might call "celebration" and something we might call "terror," or something we might call "optimism" and something we might call "pessimism," or something we might call "Afro-diasporic cosmopolitanism" and something we might call "the African American cultural field," or something we might call "aesthetics" and something we might call "politics," often become legible only via an unwarranted polarization that Moten's work not only sidesteps but also labors to offer alternatives to. It feels more vital to me to use this moment to note how *Black and Blur* produces felt experiences of such alternatives, carves new pathways through art and thought, which, in turn, remakes and multiplies the possible relations between them.

Such a focus admittedly forgoes, at least for the moment, any granular attention to *Black and Blur*'s specific content (the essays include kaleidoscopic ruminations on Patrice Lumumba, Glenn Gould, Miles Davis, Lord Invader, Charles Mingus, Pras/Ol' Dirty Bastard/Mýa, Theodor Adorno, Benjamin Patterson, Thornton Dial, Masao Miyoshi, Mike Kelley, Jimmie Durham, Theaster Gates, Charles Gaines, Wu Tsang, Bobby Lee, and

many others—ruminations made ocean-deep via Moten's particular style of layering figures and discourses atop each other). But it has the benefit of shedding light on how and why Moten's writing has become so crucial to so many in recent years, which links to how and why the publication of *Black and Blur* feels like nothing less than an ecstatic occasion—both in and of itself, and as a promissory note of more to come.

Simply put, Moten is offering up some of the most affecting, most *useful*, theoretical thinking that exists today—a true leg out of the rut so much criticism has fallen into of pointing out how a certain phenomenon has both subversive and hegemonic effects ("kinda hegemonic, kinda subversive," as Eve Kosofsky Sedgwick once put it) that has proven so durable since (at least) Foucault. It's hard to write such sentences without being (happily) haunted by the fact that *Black and Blur*, like all Moten's writing, disallows the kind of heroic "radical singularity" that might otherwise attach itself to the proper names of Moten's subjects, including "Fred Moten." (Hence, the "consent not to be a single being" rubric.) As Moten writes about Black Panther Bobby Lee in *Black and Blur*'s final chapter: "Bobby Lee is another name we give to the xeno-generosity of entanglement: the jam, that stone gas, a block club in a block experiment, an underpolitical block party, a maternal ecology of undercommon stock in poverty, in service, genius in black and blur." In a 2015 interview, Moten explains further, vis-à-vis Bessie Smith: "I don't think I'm so committed to the idea of the radical singularity of Bessie Smith as I am committed to a kind of *radicalization of singularity*, that we now come to recognize under the name of Bessie Smith, which the figure, the avatar, that we now know as Bessie Smith was sent to give us some message about. I think of Bessie as an effect of sociality—she was sent by sociality to sociality, in that way that then allows us to understand something about how the deep and fundamental entanglement that we are still exists in relation to and by way of and as a function of this intense, radical, constant differentiation."

As moved and impressed as I am by Moten's writing—its spectacular range, its unending nuance, its voluminousness, its flashes of pique (don't miss the endnote to chapter six addressing British scholar Paul Gilroy), its

swerve and song—I'm perhaps even more inspired by the way it feels and communicates what it means to be sent "by sociality to sociality," and its depth of commitment to enmeshment, manifest in its style, orientation, and sound. Back in the 1980s, critic Barbara Johnson pointed out that the self-resistance performed by so many (white) male post-structuralist theorists often had the paradoxical (though altogether predictable) effect of consolidating the theorists' authority and visibility. It's like, given the system's (name a system) long-standing need/desire for male genius, those dudes couldn't even give it away. Some might argue that the ultra-passionate lauding of Moten courts a similar effect. But I'm not worried. Unlike a lot of those guys, Moten doesn't care about that consolidation. He really doesn't. His work tirelessly deflects it, unravels it, renders it irrelevant and antithetical to the tasks at hand. Selflessness, for him, and for us in reading him, isn't a new coin to spin in the marketplace. Rather, as he writes, "It's nothing. It ain't no thing. Selflessness ain't about nobility or even generosity. The substance of its ethics is of no account, no count off, no one two, just a cut and then people be grooving."

Black and Blur differs from *In the Break* (and 2013's *The Undercommons: Fugitive Planning & Black Study*) in that many of the pieces it collects—like the ones about Kelley, Gates, Patterson, Tsang, and Durham—first circulated in an art context. For this reason, it makes sense to consider *Black and Blur* as an event in art criticism today. That Moten has become a much sought after art writer delights me for many reasons. One, I get to read him on artists I already care about, or whom I will soon care about via the light of his attention. Two, it means more of his presence at museums and galleries—in programming, in print, and, as in the newly opened *Trigger: Gender as a Tool and a Weapon* show at the New Museum, in the plotting of exhibitions. Three, his wide-ranging, theoretically dense style marks something of a surprise turn in an art world that has been aspiring, over the past decade or so, to move *away* from the high-theory-soaked language of the *October* magazine era. It's almost as if what Moten has on offer is so compelling that it's made everyone give up on the desire for something more "accessible"—or, at least, to give up on it in regard to him. Personally, I see Moten's art writing as shooting

off in a new, as yet underdeveloped direction, one that derives from an increased appetite and capacity for philosophy, history, experiment, and lyricism (I am thinking of Deleuze on Francis Bacon, for example, or Avital Ronell's philosophizing "by way of literature"). I'm all for this development, even if Moten ends up one of its sole or primary practitioners. (Lest we forget: *we don't all have to do the same thing.*)

It's easier, as we have all come to know in abundance these days, to tear down than it is to build, or even to explore; academics have known this for a long time, which is why there's such a hunger, I think, for theory that feels like it's whacking its way somewhere fraught and novel with improvised tools, rather than just illuminating that which we already know in increasingly keen measures, no matter how hotshot radical. Moten's essays bypass the paranoid logic that has come to characterize "the academy of misery" and instead snowball forth via odd procedures like rubbing, blurring, deviation, infodump, and accretion. Chapters often start out with pellucid, road map–style theses ("In examining this coincidence, and placing it within the context of Lord Invader's and Mingus's musical careers and lineages, I hope to attend to some of what is left for us to emulate and correct in the tradition of anticolonial, antiracist, transoceanic aesthetic and political endeavor"); a few pages later, we're "comparing Wilhelm Furtwängler's and Arturo Toscanini's divergent modes of conducting Beethoven's Fifth Symphony"; another page in, and we're teasing out "a discourse on the relation between jazz and democracy that moves from Ralph Ellison to Hazel Carby"; then we're dropping deep into a historical scene of African American soldiers marauding in Trinidad in 1943. The sprawl is loose and hot, and I never doubt its importance and direction, disoriented as I may at times become.

Moten's sentences often proceed with similar effect, as in the indelible opening of "Bobby Lee's Hands": "Held in the very idea of white people— in the illusion of their strength, in the fantasy of their allyship, in the poverty of their rescue, in the silliness of their melancholy, in the power of their networks, in the besotted rejection of their impossible purity, in the repeated critique of their pitiful cartoon—is that thing about waiting for

vacancy to shake your hand while the drone's drone gives air a boundary."
Trenchant critique that feels headed for a ferocious conclusion suddenly
swerves out to "the drone's drone [giving] air a boundary." It bewilders
and pleases me that such *WTF?* moments in Moten's writing—and there
are many—never exasperate me. Instead, I face a choice: I can pause, per-
haps endlessly, and self-consciously engage the project of deciphering, or I
can skip on, knowing that the sentence will still be there for me, perhaps
in five minutes, perhaps in five years, available for re-sounding.

Which brings me to the last thing I want to talk about, which is the way
that Moten's work makes the activities of reading and thinking feel pal-
pably fresh, weird, and vital. I knew, for example, when I agreed to write
this piece, that I was agreeing to an impossible task—even before laying
eyes on the galley, I knew there was no earthly way I could read *Black and
Blur* in the approximately thirty days I had before deadline. Don't mis-
understand me—this isn't one of those Amazon reviews exulting in its
"I could only read the first ten pages of this book but I'm going to weigh
in on it anyway" attitude. I READ *Black and Blur*, by which I mean
every word of it passed through my eyes and ostensibly into my brain.
But one of the ontological gifts of Moten's writing is that you simply can't
(or, I should say, *I* simply can't) TAKE IN his sentences in any norma-
tive, temporal way. Their intricate design, their dense folds of linkage and
reference, their insistence on evacuation and complex arrival, demand re-
reading, across space and time, more than almost any other writing I can
think of.

And so—in the month or so that I've lived with *Black and Blur*, I've read
it in the waiting room of the dermatologist's office, while watching my
son at the playground, on an airplane, perched on the metal stool of a Los
Angeles poké bar, in bed, in my office on lockdown due to a phantasma-
gorical active shooter the day after the Vegas massacre, falling in and out
of sleep from jet lag on a park bench in Stockholm, and elsewhere. I re-
member all these places because in each one I understood something dif-
ferent in the writing, found myself able to hear a different tune or tone.
I heard myself struggling to think, then I heard myself thinking. I felt

smart, then I felt stupid. I felt in between, then I felt "not in between," à la C. L. R. James and the title of *Black and Blur*'s first chapter. In short, I felt myself reading.

In and around all this time, I read the news. I sat on panels. I talked with my partner, my children, friends, and strangers. Sometimes I felt overcome by the frustration—which sometimes threatens to tip into rage—that you feel when the conversations you're having are not the ones you wish you were having (*Why do you write about the body Did the administration do a good job in Puerto Rico Will tax cuts for the rich produce gains for the middle class Is he a white supremacist or does he just act like one Do you feel ashamed to write the way you write because you have children What are the limits of free speech™ Has feminism really been a net gain for women Who has the right to depict what suffering Why do you work in so many different genres*, and so on). But here's the thing: we all know the conversations that we don't want to be having. We all know how it feels when the terms on offer feel rotten, debased, unworkable. The problem is, in the swirl, we forget what we wanted to be talking about in the first place. (*Was* there a first place?) Or, the conversations we want to be having seem like they're over there, while we're over here. We get lost in what Moten has hilariously described (in *The Undercommons*) as "some kind of warped communal alienation in which people are tied together not by blood or a common language but by the bad feeling they compete over." In which case, you end up with a whole lot of people spending "a whole lot of time thinking about stuff that they don't want to do, thinking about stuff that they don't want to be, rather than beginning with, and acting out, what they want."

Meanwhile, my stained galley of *Black and Blur* is in front of me, beside me, as it has been for the past thirty days, chock-full of conversations that I DO want to be having, about "the armature, the arsenal, of the poor, the ones who, in having nothing, have everything"; "the refusal to fall for the ruses of incorporation and exclusion that say all we can and should desire is citizenship and subjectivity"; "the very idea of trash, of disposability, that is given to the ones relegated to the heap"; the human

as "nothing other than this constancy of being both more and less than itself"; the relation between "aesthetic indiscretion and the critique of sovereignty"; "the exhaustion of relational individuality"; and more. It's full of ways of thinking, looking, feeling, and writing that I want, ways of being that I want, in part because they work on undoing the *I* and the *want*. Maybe even the *being* too. "Here in this vestibule, where we belatedly await our own invention of, our own coming upon, the liberatory, we operate within an incessant escape that might be said to cohabitate with incessant listening." *Black and Blur* is there, will be there, for our incessant listening, just as *In the Break* and *The Undercommons* have been there for some time now, for repeated, ever-deepening consult and company.

Not only that, but there will be more. There will be *Stolen Life*, there will be *The Universal Machine*. Some might call this trilogy an embarrassment of riches, but I'm not embarrassed. I'm euphoric. For if there's one thing Moten's writing and being has taught me, it's that instead of worrying over "too much of a good thing" in a world overfull with shitty things, we might instead ensure that there are too many good things, too. *Black and Blur* is part of that.

(2017)

A LIFE, A FACE, A GAZE

Conversation with Moyra Davey

MOYRA DAVEY: I got hooked on Karl Ove Knausgaard because my friend, Jill Schoolman, publishes him and the books arrived on my doorstep. I read volumes 1 and 2 of *My Struggle*, and will start volume 3 soon. He's a bit of an unlikely fit in the sense that I don't usually read such long books, but the genre, autofiction, is something I've been drawn to for a long time. KOK wrote explicitly about shame in an article for the *New York Times Magazine*, about how in Norway you're raised to never call attention to yourself, to never think you are better or more important than anyone else, etc. And so for him, everything he writes is a shameful act, yet he is also driven to do it. There is so much writing generated you wonder how he can live his life.

In a second *NYT* article (just out two weeks ago, and he's on the cover of the mag), ostensibly a kind of travel narrative to describe Viking remains in North America, he writes about taking a giant shit in a hotel room in Newfoundland, clogging the toilet, and twice sticking his hand down the hole to try and unplug. Seems kind of like a fuck you to the *NYT*'s

This conversation with artist and writer Moyra Davey was conducted by email for a book about photography to be edited by Shannon Ebner and Arthur Ou. When that book never came into being, the exchange found a home in *Artforum*.

conceit for the article. . . . I loved it. He stayed so true to himself, even in this journalistic genre, and I wonder if the *Times* has ever published anything like it.

I grew up in a culture of shame and guilt in Catholic Quebec. I have a lot of shame around money, especially, but also around some of the unseemly "calling attention to self" that Knausgaard writes about. I always deal with it in the videos and in my writing, but daintily. I have this fantasy of a vehicle that would hold an outpouring of all the shame and guilt (a "pathography"—Paul Thek's term), but know it will probably never happen. I was in analysis for almost six years and barely scratched the surface. I am anal and repressed!

Enough about me. Shame came up in relation to you because you seem free of shame. Your writing has a quality of openness, ease, generosity. It flows, it's the opposite of retentive. You can talk about anal sex, which I know a lot of men will talk/write about, but far less common for a woman to do so. The question I would have asked you when you read in NYC (at NYU?) is: Do you ever have a sense of shame, do you censor yourself, do you edit out certain things from your writing that you consider too far out there? Do you leave in things you feel uneasy about because you want to risk something? Do you agree with Orwell who said: "You can't trust an autobiography unless it reveals something shameful"? Maybe these are questions you've dealt with a lot and don't want to keep rehashing, and if so, that's fine.

MAGGIE NELSON: I'm interested in your notion of your videos as dealing "daintily" with "calling attention to self." I wouldn't use the word "daintily"! I think what you're doing, especially in *Les Goddesses*, is so much more deft, and in its own way, bold, rather than dainty. By filming yourself walking around your house and talking about literature and theory and your family, you're giving us this remarkably generous self-portrait—of what you think about most, what you read, your own artistic journey, and perhaps most of all, your body and voice moving through space in the most banal but also intimate and compelling of ways. I be-

came obsessed with the moments when you pulled up your jeans from time to time, for example! Your posture, your voice, all these elements that one can't really control, felt very central to me. I just loved it.

I read the 2012 *New Yorker* piece on *Les Goddesses*, and while I was glad that it was so positive and in many ways astute, I felt annoyed by the way it felt the need to compliment your great video by setting it up as superior to the straw man of the "narcissistic tell-all." The critic writes: "By the end of the video, you've learned that Davey has multiple sclerosis and has a young son named Barney, who hates art museums. But it's hard to discern how well you know her. She provides these facts off-handedly and there's a sense that she's leaving out as much, if not more, than she includes. There's a naturalism to this approach that makes *Les Goddesses* appealing in a way that tell-all memoirs are not. Memoirs so often beg the question, Why would you want to tell me all this?"

Besides mainstream celebrity memoirs or other genres in which artistry need not apply, I don't know where all these narcissistic tell-alls are, not to mention the fact that there can literally be no such thing as a "tell-all." All autobiographical presentations are curated— with more or less care, surely, but still. Personally, I never think to myself while reading, "Why would you want to tell me all this?" That question seems to me to speak volumes about the reader/critic more than about the writer. What I hear in that question is the baseline assumption that the writer should *not* be telling you all this, unless proven otherwise—that there's shame in the telling, and the critic's job is to wake the artist or writer up to the shame she/he may have missed. At the far end of this logic lies the virulent idea that we're better off with less speech, less telling, less expression; nearly every nasty review of a work of autobiography I've read contains this latent or manifest wish that the writer/artist would just shut up. Maybe this is just journalistic laziness, but it bugs the hell out of me.

Maybe it's clear by now that I don't really think of my writing in a matrix about shame and exposure and revelation and so on. That's not really the tradition of writing that interests me the most. It's a moralistic cul-de-sac

that impedes the capacity to discuss other things. I'm not naive enough to think one can escape what Foucault called the logic of a confessing society. But I do think it's worthwhile to use our critical and creative imaginations to make or take in work without shoving it in those boxes, whether in an attempt to laud or to denigrate it.

For those reasons and more, I'm very glad if I seem free of shame to you! I mean, on the one hand, how silly and frightening and probably impossible—a human free of shame! But on the other, it's true that I just don't feel a lot of shame these days. Or, rather, I don't feel shame around certain subjects that seemingly make others tense. (I've also spent most of my adult life surrounded by artists and writers whose work and company make mine feel decidedly prudish in comparison.) Often I have the experience that I'm hoarding shame around something that registers as a zero for others. Like in *Bluets*, I felt ashamed to write about alcohol—much more than about being horny or heartbroken. But no one has ever asked me about that, which tells me something. It also might be a clue as to the nature of shame itself—it can be so private, and as often as not, met with a shrug by others.

To answer your more specific questions—of course I edit things out from my writing, but usually they are things that I worry might hurt other people, not things that I'm worried about saying about myself. Probably I do leave in things I'm uneasy with for the reasons you say, about taking risks, but luckily, by the time a book is coming out (which takes about a year, after you've made the last changes), I've made my peace with it, and the uneasiness factor has faded.

I've read three volumes of *My Struggle* now and I love them. I completely understand and agree with everyone who has noted that women writing about stuffing their toddlers into their shoes and strollers would and do get a completely different treatment, and there's no doubt that a lot of the frisson of the writing comes from internal and external expectations about masculinity rubbing up against this insistent, often very boring cataloguing of his days, without any *Ulysses*-like mythos or heroism.

But I find the sheer immensity of the project conceptually fascinating, and I too have enjoyed the frank discourse on shame in his work. A lot of the work I love becomes shameless as it delves headlong into shame, and I would put *My Struggle* in that category. (Importantly, I've also read that he personally never thought of the project as "about male shame," as a reporter once put it to him; for reasons I've already gone into, I completely relate to this disavowal. The writing has already alchemized shame and transcended it, so it often seems like it's the reader who wants to pin the writer back to that incipient state.)

MD: I guess if Knausgaard can write so "shamelessly" about taking a giant shit, it makes you wonder what could he *not* write about. My friend, Alison Strayer, and I have debated whether he is truly exposing his shame. She doesn't buy it, finds him a bit disingenuous; in the two books I've read, the only place I can really locate the shame is in his drunkenness, which you mention too, apropos of *Bluets*. I will mention one other conversation on the topic of Knausgaard and shame: my partner, Jason Simon, put forth Teju Cole as an example of someone who truly exposes his shame, as in the shocking revelation that he, or his character (in *Open City*), may have raped a woman when they were both students. This may be a special case, since until that moment, the novel has read as something closely derived from life—the narrator is a psychiatrist who eases pain, takes long walks, writes about the birds in his neighborhood and histories of social injustice embedded in the city. The confrontation from the woman pivots the structure and throws into doubt any assumptions the reader might have made about genre (autofiction?) and veracity.

On Christina Crosby's panel (at Barnard), which centered on her memoir about her paralysis, *A Body, Undone*, her partner, Janet, said that in the memoir she is sometimes Janet, and sometimes *not*, the character "Janet." When I perform the narrations for my videos I try to dissociate in the hopes that the figure on screen will be read as "me" and "not me." And because I quote a lot, I've even resorted to small fibs/distortions, such as making an unsavory anecdote of my own appear as though it might have been written by Kafka.

When I saw you in New York, you mentioned, perhaps half-jokingly, that your genre is "autotheory," and then on the panel, I think you said certain readers hungered for you to "make it *more* personal." To my dismay I've had people say similar things to me. I always thought the literary bits were what made my confessions palatable—they were my cover for the darker stuff I wanted to write. Borges recounts that in his long history of lecturing he found audiences drawn much more to the concrete than the abstract, and he kind of sums it up by saying: "People long for confessions and I have no reason to deny them mine." In my view you strike a perfect balance between the intimate and the theoretical. But as per Borges I utterly savor and retain your passages such as caring for and playing with a small child in a way that is utterly devoid of rancor and boredom; Harry's last night with his dying mother, the love and strength he brings to this moment of passage, followed by the no-holds-barred account of you giving birth to your son—it is all pretty transformative stuff, and supergenerous to the reader. And into all of this you weave radical politics, theory, critique, and you are not shy about calling people out, expressing strong opinion.

I don't mean to curtail this particular discussion on shame and autofiction theory (we can circle back to it), but since Shannon and Arthur have titled their book *Photography and Its Entanglements*, I thought to introduce an idea I heard Barthes talk about in an interview (a few years before *Camera Lucida* was published), apropos of photography, where he asserts that for him, "fascination" is the defining principle of the medium. He sets it up in a kind of drastic way, marginalizing "art photography" ("devoid of interest, it wants to compete with painting"), and journalism, which he says can be very beautiful but entails a separate philosophy.

He says any ontology of photography revolves around fascination, which by (his) definition makes it "outside language." He calls it a tautological problem: something is fascinating, you want to talk about it, but you can't, precisely because it's fascinating (this is my attempt at parsing his tautology). I'm paraphrasing and quoting here; I've listened to the recording multiple times (I can probably send you the audio file in French, if you like). It's an audacious claim, and I really relate to it! I find it so free-

ing. I almost never want to talk about photography in the abstract, I always found the historical debates quite boring and pointless (e.g., "can it be art if a machine made it?"), and I have a suspicion that the current fixation on the transition from analog to digital is just a new spin on some of the old arguments (pictorialism versus straight, appropriation versus documentary, etc.).

I know you are into Barthes, wondering what you think of this "fascination" idea, which seems to me distinct from his notion of the punctum.

MN: I haven't read the Barthes quotation you mention but from what you say here, I am quite interested in it. Not so much in what lies outside language, but rather the idea that "something is fascinating, you want to talk about it, but you can't, precisely because it's fascinating." This seems to me the basic seed to all writing projects—a seed that makes them, perhaps, more paradoxical than photography, because in photography you can follow fascinations without having to talk about them in words.

When Barthes says fascination is a defining principle of the medium, is that something he locates in the photographer, or in the medium itself?

MD: It's a fascination for actual photographs. The interview predates *Camera Lucida* by a few years, it was done in 1977. Perhaps Barthes evolved "fascination" into the punctum as a solution to his problem of not being able to articulate the former.

MN: In any case, your desire not to talk about photography in the abstract seems a wise one to me.

I also want to tell you that I'm traveling right now and I brought with me on the plane the package of your books that you sent, including your essay and photograph collection *Long Life Cool White*, and I read them all happily and hungrily.

MD: Thank you!

MN: In your essay "Mothers," I was happy to be turned on to Mary Gaitskill's "Gattino." And I like the unusual gathering of artists you have here. It makes me want to look anew at Frances Stark, and find the Xavier Dolan film. Mostly, though—and maybe here's my own "make it more personal" request—I couldn't help but wonder about the maternal transgressions you refer to, re: your own parenting. You say "I blew it with B., my one and only." As it seems so clear to me that you *didn't* blow it, I can't help but wonder what you think your transgressions were . . .

MD: I wish I could have been a more patient, calmer, happier person when B. was small. I see women with their tiny babies enveloped in a love cocoon, and I never had that because B. had colic and screamed for three months. It was hair-raising, and kind of set the tone for the next four years. I always think about Margaret Mead's question, something to the effect of: "Does the sunny, happy baby produce the happy mother, or is it the other way around." And of course you can substitute *happy* for "cranky" and ask the question the same way, and that's where I dwell on my flaws and wonder what I might have done differently. I love the way you write about caring for your kids in *The Argonauts*, it is so full of tenderness and pleasure. You marvel at the routine tasks, like folding tiny socks.

MN: Yeah, well, maybe my cranky/failed mom memoir is yet to come! (Or maybe I'll leave it to my kids to dwell on my flaws in public . . . as someone who has repeatedly raked my mom over the coals in print, and as someone who also reads tons of student work of this nature, I now know that this is one of the most common subsets, if not the most common, of the autobiographical genre, à la Philip Larkin's "They fuck you up, your mum and dad. / They may not mean to, but they do.")

I was also interested in the way you write about reading, in your essay "Notes on Photography & Accident." You describe reading as "a literal ingestion, a bulimic gobbling up of words as if they were fast food." I feel embarrassed when people treat me like a big reader, as I actually feel ashamed of how little I actually read, or how poorly I read. I don't know

if this is a result of the internet like everyone says or if it has more to do with this "bulimic gobbling up of words," the selective gusto of reading as a writer, looking for what you need. When I was getting a PhD, I often imagined there could be a kind of IV drip of books, because I needed to read more than I had time to read—I didn't know how to, say, ingest all of *The Last of the Mohicans* in a day, or a week, so I started fantasizing other ways to get it in my head, my body. I forgot, or never realized, how to savor. I just crammed it in.

MD: People think I read a lot too, but it's getting to be less and less. Recently I had to give a talk and a seminar at Rutgers, so I reread a bunch of my stuff in preparation, and I watched some of the videos. I've grown weary by how much I quote and how much I rely on reading to write. I love how you put it—"looking for what you need"—and the excitement that arises when you find the right thing. But I feel more and more self-conscious. In the thing I'm writing now for my next video, I'm trying to refer, for example, to Godard and Barthes, without using their names. That's how desperate I am to change things up!

MN: I say all this in confusion, because I've also spent a lot of time reading poetry, which is supposed to be read "slowly," so I presume somewhere I know how to read in a different fashion. But I worry. I wonder whether your reading style has changed over time, the physical phenomenology of it.

MD: It has changed. For one thing, I read too much on screens, and it kills my eyes. I'm a bit stuck at the moment with this new project—it's for Norway, so I reread Mary Wollstonecraft's Scandinavian letters, and that was pure pleasure for the way she writes about the natural world. She was in a terrible state of depression, and the landscape rescued her, at least for a time. But I am also writing about my son, and I find that SO difficult and uncomfortable, writing about missing him. I feel like I don't have the right to write about the privileged ritual of a young adult leaving home for college when some people have permanently lost their children. I could read Winnicott, but some part of me is in rebellion. My friend

Jennifer Montgomery said: look and listen instead. So I've been listening to Chantal Akerman, and I can't get enough of her. I am utterly smitten. You can watch a ton of interviews, panels, artist talks, and she is warm, flirtatious—she has that raspy smoker's voice—she is also tough, fearless, honest. Talk about bulimia and rabbit holes, I will lose myself to her for hours. She is my greatest inspiration at the moment.

MN: I guess I'm interested in this because I'm fascinated by how your work seems very of the moment, very in the present, while also performing a dedication to slowness, an attention to dust, to B sides, to physicality, to acts of physical lost-and-foundness, to archives, which some people don't associate with the so-called digital age, something hot, rushing, dematerialized, sleek (though the abjection of precarity and the reminder of the intense physical costs of the so-called virtual are, I think, gaining in attention as of late, as in, for example, some bad and weird weather). But I don't feel nostalgia in your work, I feel presence. I also feel recognition: I know those rooms, those book backs, those dust bunnies, that fridge. (I really, really like your writing about the fridge!)

MD: You also write about the domestic and the mundane, and there is such a quality of lightness and a gentle, cajoling humor to the way you do it. It's a poetic voice embedded in a prose writing style. We can feel you taking real pleasure in the rituals of food, drink, hanging out with little kids, being with Harry, and then pleasure again as you shape the experiences into writing.

MN: Speaking of those spaces, I had a dream last night, here in an oppressive conference center in Flagstaff, Arizona, that I was back in a perfect East Village apartment that I'd lived in my whole life: a diminutive studio, arched tin ceilings painted light turquoise, bathtub in kitchen covered by a board, Patti Smith had lived there once, there were scrawlings all over the ceiling, some of which were mine. It was all part Nan Goldin, part Larry Clark, part Moyra Davey. And I realize now I invented this dreamspace after immersing myself in your books all day. And it feels so strange to me, to know this space as foundational, a kind of recur-

ring foundation in my unconscious, but to live now in Los Angeles, with nothing resembling it whatsoever. As if one's foundation were a dream. Not a day goes by when I don't feel grateful that my formative years were all lived without the internet.

MD: I was just reading something by Joan Didion, about the utter confusion of what is home: the West Coast, where she grew up, or New York, where she ended up. Your dream apartment sounds pretty appealing. Early Goldin, Clark, and Patti Smith are still touchstones for me. Maybe part of the fatigue (and potential bulimia) of the internet comes from knowing that *everything* is available to us at the touch of a finger. It's all there to read instantaneously, or it can be on your doorstep in two days.

MN: Speaking of Patti Smith, I'm on a plane to NYC right now, and I just finished her new book, *M Train*, have you read it? I adored *Just Kids*, but I have to admit, about this next one, I'm kind of baffled by it—baffled by her profoundly non-twenty-first-century psychology, her true capacity to drift in what seems to be a magic, or at least talismanic, space, created in part by a deep romantic attachment to objects and writers. I mean, the whole book is kind of structured around her need to bring these stones from a prison that Genet hoped to be imprisoned at (but never was) to his grave. There are a lot of other pilgrimages in the pages as well. But she even makes taking the train to Rockaway or going to a 7-Eleven to get a large coffee and a donut sound infused with magic. I guess I thought of you because of your own connection to Genet, and to a kind of sloweddown, object-oriented, somewhat romantic relation to other writers, but also because of Patti Smith's strong relationship to photography. The book contains her photographs, mostly of these talismanic objects or places; besides her obsession with coffee, the book seems to be working out an obsession with taking photos. I have to confess to you, the whole thing left me kind of cold, which made me wonder whether I was in some ways depressed, or deadened. I mean, I used to be very romantically attached to certain objects and figures; my book *Bluets* was an homage to that modality. It is a means of feeling very alive, a means of feeling as though the world is interesting enough to photograph. I don't feel able to access that

space, my more or less completely American existence, my totally un-generous suspicion of the politics of Smith's infatuations, or what. At the very least it made me question how far I've come from certain magical states of mind, and wonder if I'm missing anything right now, and if so, what. Because I don't really miss my more adolescent infatuations with writers or objects; in some ways I feel kind of Zen about the fleetingness of time these days, like I'm just watching my life (by which I might mean, my son's childhood) go by, and along for that ride, without needing to pick up any stones or document it all in too mannered a fashion. Anyway, I'm curious to know if you've looked at the book, what you think.

MD: I've not yet read *M Train*. I was tempted to pick it up recently, but I'm trying to stay on track with reading related to a new video I've been writing and now shooting. From a superficial take, *M Train* feels decid-edly old school in its approach. I will definitely look closer as I know it re-lates to my conundrum with contemporary photography.

"Feeling as though the world is interesting enough to photograph," as you put it, is at the heart of things. Looking at contemporary work by art-ists who are one, two generations younger than me, I have the sense that many have given up on the "world" and the practice of rendering it via an image. Why bother, it's all been done to death. Many are opting to make images of images in another round of "pictures generation" appro-priation, minus the political critique (in many cases). I can totally relate to an ennui of images, given that we are inundated by them at every turn. It is a real dilemma because I am baffled/perplexed/bored by the highly abstract, photoshopped appropriations, yet I know the alternative, the ro-mantic, unfettered approach is just as untenable. Photography for its own sake is tough. When it gets linked to writing, performance, even other objects, is when it becomes more viable and interesting to me. Re: the "magical state of mind" in relation to reading and writing: in my opinion it grows out of pain, fear, anxiety. A few years back I wrote a text called "Index Cards." I was in physical pain, weird stuff was happening to my body, I had just moved to Paris for a year with my son and was witnessing his trajectory through the rigid, unforgiving French school system and re-

living bad memories of my own French elementary school. "Index Cards" rounds up Benjamin on hashish, Jane Bowles's letters, Kafka's notebooks and diaries, and I forget what else, but it was almost as though I was constructing a talismanic cocoon to stave off fear. When I read that text now it brings back the anxiety of the moment, but also the intense investment I had in these writers, and probably the "magical" belief that I'd be saved by them.

MN: That's interesting, to think of that magical state of mind as coming out of pain, whereas I was assuming that depression might bar one's access to it. I think I've always understood turning to texts with the hope that they would save me; it's objects and landscape I've had more trouble with (which makes sense, I guess, for a writer). That difference was something I was trying to work out in *Bluets*. I guess it's why I still think of it as a book about beauty.

I was interested to hear your thoughts on psychoanalysis, in the video transcript "Fifty Minutes," where you're looking in on your analysis from the outside, as it were—like, you tell us of your fidelity to the rule of having to speak unspeakable things, but for the most part you don't tell us what those unspeakable things were. I guess I've been thinking a lot about the fate of "free association" in this moment, which some think of as decidedly "postpsychoanalysis"—I just saw my friend Wayne Koestenbaum do an amazing piano performance the other day, which seemed a kind of retro, or very of the present, I don't know, homage to free association. It seemed no accident that a lot of what he riffed on while playing had to do with the twentieth century, its history of horrors.

MD: There are so many unspeakable things that will probably remain so. Part of the reason I think so much about getting them out is that the writers I admire are the ones who find a way to do it, to take something taboo or shameful and "make a thing out of it" as Tilda Swinton said apropos of Derek Jarman when he embraced his illness and mortality and made *Blue*. I have the impression you yourself can write about *anything*. I think it has to do with really knowing yourself, and not being rancorous. Again,

Chantal Akerman comes to mind: she was warm and generous, but she would also speak her mind on a dime if the situation called for it. When you have generosity toward others, self-love is possible, or is it vice versa?

MN: Not to repeat myself, but I find myself not thinking very much about taboo or shame these days. If I do, I'm a little more prone to thinking about the relationship of white people to abjection—like, what forms of abjection does whiteness create and depend upon for power; how does a white obsession with abjection serve as a means for white folks to access the abjection that is forced upon other bodies—brown bodies, poor bodies.

There are parts of this bridge-making that seem worthwhile and powerful to me, and parts that seem loaded and ugly and damaging. I think all this is partly why I have a harder time getting TOO excited about the notion of Knausgaard writing about his shit in the *New York Times* as a big transgression (though I may like it for other reasons). The shit of the lauded white guy isn't the same as other people's shit. That doesn't mean I don't appreciate it, as I say, for other reasons (I grew up loving Bukowski's beer shits, too). But it's important to remember that these gestures circulate in a context. Maybe this brings me back to Patti Smith—whom I adore, of course—and her beloved Beats, and Artaud, and Paul Bowles, and Rimbaud, and Genet, to some extent—all these white guys who were looking for some kind of magic or freedom or gravity or eros or danger in non-Western cultures, thinking European or American culture had foreclosed certain possibilities. I was transfixed by many of these figures in my youth—a lot of it *through* figures like Smith, who led me to many of them—but having grown up, it just doesn't play for me anymore in any simple fashion.

MD: I'm not apolitical, but when I read, I don't make political choices. I follow my nose, I read what interests me, what will feed me, I "read to write," as per Barthes, mostly. So that can take me anywhere. I'm very seduced by happenstance and *dérive* as a way to not feel totally overwhelmed by choice, more so now than ever as my reading has, by neces-

sity, slowed down. I of course take your point about the shame of white privilege. I feel it. If they were not already, our eyes are being opened daily to institutionalized racism. It's a fast and furious outpouring, and the rage is palpable. In terms of literature, everyone has their threshold—my sister-in-law, a very smart, principled, feminist abstract painter, has been reading Céline her whole life, because it feeds her in some elemental way. But to me he's repugnant and I'll probably never read his books.

Here is a passage from one of the Knausgaard novels that sums up what I'm looking for when I read: "The only genres I saw value in, which still conferred meaning, were diaries and essays, the types of literature that did not deal with narrative, that were not about anything, but just consisted of a voice, the voice of your own personality, a life, a face, a gaze you could meet. What is a work of art if not the gaze of another person?" He could easily be referring to one of your books . . .

Those are some morning thoughts! I know we've got to get back to photography soon. But to break my long silence, here you go.

MN: "What is a work of art if not the gaze of another person?" This is complicated, as it posits the author as the gazer, rather than the viewer. I'll think on this.

(2017)

SUICIDE BLONDE AT 25

On Darcey Steinke

"Was it the bourbon or the dye fumes that made the pink walls quiver like vaginal lips?" So begins Darcey Steinke's "sensational" second novel, *Suicide Blonde*. I put the word in quotation marks because a host of similar adjectives ("shocking," "daring," "scandalous," and so on) greeted the novel at its publication in 1992. This may have given the book a well-deserved public velocity, but insofar as such adjectives also reflect the prudishness and insularity of many reviewers and readers, they also ran the risk of occluding some of the novel's truest achievements, all of which are on display, in miniature, in its unforgettable opening sentence.

The swirl of bourbon, blond hair dye, and vaginal lips is audacious, sure, but it's also funny, and evidences a fairly rare and delightful phenomenon I might call feminist camp. Feminist camp—which can be practiced by persons of any gender (see John Waters, who regularly identifies as a radical feminist)—doesn't waste time exhibiting its feminist credentials. It simply moves with invention and forcefulness into a new field, one that belongs to a canon of outlaw writers (Georges Bataille, Jean Genet, Alexander Trocchi, William S. Burroughs, etc.) while also creating new ground to stand on (Kathy Acker, Leslie Dick, Virginie Despentes, and more). *Suicide Blonde* belongs to both of these traditions, as well as to other notable subsets, including noir; queer lit of the '80s and

'90s (Michelle Tea, Leslie Feinberg, Bruce Benderson, Dennis Cooper, Eileen Myles); classic twentieth-century fiction featuring itinerant, urbane women experimenting with dissolution and desire (Jean Rhys, Iris Owens, Renata Adler, Marguerite Duras, Patricia Highsmith); maybe even erotica (Steinke remains one of the few writers I know whose writing about sex manages to be both literary and hot).

As *Suicide Blonde*'s opening question makes clear, its home base is the consciousness of a questing female, for whom the words "abjection" or "debasement" are someone else's, insistences of a culture stubbornly deaf to the mess of female journeying in extremis. Indeed, what some reviewers mistook as an attempt to shock ("So self-consciously seeking 'that exquisite kick of perversity,' this callow fiction comes off as something along the lines of a much more sincere *American Psycho*. All the more pathetic," wrote some stooge at *Kirkus*) I hear as an uncommonly confident, entertaining over-the-topness, especially re: bodies, as in "Pig's head dropped lower. She gagged and a long line of glittering burgundy ribboned down the stairwell."

Turning wine vomit into glittering burgundy ribbon is just one of the alchemical transformations regularly performed by Steinke's prose. This alchemy isn't a sign that Steinke is on the run from materiality, however—despite (or because of?) Steinke's Christian background, vomit remains vomit. Instead she's after the glittering, the way the sublunary world flickers with possibility, divinity, multivalence, from the inside out. The novel's tone shares this commitment to flicker, or suspension: it feels melodramatic and restrained, mordant and good-hearted, suffused with high-order irony and casual sincerity. Likewise, the novel reads like an allegory set in any dystopic, late-twentieth-century city (opaquely emblematic character names such as Bell and Pig further this impression), while also offering a portrait of a very particular time and place—the San Francisco of the early '90s, of the Lusty Lady, of parties at which one might meet "a feminist trying to destroy the myth of the aesthetic canon, musicians who insisted house music was the blues of the nineties and a performance artist who covered himself with animal blood and said narrative was dead."

Like all of Steinke's novels, *Suicide Blonde* has been lauded for its "gorgeous prose," and justly so. I'd like to pause here, however, and disrupt the critical tendency to act as if "gorgeous prose" were a kind of decorative accent on a novel that could survive without this value-added. Certain novels may be palatable, or even compelling, in spite of their unremarkable or unlovely sentences. But those cannot be great novels. Despite the hopes of mediocre sentence writers everywhere, novels cannot be separated from the prose that comprises them. So if I reiterate here that Steinke's prose is gorgeous, I don't do so to turn an A into an A+. I mean to underscore that she is writing in a tradition of novel writing that doesn't depend on tricks of narrative momentum or emotional setups to make us endure uninteresting prose. Rather, Steinke's sentences reliably deliver concision, beauty, and surprise, via either unexpected, unlabored metaphors ("We entered the noisy bar full of men's faces, numerous and similar as kidney beans," our narrator Jess says as she faces the group of men for whom she will whore for the first time) or unusual, amusing progressions of thought. (Jess again: "I remembered the story of one saint, a virgin, who cut off her breasts rather than succumb to a rapist. I made myself think *God is dead*, but it seemed dangerous. Then I thought, *my pussy is the same color as this carpet*. This comforted me somehow.") Steinke also has a poet's feel for imagistic patterns that accrue into their own kind of plot or argument (keep your eye on the color burgundy, as per the wine vomit), as well as a poet's instinct for hotshot lines that move us in and out of her novels. The feeling I typically get when I finish a Steinke novel is one of exhilaration and relief, as I realize with delight that her performance has sustained its unique pitch from start to finish, no wobble.

This exquisite technique does more than impress. It also builds trust. In the case of Steinke's writing, this trust is especially crucial, insofar as she traffics in transgression, gliding with Fassbinderesque grace from scenes of abuse to rape to suicide to high glamour to boredom to pleasure to abandon to myriad other forms of exaltation and ruination. ("Because fucking, when it's good, seems like everything and there is pain in the pleasure when you remember that things are horrible, until you are hardly alive," Jess tells us while fucking her gloomy, bisexual boyfriend, Bell.) Smart

sentence by smart sentence, dicey scene by dicey scene, exceptional novel by exceptional novel, I have come to trust Steinke to the point where I will follow her anywhere she decides to go. Most often, she takes her heroine/the reader to the cusp of a deep badness, then pulls back; sometimes, most notably in *Jesus Saves*, things go all the way bad. (I'll never forget my first time reading *Jesus Saves*: I felt sick about the ending; I wanted to undo what the novel had done; maybe I even felt betrayed. But upon reflection, I could see why Steinke made her narrative choices; over time, I've come to respect that ending as a kind of limit test of what is possible in her novels, an edge she knows how to topple over or ride.)

Suicide Blonde doesn't go all the way dark—as in most Steinke novels, not everyone survives, but (spoiler alert) our heroine does. We're never entirely sure of her fate after the story ends, however, because Steinke is into ongoing odyssey, not moralistic parable. Unlike some of my favorite dissolute novels by women—I'm thinking of *After Claude* or *After Leaving Mr. Mackenzie*, for example—Steinke's daring or wit is not wrought from a certain meanness or nihilism. *Suicide Blonde*'s antihero Madison may tell Jess that "there are a million ways to kill off the soft parts of yourself," but no matter what experiences Jess undertakes or surrenders to, she seems almost quizzically unable to kill her soft parts, probably because her soft parts and her hard parts are marbled together. I can barely think of another writer—much less a religiously infused writer—who so naturally eschews binaries, who feels and renders the world's marbled complexity with such poetic ease.

It comes off as easy, but I doubt it is—writing well isn't easy for anyone—but Steinke's writing has been marked by a kind of languid sureness from the start. Like so many naturals with a singular vision and an unyielding gift, Steinke wrote a perfect book nearly right out of the gate, one that both emanates from its time and will last the test of time. I'm glad, on the occasion of its twenty-fifth anniversary, for *Suicide Blonde* to come around again, to show us how it's done.

(2017)

LIKE LOVE

A Tribute to Hilton Als

In attempting to take stock of the achievements of Hilton Als, I almost began to disbelieve that he exists. How could any writer be as omnivorous, incisive, and productive as Hilton has been, for so many years now? How could anyone be as ubiquitous and wide ranging without ever seeming to phone it in or skim the surface, especially since good writing, not to mention good thinking, takes so much goddamn time? How does one become someone who can write authoritatively and penetratingly on Kara Walker, Amy Schumer, Edward Albee, Lady Bunny, Nan Goldin, Samuel Beckett, Beyoncé, Roberto Bolaño, David Mamet, Taylor Mac, Derek Walcott, Tennessee Williams, Eugene O'Neill, Justin Vivian Bond, Burt Bacharach, Okwui Okpokwasili, Bette Midler, Paul Robeson, Diane Arbus, Matthew Barney, Lily Tomlin, Bill Cunningham, Richard Pryor, and literally *hundreds* more? How does someone so often write reviews or essays that become iconic in their own right without having their criticism usurp the work of art at hand, as Susan Sontag famously warned against? How does one manage to write eulogies—about Prince, David Bowie, and, most recently, Sam Shepard—that so many of us turn to in order to reckon with our loss, knowing that Hilton's estimation will provide exactly the kind of uncommon insight and remembrance we are craving? How does someone do all this *and also* write incomparable book-length works, such as 1996's *The Women*, and 2013's

White Girls—two books that, were they the only words Hilton had ever let sail—would qualify him as one of nonfiction's most innovative and crucial practitioners?

Then add to this Hilton's curatorial work, which has included, most recently, his tour de force "emotional retrospective" at the Artist's Institute in New York in 2016, in which he created three different exhibits, one paying tribute to Holly Woodlawn, Candy Darling, and other "personages who lived in a pre-*Transparent*, pre-Caitlyn, pre-anything world"; one dedicated to James Baldwin, Jim Brown, and their "children"; and one featuring Sheryl Sutton, Senga Nengudi, his sister, his mother, and a host of other artists and friends. And Hilton recently curated a show called *Alice Neel: Uptown*, which consists of decades of portraits of people of color that Neel painted while living in Spanish Harlem (he wrote on Neel, too).

And don't even get me started on his legendary Instagram account, one of the most graceful cultural archives on the internet, or on his beautiful broadsheet series *After Dark* (named after the homoerotic entertainment magazine from the '70s), which magically arrives by SNAIL MAIL every few months with an original essay or poem printed on the back of a poster-size photograph, be it of Warhol and his mother, a very young Diane Keaton, or Angela Davis and Toni Morrison walking down a city street, engrossed in conversation.

Suffice it to say, Hilton has had an inspiring and sometimes intimidating career, guided by the principle he so admires in Neel, about whom he says: "It was just about the work for her, and I respect that. That is something to aspire to. Do your work."

But what I most want to honor here is something more difficult to describe, even for those of us in the business of words, which is Hilton's sensibility.

For some time now we have lived in a culture in which "PC" and "anti-PC" (or their various zombie incarnations, such as "woke" and "anti-woke")

have become code words for, on the one hand, attempting, however im-
perfectly, to resist and dismantle white supremacy and a host of related
excrescences, and, on the other, perpetuating such poisons without shame
and often with gusto. Where and how in such a climate do writers do
their work of investigating and illuminating what Hilton has called "the
delicacy of complication—the idea that people are not really one thing
or the other, that there is this amalgamation of all sorts of nerve end-
ings and truths"? How to explore these many nerve endings and truths—
the ungoverned, often anarchic, realms of identification, aesthetics, and
desire—without making recourse to hashed party lines, or equally hashed
reactionary provocations? How do we expose the ways in which cate-
gorization, boundary making, the repetition of predictable tropes and
stances, can be utterly murderous to the operations of art, thought, and
love, while also recognizing that there are of course moments when one
must take a stand in more simple, at times even simplistic, terms?

One good answer is, read Hilton Als. Hilton writes straight into the deli-
cate, complicated heart of race, gender, sexuality, and aesthetics, all the
while modeling what an idiosyncratic, disobedient, erudite, take-no-
prisoners sensibility can be and do. In a scathing piece in *White Girls*
titled "Philosopher or Dog?," he writes: "Writers of a color write stupidly
on this wall of race for the approval of very stupid people who, in granting
their approval, may decide not to kill you. If these stupid people decide
not to kill you, something must be compromised, given up. Generally,
what is compromised is one's voice. That voice—it is all a writer has."
Hilton has never given up, will never give up, his voice. It's the voice of
someone who has trained himself—or who knows? maybe he just came
out this way—to say precisely what he thinks, rather than what anyone—
white or otherwise—expects, demands, or hopes.

Hilton has used his voice—in the *New Yorker*, of course, but in many
other venues as well—to give recognition and visibility to countless art-
ists and writers who otherwise may not have had much mainstream at-
tention (I count myself among them). At the same time, he is keenly
aware of the ways in which mainstream visibility often involves a sort of

political or moral hygiene—a respectability politics, you might say—that can neuter or render invisible the very thing about the subject that made it so great in the first place. As he asks in an essay about the drag queens of the Warhol era, "Does the status quo always have to confer legitimacy on the marginal—i.e., transforming the creepy into 'sexual radicals'—in order to see them?" Part of the high-wire act of Hilton's writing is how he is able to honor the marginal, the illegitimate, the fucked up, the creepy, even as he brings it into fuller view, under brighter lights.

Hilton's sensibility is also marked by its deep and wild exploration of identification (or disidentification, as the queer theorists like to say), and its wily, torturous relationship to desire. (Do you want to be them, do you feel you are them, do you see parts of yourself in them, do you want to sleep with them, just hang around them, behold them from afar, fuse with them, and so on.) Again, we are living in a moment when identification with "unlike others" often gets touted as a great, necessary tool to achieve the goals of empathy and justice, or pilloried as a naive, even nefarious sentiment pursued by the tone-deaf or ignorant. Hilton's persistent forays into these wilds chart another course altogether, one that shrugs off demands for political efficacy or mea culpas, and makes no a priori presumptions about where or how connections will be found.

Connections and identifications have the power to surprise us, to bind and repel us. As Hilton explores via a study of a pivotal friendship in *White Girls*: "By the time we met we were anxious to share our black American maleness with another person who knew how flat and not descriptive those words were since they did not include how it had more than its share of Daisy Buchanan and Jordan Baker in it, women who passed their 'white girlhood' together." He and his friend also found themselves in Joni Mitchell, in Barbara Smith and her twin sister, Beverly, in Jennie Livingston's *Paris Is Burning*, in Shulamith Firestone's *The Dialectic of Sex*, and more. Of his friend, he says: "I was attracted to him from the first because I am always attracted to people who are not myself but are." Who doesn't recognize their own process of self-formation or edification here, even if the proper names on our lists may differ? "Sitting on the sub-

way," he writes, "the lights go by but the people don't. Standing above me and around me I see how we are all the same, that none of us are white women or black men; rather, we're a series of mouths, and that every mouth needs filling: with something wet or dry, like love, or unfamiliar and savory, like love." I'm quoting at length here not to shirk my own verbal duties, but rather to show you that it's one thing to theorize the workings of identity and desire, as so many have done; it's another to set those workings loose in language and let them rip. To give them *mouths*.

Hilton sometimes says his art is "other people," which may sound simply descriptive or humble. But by focusing on so many others through the ultrasensitive and original lens of himself, Hilton has invented a new way of being in the world, one that encompasses observer, writer, maker, critic, curator, and friend. In his introduction to his Baldwin show at the Artist's Institute, Hilton explains how this way—however trenchant—is shaped by love:

> I don't want to talk about this show too much but I've been asked to, and in order to survive in a culture of explanation, one must explain. But how to explain the heart? A sensibility? Love? I love all the artists in this show. The friends who contributed their time to making it work. And what I learned from them. There is no point in making things if you don't learn something about the world, oneself. What did I learn putting this together? That I am in love, still, with sharing my enthusiasms, those artists and writers who changed me.
>
> . . .
>
> I am alive because they want me to be. I am looking at them because they want me to see them, which is an act of love, among the more profound, and I am looking at the artists in this show and introducing them to you through words because it is all that is left to me here. Look at them and look at the love I have for them, individually and collectively.

As we do this looking, Hilton says, we will see nothing less than "an un-qualified yes to life," which is what Hilton says Baldwin was after. It's what Hilton's after, too.

It's so rare, this unqualified YES—a YES made all the more fierce when issued by writers as alert to brutality and delicacy as Baldwin was, as Hilton is. For even in our YES, we will find ourselves up against the fact that, as Hilton puts it, "It is difficult to forgive the world for not being a place conducive to this complexity." I find this difficult, too. There's too much in it that's crushing, not just of complexity, but of bodies, souls, histories, futures. But given that it's the same world that produced Hilton Als, and the same world that has brought us together to celebrate him to-night, I'm mostly just awed and grateful.

(2017)

O THAT WAVE

On Samantha Hunt's *The Seas*

I first read *The Seas* when it came out in 2004 and was scalded by its beauty. It took me back to how I felt as a kid, when you're newly shocked by literature's capacity to cast a spell—you know the feeling, when you turn the last page of a novel that you've burrowed into and has burrowed into you, and suddenly find that the book has become more than a book, it's become a talisman, something precious. A little scary, a little holy.

The Seas felt like that to me. Radiant with magic, some of it dangerous. Some of it hurt. Probably I feared it a bit—not only how perfect it was, as a piece of writing, but also how much it made me feel. About the gigantic, all-consuming blue wave that begins and ends and haunts *The Seas*, our nineteen-year-old narrator writes: "It is truly a gorgeous color. This blue is chaotic and changing. I recognize it immediately." I recognized, recognize, it too. It's the wave that holds the narrator's grief for her lost father, her wobbly faith in language and etymology, her enthrallment with the oceanic, her fixation on the color blue, her complex relationship to her mother, her bobbing amid a sea of alcoholics, her own fierce sexual desire, her loneliness, her conviction of her mermaid nature, her love for a mortal in deep pain whose suffering mirrors, alleviates, and exacerbates her own. It's the wave that reveals the painful, exhilarating scope of her small and swelling life. O that wave.

And so I put *The Seas* up on a high shelf, not because I didn't love it, but because its power felt so acute I needed to dim it a little, save it for another day. Its rerelease has thankfully provided that occasion.

Like so much of Hunt's storytelling since, *The Seas* performs a mysterious balancing act between the so-called real and the so-called fantastical, making words like "magical realism," "surrealism," "allegory," or "fairytale" swirl around her work. I read *The Seas* a little differently, however. I read it as a portrait of human psychology that imagines human emotion as an elemental force on par with air, water, wind, and fire. Seen this way, whatever is "not real" in *The Seas* could also be read as a deep, perhaps the deepest, sort of realism—a vision akin to, say, the penetrating insight of shamanistic trance. At the same time, there exists the real possibility throughout that the narrator is not just unreliable but insane, drifting further and further toward a destructive psychosis. You can hear both possibilities pulse in the sentence: "He is gone and the water rushes up behind me like a couple of police officers with their blue lights flashing, with their steel blue guns drawn." It will take 150 more pages for the reader to fathom the nature of the simile, and even then, there will be room to wonder.

As its nesting doll epigraph suggests (*It was a dark and stormy night, / and the ship was on the sea. / The captain said, "Sailor, tell us a story," / and the sailor began, / "It was a dark and stormy night, / and the ship was at sea . . ."*), *The Seas* has what we once might have called "postmodern" structure, in terms of its attention to stories within stories, and its slow, perhaps even deconstructive inquiry into the granular nature of language itself, even down to the atomistic nature of individual letters. But as its epigraph also suggests, there's an ancient, Scheherazade-like framing at work here as well. Despite the occasional entrance of historical markers (the carnies with tattooed teardrops, the Iraq War, the sociologists visiting the oceanside town to study its high rates of alcoholism), the story of *The Seas* feels timeless, archetypal. It is a tale of love and war.

A tale of love and war that is narrated, importantly, by a woman. In this *The Seas* never fails to bring to my mind the work of visionary poet Alice

Notley, who has "channeled" her dead father, who died of alcoholism, and her dead brother, a Vietnam vet traumatized by the war, as a means of composing long poems (*Close to Me and Closer* . . . [*The Language of Heaven*] and "White Phosphorus," respectively). I think of how, after writing these works, Notley says she grew impatient with woman's role as "essentially passive: sufferer, survivor." What do women *do*, Notley wondered, besides serve as witness? Eventually Notley came up with the following answer: "Insomuch as women dream, they participate in stories every night of their lives. Profound stories which may involve sex, death, violence, journeys, quests, all the stuff of epic & much of narrative." Against the idea that dreams have relevance only on the margins of psychic or historical life, Notley argues that "life is a dream; that we construct reality in a dreamlike way; that we agree to be in the same dream; and that the only way to change reality is to recognize its dreamlike qualities and act as if it is malleable."

Such questions, along with Notley's answers, are at the heart of *The Seas*, in which Hunt showcases her own uncanny ability to "recognize [reality's] dreamlike qualities and act as if it is malleable." And while our narrator may be subsumed by her Iraq War vet's trauma, her desire for him is sharply wrought, and all her own: "Some nights I want Jude so badly that I imagine I am giving birth to him. I pretend to sweat. I toss and wring my insides out. Mostly I think this because that's how badly I want Jude's head between my legs." "Jude thinks he is too old for me. I think I could cut a strip of flesh from his upper arm and eat it."

Since *The Seas,* Hunt has written two ambitious novels and a collection of short stories, all of which demonstrate her ever-deepening access to the strange, the inventive, the magic, and the dark—indeed, the "dark dark," as in the title of her most recent collection. I love and admire all of this work, but *The Seas* will always occupy a special place for me, standing, as it does, on a precipice overlooking deep reserves of desire, liminality, mystery, and pain. Do you know that Björk song "Anchor Song"? Look it up, and listen to it alongside *The Seas*. I think you will find it a fitting companion, as it is another plainspoken seaside anthem, sung by a woman with formidable grace and power.

And yet. Unlike "Anchor Song," in which the singer asserts that she's staying put, *The Seas* swerves. For just as the novel seems to merge our narrator's and Jude's tragic fates, echoing the countless romantic narratives in which true love means (literally, in this case) drowning in one another's sorrows, our narrator (spoiler alert!) pulls out ahead and starts swimming toward a different future. (I think she does, anyway—there's room to wonder here as well.) In a way that feels earned and also surprising, *The Seas* edges away from the consuming whirlpools of drunk, dead father and drunk, tortured ex-soldier, and toward a fresh reckoning between a living mother and her living daughter, not to mention between a young woman and herself. In so doing, Hunt gifts us not only an incisive, compassionate portrait of how and why we remain anchored to our fucked-up towns, our fucked-up loves, our fucked-up families, our fucked-up habits, our fucked-up substances, our fucked-up homes, and our fucked-up wars, but also a model as to how we might—seemingly against all odds—pull up and set out.

(2017)

NO EXCUSES

The Art of Sarah Lucas

I was twenty-six years old when I first saw Sarah Lucas's work in the 1999 exhibition *Sensation* at the Brooklyn Museum. Chris Ofili and Damien Hirst may have been making the headlines (their work having been targeted as "sick stuff" by New York's then mayor, Rudy Giuliani), but it was Lucas's work that hit and lodged. I didn't need or want to hear interpretations of *Two Fried Eggs and a Kebab* (1992). I got it, or at least I felt I got it, which was enough. It was a wink, a portal, a stab of recognition from across the pond. "I live with remarks like that all my life," Lucas said about *Two Fried Eggs*. "And I think, 'Well yeah, I can make that same kind of remark just like you can, and I can make it look fucking good into the bargain." Note that she isn't tossing the language back to say— or solely to say—"What a gross phrase, which offends and degrades me." She's saying, "You think you're foul? I'll give you foul, plus a funny, multivalent, good looking piece of art to boot." Most of my peers and idols at the time—from Tribe 8 to DANCENOISE to Lydia Lunch to Annie Sprinkle to Bikini Kill to Free Kitten and more—were doing something similar. And while I didn't know then about Lucas's shop with Tracey Emin, where they sold their "I'm so fucky," "She's kebab," and "Complete arsehole" T-shirts, ostentatiously making art and partying with kin and strangers until the shop's closing in 1993, I recognize it now as part of an international network of punk, DIY, women-artist-run spaces fueled

by experiment, brazenness, pleasure, and humor—the likes of which we needed then, and frankly could use more of now.

I'm starting with *Sensation* not to rehash the tiresome narrative that dogs nearly every journalistic account of Lucas, which consists mostly of variations on the theme of "brashest angriest baddest drunkest most in-your-face girl of the YBA goes on to have many-decade career of totally amazing, probing art—who would have thought?" I'm doing so mostly to note that, to many of us, this narrative sounds the same willfully ignorant and constricted tune that typically greets female artists with as much raw power and capacity as Lucas has. For her part, Lucas has admirably parried this narrative for years with sage, patient responses: "I don't know if the work is as 'fuck off' as other people seem to take it"; "I always think it's a bit funny, when you see all the shocking things in the world, endless women getting tortured and murdered. You think: why the hell would anyone be shocked by a cigarette in somebody's bum?" In one of my favorite moments, she turns the tables on a male interviewer who has characterized her work as "pessimistic": "Let me ask you something," she says. "Could it be that my sculptures make you feel so pessimistic because you're a man? Do you feel them to be directed at you personally? What kind of man would you say you are?" When the interviewer says he thinks of himself more as a person than as a man (sigh) and asks Lucas what kind of woman she thinks she is, she offers: "I'm a kindly, maternal even—although I don't have children of my own—middle-aged woman; still quite childlike, with a brutal edge that pops out sometimes, often in the form of a rather masculine sense of humor. I'm optimistic by nature and can generally find something worthwhile in pretty grim situations—or, at least, brighten them up." Would that we all could summon as much lucid self-insight, or have Lucas's capacity for brightening the grim (the uncompromising, all-over yellow of her exhibition *I SCREAM DADDIO* for the British Pavilion at the 2015 Venice Biennale leaps immediately to mind).

All of which is to say: I value this New Museum retrospective so much, as it sidesteps the narrative of the mellowing of an angry, feral soul—

that "calming down" many inexplicably wish on our most crackling messengers—and instead allows us the time and space to look at the expanse of what Lucas has been doing from the start: making objects that "look fucking good" out of a shape-shifting devotion to questions of anatomy, presence, ambivalence, rudeness, and humor. It's a story of objects, and also of ways of being together—with objects, with each other.

Lucas has long been curious about the alchemical properties of reclamation and *détournement*, especially in regard to gender. "I quite like insinuating myself into blokiness, definitely," she says. "That's why I would say something spurious, like 'I'm a better bloke than most blokes.' But it adds so much to the work I do that I'm a woman doing it. And that fascinates me, why it should be so much more powerful because I'm gender-bending, in a way. But it is." It is, indeed—but as her word "fascinates" suggests, this "gender-bending" exceeds any singular interpretation. It has no fixed tone. It opens up questions, piece by piece. Anatomies detach and reattach to points of origin ("He was the tit," she says of her milkman father); she rotates shapes kaleidoscopically, reflecting the multiple impulses in her curiosity: "Reasons to make a penis: appropriation, because I don't have one; voodoo economics; totemism; they're a convenient size for the lap; fetishism; compact power; Dad; why make the whole bloke?; gents; gnomey; because you don't see them on display very much; for religious reasons having to do with the spark."

No one has really figured out the workings of reclamation/*détournement*/appropriation, because there is nothing once and for all to figure out. There is a kind of churning, a field of play, and Lucas is all over it, splattering it with questions: "Is smoking masculine? It used to be, but then so did the vote. Is a cigarette masculine? It stands for, in for, something. A nipple? A penis? Is a cigar a way of saying, I have a big dick? Or is it saying, my mother's nipple is bigger than your mother's nipple?" Like William Pope.L, who since 2000 has been distributing flyers reading "THIS IS A PAINTING OF MARTIN LUTHER KING'S PENIS FROM INSIDE MY FATHER'S VAGINA," Lucas is expert at getting us to "look at [the] body in a way we're not used to" (Pope.L's stated aim

re: King's body). Also like Pope.L, Lucas is an idea person. But her fidelity to shape and material trumps intellectual dogma, including feminist creed. This orientation allows her, among other things, an unbridled formal exploration of dicks: "As it turns out, a dick with two balls is a really convenient object. You can make it and it's already whole. It can already stand up and do all those things that you'd expect any sculpture to do. In that way it's really handy. I mean I could start thinking about making vulvas but then I'd have to start thinking about where the edges are going to be." Fair enough. (She gets around to this structural problem with her *Muses*, in which legs become the anchor, the vulva or asshole punctuated by cigarette.)

In 2017, these *Muses* were exhibited in San Francisco in a show at the Legion of Honor called *Good Muse*, installed alongside (and sometimes on top of) Auguste Rodin's sculptures. Her work blazed like hot oil through the galleries, demonstrating how forceful and disruptive her gestures can be when placed into conversation with art history. And yet—one of my favorite aspects of her work is its palpable disinterest in art qua art. Asked by an interviewer about the first piece of art that really mattered to her, Lucas answered, "I'm not making art about art. I didn't buy a ticket." (Can I get that on a T-shirt?) Relatedly, Lucas has long spurned traditional studio practice in favor of the mess of mold-making on the kitchen table. "The kitchen is the ideal spot for making stuff, and brewing up—ideas, a working philosophy, genius in being ready," writes her boyfriend, Julian Simmons. "Fuck mausoleums and their nine-to-five earnestness, Sarah never had one." I love this weirding of the domestic, this philosophy in the kitchen, with lots of eggs.

It's a truism that all art (or all good art) somehow transforms the ordinary. But not all art (not even all good art) makes ordinary things feel magic. I don't know exactly what Lucas means when she says she makes dicks in part "for religious reasons having to do with the spark," but I do know that she is uniquely attuned to that spark. It's not something one can really describe or explain, nor is it something shared by all sculptors.

(Joseph Cornell, who famously disliked anything that did not grant him access to a force he called "'the spark,' or 'the lift' or 'the zest,'" had it too, in spades). It's a capacity to work with fairly plain materials until they shimmer into something uncanny and precise, akin to summoning fetish. "Well that's it really," Lucas says when asked how she knows a piece is finished. "It jumps to life. Becomes more than the sum of its parts. Has a character. Is something seen for the first time." A retrospective allows us to watch Lucas hunt for this zest, this "something seen for the first time," over a number of years, across a number of mediums: chairs, mattresses, toilets, photographs, resin, rubber, nylons, wax, cigarettes, plaster, concrete, bronze, eggs, and more.

Of aging, Lucas has said: "When you are younger, everything has potential—people you might meet, the world, things that will be in your life. What does start to weigh, as you get older, is a lack of potential. Potential is diminishing all the time." When I was younger, I would have rejected such a pronouncement as wrong and sad. I would have felt sorry for all those blinkered adults who saw winnowing potential everywhere. Now I think Lucas is describing a pretty straightforward neurological and emotional challenge that typically attends the condition of having lived on the planet for over four decades. But just because potential may be diminishing, you don't quit looking for it. The hunt deepens, complicates, sends one to roam. I watch a little video online of Lucas buying eggs at a farmers market—she needs one hundred, no, two hundred—and I can see her, feel her, hunting.

She's also desiring. She wants those eggs, she wants that yellow. She wants to throw the eggs, to watch others throw them, she wants to watch them drip. In a little essay called "Classic Pervery," Lucas differentiates something she calls "the ordinary perve" from "the classic perve." The former goes in for "pornography of the hardcore or tabloid type, or celebrity, or gratuitous violence"; the latter "is more likely to be rubbing his hands down his jumper, enjoying the soft nap of the wool and at the same time considering putting the kettle on for tea to go with his orange syrup

cake." Needless to say, Lucas is a "classic perve." "Why else," she writes, "would an artist spend six months, or years, carving, from life, and scaled up to rather large proportions, a plum that looks like a bum? Why would someone knit or crochet the neck only of a roll-neck jumper and call it a 'Hot Neck'? Or make a rag doll in a long, old-fashioned, ladies' dress concealing hairy armpits and a nob and bollocks, and call it Danger Man." Why else, indeed?

These days we are surrounded by, sometimes drowning in, discourse about "consent." Given the pathetic state of affairs we continue to suffer under patriarchy, this makes sense. But the conversation leaves vast plains of pervery and desire totally untouched. Political philosopher Wendy Brown explains (in *States of Injury*): "If, in rape law, men are seen to *do* sex while women *consent* to it, if the measure of rape is not whether a woman sought or desired sex but whether she acceded to it or refused it when it was pressed upon her, then consent operates both as a sign of subordination and a means of its legitimation. Consent is thus a response to power—it adds or withdraws legitimacy—but it is not a mode of enacting or sharing in power."

One thing is for certain: Lucas's work enacts and shares in power. "Power. The word keeps coming up," Olivia Laing wrote in a 2015 profile. "Lucas is aware that she possesses it herself, both as an artist and as a person." Perhaps this is what Lucas means when she says she believes in "beyond feminism." Not that feminism didn't or doesn't have to do with power. But it's easy to slip into presuming that power is only out there, something to be wielded against you, or something on the horizon to struggle dourly toward. How to be alive—and even more alive—to the power we already have? How to make good pervy use of it, how not to let it turn against you, how to stay on its pulse? As I write this, Lucas's 2005 sculpture *Liberty* floats into my mind: a plaster arm in Rosie the Riveter formation, a cigarette wedged between index and middle fingers, sticking straight up. Juvenile and toxic power mix with an aura of genuine strength, all held together under a title that flickers between irony and sincerity, depending on the light.

Considering Lucas's recent work with Simmons (*NOB, Penetralia)*, and her relationships with other male collaborators and friends (Angus Fairhurst, Franz West, and Olivier Garbay come to mind, along with the "old blokes down at the pub" whom she quasi-jokingly cites as her "main influence"), I'm reminded of Carolee Schneemann, another artist known for her generative, pleasurable enmeshments with men, not to mention for using her genitals to make art. Describing the heterosexual relations she and her peers forged in the 1960s, Schneemann writes, "We were young women taking tremendous freedoms, maintaining self-definition and an erotic confidence in choosing partners spontaneously in the firm expectation of great times to be won together." Doubtless this was—is—easier said than done. But after hearing so many young women in these #MeToo days recount stories of contemptible sex, zeroed desire, and feelings of powerlessness, it seems especially critical to make space for not just the expectation, but also the lived reality of what Schneemann here describes. Lucas lives it, too. Whether she's shoveling mud in the Suffolk countryside, smiling at Simmons while wiping herself on a toilet in Mexico with one of her nylon sculptures draped around her neck, or directing a group of women to throw one thousand eggs at a gallery wall in Berlin, she sure seems like she's having a great time (and making it look fucking good into the bargain).

No doubt this time is marbled with loss, grimness, hangovers, and "brutal edges." (Who can easily forget the chill of a piece like 1996's *Is Suicide Genetic?*, in which those words appear in brown graffiti on a scuzzy toilet bowl, as if a last cry for help as their author circles the drain?) But it's also visibly rich with wit, fearlessness, labor, and laughter (not to mention wet with plaster, yolk, mud, and butter). "I don't want to be scared of anything," Lucas has said. "I hate excuses. Loathe excuses. I don't want to make them, I don't want to listen to them, I don't want to live one." I don't need a T-shirt for that. I'm going to remember it for the rest of my life.

(2018)

A CONTINUITY, IMAGINED

Conversation with Björk

dearest maggie

not sure exactly how to start this but
let's tip this toe into the unknown

i have lived a few months a year for the
last 18 in new york and i soo o sorely
needed this conversation!
i lived up the hudson and in brooklyn,
in a perhaps not so subtle radius
circling on orbit around that ever
complex manhattan
it was during this side of the
millennium, from january 2000
to be precise
and so often i found it tricksy
to find a stance to thrive
9/11, school shootings and then trump

i hope you don't mind if we talk a little
about your book "the art of cruelty"?
it heroically assembled the moments of

violence in art the last couple
of centuries
i have to congratulate you! just making
that archive is a feat!!
so incredibly informative!!
someone should do a tv series based on
that book . . .

what was so liberating about it was that
it refused to go extremely black
or white about those subject matters
it was openly inclusive discussing
impulses, wildness and cruelty
but also allowed itself to defend life
and justice when needed and
i surprisingly found myself agreeing
with you like almost every single time
so familiar that curious feeling after
you watch a film and it pushes buttons
and your brain says one thing and the
heart something else
but your angle on it truly gave me faith
that one can trust one's gut

is it ok if i ask you several questions?

or should we have this more like a chat?

or perhaps i start and we can do
a bit of both?

is that book a conscious attempt
to build a bridge between liberal
intelligentsia in the usa and feminism?
to do some sort of damage control on
the inbred misogyny of the left?

i found myself and i suspect many other
women did too, sometimes mirroring
myself in your angle,
when i have found myself
overcompensating and giving them
liberal left bad boys an alibi
with clairvoyance feeling them out and
like developing a film, giving that dark
side a humanness and vocabulary that
is often lacking?

i wonder if i have been guilty
of vanity in how i have offered
to overturn nihilism?
if so, do you recognise that feeling?
to pride oneself in absorbing the dark
and overturn it?
if so, is it some sort of alchemy?

ha ha ha ha

million questions sorry

my friend felt he complimented
me last year saying that when it comes
to relation and friendships i can host
the unhostable and it made me wonder
if that was something i wanted to be?
or not? it's an arid terrain
i'm probably the only one who knows
the answers to these questions

but do those feelings ring bells?

i adore one of the phrases you had
compiled which is so so so maggie,

never ever polarising always always
uniting:
("the point of art is to show people
that life is worth living by showing that
it isn't" fanny howe)

you then say: "luce irigaray has gone so
far as to call matricide 'the blind spot
of western patriarchal civilisation';
scholar amber jacobs has described it
as the 'death that will not deliver,'
a 'non-concept' long denied any
structural generativity by classical
psychoanalytic thought"

this might be boring subject matter
but sometimes the obvious is best . . .
i guess in a conversation between
me and you right after me reading
a book about cruelty in art
it is kinda unavoidable to at least
mention my collaboration with lars
von trier (sorry guys you are probably
yawning at this point) but when i read
the above sentence it made me think
of my instinct with him when i refused
to be a victim. i remember him saying
something along the lines of that
he was surprised i didn't just want him
to destroy me completely because
i would then go through a
transformative birth and be reborn. in
the lunacy of his world it would have
been easier. but every cell in my body
screamed that i didn't want to repeat
the mythology of joan of arc or

maria callas, it wasn't that i was too
scared or i couldn't, it was more that all
the work of my mom's generation
of feminists would have gone to waste
if i repeated that tale, it felt boring
and predictable to me.
you also write: "mary daly, melanie klein,
julia kristeva have noted that it is a
hallmark of patriarchal religion, culture
and psychology to have a repressed
symbolic matricide at its root
– a matricide cast as necessary for the
human subject to leave the mess
of nature and bodily dependency behind
and to become a full participant in
subjectivity, language, and culture
(all of which in phallocentric discourse
are identified with the male). as kristeva
famously puts it 'for a man and for
a woman the loss of mother is a biological
and physical necessity, the first step
on the way to becoming autonomous.
matricide is our vital necessity, the sine
qua non of our individuation.' note
that the subject here imagined doesn't
simply outgrow or separate from the
mother. it murders her."

maggie, i am craving so hard other
narratives for us, is it just laziness or lack
of imagination?

that is why when i read your
masterpiece "the argonauts" i absolutely
beamed with hope.

can we also in this chat discuss hope?
and where we are heading now?

you address it in that book so bravely,
forming a family of the future across
gender across all borders.

one of the most romantic and life
affirming books i have read like ever.

can we all please invent a continuity?

perhaps i can offer some suggestion
hidden in the icelander's relationship with
nature . . . would that interest you?
i feel sometimes the western
civilisation's narrative, of that gigantic
titanic going down slowly slo-mo for the
last century or so, so one-sided, full
of self importance, self pity and vanity
in a way. like it is asking everybody else
to hold their breaths and watch them
dying, kinda narcissistic? instead of
acting environmentally it feels paralysed
with guilt perhaps there is more
optimism in second world countries who
missed the industrial revolution like for
example some south american countries
and southeast asian . . . ?

i for example read about Tasmanian
gothic literature and how it differed from
eurogoth: not urban but nature, sounds
kinda familiar to me

for me sometimes the female
surrealists like leonora carrington (her
"hearing trumpet" is divine!!) remedios
varo, méret Oppenheim also offer hope.
 i felt they took over the often over-
conceptual ideological surrealism of the
twenties and in the next generation gave
it flesh, nature, mythology, emotions.

have you come across the
apocalyptics? i found this in a book about
welsh painter ithell colquhoun:

"morphology: where species mix
the new apocalypse's starting point was
a belief in the wholeness of man. this
longstanding romantic idea had been
affirmed most recently by DH Lawrence
in apocalypse, the book that suggested
the movement's name.
 in it he emphasised the importance
of harmony with nature.

the apocalyptics rejected the
centralisation, authoritarianism and
dehumanising tendencies of modern
society in favour of the small, the local
and the individual. they also objected
to surrealist unreason championing the
right to exercise conscious control
over mental and social processes [. . .]
by opposing the privileging of the
unconscious, they saw themselves as
offering a development of surrealism.
they were accordingly suspicious

of automatism as a denial of free will and
because it bypassed technical skill
and aesthetic sensibility [. . .] in a letter
of late 1941 to the artist conroy maddox
in which she described her painting,
she wrote that she was undertaking
morphological research, investigating
'the relationship between human
forms and those of rocks, trees and
sometimes architecture' this fits with the
apocalyptics' concern with wholeness,
although they might have balked at
the mystical interpretation of unity
and wholeness, at least to the extent
that she later expressed in her essay
'the night side of nature'"

i am sorry for my clumsy beginning and
if you want to offer other subject matters

i am all in

or another format
or another angle to start from

consider this simply a suggestion
of where to start

respect

warmth

björk

Dear Björk,

First of all, I want to say that the honor of this conversation is all mine. If you had told me, back when I was thirteen and listening to Kukl, that I would someday be conversing with you, or, even more implausibly, that I would someday write books that you would read and care about, I would never, EVER have believed it. And yet, here we are. Suffice it to say it's so meaningful to me that you thought of me for this conversation. Thank you.

I'm so glad you liked *The Art of Cruelty* and want to talk about it. One of the best things about people reading *The Argonauts* is that its visibility resummoned interest in earlier books of mine, like the cruelty book, which otherwise didn't travel as far and wide as I might have hoped at the time. It's really funny what you say about there being a TV show based on the book—I have a curator friend who told me the other day that she is thinking about basing an exhibition on the book, which seems like a totally exciting and also challenging idea, since so much of the work in question seems to me best experienced in smaller doses—I can easily see how putting all of it in one place might overwhelm, or paralyze, critical or perceptual capacity. BUT, given how important the notions of violence and darkness and shock and cruelty have been in art (forever, of course, but in my book's purview, for the past hundred years or so), it also seems that the show could be worthwhile . . . we'll see.

Your reading of the book seems spot-on to me—which maybe shouldn't be a surprise, but it is certainly a satisfaction. Especially your comments about "giving that dark side a humanness and vocabulary which is often lacking." I do think that I, perhaps like you, started off my intellectual and artistic life somewhat enthralled by the "bad boys" (Bataille, Artaud, the Marquis de Sade, and so on), perhaps because they were sold to me as representing transgression itself. As I grew up into a more overtly feminist sensibility, the questions of how, why, and if my appreciation of a lot of that work would hold—not to mention the journey of finding out what else was out there—became sometimes acute. I became fascinated by what forms of cruelty or darkness seemed to merit or even increase

my curiosity, and what forms made me say Fuck you, I'm out of here. The book was very much a feminist exercise, but I decided early on that it wouldn't announce itself or structure itself as such—rather, it would weave in this perspective along with the rest, so that conversations about female aggression or matricide or what have you weren't posed as a corrective, or as second-tier art history.

I am glad you say that your instincts often aligned with mine as you read the book! The book is a lot about instinct, or visceral response, what it means, what to do with it. I think one thing you realize over time in looking at art/reading certain writers is that how far one is willing to go with them has a lot to do with how much you trust their sensibility—maybe not totally dissimilarly to the way you'd trust someone (or not) in a back alley. Often that trust has something to do with gender, even if not everything.

Maybe I am saying all this to back into the von Trier question, which is totally fascinating to me, if only because talking with you about it directly gives me a profound—if surreal, and folded-in-time—sense of a circle coming closed, at long last. Because I think it possible that my experience of seeing *Dancer in the Dark* planted the seeds for the entire *Art of Cruelty* project. I don't know if you know a book of mine called *The Red Parts*, from 2007, but I wrote it in the years directly prior to writing *The Art of Cruelty*—it has to do with the 1969 murder of my mother's sister Jane, and tells the story of my mother and me attending the trial for a new suspect in 2005 (he was convicted, thirty-six years after the fact). *The Red Parts* contains this paragraph, which comes while my family is awaiting the verdict:

> Beyond murder mind, the worst thing I can imagine is walking to your execution. Movies which contain these scenes upset me more than all other kinds of movie violence combined. After Lars von Trier's *Dancer in the Dark*, which ends with Björk singing and dancing her way to her death on the gallows, I literally could not leave the theatre. I thought I might

have to be carried out by an usher. This has something to do with my deep moral and political opposition to capital punishment, but clearly it goes beyond that. I simply can't bear the idea of walking toward your death knowing you might not be ready for it. Your bowels letting loose, your legs gone to rubber. Perhaps this is another way of saying that I can't bear the human condition. *Life is like getting into a boat that's just about to sail out to sea and sink*, the Buddhists say. And so it is. Tibetan Buddhists talk about death as a moment of "potent opportunity," but one you have to practice for in order to know what to do with it. You have to practice so that even if you were, say, suddenly shot in the head at close range, or even if, say, your heart exploded in the middle of the night, you'd be instantaneously ready to go, to pass through the bardo. I know that I'm not ready, and I'm terrified that I won't learn in time. How can I learn if I'm not even trying?

As I say in that passage, I broke down in the theater after *Dancer in the Dark*, my own legs turned to rubber. But in retrospect, it wasn't just due to the movie's melodrama or the mortality concerns as described above. It also had to do with my having been a huge fan of yours for my entire life, from age thirteen onward and then, all these years later, I was sitting in the dark by myself in a NYC movie theater feeling the director's desire to destroy your character completely, as you put it, and it made me soul sick, soul sickened. And angry. At any rate, something about the whole affair made it feel of interest to me to analyze when and how I think shock and cruelty feel worthwhile and when they feel dead-end. Thus, *The Art of Cruelty*.

As far as "priding oneself on the dark and overturning it"—I think this was an abiding preoccupation of mine for many years, all of which crested with the publication of my three books on violence, *Jane: A Murder*, *The Red Parts*, and *The Art of Cruelty*. Since the first two of those books had to do with a sexualized murder of a family member, a lot of this inquiry was mixed up for me in questions of sexual violence and, to a certain extent,

gender relations more broadly. As a kid, I wanted to be able to talk Sade and Bataille with the dirtiest punks and geeks; in writing about my aunt, I kind of wanted to show that I could look at what had been done to her life and body straight up—I wanted to show that I was strong enough to face down the effects of sexual violence instead of being intimidated by them.

BUT, of course, there's facing down something hard in service of confronting injustice, and then there's immersing oneself in hard things for more complicated reasons, such as the fact that one may feel oneself home to unhostable things; one may be looking for mirroring, identification, communion, alchemy, or just company in others who seem like they might offer kinship or understanding. Because men don't own darkness, they don't own aggression, they don't own destruction or self-destruction. It's hard, I think, for women to know what share of that darkness is ours because we too are human animals, and what share is a result of having to live in a world sick unto death with the destructive forces of misogyny and male aggression. I think I used to think I might be able to, like, figure this out, unravel the knot; chapters like "Everything Is Nice" in *The Art of Cruelty* grapple with such questions head-on.

Now I'm more inclined to think we're all so contaminated and imbricated with one another, it's something of a fool's errand to try to tease it all apart (not to mention the fact that gender itself flickers in and out of seeming a useful category). And yet, sometimes it's not a fool's errand, and simple things still need to be said. (You said some of them to *Pitchfork* a few years back, which was great.)

In any event: I'm so glad you had the instincts you had vis-à-vis von Trier, and that you honored them. Of course you weren't scared—you just knew better!!

So, when you ask if the notion of hosting the unhostable rings any bells, the answer is yes—in fact, I would say, it rings a symphony! Probably I

thought that was my job for some time, both emotionally and artisti-cally. I am less sure that I ever had as much alchemical propensity as you seem to have—it seems to me that you likely have more transformational skills, more alchemical ability, than I ever managed. Often I've felt that all I had to offer in this arena is a certain rerendering of the unhostable with added clarity. Maybe clarity performs its own version of alchemy, I'm not sure. But here is where words seem very paltry in the face of music and sound—you can create whole soundscapes that add infinite texture to simple sentences, whereas I'm just stuck with the simple sentences, in all their flat reverb. My task is to figure out how to get words to be more than their parts. I still don't really know how to do this, or how to TRY to do this; I only know how to try to get clearer.

Sometimes this clarity shimmers into something lyrical or pretty, but while I'm writing I find I have to give up going for that, and live with what feel like hopelessly flat words, sentences, even ideas. I often feel very, very stupid while I'm writing, as if what I'm saying is obvious to every-one in the world except me, and I'm the slow-witted person at the party still stuck on the basics. (This is why I love Wittgenstein and others who reiterate that thinking and saying often means feeling or seeming utterly stupid, even to the point of insanity—I love the passage in *On Certainty* where Wittgenstein says, "I am sitting with a philosopher in the garden; he says again and again 'I know that that's a tree,' pointing to a tree that is near us. Someone else arrives and hears this, and I tell him: 'This fellow isn't insane. We are only doing philosophy.'") After writing those three books about violence, however, I kind of retired from this job. Even as I say all this, however, I realize that, in what I've been writing lately (which is a book that tries to do for the word "freedom" or "liberation" what I once did with the word "cruelty"—that is, rotate the concept around in a bunch of different lights, to see what shades and angles might be newly found), it strikes me as entirely possible that I am still trying to do the work of alchemy and hosting, in this case around PRECISELY the issues you name, re: hope, ecology, not giving in to the narcissistic spectacle of the slo-mo *Titanic* going down.

I had the pleasure of reading your letters with Timothy Morton and I find much in there of urgent interest and sustenance. I have enjoyed teaching *Dark Ecology* as of late—I really like the idea of theory taking someone on a journey, in a *Tibetan Book of the Dead* kind of way—and I like the idea that this journey (i.e., that of *Dark Ecology*) is essentially a willingness to feel all sorts of hard feelings, from the uncanny to the dark-sweet to the vertiginously terrifying and so on. This is another means of hosting the unhostable, but instead of hosting, like, aggression, it's about hosting grief—grief for the human species, for so many other species, for the earth as we've known it, and so on—not to mention fear for the instability we justly worry will intensify and spread in the future. But, in the end, perhaps these are not such different emotional tasks, as this grief brings us back to the matricide thing—not to get all 1970s ecofeminist, but part of what we're grieving, it seems to me, is the large-scale effects of killing "mother earth" . . . all that individuation and dominance reaching its apotheosis in a suicidal/geocidal madness—

AND YET you're absolutely right, that narrative is so boring, even if in some ways it's an accurate read on what's going on. So I guess what I'm trying to do in my writing/feeling life these days is figure out the affective space for something different—not by making arguments per se (I'm not actually very good at making arguments, which is why I'm not, like, a crack critic; I can't get compelled by "standing behind" anything, I guess because I like shifting sands too much), but more like—how do I combine the aesthetic problem of making individual, flat words add up to something that feels bigger than their individual parts, with the political/ethical problem of, how do we make our moods matter (even in a literal sense); how does making affective/aesthetic shifts create new worlds, new ways of being, or coexisting?

I care about all that a lot. But I don't mean to suggest that the criterion for interesting art should be, Does it make the world a better place? I've never been literal-minded like that; it's not how I think art works. At the same time, I think my issue with von Trier or anyone else whose work seems to be hitting a senselessly boring gong is that it's not making new things

feel possible, it's not "redistributing the sensible," as Rancière would put it. Because when something truly redistributes the sensible, then the laziness, the lack of imagination, which you decry, begins to desolidify. A space is cleared; a new sound begins to grow. Your work has always done that, which is partly why it's so hugely important to me and so many others.

Well, I think I've gone on for long enough—I can tell, because the sun has moved a full arc across my room. Thanks again for taking the time to talk, and warmth back to you.

Maggie

 dearest maggie

 i have to say receiving your letter was the
 way starstruckethest i've been what a
 joy!!! ha ha ha when that universal voice
 in your books shapeshifted into a personal
 voice to me: it was humbling

 well

 o

 well

 i did reread your "the argonauts" again
 though and it was such a heightened
 curious feeling, i understand why so many
 people online say that they keep rereading
 it. the text is so beautifully edited down,
 streamlined, distilled and condensed
 that each time it reads differently and one

can probably mirror one's life in it
and a completely new book appears like
every single time?

i so adore what you say there ". . . i am
more of a serial minimalist—an employee
however productive, of the condensery.
rather than a philosopher or a pluraliser
i may be more of an empiricist insofar
as my *aim is not to rediscover the eternal*
or the universal, but to find the conditions
under which something new is produced"
(deleuze/parnet)
and you mention that this is the source
of creativeness and i so soo o oo agree
with you. you have no idea how much
i adore your clarity and need it, it feels
like the biggest vitamin deficiency like
ever gets cured, a life force scurvy-cure
in print! and i have to disagree with
you, just like music words surely reach
parts where nothing else comes even
close. and perhaps the absolute joy
of reading your books comes from your
refusal of stating the obvious or swaying
too much left or right but just staying
in that b e a m without frills or décor
and just saying it like it is
and on the subject of flattery

. . . hmmm . . .

i felt very flattered how you wrote
in your letter about my transformational
skills, perhaps in some ways i deserve

these compliments but i have to
emphasize, MOSTLY i try like tons and
most often i fail. perhaps in the songs
i make i try to offer some sort of relief
or solutions so perhaps unintentionally
that comes across as me always having
an amazing day and never short
of solutions but the truth is that i only
write like one song a month or even every
other month and often that moment
happens to be when finally some clarity
appears so i probably unknowingly
set myself up as a little-miss-know-it-all,
sorry about that

i hope i am not trespassing into the banal
if i compare the journey you took in:
bluets / art of cruelty / the argonauts
to my vulnicura / utopia –
the way it went from heartbreak and
disappointment to rebirth and optimism
offering a new personal manifesto.
or just to quote you "if one does one's
solitude right, this is the prize"
but perhaps i missed out on the trial and
cleanse of "art of cruelty", went straight
from "bluets" to "argonauts"
ha ha ha and therefore craved "art of
cruelty" really bad and loved it so hard.
perhaps. (oh, that gentle
(non)confrontation how i admire it)
or so i quote you again: (or were you
quoting relationship self-help books,
not sure?) "do you want to be right or
do you want to connect?"

as you so magnificently do, see-sawing
on polarity and refusing to take a side
you knew: the peace is found
in uniting

the books on jane and "red parts" are
books of yours i haven't read yet
actually . . . and i wasn't aware of you
writing in it about "dancer in the dark."
so i am relieved to hear you say that
it triggered some good stuff. i think the
biggest grief i felt during it was perhaps
knowing that as much as i would recover
as a person and be fine in a few months,
the real destruction was more symbolical:
he took one of the most public
scandinavian women at the time and
humiliated her, punished her. it was
a male dane forcing a female icelander
on her knees. it's a little boring but
as you probably know Iceland used
to be denmark's colony for 600 years.
we only recently got independent. i have
comforted myself at times that
in some way i took one for the team there.
as much as i did not understand at
the time "what" it was
(the whole thing felt so wrapped,
a force of impulsion veiled in mystery)
but i still somehow felt confident that
even though i had perhaps lost a battle
i had won some type of a war

and what a big unexplainable
humongous war it is maggie!

i said at the time somewhere that the
director does not provide soul
to his movies and he knows it. he needs
a female to provide it and he envies them
and hates them for it. so he has
to destroy them during the filming and
hide the evidence. it is curious that in
his last film he has a protagonist that
is male and apparently represents him.
so i guess there has been some evolution
there . . . in some ways he is owning it?

but enough of ancient wars
or sedgwick's "that's enough,
you can stop now":

i am so incredibly excited about your new
book about freedom, my friend alejandro
(arca) gave me "the fear
of freedom" by erich fromm for christmas
and what a vital topic nowadays!
just started reading it. and there he goes
writing in 1941 on page two: "another
common illusion, perhaps the most
dangerous of all, was that men like hitler
had gained power over the vast apparatus
of the state through nothing but cunning
and trickery, that they and their
satellites ruled merely by sheer force;
that the whole population was only the
will-less object of betrayal and terror"
sounds familiar the voters know
what they are doing . . . is the freedom
theirs and they don't want it? if so,

that's the scary part . . . can't wait to finish
that book

i find myself in my worklife
reinventing freedom and then losing
it nonstop ha ha ha, i try to change
my work environment randomly to keep
me on my toes. go from home studio
to cabin to island and back. i also feel
my main field of freedom fighting prob-
ably happens within my body,
i guess when that is your main
instrument, you can have dramatic effect
on your work with what you eat and what
not. then i hike a lot and swim and bike
and probably have an intense magnifying
lens reading every muscle and cell like
all the time ha ha ha ha

you should be a fly on the wall when
singers meet, the talk of nutrition and
exercise goes to intense levels.
but i am immensely grateful for it too,
it carries all my discipline and restriction
but also all of my freedom as well.

but this is probably getting too long
the sun has fully risen here
in my over christmas-decorated house
i should move on, i have my first project
of the year
heading to my cabin to meet some work
collaborators for a three day improv

before i leave i would like to thank you
for unknowingly holding my hand the
last few years
you dare to step into the future like
no one else atm
no philosopher is doing what you
are doing (if so can you please tell me
their names!) perhaps in the future
we don't need them like we did, rather
we need someone like you who collects
the writings of our species, merges it
and distills it into a human form adding
diaries and emotional responsibility?
i just read somewhere that the difference
between someone who has anxiety
or someone who is narcissistic is simply
the level of emotional responsibility,
the ones with anxiety have too much,
the ones with narcissism too little.
perhaps books written in the latter
manner have no relevance anymore.
is the 20th century guitar solo of
nietzsche and warhol's heroes over?

and in this age where immediate
environmental action is needed,
or as you say:
". . . all that individuation and dominance
reaching its apotheosis in a suicidal
/ geocidal madness—" . . . the way to
overturn it is perhaps similar to how you
write books, not with dry philosophy
but you act as if there was an emergency,
it needs to be functional, ready to apply
to your life like now, like outdoor gear

shop style literature, survivalism you
pack your bags, the human race's
biggest wisdom, leave the past behind
and take only what is absolutely
essential and march on.

and obvs most importantly: humor!

perhaps being a serial minimalist,
condensery-ist and empiricist is
the way to go?

(i am not sure if you are aware of my
dear friend oddný eir's books. she is
an icelandic philosopher that studied
under derrida and has written a lot
about hannah arendt. her books are very
different from yours but you share this
thing of generously wrapping the reader
with education, you are nourished with
the archives (one of her books
for example was about archaeology and
homebuilding of icelandic farms and
roots) and then she mixes it with her own
life and fantasy. and something you both
share in bulk: delicious dark humor.)

anyways
i have to go

let's turn this

you say:
"let's make new things feel possible
it's not 'redistributing

the sensible,' as Rancière would put it.
Because when something truly
redistributes the sensible, then the
laziness, the lack of imagination,
which you
rightly decry, begins to desolidify.
A space is cleared; a new sound begins
to grow. Your work has always done that,
which is partly why it's so hugely
important to me and so many others."

that means a lot to me especially coming
from you

thank you maggie, that gives me hope

let's imagine a continuity

love

birch

(2019)

THE UNDERSTORY

On Kara Walker's *Event Horizon*

I start under the stairs. I had thought that I might need special access—leave an ID at the counter, etc.—but the guard at the building just lets me in, points me toward what I'm looking for, and leaves me alone with it.

I start under the stairs. Face to face with the strangest scene of all, so strange I have to draw it in my notebook to apprehend it. At the installation's base, a female figure (inflated butt, iconic head rag) appears to be fisting or stuffing a man's butt, her hand disappeared up to her forearm. The man appears legless, reaches up in agony. She is studious, patient in the face of his suffering. *Give me just a moment, I'm almost done.* A doctor's intervention; Princess Leia uploading into R2-D2 the plans for the Death Star. A preparation, an impregnation. Some kind of necessity. She seems all powerful, but she also appears in danger of being crushed by a giant foot, which is also just the bulge of earth hovering over her, encasing her at the bottom.

The title of the installation is *Event Horizon*, a term that, in astronomy, correlates to the edge of a black hole, "a celestial event so massive that no nearby matter or radiation can escape its gravitational field." The easiest interpretation is that the event at hand is American chattel slavery, a multicentury institution and atrocity that has arguably created the most

powerful, virulent, and ongoing gravitational pull in American history and lived life.

But the title also draws our attention to a formal problem: whatever horizontal boundary these players may have been sucked over (or, more exactly, lashed into: a master figure at one cliff top whips a female figure over the edge, seemingly driving this Dantesque world into action), the momentum now is vertical. The operative metaphor here may be that of the Underground Railroad, but there is no forward motion, no visible means of escape. Instead, the figures play out scenes in womblike bulges, recalling the words of Saidiya Hartman: "*The slave ship is a womb/abyss. The plantation is the belly of the world. Partus sequitur ventrem*—the child follows the belly . . . the mother's only claim—to transfer her dispossession to the child."

Indeed, scenes of natal alienation and maternal distress abound. In the middle of one wall, a woman tumbles headfirst, reaching in vain after a baby inexorably falling; a well-meaning man crouched nearby reaches out, but is unable to help. Another woman with a baby affixed to her back sits curled in a cul-de-sac, hands to her head; the baby appears distraught, but the woman is too occupied by her suffering to attend to it. Directly across the stairwell from the master with the whip, a young girl sits atop another cliff, playing with a dirt clod that, upon closer inspection and in context, may be a severed head (dismembered appendages litter the tunnel). Elsewhere underground, a young girl holding a doll picks at the wall with her foot, loosening dirt and ignoring, for the moment, the various dramas of failed assistance and suffering around her. Two other adult figures, crouched inches from the woman falling headfirst after her baby, appear to be playing a clapping game.

The apparent boredom of the girl with the doll, the playfulness of the girl at the cliff top with the head-clod, the figures passing time with a hand game: this variety of affect is one of the most fascinating and disturbing aspects of Walker's work. It indicates how even the most one-dimensional, flattening forces of sadism and control (represented here by

the man with the whip) produce scenes of diverse, unpredictable, complex behavior.

The whole time I'm there, an actual baby is crying at the top of the stairs. Eventually I ascend, to check it out. On my way up, I notice that the perfect black of Walker's installation is rippling in places, scuffed. I find this satisfying, after seeing Walker's work in museums for years, justly and amply guarded. No one is watching me here, so I reach out and touch the wall.

Later, I read the New School's press release on *Event Horizon*, which characterizes the work's action as follows: "A slave driver in the left-hand corner of the work attempts to drive the characters down the tunnel, but they aspire to climb out to freedom and opportunity." The release then quotes New School president Bob Kerrey: "A metaphorical Underground Railroad, the piece can be seen not only as a commentary on the African-American community's historical struggle for freedom, but [also as] education's role in today's society as a route to opportunity." And just like that, the complexity of the piece—all the despair, idleness, free fall, enigma, boredom, sadism, and loss—gets refigured as a "struggle for freedom and opportunity"—the default narrative that is so often the only one we are willing to promulgate, see, or make visible.

Thankfully, there's Kara Walker, who was seemingly put on this earth to complicate such narratives. As she once said in an interview, "I read somewhere about how Frederick Douglass's narrative, or variations on his narrative, have this very American rags-to-riches or boy-to-man construction, whereas—and maybe I just intuited this—women's narratives are confronted with silences: rape, child death, illegitimate childbirth." With no one objective, Walker keeps on addressing such silences with unyielding narrative and image.

At the top of the stairs, in an open reading room of sorts, I find the crying baby. It's strapped to the chest of a man, presumably its father, in an Ergo, facing outward. The man is talking to a woman in business attire,

who has the vibe of someone in charge of things around here. He bounces the baby as he talks, trying to calm it down; I wonder if the woman is his employer, professor, or friend. I'm a white lady with a notebook, lurking under and on the stairs. Nothing about the scene correlates directly to the world of *Event Horizon,* but nonetheless, here we are, its inscrutable inheritors, arranged in our own complex tableaux of work, caretaking, power, and consolation.

Meanwhile, scholars such as Hartman continue to ask if or how insubordinate Black women ("the sex drudge, recalcitrant domestic, broken mother, or sullen wet-nurse") can fit into more customary narratives of Black liberation (such as Douglass's boy-to-man construction, or the worker-hero of the general strike). "What is the text of her insurgency and the genre of her refusal?" Hartman asks. "Or is she, as [Hortense] Spillers observes, a subject still awaiting her verb?" The glory and plenty of Walker's work lie in how many verbs she provides for her many subjects. In *Event Horizon,* they fall, hunker down, grieve, reach out, play, and—perhaps most crucially—protect their mysteries.

(2019)

EIGHTEEN THESES ON RACHEL HARRISON

1. Look, you're going to be confronted with the remains of a dinner Rachel Harrison had twenty-eight years ago at Flamingo East in the East Village. (No, the restaurant isn't there anymore.) First the dinner became leftovers in Ziploc baggies and then it became leftovers spawning maggots in Ziploc baggies and then, after complaints about flies, the baggies went into Ball jars. And here they are.

It's pretty gross, without a doubt. You might be forgiven for feeling as though the crudeness were at your expense in some way, but I would encourage you to let go of this feeling. (The feeling that some kind of joke is being played, but with no clear object or arc, may recur; my advice is to float in this feeling, allow a degree of surrender to it.) For *Dinner* surely started, like all of Harrison's work, as a gesture or experiment of interest to her, one whose reasons may have been inscrutable even to herself. Think about it: she bagged this food one night twenty-eight years ago, with no foreknowledge of this moment we are now sharing together. It was, you might say, an intuition.

2. Harrison's work doesn't just rely on intuition. It showcases it, elevates it to a category of ontological fascination. Why, why, why? you might ask, in front of a Harrison sculpture; eventually your own questioning may

turn into a kind of music—the music of thinking—playing alongside hers. Your thinking may or may not have content; it is unlikely to land upon answers. Indeed, Harrison's sculptures are remarkable for their capacity to stir up the primal agitation at the root of cognition and analysis, the whir of thinking.

3. A big exhibit of Harrison's work fruitfully showcases, over and over again, the force of intuition exposed to the force of time. No doubt *Dinner* has meant many different things over the past twenty-eight years, and will mean altogether different things in twenty-eight more. Dadaist stunt gives way to meditation on the longevity of plastic, or to the tendency of all organic matter to break down into repellent murky strands. Eventually some other species may note that a species called human beings once ate something called food, which they preserved for unknowable reasons in plastic and glass. "This one was arugula," the person guiding me through the show says, face straight as a horse.

4. Re: *I Like What's Nice* (c. 1995)—we've all probably mucked up a nice lady from an advertisement at some point or another, even Martha Rosler. As with any standard Barbie decapitation or *détournement*, there's some sadism in the house. It looks like Harrison reprinted the photo, then lobbed a big piece of mud or shit at the vaginal area, though I've been told it's "a very old baked potato," in which case it may have been more placed or arranged. The piece reminds me of Sarah Lucas's *Two Fried Eggs and a Kebab* (1992), but it feels more like a violation than a revelation or distillation— like, maybe this nice lady doesn't even know the blob is there; maybe the joke is at her expense. Or maybe she's in on it, and her serenity is a form of bravado: This is my big brown mound, so what? The piece feels hostile and breezy, if something can feel breezy and hostile. Harrison's sculptures can. Elsewhere, a young John Davidson comes in for similar treatment. This time it's as if someone's thrown a mop from afar and speared his forehead: artist as Zeus, pop-cultural figure as mortal plaything.

5. "Part ridicule and part homage," a critic once wrote about Harrison's relation to Willem de Kooning. I'm thinking about this phrase while look-

ing at *Circle Jerk* (1989). At first I feel like an idiot because I realize that I never really thought of Dan Flavin's light sticks as phallic before, even when he installed a yellow fluorescent tube at a forty-five-degree angle and dedicated it to Constantin Brâncuşi and his "endless column." But for some reason I've always found critiques of phallic imagery kind of cheap. Why does the phallus own certain shapes, certain angles? Maybe Harrison feels this way too; maybe that's why her title both summons an invisible circle and also names her own sculpture as a jerk.

I like Harrison's claim on jerks of all kinds, including the jerk of abruptness. Abruptness makes up part of the rhythm of thinking, especially Harrison's.

6. *Circle Jerk.* I end up thinking for some time, as I often do, about Harrison's title. Can one jerk make a circle? Is art the phantasmagorical circle? If a circle jerk is a closed unit of homosociality, what does it do to its circuitry to make a sculpture that both disrupts it and also makes its own contribution to the ritual? How does the ritual of art, its inner cycles of scorn and praise, satire and homage, change when the jig is up, the inner sanctum disturbed? "Women can't have heroes," Harrison says. I agree.

7. When Harrison made the *Voyage of the Beagle* series (2007), she also made boxes of postcards of the images. For some reason I ended up with several of these boxes, with which I lived vividly and strangely for years. They sat in my front desk drawer, ready to be deployed as missives with gifts or as stand-alone thank you cards, but whenever I went to use one, it felt radioactive, unsendable. Its meaning, once untethered from the pack, seemed to fall somewhere between indecipherable and offensive. A carved Indian bust outside a shop, a cartoonish head asphyxiated in plastic wrap, a Statue of Liberty replica with purple lipstick who looks like she's just swallowed a worm, a Jesus mannequin with puffs of dark hair adhesived to its chest—each seemed to herald a messy and bewildering significance that fell apart in isolation. They belong all together, I would end up thinking, putting the box back in the drawer.

8. Many elements of Harrison's practice are not communicable save in concert. This is true of much art that, like Harrison's, depends so profoundly on the genius and originality of its tone, and on the total trust the artist puts in it, and that we in turn put in her.

Tone, in art, is no small thing. In fact there are days when I think it is everything. Eileen Myles once said that poetry is where "lots of citizens get the real and irregular news of how others around them think and feel." How we get this irregular news has a lot to do with our apprehension of others' tone.

9. Harrison's tone feels utterly idiosyncratic—some improbable combination of jaunty, caustic, rangy, and rapt, running asymptotic to the more usual sounds of satire, insubordination, insouciance, and absurdity. Often I feel as though she's driving a car—a pretty fast car—right alongside these categories, but somehow she remains in an outer lane, a fugitive from their certainty or recognizability.

10. I don't know how into Lars von Trier's films Harrison is, more generally, but the summoning here of his 2003 film *Dogville* feels exactly right, and has illuminated some things about Harrison's work, or at least my response to it, that might otherwise have remained muddy to me. The first is the Brechtian quality of Harrison's sculptures, which I first thought to describe as having a certain coldness. But cold isn't, wasn't, the right word, just as Brechtian distance isn't really chilly. Her emphasis on presentation, artifice, plinth, packaging, and palette returns everyday objects to us in a way that inspires analytical thought. But—and this is key, I think—Harrison's sculptures don't think for us. They are more like an allegory, or a theater, of thinking.

11. Harrison: "[My work] is often about directing my thought process externally, because in my head the thoughts are going so fast. At what point can I see them? At what point can I have a conversation with forms and myself and the objects that I make that is *without* language?"

Does a conversation without language inherit the formal qualities of speech (syntax, rhythm, intonation, the simultaneous delivery of sound and meaning), or does it, can it, move into another realm entirely? In Harrison's case, no matter how literary or literary-ish the gesture, I tend to think it's the latter. She says she likes William Carlos Williams's edict "No ideas but in things." I do too. But what it means to find an idea in a thing, or to find ideas only in things, has never been self-evident.

This is one of the reasons I find Harrison's work captivating: she may focus on things and ideas, but she preserves a quality of puzzlement—maybe even secrecy—about their relationship, or their potential relationships. Because when we see a thought, it may become something else entirely.

12. *Dogville* is a brutal movie and von Trier is known as a brutal director. I don't know enough about Harrison's feelings about her own work to know if she would disavow or welcome the apprehension of brutality in it, but I feel it there decidedly. I feel it in its aggressive ugliness, its diffuse mockery, its employment of cultural figures as props, its impulse to deface, distort, or otherwise render gruesome (as with Amy Winehouse), its refusal to give its audience what they want, to even pretend to reckon with what they want.

I like this aspect of Harrison's work. I like brutal edges in work by women who don't feel compelled to apologize for or justify them as there solely to critique a brutal society or species that could be otherwise.

13. *Dogville*, like many von Trier films, opts to focus this brutality on women. By re-creating *Dogville*'s streets to use as a staging ground for her sculpture in her 2019 survey at the Whitney, Harrison defangs von Trier's alleged misogyny in a most unusual way: she out-Brechts him, stages her own show on his stage, and returns the question of brutality to the province of the abstract. She moves us into Sculpture Town.

14. "Are you a feminist?" asks an interviewer. "Woof," answers Harrison.

15. As the history of Dada makes clear, brutality, especially abstract brutality, has tremendous energy. Often it is the energy of collision. Mary Ann Caws (among others) has noted that while Surrealism focuses on swinging doors, communicating vessels, and bridges stretched across the abyss, Dada has more to do with simple, abrupt encounter, "the point where yes and no meet, not solemnly in the castles of human philosophy, but very simply on the corner like dogs and grasshoppers" (Tristan Tzara). Harrison's use of juxtaposition seems more in touch with this unsolemn meeting of yes and no on the corner than almost any contemporary artist I can think of. In *Dogville*, that street corner is literalized. Woof.

16. Despite, or alongside, the Zen-like quality of Dada, there often runs a current of nihilism, including of the homicidal or suicidal variety. Sometimes this nihilism has to do with guns. Think of Dadaist Jacques Rigaut's meticulously planned (and executed) self-administered bullet to the heart; think also of André Breton's contention (unrealized) that "the simplest Surrealist act consists of dashing down the street, pistol in hand, and firing blindly, as fast as you can pull the trigger, into the crowd." ("Anyone," Breton adds, "who, at least once in his life, has not dreamed of thus putting an end to the petty system of debasement and cretinization in effect has a well-defined place in that crowd with his belly at barrel-level.")

This current of nihilism or violence has been present in Harrison's work for some time, via its excavation of America and Americana; in 2015, it became literalized, when actual bullets were fired into her work at the Wexner Center for the Arts in Columbus, Ohio, by an ex–security guard who spray-painted and shot several pieces of art in the *After Picasso: 80 Contemporary Artists* exhibit before taking his own life. After defacing the art—including sending a bullet into the forehead of a framed drawing of Al Pacino in Harrison's 2012 sculpture *Valid Like Salad* (a new, tragic echo of Davidson's mop in the head)—the ex-guard, Dean Sturgis, sat in a folding chair and shot himself in the head (a new, tragic link to *Circle Jerk*).

Whatever urge toward defacement, whatever hostility toward art qua art, whatever exploration, however lighthearted, of American strains of masculinity, celebrity, and sociopathy may have been at play in Harrison's work prior (in 2007, she titled a show *If I Did It*, after O. J. Simpson's memoir)—all must now sit uneasily with the legacy of Sturgis. His bullet holes serve to remind us—should we need reminding—that our everyday includes mortal threat and terror as much as it does remote controls and air fresheners.

17. The pathos and beauty of much Dada writing, such as Tzara's, lies in how it wants to access the energy of collision and violence—to enact it, even—without becoming bogged down by language's representational, argumentative, and communicative burdens. But language does not shed such burdens easily. In this sense there is a kinship between Harrison's desire to stage a conversation between forms, herself, and the objects she makes "without language" and Tzara's lauding of art as "the only construction complete unto itself, about which nothing more can be said."

In the face of such aspirations, I sometimes wonder, as a writer, what the hell I'm doing here. "Language is forced on art," Harrison has said. "Is that really best for art? Is that really good for art? Does that make art happy?" Probably not; the errand quite often seems designed for fools. But then I hear Harrison saying "I'm not afraid of stupid," and I stay in the game.

18. Part of not being afraid of stupid is staying interested in the stupidity, or the gullibility, or just the plain humanity, of ourselves and others, which brings me to Perth Amboy. Perth Amboy is the town in New Jersey where, in 2000, Ramona and Marcelino Collado said they saw an apparition of the Virgin Mary appear in their second-story thermal-pane window. Hundreds of people subsequently pilgrimaged to the site to see and touch the spot, suddenly made holy. Harrison was among them: she photographed the window from below, capturing the rainbow constellation of handprints left behind on the glass.

A *Wall Street Journal* article from the time quotes a nun who made the journey: "I went to see for myself. I didn't see Our Lady's image in the glass. But what moved me was the people's desire to be attuned to God's presence in their lives." Amid all its comedy and shrewdness, Harrison's work feels motivated by a related desire: to be attuned, not to God per se, but to possibility, wormholes, collisions of spheres, profound eccentricity, the seam between farce and enigma, all of which permeate our mental and physical landscapes, if and when we let them.

To find these qualities in thermal panes, pinups, bullet holes, olive cans, velvet pants, the disintegrating scraps of a dinner from long ago—to work relentlessly, over many decades, to find innovative ways to stage them for us, so that we, too, might go along for the ride—what can I say? I went to see for myself, and it moved me.

(2019)

AT GIRÒ'S

On rereading Natalia Ginzburg's "Winter in the Abruzzi" at the start of a pandemic

I don't feel much like reading these days; who does? Who has the time, with all the kids at home? Who can concentrate? Yesterday, my reading consisted of *Go, Dog. Go!*, a feat achieved while trying to fathom, or simply to bear, the feeling of delighting in phonetic discovery as I sit on a warm couch next to a person I adore, while so much fear, sorrow, uncertainty, and panic surges outside. An outside that looks like nothing but an empty street, flat—if not radiant—with the new calm.

The feeling led me to pull Natalia Ginzburg down from the shelf; I felt a sudden need to reread "Winter in the Abruzzi," an essay I consider one of the most perfect and devastating ever written. It's only five and a half pages; I managed to read it while shepherding my son through another utterly chaotic, thoroughly well intentioned Zoom class for second graders.

Ginzburg's essay begins as a descriptive tale of a small Italian town in winter: cavernous kitchens lit by oak fires, prosciutto hanging from the ceilings, women who've lost their teeth by age thirty, deepening snow. Then, on the second page, Ginzburg tells us simply, "Our lot was exile." She doesn't say why, but it's the early nineteen-forties in Italy, so we can

imagine. She then tells us about her new life in the village with her young children and her husband, an antifascist professor who writes at an oval table in their kitchen. We hear about their routines, their bitterness, their delights, and their trepidation, suspended, as they are, in a rich and eerie lull. The essay wears an epigraph from Virgil: *Deus nobis haec otia fecit.* God has granted us this respite.

And a respite it turns out to be, as the appalling, crystalline last paragraph of the essay makes clear: "My husband died in Regina Coeli prison in Rome a few months after we left the village. When I confront the horror of his solitary death, of the anguished choices that preceded his death, I have to wonder if this really happened to us, we who bought oranges at Girò's and went walking in the snow. I had faith then in a simple, happy future, rich with fulfilled desires, with shared experiences and ventures. But that was the best time of my life, and only now, that it's gone forever, do I know it." The essay closes with a date, 1944.

As the wise wisely instruct us to count our blessings—which I do—I also can't help but wonder how to sustain this sense of gratitude through the undulations of daily domestic life when so many of our homes balloon not only with love and recognition but also with stress, turbulence, even violence, from forces within and without. If this question is rhetorical, it's because I don't want anyone—including myself—to feel that they're doing kinship wrong if and when it hurts. Today, for me, it hurts. It is sweet, and it hurts. I think it hurt sometimes for Ginzburg, too, and it's not clear to me that it could have been different, even if she knew all that was to come.

The murder of Ginzburg's faith in "a simple, happy future, rich with fulfilled desires" is cruel. It is also the sound of human lives cresting against material and mortal limits, of flesh grinding into history. Earlier in the essay, she drives the point home: "There is a certain dull uniformity in human destiny. The course of our lives follows ancient and immutable laws, with an ancient, changeless rhythm. Dreams never come true, and the instant they are shattered, we realize how the greatest joys of our life

lie beyond the realm of reality." I differ from Ginzburg in that I have never been able to look for (or find) any joys, great or small, beyond the realm of reality, whatever that means (I am reading her, after all, in translation). Or, at least, I haven't yet. But her sense of ancient and immutable law seems to me spot-on, and, in certain circumstances, a great relief.

I don't mean to imply that there aren't ten thousand reasons that we shouldn't be where we are today, or that no one is responsible for the suffering at hand and to come. People are responsible, and we know their names. People were also responsible for the murder of Ginzburg's husband, who went from writing at that oval table surrounded by his children's toys to dying of cardiac arrest and acute cholecystitis in prison (the latter being a gallbladder infection likely brought on by torture). I only mean to say that, for those steeped in the belief that great calamity should not, cannot, be our lot—or that, if we work hard enough or try hard enough or hope hard enough or are good or inventive enough, we might be able to outfox it—it can be a relief to admit our folly and rejoin the species, which is defined, as are all forms of life, by a terrible and precious precarity, to which some bodies need no reintroduction.

I reached for "Winter in the Abruzzi" because I needed this reminder, I needed its stern and tender fellowship, which it delivered to me today across seventy-six years and 6,331 miles. That the essay brought me to tears was not new. But this time, rather than weep for Ginzburg alone, I wept for us all, as we, too, bought oranges at Girò's, and went walking in the snow.

(2020)

COMING HUNGRY TO NO WRONG HOLES

The Art of Nayland Blake

I came hungry to *No Wrong Holes*, the thirty-year survey of Nayland Blake's work at the Institute of Contemporary Art, Los Angeles. I came hungry because I'd only ever seen individual pieces of Blake's, in very different mediums, scattered in the world, and I craved getting a firmer grasp on the whole that had heretofore eluded me. I knew this desire would be in tension with one of Blake's defining impulses as an artist (and thinker, and curator), which is to slip out of something as soon as it risks getting codified, to make a hole out of a whole, to wander off whenever people begin calling something to order, to start a new scene. But insofar as Blake inspires us to cop to our desires, I hereby oblige.

I have long thought of Blake as a good witch—a "self-identified freak" not looking "to society to make it nice for [them]"—who has, for decades now, increased the available space on earth for perviness, paradox, and pleasure. (Blake would seem to agree, as in the 2014 interview in which they take issue with the privileging of suffering and pain in the documentary tradition: "I don't necessarily agree with it," Blake says. "It's especially problematic for social movements that are trying to argue for pleasure when the depiction of pleasure is seen as somehow less serious than images of pain.") The question of how pleasure, especially sexual pleasure, manifests in aestheticized objects could be said to haunt all sculpture. But not

all artists are as explicit as Blake has been about foregrounding sexuality, or calling out the art world's habit of sublimating "the sexual . . . into formalism." "I don't really see the work as a vehicle for expressing an idea about my sexuality," Blake has said. "I see it as another form of practicing my sexuality." Elsewhere Blake explains that their work is "not about a kind of intellectual finesse or coolness. The fact that you're acknowledging your own desire and pleasure knocks it out of being that distanced, 'I'm above all of this' attitude, which is often the way people mark their presence in the art world."

Putting one's own desires on the table inevitably conjures the specter of shame. ("Hopefully," Blake says in one of their videos, "my shame is showing.") The weird thing about shame, however—as most people who take the risk of publicly plumbing it learn—is that, when it is exposed to light, it tends to reveal itself as instable, a portal to other phenomena. In Blake's case, letting their shame show allows the artist to hit chromatic chords of varying intensities, across mediums, across time. You can hear these chords in the cute, hectoring, eventually almost unbearable monologue of *Negative Bunny*, an AIDS-era video in which a stuffed bunny, voiced by Blake, spends thirty minutes trying to cajole the listener into having sex, using lines like "I'm really, really, negative!" (At a recent screening of *Negative Bunny*, the video provoked the audience to laughter, then boredom, then outrage, culminating in a sort of lunatic exasperation.) You can hear it in *Gorge*, a *Rhythm O*–type performance in which a shirtless Blake sits by a table full of food and commits to eating whatever is presented to them over the course of an hour; the scenario hits notes of the sadistic, the nauseating, the comedic, the worrisome, and the tender. (In a 1998 version of *Gorge*, a single collaborator—who is part of the "gaining and encouraging" scene—presents the food to Blake; in a 2009 version, audience members do the feeding.) The same instable moodiness characterizes *Starting Over*, a video in which Blake tap dances themself into a state of exhaustion while wearing a bunny suit weighted down with 147 pounds of navy beans. The humor and charm of the piece coexist with our deepening concern for the artist's well-being, especially as we watch them struggle at the end to dismount the raised stage, seemingly

risking real injury. (The Michael Jackson soundtrack to the piece complicates matters further, as Jackson's own relationship to perversity, endurance, care, harm, and self-destructiveness has bloomed into view in the years since Blake made *Starting Over*.)

Blake has been forthcoming and articulate about their desire to bring together the world of art and the world of kink, even postulating a dissertation-ready theory about the relation between BDSM and performance art of the 1960s and '70s, in which leather culture serves as "the anonymous folk-art version of the supposedly more respectable gallery work." Blake has said that, as a "pseudo hippie," they never felt comfortable with the "quasi-military polish" of certain parts of the leather scene. But while the work may sidestep the bluntest or cleanest of authoritarian fetishes, it often dives into equally discomfiting territory. We may smile at the merry tableaux of Blake's stuffed bunnies in bondage gear, but that smile may fade as we contemplate the same bunnies in *Satanic Ritualized Abuse*, or as we follow them into scenes laced with lynching, KKK hoods, or the *Turner Diaries*. Blake wants it this way: their bunnies are tricksters, evoking the culturally fraught history of Br'er Rabbit (a character with racist, African, African American, and even Cherokee roots), as well as that of passing, being a race traitor (Blake is biracial and white-passing). Part of the mess and fun and anxiety of the trickster has to do with an agitating unclarity as to whether we can or should always interpret its amorality as a form of resistance to external forms of persecution and oppression, or whether it has more moral ambiguity than certain political calculations suggest. Along with the creepy bunnies waving you goodbye at the top of Disneyland's Splash Mountain, Blake's bunnies are some of the scariest bunnies in the world.

How does someone fully inhabit and model a space of generosity, good witchery, and "niceness" while making decidedly "not nice" work? What is the relationship between grimness and pleasure? I find myself thinking about such things while standing in front of some of Blake's early BDSM-inspired sculptures, which make use of chilly stainless steel, intimidating black rubber gloves, and a wind chime of meat cleavers. For some, such

objects might evoke a pleasure-giving subculture; for others, they might evoke medical nightmares or slasher films. (They might also do both.) The standard way to think about such a collision might be to imagine pleasure and grimness standing at the ready to check or limit each other, much the same way psychologist Silvan Tomkins once imagined the hydraulics of shame + interest/enjoyment: "Like disgust, [shame] operates ordinarily only after interest or enjoyment has been activated, and inhibits one or the other or both." But I think Blake is onto something different, more along the lines of the *pleasures of the grim*, or *the grimness of pleasure*, or their interpenetration. (To note—this isn't the same dyad as pleasure and pain; grimness is a tone, not a sensation per se. It's also my word, not Blake's.)

Blake's aversion to fixity means that not even the kink aspect of their work can or intends to guarantee any rote effect of liberation. As Blake once told an interviewer at *Vice*, there are plenty of people in the kink scene "for whom it's all about reaffirming a really rigid role, like they're a master and that's that. . . . If you're not an introspective person, you won't get any more benefit out of [kink] than anything else that you do." Elsewhere, they elaborate: "These identities get postulated by people who are trying to break out of categories and escape that trap, but once that space of freedom is opened up, it gets filled up with all these other people who want to police the border. I've always found myself disappointed in that. It's much more interesting when the boundary is kind of fucked up." In a world in which it's all too easy and common to lapse into treating homogeneity as a prerequisite for solidarity, or in which well-intentioned people still prop up categories (such as "the queer") by plastering them with qualifying adjectives and boundary demarcations, Blake's ethos serves as a beacon for those seeking a more open-ended, if rocky, path.

Of course, even in our railing against categories, none of us is immune to their clarifying lure, as when Blake says that they believe "there are two types of people: people who fuck to confirm an idea they already have about their identity and people who fuck to explore all the possibilities of their identity." But what happens if and when we find that we ourselves

are—or are at least are capable of slipping in and out of being—both types? Blake's sensibility accounts for this possibility, too. Exploration, for Blake, doesn't mean inhabiting some kind of neutral muddle. In fact, Blake is deeply interested in strong subcultural identifications, be it "feeders," "bears," or, more recently, "furries." Blake moves in and around these categories, illuminating their weirdest corners. If you believe, as Blake does, that "a progressive idea of a society is one that understands and values difference in and of itself," then "acknowledging your own desire and pleasure" is one way to showcase this difference. With difference so valued, whatever attraction, indifference, or repulsion we may feel when we *don't* share someone else's desires and pleasures can become a cue to hail dissimilitude, bear it witness.

Writing on their blog in response to an artist who has asked how to *"keep the faith when everyone tells me my work is great and yet I can't land a NY gallery,"* Blake says: "Who knows what the next model for the distribution of art is going to look like? I do know this: the history of market success and the history of interesting ideas in art diverge more often than they connect. I grew up seeing an art world where that success immediately made your ideas suspect. You grew up seeing one where market failure meant a failure of idea as well. Each situation was fleeting and in the larger sense meaningless." Note that Blake resists the simple reversal, and understands *both* interpretations of market success (i.e., as proof of the interestingness, or the uninterestingness, of one's ideas) as baseless, and not where the real action is. The real action, for Blake, lies in the ongoing, uncertain work of making art, come what may (as in Blake's *#IDrawEveryDay* project, undertaken on January 1, 2015, and carried out over the next three years). Such experiments remind us that the capacity—the luck, really—to devote at least portions of our days to the activities and ideas that interest us most is the real prize. (Some of the ideas I'm still thinking about from *No Wrong Holes*: the lack of partition between things that turn us on and oppress us most; leather culture as "the anonymous folk-art version of the supposedly more respectable gallery work"; the kinship between violence and comedy; the excitement and price of visibility, be it of shame, race, fat, art, or outed subcultures; and more.)

Blake has said that they're interested in "letting art escape from the mechanisms of art history and consensus," so that it can come across as truly alive, the way work by some of Blake's heroes—from Joseph Cornell to Kathy Acker to Lynda Benglis to Richard Foreman to the Marquis de Sade—strikes them as truly alive. But to feel alive—not to mention to make work that feels alive—is no simple thing, if only because, as Foucault had it, *life constantly escapes*. You might go to a survey show to gain a firmer grasp on an artist, and instead emerge thinking about Henry James Sr.'s line on Emerson, that he was "a man without a handle." You might one day go to a New York museum and find the artist wearing the gigantic costume they've constructed to be their official "fursona," a bear-bison hybrid of malleable sex and gender named Gnomen. Gnomen might invite you to take a selfie with them, cuddle them, or pin a hot-pink ribbon to their shag. Then on another day, you might encounter Gnomen hanging empty in a gallery in Los Angeles, its copious bright ribbons signifying a party you didn't attend. The artist has given the suit the slip, its heft now ghosted by wind.

(2020)

THE LONGEST ROAD

Conversation with Jacqueline Rose

MAGGIE NELSON: As proof of how much you mean to me, I just pulled my copy of *The Haunting of Sylvia Plath* off the shelf, and in it I saved my program to *A Tribute to Sylvia Plath* at the New York Public Library in 1997. I had never in my life had a book signed, but your book was *so* important to me that I waited in line and then you signed it.

JACQUELINE ROSE: Amazing!

MN: It was a very important night for me.

JR: I notice that you quote *The Haunting of Sylvia Plath* in your book *The Art of Cruelty*.

MN: Yes. Right. I won't belabor the point, but it's hard for me to overestimate how influential your work has been for me, from my upcoming book [*On Freedom*, 2021] all the way back. It's so deep. It's not just what you have said but it's how you think, and also how you write, how you

This conversation with feminist critic and scholar Jacqueline Rose was conducted over Zoom with *Grand Journal* editor Aaron Hicklin present, then transcribed and edited for publication in the magazine.

219

make sentences. I taught *Mothers: An Essay on Love and Cruelty*, many times last year in my graduate classes.

JR: When I wrote *Mothers*, I don't think I'd read *The Art of Cruelty*. Also, I have to confess—everybody was telling me to read *The Argonauts*, and I read it and I stopped, and then I started reading it again and literally could not put it down. Of course, if I had read *The Argonauts* before I published *Mothers*, I would have quoted you. So, what we're doing is getting out of the way our sense of not fully acknowledged indebtedness, which flows in both directions.

MN: I agree and I've actually had the same experience with your essay on sexual harassment, and your essay on mothers, both of which I read in the process of writing, and thought, *I'm not sure I should read this because Jacqueline Rose is going to say this much better than I can. And I'm very close to a similar idea and I'm frightened that I won't be able to go back to it.* But I don't feel like that about very many writers.

GRAND JOURNAL: I wonder if we can start with a quote from Maggie's upcoming book, *On Freedom*, in which she writes that "[James] Baldwin well understood the dangers of focusing on so-called inner freedom at the expense of gaining and wielding political power. But he also sternly warned against ignoring the former in pursuit of the latter." In this past year, how have you balanced your own internal conversations with those swirling around us?

JR: Of course, what Baldwin also says is that freedom is hard to bear. So, I think you have to factor that in, because you can't have a concept of inner freedom unless you understand the inner obstacles to freedom. And one of the strengths of your books, Maggie, is that you write about the struggle for freedom, but you're constantly tripping, in a really interesting way, on the inner resistance to freedom. So, the key bit of that Baldwin quote for me is our struggle with freedom. In terms of the swirling conversation in and out, I've had a very split year because I started by getting

immediately embroiled in pieces of writing, all of which were implicated in the pandemic. The first was Camus's *The Plague*, which has so much to say about the relationship between what is putrefying inside the city walls and what is sick about our social arrangements, the plague for which we are all accountable. I also wrote about living one's own death through Freud's concept of the death drive for the Vienna Freud Museum anniversary lecture and other things. But then I just stalled—teaching took over, a real challenge online—but I also think I needed to pause for thought.

MN: My experience of the past year has been 97 percent dominated by having a child at home and by my side nearly twenty-four hours a day. I'm grateful that I had drafted my freedom book [before the pandemic], but in January or February of 2020, my editor sent back that manuscript with many, many queries to revise, and I had to turn it in at the end of August. So, from February to August, I had this huge task that was suddenly being done not alone, and under a lot of psychic distress about what was going on in the world.

JR: I want to go back to the freedom question, because the awful pain of the last year is that we've had so little freedom other than to obey rules, which we're not even sure that we can trust. And as you say in your book, the freedom discourse has been co-opted by the antivaxxers and the antilockdown people. That's to say that it's been a very upsetting moment of having to watch freedom become a tool in the hands of people whom we see as very negative and dangerous and destructive. I think this confirms one of the arguments in your book, which is that it's not as if there's this thing called freedom—there's something having to be negotiated and fought for in relationship to this term every step of the way. There's never a moment where you've achieved it in that sense. Ten years ago, [the psychoanalyst and socialist feminist] Juliet Mitchell and I were interviewed for *Women: A Cultural Review*, and the interviewer asked us what we thought had been the successes and failures of feminism. I was like a well-behaved schoolgirl and basically said, "Well, I think we did very well in terms of legislation for equal pay and equal rights, many,

many achievements, but on the other hand, we were very blind about different sexualities and race." And Juliet said, "It's been 100 percent a success, because it is the longest revolution." All the setbacks, and all the struggles, and all the backlash, and all the difficulties, and all the tripping over is part of the transformational process. It's never achieved, it's never accomplished. It's a form of perpetual vigilance. I feel that is one of the things you're saying in your book, and it's never been so true as now.

MN: On that same note, you talk about the speed with which a progressive cause can be complicit with, or co-opted by, nasty political agendas. I presume that you were talking about different forms of carceral feminism or TERFs [trans-exclusionary radical feminists] and the unlikely bedfellows that they create. I don't feel in crisis with feminism per se, but I will admit that with the carceral feminism or TERF stuff coming in, I do find myself having miniature driftings away from the word in public forums, just because I'm not always sure what I'm identifying with. And when I read your work, I don't feel that same drift or anxiety. Denise Riley, in one of my favorite quotes, says, "That 'women' is indeterminate and impossible is no cause for lament. It is what makes feminism." When I read you, I'm reminded of that and I feel happy again, but I wonder if you feel any of this drift or anxiety?

JR: Well, how long have you got?

MN: I've been waiting for twenty-seven years.

JR: This will be a to-and-fro, but the TERF attitude to trans women, which includes endangering them by saying they're a danger to women, has made me very despondent at moments, it's true. It's so destructive of potential alliances, and doesn't allow for the fact that any trans woman has rejected masculinity in a certain form, by definition, if they are male to female. There is something so profound about the journey they've been on, that it feels to me as if women who haven't been on that journey have everything to learn from it. Carceral feminism is a right (wing) agenda

that I think is so difficult to deal with, because on the one hand, we wanted Derek Chauvin to go down, right? I know I did. And I wanted Weinstein to go down. So there are certain struggles we are involved in when you want the state to move in and the law to act. But we do not want to be on the side of the carceral state. Sexual harassment must stop, the law must intervene if need be; but sexuality is lawless. How you move with all those three things at once, knowing that in a sense they contradict each other, has become the task I have set myself as a feminist.

MN: In Dean Spade's *Normal Life*, as I recall, the argument is that the fight for legal recognition in and around trans rights will fail to benefit trans people. It will fail to benefit them because it's in the dismantling of systems of state violence more generally, not in any fight for rights, that benefit will be found. It doesn't get us out of the problem that you name of wanting Chauvin to get forty years. But one thing I like about prison abolition as a movement is that there's so much intelligence around [what it requires]. People say, "Well, if I can't call the police when they're killing my mother, what can I do? You're going to tell me not to call the police?" Prison abolitionists might say, "We're not advocating taking away all capacity right now, today, to find any forms of safety or redress." That's why you have to build structures in the meantime. As the prison state withers away, there will be things that replace it.

JR: I think you've touched on something so difficult, which is the relationship between demolition and the creation of new forms that will sustain the lives that we want to protect. I'm thinking of something very different, which is Barbara Taylor's book, *The Last Asylum*, about the destruction of the mental asylums in the UK in the first half of the twentieth century in favor of reintegrating mentally disturbed people into the community. And she says that was a mistake, arguing not from the right— that these people are dangerous and should be locked away—but from the other side. She says that mental asylums aren't incarceration, they're places to breathe, and for people inside them to feel safe. So, whatever you think about the details of the argument, it just makes more complex this

idea that there are alternative structures of communal beingness, togetherness, that somehow could replace the carceral system. And I'm just not sure about that. I think it's very, very difficult.

MN: Something that I value so much in your book is that you say, "How can we as feminists make the gap between maleness and the infinite complexity of the human mind the beating heart of women's fight against oppression, against the stultifying ideology of what women are meant to be, and *not* allow the same internal breathing space to men?" This is so important. And it's also so important because it extends far beyond just women and men. As I go around to talk about *The Argonauts*, I find that people's dedication to the idea of the queer and the heteronormative as opposing forces is so fierce that it's occassionally difficult to pull people into this idea that *everybody* deserves the kind of nonstultifying internal breathing space of fluidity or instability that is attributed to queers, or to women, or whatever. But it's by no means their province only.

JR: But you're now leading into something I really was hoping we would talk about, because you write beautifully about fluidity and instability and mobility. One of my favorite moments in *The Argonauts*, which links it to your new book, *On Freedom*, is when your partner has had top surgery, and you're sitting and writing, and they're producing art, and you say something like, "I'm no longer sure which of us is more at home in the world, which of us is more free." It's a really beautiful moment where you're just thinking, *Who's really free here? Am I free?* Even if you're moving the borders of your body around, there's something that's very hard to give full space to. The reason why psychoanalysis is hated by some people is that it says that whatever you end up doing, you will always be negotiating the law of sexual difference, because there's no culture that doesn't have it, and wherever you end up you will have to inscribe that on your body one way or another. If I'm absolutely honest, I'm not sure that has to be forever. When Julia Kristeva wrote [her essay] "Women's Time," she said, "First phase was the struggle for rights; second phase was the struggle for the affirmation of femininity as difference; third stage, sexual difference will be seen as a metaphysical category." So, that would be a

decisive displacement of the fundamental tenet of Freudian psychoanalysis, to say the least.

MN: How do you understand the metaphysic? I'm trying to figure out her third phase.

JR: I'll put it much more simply. Her third phase: sexual difference will be seen as a fraud.

MN: I feel like my life, even my personal life, is sometimes dominated by feeling like a sherpa from phase two to phase three that you just described, both for myself and for others. I'm thinking of the time I tried to explain to a class parent at my kid's school that dividing the welcome nights for new families into a "moms' wine night" and a "dads' beer night" wasn't a great idea. It's not that I disagree with people's right to self-identify as mothers and have wine together. My point was that if they're imagining these two nights as welcoming to all peoples, they need to know that not all parents identify as mothers or fathers. The initial reaction is usually to say, "Oh, but people can go to whichever night they want!" And I'm like yeah, but really the whole point is to ask, Why are we dividing such activities by binary gender? I try to say, "Look, I don't know where we will end up after we abolish moms' night, and I know that there will be something to mourn. But I feel confident that we're going somewhere better, even if all of its contours are not yet clear to any of us."

JR: Somewhere in all of this, I agree with you, things are getting better. But the virulence that's coming to meet it, the hostility! I would love to be a fly on the wall when you're having these conversations with the moms at your school. Are they nice to you? Or did they get cross?

MN: Mostly everybody wants to do things right. And sometimes when I intervene, I don't offer a solution for how they should do it, I just want to draw their attention to thinking about the problem.

JR: You're not campaigning.

MN: No, I try to invite people to thought without telling them how I think they should do it, which is sometimes frustrating to them. They would much rather just know what's the PC way to run our welcome night: just tell us, and we'll deal with it. But I'm interested in the slowing down—in the thinking. Over and over again in your book, you characterize its aim as to slow the pace, to resist the will to action at any price. You write, "If there's one thing of which writing about violence has convinced me, it is that if we do not make time for thought, which must include the equivocations of our inner lives, we will do nothing to end violence in our world, while we will surely be doing violence to ourselves." And I wonder two things: one, what might making time for thought look like, especially for people who don't consider themselves, say, intellectuals in the way that you and I might? And secondly: how do you conceptualize the lack of doing so as a form of doing violence unto ourselves?

JR: Okay. Arundhati Roy gave this amazing interview, which really fed me my line, in which she suggests that an understanding of "the density of being human" is the only antidote to the crass, mind-numbing, and crushing simplifications of resurgent fascism. I felt that what she was saying was that the way that fascism works, the way that people like Bolsonaro and Modi work, is by offering such a simplification of what is acceptable to be thought. I am of the school that sees the belief that you can master your mind and control the world as a form of narcissistic entitlement that covers over a deeply felt but hidden recognition that nobody can, and therefore an increasing desperation to do so. It is a psychotic delusion that does not work. That's why for me, such a key moment was when Weinstein entered the courtroom on a Zimmer frame [a walker], although it was a complete lie. In court, it also gradually emerged that his sexual behavior was, above all, about the seduction of coercion. The longer the resistance went on, the more he was determined to prove and drive home his point, to put it slightly euphemistically. You say a version of this in, I think, *The Argonauts*. You start off with primary maternal preoccupation, where you give everything to your baby. And it's heaven, right? Because all that baby needs is warmth, hugging, feeding, and sleeping, and a bit of smiling and laughing. One's life is never as simple as

when one has a young baby. And then you realize after about a year that if you carry on like this, you're going to produce a fucking monster.

MN: You will die yourself.

JR: And you will also die. So there's this ghastly moment when the omnipotence you have fostered in your child has to give way to something other than that kind of entrenched narcissism. And the people who feel entitled do not go through that internal correction; they continue to believe that the world will fall to their feet. The only thing is that as you get a bit older, and as that never happens completely, you know it's a delusion. For me, the most virulent forms of masculine violence have to do with trying to ward off the knowledge of the delusion. I think what I'm saying is that thoughtfulness is the ability to have a reckoning with what you cannot control, master, or know fully. You write about this a lot. It makes it harder to kill, harder to attack, harder to assault if you've had an inner reckoning with the fragility and the precariousness of what it means to be human, with human dependency, with the aggression attached to human dependency. If you've reckoned with the complexity of that, then you're less likely to try violence because it won't work for you. And, of course I take it from Hannah Arendt who says that violence increases when power is fraudulent and diminishing, which is an account of most men for me.

MN: When you say that it makes it harder to kill if you've had that reckoning, I believe you. But having just lived through these Trump years, I'm curious and worried about something else you describe, which is that when power is diminishing or fraudulent, or illegitimate, that's precisely when it's most dangerous. In the United States, people I know would say, over and over again, "Trump is the last gasp, he's the dying of the patriarchy." But as they're saying that, we're also watching jillions of seventeen-to-twenty-five-year-old men rising up like zombies to rebirth this thing anew.

JR: You're absolutely right. Trump's law-breaking was part of the pull. It wasn't that he got away with it, or could do no wrong. It's that he was

adulated in proportion to the wrong that he could do. This is, for me, one of the most profound insights of Freud's *Civilization and Its Discontents*, the analysis of "love thy neighbor" and how difficult it is to do that. And how the voice inside your head telling you to be nice is not a nice voice. It's coercive, it's controlling. There is a sense in which we all are law-breakers inside our heads. And a lawbreaker in a position of power is deeply, deeply attractive, because it exonerates everybody else of the internal guilt. What Trump has done is send the unconscious frog marching in the street: the abuse of women, the right to shoot anybody on Fifth Avenue and get away with it. There's something about somebody who is parading the right to violate the terms of our internal legislator that is immensely attractive. And again, it's Hannah Arendt who says that under totalitarianism, the desire to do good becomes a temptation that has to be resisted. The internal arrangement of what is good and what is bad gets moved around. I haven't been very clear, I realize.

MN: No, I think you have. I think what you see happening in the States right now—all the trials of the people who stormed the Capitol on January 6—is that the psychotic conviction doesn't work, at least not in the long run. That is to say, a lot of these people are now feeling very broken and very vulnerable, and are facing serious charges for what they did. The problem is that the psychotic conviction works until it doesn't work. In the meantime, a lot of damage can get done, both to the self and to others.

JR: Yes. I agree. But I think here we have to become a little bit more materialist. I mean, 70 million people voted for Donald Trump this time. This is not going away anytime soon. I remember [the feminist theorist] Drucilla Cornell talking to me about canvassing for the Democrats in a trailer park. She ended up spending three hours with a woman who had lost custody of her children, she'd been holding down five jobs to look after them. And she just said, "The feminists in Washington have done nothing for me, my life is an absolute wreck, so I'm voting for Donald Trump." So we have to include the extent to which one of the geniuses of

what he did was to capture disaffection, and to promise omnipotence as an alternative.

MN: As a feminist, one of the most chilling things I've heard—meaning I won't forget it—was a woman interviewed around the time of the Brett Kavanaugh hearings who literally told the reporter, "My daughter was abducted and raped in a hotel room, and it's been about a year, and she's fine now. So I don't want to hear about what happened to you thirty years ago at this party." She was talking about Christine Blasey Ford, but the image of her daughter that she conjured in this off-the-cuff interview was very profound to me, because I also understood her point—which was the deep need and desire for her daughter to be fine now. That was overriding as a need, and anyone who told you that it was going to be scarring and life-changing, that there was no capacity to move on, to her was not acceptable.

JR: I think we're talking about something really important here, which is what [the philosopher] Julia Kristeva calls the phobic core of humanity— which is the core of humanity that knows but does not want to recognize fragility, precariousness, mortality, illness, failure. She says that the reason why so many women are being killed during lockdown is that normally it is the task of the mother to tell the world that the world and the baby are safe and happy and healthy. There are two things that you know within five minutes of being a mother: one, that the world is not fair, and two, that the inner world is complex and fragile. The reason why women are often hated, I feel, is that the task enjoined on them is one they know they can't fulfill, and they're not forgiven for that. What Kristeva was saying is that women are being punished because nobody in a time of pandemic when everybody's dying can protect humanity from mortality. That role is just not available to women anymore. Women are also being punished for the fact that men locked in the home feel like women. We're really touching on something important here, which is that violence against women in the time of pandemic is a response to the collapse of any possibility of holding off those forms of fragility.

MN: Maybe that's why we all feel so bad. I mean, my son's school is open-ing, and it'll be bad for me to keep him home and keep playing too many video games, and it will be bad if he goes to school and gets sick. Everything's bad. Everything's wrong. There's no right answer. It's always like this, but now it's on steroids every day, all day. And your child's still looking to you to tell them—

JR: "It's all going to be okay."

MN: Yes. Which brings me to another question: At the end of your book, or near the end, you called the renewal of hope the only question. What did you mean?

JR: The renewal of hope is the ability to tolerate the internal ambiguity of psychic life.

MN: I like that very much. Here's another question: I want to ask about this movement going on across the pond against critical race theory, and against gender theory, that I didn't even know was happening until I went to France, and other countries, with *The Argonauts*. It seems al-most funny to me, because the theory seems so esoteric, but it's clearly not being treated in an esoteric fashion, and the reasons for the move-ment against it aren't funny at all.

JR: But it's happening in the UK as well. A report was issued recently that said Britain is not institutionally racist, and it's caused an absolute outcry. What I feel, and you'll appreciate this because you've been in academia for twenty years—I've been in academia for more than forty—is that one of the most serious things in British political life at the moment is the fight over the curriculum: how history is going to be taught, how gender is going to be taught, how race is going to be taught. That is to say, there is a hideous backlash in terms of what we used to call theory—feminism, race, gender—and we've all got to be hyperalert.

MN: What does hyperalertness entail?

JR: It entails keeping up the public conversation, insisting that it continues in such a way that as many people as possible have access to it. Wherever we are in the educational system, there is a culture war on at the moment that has to be fought by what you teach and how you teach it. Tell me how it's affecting you, Maggie.

MN: It's not affecting me insofar as I don't interface with a lot of haters. I teach at the University of Southern California. I've been here for four years, and prior to that all of my teaching has been at the far corners of American progressive education, namely art schools.

JR: Yeah, so you're fine. Well, Birkbeck is also fine. I've been at Birkbeck, Sussex, Queen Mary, they've all been radical institutions. So we've protected ourselves, at least in terms of what we are permitted to teach and to say.

MN: Because I began in poetry, and because I've written a lot of books that I would call, for lack of a better word, literary art, I don't walk into interviews perceiving myself as someone who's ready to explain issues, or to be a spokesperson.

JR: But that is being laid upon your shoulders, I would say.

MN: Correct. In your sexual harassment essay you say that you'd never so regretted agreeing to write about a topic. I love that, and I wanted you to say more. I also felt, over and over again while I was writing *On Freedom*, that it felt like a very bad idea. Unlike *The Art of Cruelty*, it felt much more current. I wanted to have range, and be ambitious, and write what I wanted to write, but I was aware of the fact—and now I'm kind of looking toward it, when the book comes out—that I can't keep saying "I'm not a social commentator" when I've written a book that's essentially all social commentary.

JR: Indeed. But you could also read *The Argonauts* as a kind of manifesto. For me, it goes alongside Susan Stryker's "My Words to Victor

Frankenstein" as a representation of trans experience in relation to giv-
ing birth. Both are saying "This is another way it can work out." It's not
a political statement, it's an intervention, a type of performance. In *On
Violence*, I am consistently on the lookout for writing that has its ear to
the ground, pushing the boat out in terms of what it is possible and im-
possible to say.

(2021)

THIS LIVING HAND, OR,
MY HERVÉ GUIBERT

On an afternoon in 2003, when I am on a road trip with the writer Brian Blanchfield, in pursuit of an empty condo owned by a distant relative of his in Palm City, Florida, Brian takes out his weathered copy of Hervé Guibert's *My Parents* (then published by Serpent's Tail) and begins to read aloud to me as I drive. I remember feeling abashed that I hadn't yet heard of this writer of such obvious importance to Brian, whose literary taste I consider impeccable, as I heard the first words (in translation, of course) of a writer who would soon become vital to me. "On Thursday 21 July 1983, when I am on the island of Elba and her sister Suzanne is at her country place in Gisors, my 76-year-old great-aunt Louise has a bad turn on the number 49 bus going toward Gare du Nord . . . "

About a decade later, I read a stunning essay on Guibert in *Bookforum* by another friend, the writer Wayne Koestenbaum, in which Koestenbaum says he cannot "objectively evaluate the work of a writer [he takes] personally"; groups Guibert with writers and artists such as Guy Hocquenghem, Michel Foucault, Tony Duvert, Dennis Cooper, Pierre Guyotat, Robert Mapplethorpe, David Wojnarowicz, Jack Smith, Jimmy De Sana, Mark Morrisroe, Félix González-Torres, and Paul Thek; and hopes that renewed interest in Guibert's work will bring back

into prominence the "philosophically inclined subset of body-smeared literature" that Guibert both contributed to and transformed.

I'm thinking of these two moments, and these two friends, as I sit down to write about *To the Friend Who Did Not Save My Life*, a book that has come to occupy an immoderately important place in my canon. I'm wondering how I, too, came to take Guibert personally—how he became "my Hervé Guibert" (à la Susan Howe's "my Emily Dickinson")—and what it means.

My Parents may have come first, but it was the opening page of *To the Friend Who Did Not Save My Life* that staked its claim. To this day, I cannot think of a more perfect example of the performative, dauntless writing of the body-in-time as it faces down the twin miracles of mundanity and mortality, the capacity of literature I likely care about most. It wasn't just the first page, of course—it was also the second and the third, which quickly reveal the complexity of Guibert's temporal and tonal fretwork. The past tense of the book's opening line—"I had AIDS for three months"—mobilizes the comfort of retrospective storytelling, of survival ("I told no one save these same friends that I was going to make it, that I would become, by an extraordinary stroke of luck, one of the first people on earth to survive this deadly malady"). Turn the page, however, and the opening gambit crashes. Alone in Rome, Guibert now wavers "between doubt and lucidity, having reached the limits of both hope and despair." He spurs himself on to write the book we are holding in our hands by telling himself that its raison d'être lies "along this borderline of uncertainty, so familiar to sick people everywhere."

Harrowing uncertainty is the soil in which *To the Friend Who Did Not Save My Life* grows. Alas, one aspect of the case has since been decided: Guibert did not survive the malady. In fact, he died within a year of the book's publication. Knowing this before we begin, the book's opening page is radiant with irony and tragedy. From there, the book unfurls like an extended, salacious riff on John Keats's fragment (written when Keats was dying from tuberculosis): "This living hand, now warm and

capable . . . see here it is– / I hold it towards you." Guibert knew, as did Keats, that the hand here proffered would soon be that of a dead man. Rather than pity him for it, we might recognize that we share his fate, the difference being that he felt it acutely, and was uncommonly capable of scribing the disaster.

It has been thirty years since Guibert died, and just over thirty since *To the Friend Who Did Not Save My Life* was first published in French. Not so much time, really, but enough that certain aspects of its original scene of reception have significantly altered. The scandal of the book's outing of Foucault (who appears here under the name Muzil) as someone who died of AIDS and had a closet full of BDSM equipment has thankfully passed. By the time I came to Foucault in the early 1990s, such facts were—partly due to Guibert—a given, and only deepened my interest in Foucault's work. Some critics and readers continue to feel perturbed by Guibert's revelations (often called betrayals); for others of us, there is no sting. Perhaps this is unsurprising, as his work inevitably comes off differently to those of us who also swim in the choppy waters of high-stakes life writing, and are familiar with the ethical and aesthetic challenges that come with it (not to mention with how intensely outsiders judge the venture).

Many life writers eventually come to understand that a reader's sense of scandal or sensationalism tells us as much or more about her than about the writer; certain sensibilities, sentiments, and activities that are shocking to some make others feel at home. Likewise, the charge that Guibert's obscenity lacks in higher purpose—that unlike, say, Genet or Bataille, he was just "a young man out to trigger the middle-class world, espousing extreme self-exposure for its own sake" (as one critic recently put it in the *New Yorker*)—lands a punch only if "extreme self-exposure for its own sake" strikes you as obviously thin or bad. Damning accusation for some; cherished, fecund credo for others. It all depends on who you are, how you roll.

Not for the first time, I am wondering what it means to have been so profoundly shaped by the artists and writers on Koestenbaum's list (especially Wojnarowicz, whose own 1991 memoir of disintegration from AIDS,

Close to the Knives, reordered my world when I was eighteen). There were women, of course, and there would be more. But even of those, the ones I revered most tended to be those who formed some kind of bridge between genders, between worlds: Eileen Myles, Eve Sedgwick, Judith Butler, Cookie Mueller, Nan Goldin, Gayle Rubin, Jane Gallop, and so on. As is typical for young women confronting male-dominated coteries in literature and in life, I revered and loved so many of these men without knowing if that reverence or love ever would or could be reciprocated—whether the tradition of philosophically inclined, body-smeared literature that Guibert represents ever would or could be understood as part of the same flow that contained so many of the not-men writers I also admired. (Men can probably be not-men too—forgive me, I'm speaking here in broad strokes.)

I say all this to explain the somewhat juvenile claim of my title, which I don't mean in a proprietorial way, but rather as an attempt to place Guibert in this flow, which for me encompasses everyone from Myles to Paul Preciado to Claudia Rankine to Gloria Anzaldúa to Anne Carson to Hilton Als to Bruce Benderson to Karl Ove Knausgaard to Catherine Millet to Frank Wilderson to Mattilda Bernstein Sycamore to Emmanuel Carrère to Patricia Williams to Marguerite Duras to Harry Dodge to James Baldwin to Roland Barthes to Audre Lorde to Violette Leduc to Annie Ernaux (not to mention Blanchfield and Koestenbaum, and many more). Without giving it a name (like "queer"), I want to celebrate this riotous, motley heritage as characterized by ravenous intellectual appetite; a wry and unflinching devotion to chronicling corporality; a dedication to formal experiment, up to and including the detonation of genre; and a certain curiosity and fearlessness where others might expect (or project) shame.

To the Friend Who Did Not Save My Life is not a perfect book. Each time I read it, I find myself riveted by its first half, then somewhat irritated and distracted by the second, which perseverates on the eponymous, unctuous friend "Bill" who fails to deliver the drug that might keep the narrator alive. Because we know how the story ends, and because we know how

it ended for so many others, it's painful and maddening to watch Guibert chase the idiot doctor, the fraudulent cure. Now that there's an internet, I find myself drifting away from the text and into deep Google holes about the various figures here fictionalized, from Isabelle Adjani ("Marine") to Daniel Defert ("Stéphane") to Thierry Journo ("Jules"), all the while trying to remind myself—mostly in vain—that it's *a novel*, one that Defert, Foucault's surviving companion, termed "a vicious fantasy."

But the book remains a masterpiece, not despite its imperfections, but because of them. Imperfection was key to Guibert's style—as Koestenbaum puts it: "Futility and botched execution are the immortal matter of Guibert's method." As is often the case in reading Guibert, after you turn the last page of *To the Friend Who Did Not Save My Life*, you can't believe it's over. That was it? It's really going to end right there? With Guibert in deep shit, his arms and legs "as slender as they were when [he] was a child"?

Yes, that's it. That's all you get. In the end, it's an astonishing bounty: at age thirty-six, Guibert left behind over twenty-five books, along with a remarkable body of work in photography and film, with *To the Friend Who Did Not Save My Life* one of the constellation's brightest stars. If you haven't read it yet, there's no need to feel ashamed. You can instead feel grateful that you—any of you, all of us—can now enter.

(2021)

I JUST WANT TO KNOW WHAT ELSE MIGHT BE AVAILABLE

Conversation with Simone White

SIMONE WHITE: Your new book, *On Freedom*, gathers a constellation of texts that allows you to stage difficult conversations about controversial practices and transgressive behavior, from sex to drugs to art. You draw from conversations and texts—Eileen Myles's *Chelsea Girls* (1994) and Denise Ferreira da Silva's "Difference Without Separability" (2016) come immediately to mind—to address a public that might not be aware of all these texts, or might not have put them in conversation with each other. Sometimes a vocabulary will emerge from a reading of a specific text, such as Stefano Harvey and Fred Moten's *The Undercommons* (2013), that then infuses the entire book. I'm thinking of the phrase "riding the blinds" (an expression that crops up periodically in Moten's work and that serves as the title of the final section of *On Freedom*) as a kind of key to the method of your new book.

In the chapter on sex, called "The Ballad of Sexual Optimism," it seems to me that instead of discovering anything about sex acts or your own

This conversation with poet and critic Simone White was conducted over Zoom, then transcribed and edited for publication in the *Yale Review*.

sex, what we actually discover is a new way of talking about sexuality. I have been puzzled for a very long time, for example, about how we are supposed to relate to people we love and care about who get into sexual trouble, especially public sexual trouble. There's an impulse to exile those people from our social lives. But in your book you examine the possibility of turning that impulse back on ourselves—to instead ask, Have I not been the one to say in certain moments, "Thank God nobody's eyes are on me"? And, What *do* we do with the person we care about who has sexually transgressed? How do we address that person, or have a restorative conversation with them? And, What *do* we say about the difference between conflict and abuse?

MAGGIE NELSON: I really do think we're starved of gestalts for thinking about what sex means in our lives. Sometimes just hearing simple phrases that challenge certain doxa about sex—such as, to paraphrase Jennifer Doyle, "promiscuity can be a scene of potential learning," or, to paraphrase Katherine Angel, "sex can be a means of moving toward difficulty and pain"—can make us much more self-forgiving and self-curious. In some ways, that was the point of that chapter. What I want to do most of all is just model the risks and the value of being a sexual subject.

You and I have often gravitated toward the same people, whether da Silva or Gilles Deleuze, and sometimes even toward the same quotes, even though our projects are quite different. As you say, I like to put disparate people in the center of a conversation and just act like they're supposed to be there, instead of doing any special pleading for them. I like to bring nonmainstream people into mainstream conversations, be they about art or sex or drugs or climate—you know, people who are not pitching articles to the *Atlantic*, people who are going to bring a certain freshness and weirdness and beveledness and more dissonant sounds to the conversation.

I also read and taught your book *Dear Angel of Death* while I was working on this project. Your work deals in a really unusual way with sexual

freedom not just in a definitional sense—"I will now tell you what sexual freedom is and then you will watch me inhabit it"—but also more in an affective sense, by providing a seismograph of what it feels like to be a thinking and feeling sexual subject occupying space and experiencing ambivalence, conflict, pleasure, desire, anger. I say this as somebody who's looked hard—especially while writing this chapter—for first-person accounts of women talking about desire and pleasure and ambivalence and turbulence, and found that they are actually hard to come by. Yet you explore the question of sexual subjecthood so richly, both in *Dear Angel of Death* and in your new work.

sw: Yes, this is a chief concern in the work I'm currently writing: a long essay that, like my new poem, is trying to take up some of the problems around being the "other woman." The work addresses questions of sexual freedom and unfreedom—questions that are so difficult to answer because they seem to require us to condemn certain kinds of behaviors, even in ourselves, and to effect a kind of split between *experiences* of desire and community on the one hand and *concepts* of desire and community on the other.

I am still trying to understand the nature of this requirement, drawing primarily from experiences and events that led to my interest in this subject (and defy my own languaging abilities). One of my dearest friends—someone I've always thought of as an enlightened figure—called one day to talk to me about my relationship. She said, "You don't understand. What you're doing is hurting everyone around you." And I was like, "Oh, this is an intervention." It was like I was outside my body. I realized, "This is the moment where I'm supposed to renounce my antisocial behavior so that we can all be healed and be together again." But it was one of the saddest things that has ever happened to me. I realized that my behavior had gotten itself somehow outside of the circle of communion that I thought I belonged to, as if I had done something sexually that transgressed the bounds of that circle. And it wasn't the fucking. It wasn't a kind of sexual licentiousness. It wasn't whatever words you'd use to

address somebody who's having sex with somebody else's husband. It was something worse than that.

MN: What was it?

SW: I don't want to speak for other people, but for me it felt like an insistence that other people's desire come first—that the thing animating my search in life should be calibrated to what other people want. Yet something that continually comes up in my writing about being the "other woman" is the clarity of knowing that I was not going to do what anybody said. My actions in this arena would be completely self-determined, and I was not any longer bound by or responsive to certain kinds of sexual discipline. I might not intentionally have stepped outside discipline, but that was where love was, and where I was finding myself. The question became whether I was willing to accept the associated consequences and losses.

I heard Fred Moten give a lecture at Hampshire College in 2017 about David Walker. Moten was describing Walker's moralistic approach to someone he saw as insufficiently enlightened or radical, and Moten was basically asking the question "What would it be like *not* to condemn that person as insufficiently radical?" That's how I remember it, anyway. It stuck with me, this question of how we love one another despite our divergences. People talk about the tradition of uplift in Black culture, but in historical terms that's often not what it is. It's actually—and this is what I'm trying to get at, and what you're trying to get at, too—that our politics requires a sense of *condemnation*. It requires, in particular for those of us on the left, that we are grossly opposed to racial capitalism. But then how do we talk about the desire for shiny things, which is actually a core human desire? How do we talk about desire that does not map onto our liberatory schemes? I'm concerned about our inability to think about actual present entanglements, entanglements that public criticism, it seems to me, cannot fully address, precisely because it is hard, especially for Black people, to raise public questions about how liberation is constituted.

MN: I relate to that critical impulse. As you're talking, the scenario that comes most to my mind for some reason has to do with intergenerational relationships, which I've seen people invoke in public discourse in a shorthand that presumes that an older person always wields power over a younger one, and that something about the relationship is inherently wrong. I don't think that's true, nor does it apply to many couples I know. Nor do I think that a lot of the people invoking this discourse even believe the implications of what they're saying, especially as it can fail to address, as you say, their own entanglements, or those of people in their lives, in an honest or curious or generous way. I don't like dogma that prevents us from being able to take new account—socially, sexually, politically—of what's going on, and instead leads us to simply say, "I know what's going on; it's this thing; and I judge it as X."

Moralism is a hell of a drug. When it comes to sex, the things that you don't like or wouldn't want to do sexually don't just seem uninteresting to you—they tend to seem repugnant or morally reprehensible. They produce a different kind of response from someone wanting to eat mustard when you don't like to eat mustard. There's something deeper, like, "Ugh, I would never be into that," the implication being that it's disgusting or wrong. These are unintentional forms of cruelty and alienation that we can animate right when we want to call people to communion.

Part of why it's so difficult to talk about these subjects is that we're so haunted by the idea of people—women, namely—"asking for it." There's this pervasive idea of people getting punished for the bad behavior of others because they dared to be sexual selves, as if they went into these experiences seeking appalling behavior (or being unforgivably naive if they didn't see it coming) and then had only themselves to blame when they encountered it. We're so pummeled by that narrative that I think it can become really difficult, for women especially, to understand and to be curious about why they (or we) sometimes seek relationships that bring pain, or that bring pain along with "pleasure" or whatever you want to call it. I'm not necessarily talking about partners who are abusive; I'm

talking about partnerships that we pursue in order to experience things beyond or besides light and joy. After all, very few intimacies bring us *only* light and joy—in fact, most tend to activate our biggest unresolved traumas. We are humans with unhealed wounds, and we often seek others who have unhealed wounds that reflect or animate our own. There is a kind of self-knowledge about what's broken in you that you find, maybe, by seeking out other broken things. I did a lot of that, and it has not always been fun. Sometimes you learn that you have healing to do, and sometimes that healing can pitch you toward different, perhaps better, entanglements. But the difficulties never evaporate entirely. Likewise, if you're confronting, say, the subject of addiction, then it helps to be able to engage in an honest, fearless reckoning with yourself, in which you become curious about and take responsibility for your choices.

But again, we're so haunted and punished by these shaming, moralistic narratives of culpability, there's almost nowhere—beyond music and poetry—to discuss our complex and ambivalent and turbulent desires around things like sex and drugs. That seems like a real shame.

sw: It is a real shame. As you point out in your work, no person who has thought herself a free woman has ever not been punished for promiscuity, although promiscuity is not the only example of what sexual freedom might be. Trying to understand your own mind, and struggling with the problem that your own desires might lead you into a dark place rather than a place of "liberation"—and that the dark place isn't necessarily one to be condemned, but a place where your actual desire meets itself, is given substance—that's fascinating and incredibly difficult to talk about.

Maybe I value my complicated relationship and desire to get high *because* they are not leading to an even plane of experience where everything is deemed settled for me in the world. That kind of settlement is not in the nature of my own closely held fantasy of freedom and independence— which has to do, of course, with not being reliant on any kind of domestic heterosexual relationship—which I suffer greatly from. Happiness

doesn't seem like the point to me. The point is not to achieve some kind of "normal" thing that would lead to something called happiness.

MN: That reminds me of the long passage on trap music in your in-progress essay wherein you write, "[Trap] music has been for several years an informative area of ecstatic activity; it resonates with my own rageful, productive and *unrelenting* unhappiness."

In the George Oppen poem "Leviathan" that I use as the epigraph to my new book, the last lines read: "Fear / is fear. But we abandon one another." I'm kind of obsessed with how he doesn't say, "And that's terrible." Or, "And we won't anymore." He just states it as fact. But because the poem, like a lot of poetry, calls you into the space of communion, it also offers a way to be here together and just say, "Hey, we abandon one another." This relates to da Silva's estrangement/entanglement dichotomy that you and I are both so interested in. I hear Oppen saying that one of the ways in which we are entangled is that we abandon—that that's one of the things we do with our entanglement. And yes, it can put you on the outside of a relation, but you're still in a relation.

Half my life is spent, as I'm sure everyone's is, making boundaries and deciding what's okay for me and putting people who treat me unacceptably outside those boundaries. So the question of how not to abandon one another while also making and upholding boundaries that protect us—it's not something you solve. It's something you *do*.

SW: I think about this all the time. I want for us, particularly as Black people, to be able to do a better job of holding people within our ranks who might not act right—to hold open the possibility of communicating with those people. Some of the only places that I see that dilemma acknowledged is in poetry by other Black women. In Sonia Sanchez's work, in Nikki Giovanni's work, in Audre Lorde's work. They articulate something like, "It is impossible for me to abandon you. I can't do it. And yet, we have work to do here." Trap music also speaks to this in a way that

many people can't tolerate because it's an airing of dirty laundry, to some degree, about the incredible level of conflict and fear that is endemic to Black love of all kinds.

What can the true social life be for Black people who are unwilling to toe the line of respectability? That's what Saidiya Hartman takes up in *Wayward Lives* (2019), accounting for the inventions of Black women whose pain and fulfillment could not be addressed by the order of the world. But I think the idea of waywardness is a way of understanding and relating to politics—it is not exactly a politics itself, and it doesn't grant people any peace. There is no work more important to me than Hartman's. But I'm freaked out by the idea that Black people who do nothing but think about what Black freedom might look like, including me, return to imagining internal retreat and jumping off the earth. The phrase "loophole of retreat," which comes from the title of a chapter of Harriet Jacobs's *Incidents in the Life of a Slave Girl* (1861), scares me to death. The animating philosophical problem for me is how to stay on the planet we're on and not seek this moment of so-called flight where you think, "I can get out of this."

MN: It's the oldest storyline in the book, from bondage to freedom, as you've written so much about. In an interview in the *Los Angeles Review of Books*, you say you're curious about "how Black writers operate as artists in a context that makes it very, very difficult for anybody, especially Black people, to shake free of certain ideological or linguistic fetters." Which reminds me of that Oscar Zeta Acosta quote that Moten reanimates in *Stolen Life*, about "all the fighters who have been forced to carry on, chained to a war for Freedom just like a slave is chained to his master." You've written so eloquently about this problem, as when you write in "Warring" [a not yet published essay], "Even as black metaphysics causes us to think freedom as chimeric, we cling to the dream of liberation. It is too much to ask, to give it up."

To me your work is about constantly facing this dilemma, about trying to be in and with the impossible murk of "freedom as chimeric" on the

one hand, and "it is too much to ask, to give it up," on the other. Instead of treating this as a deadly impasse, you meet it with a questing spirit. As you say in *Dear Angel of Death*, in one of my all-time favorite lines of yours, "I just want to know what else might be available."

sw: The impossible murk of being in a situation where the choices you made in order to live are not supported by any-fucking-body. What does care look like for that person?

This brings me to a question about the word *care* itself, a word I'm sort of baffled by, because I'm never quite sure what we mean when we say it. Can you say something about how you understand the word *care*, since it plays an important role in your new work?

mn: The Wittgensteinian principle that a word's meaning is its use applies here. I see the word *care* everywhere these days, and it's always valenced positively, like it's *the* answer, like to be against care or to question the word's use would be crazy and inhumane. Yet its very ubiquity has made me feel curious and maybe a little disobedient about it, as I am with anything that is presented as a new piety.

I don't have a singular definition of care. The first chapter of my new book, called "Art Song," was meant to offer a light genealogy of the phrase, to chart how and where the concepts of "care" and "the reparative" have cropped up over the past fifty years in relation to art and aesthetics. As with a lot of things in the art world, both quickly became buzzwords and then suddenly appeared everywhere—in museum wall text, panel invitations, artist statements, reviews in *4Columns* and *Triple Canopy* and *Artforum*, and so on. I don't see myself as an arbiter of what the trend should be; I see myself as somebody who tries to take a step away to say, "Before we all drink this Kool-Aid, let's examine what's going on here." I'm not against care; probably nearly everything I would vote for or agitate for in the streets could fall under a "politics of care." But as we've seen during the pandemic, there's this popular idea that the left cares about other people and the right only cares about themselves; that

there's good care over here and bad freedom over there; that we value care because we're good, and the people who resist its call are monsters. And I feel that the more we repeat that dichotomy, the worse things get, and the more baffled we remain as to why. So I wanted to disrupt some of this "good dog/bad dog rhetoric of puppy obedience school" (as Eve Sedgwick put it) and inquire, as you do, what else might be available.

Also, a lot of the language we're using these days borrows from restorative justice without actually reflecting its basic principles. I think that's a problem. One of the reasons that the prison abolition movement is so inspiring to me is that it doesn't do this. It's one of the few places where these principles really are put into practice, in a way that's missing in many other places. It's missing because it's hard—much harder than condemnation and shunning.

What do you think about the word "care"?

sw: It's so hard for me, Maggie, to imagine that the care that I take among my friends and family will *ever* be replicated in the public sphere, because we live in a world that is so shot through with misogyny and racism. Therefore the word is very difficult for me to accept when we talk about public standards, and seems misplaced to a certain degree. I think I'm agreeing with you.

But if we think about art as a kind of "reparative" practice that might intervene in a deeply hostile and violent public, maybe one thing we're working through implicitly is how to form communities of mutual regard and share in practices that do not reinstitute vulnerabilities that we claim to reject, as well as those we embed in the groundwork of our "freedom dreams." If we believe that the state is not going to serve us, let's think about what it would be like to begin by trying to make connections at these incredibly small levels. Your writing about teaching helps me think about how to make these connections. You describe routinely having to negotiate questions with students and faculty of whether people's ideas cause harm. You talk about discussing these ideas as a pedagogue, but

then once you walk out of the classroom, and your pedagogue hat comes off, who are you to adjudicate these questions of harm? Do you think about how to bring this kind of openness—the openness one must bring to one's work as a teacher—to other roles?

MN: I really value the experience of being a pedagogue. Everyone is bringing into the room a different thing. As a student, you may want to watch your teacher shame people who you think say dumb things; this desire can be quite intense. (I know it was for me!) But the reason that it remains such a fantasy is that it never happens, and for a reason. And that reason is that it's not what the teacher should be doing. I take seriously this feeling that no one in my classroom is disposable. Not that you don't sometimes cut your losses, but the general idea is that we've got to all stay on the ship, and we've got to figure out how this ship can float such that no one's not feeling okay about being part of this community. It's hard work.

SW: It *is* hard work. One of the things I've been thinking about lately is how to balance my real communication style and who I feel myself to be outside the seminar with the space and encouragement I want to give as a teacher. I don't want to perform absolute acceptance or give the impression that the work we are doing in the classroom requires me to evacuate myself. I guess part of what I'm thinking about is the difference between pedagogical nurturing and mothering. But my motherhood involves similar principles of truthfulness! I totally yell when warranted and cry in front of my kid and stuff.

We haven't really talked about the deeply humbling experience of motherhood. After my son was born, I realized I no longer had total control over the things that were keeping me in a state of equilibrium. I couldn't sleep anymore. I *couldn't*—I lost the ability. Sometimes I couldn't eat. I just kind of lost my ability to regulate my own person. My relationship with drinking got really tense, too. As an extremely anxious person who is also a lover of partying, I've become so wary about drinking—fearful—in a way I was not before. This is partly because of my family history of alcoholism, but I think I am objectively spread thinner, physically and

psychically, than I could ever have previously imagined. I feel more re-sourceful and stronger in some ways but also more fragile; that sense of fragility has softened my approach to relating to everybody, I think. I wonder if your experience of motherhood has also changed your mode of address as a writer—if there's a sense that you've been humbled by this experience to the point where you can no longer speak from the soapbox.

MN: You can know theoretically that shame doesn't change people for the better. But when you're parenting and you see what the ongoing shaming of a child does to them, you may begin to see that you are developing a psychic structure in your child (and in you) that is not what you want. So you may begin to seek out other ways. (I am not saying it is easy to stop employing shame—in fact, I probably think about this so much precisely because it comes so naturally to me, as it's what was taught to me, as it was taught to my mother by her mother, and so on.)

Maybe this goes back to the story about your friend trying to perform a kind of intervention with you about your relationship. There's this idea that if we could just understand how much our compulsions and addic-tions hurt others, we would just snap to it. But my experience in twelve-step and elsewhere has taught me that that is how everybody outside addiction *wants* it to work, and how everybody inside knows it doesn't. That doesn't mean that other people's pain doesn't matter, or that it shouldn't be voiced—not at all. It matters a lot. It's just that it doesn't work as a magic bullet, because (at the risk of sounding platitudinous) people have to make changes for themselves; if they are changing for oth-ers, the changes won't stick. I also think here of Al-Anon, in that people often come to Al-Anon in pain from an alcoholic in their life, and one of the first questions they often have is a kind of should-I-stay-or-should-I-go question. And they're immediately told, "The program will never tell you what you should do. The program will tell you to focus on yourself. And our credo is that if you do enough program and focus on yourself enough, you will be able to answer your own questions in your own due time." That's always rearranging for people who want to go and feel like they're finally going to get told what to do. But it's a program that em-

powers people. It works in a way that other things don't work, because when people make decisions in this way, they trust that *they* made that decision—that they gave themselves the time to know themselves and didn't do it to please somebody else or because somebody thought what they were doing was wrong.

Shaming people in hit-and-run encounters—say, on Twitter or whatever—will not make the value of this approach clear to you. But if you have some humbling form of practice in your life, of parenting or recovery or whatever, that requires you to pay attention to certain habits of mind, and to take account of the effects they produce in and around you over time, I do think it changes who you are. And if you don't like what you see, you might get inspired to ask what else is available—even, maybe, as a critic or a poet.

(2021)

THE DARE OF TALA MADANI

The Catastrophe • *Unkillable* • *State of Play* • *Shit Mom >
No Mom* • *Pearl* • *The End of Innocence* • *Children of
This New Magic* • *Rue de la Vieille-Lanterne*

The Catastrophe

I trust Tala Madani. This trust is important, because she is inviting me,
over and over again, to the catastrophe. How does a painter pass through
the catastrophe and destroy the cliché?* Madani is a great destroyer. But
in her case, I would tweak the question: How does one pass through the
catastrophe and find laughter, fortitude, and wonder in its wake?

Madani doesn't say catastrophe. Sometimes she says accident, as in *The
Accident Series* (2009), three animations featuring a taxi crash, a hospi-
tal scene, and a mauling by subway. Despite the series title, the only true
accident takes place in the taxi; the others feature—as do many of her
animations—bad actors. (In *The Hospital* [2009], it's the little serial killer
baby patting bodies until their white sheets flood with blood; in *Subway*
[2009], it's the man who pushes another man onto the tracks, producing
spectacular carnage.)

* This question is posed by Daniel W. Smith in his translator's introduction to Gilles
Deleuze's *Francis Bacon: The Logic of Sensation.*

253

These killers aren't really villains, however. In Madani's universe, there don't seem to be any real villains at all. Acts of malice slide into mishaps of flesh, hazards of embodiment. A figure that begins under attack by others often gets into the act himself, enthusiastically carving up his own body with knives (*The Apple Tree*, 2007) or hammering himself into the ground (*Underman*, 2012), the sadistic glee of bullying and the eros and curiosity of self-harm gliding along the same Möbius strip. ("Suicide is very alien to my own psychology; perhaps that's why I'm very interested in the idea of choosing your own death," Madani says.)

This lack of villainy is partly why the frequent application of the word *critique* to Madani's work (as in, its "critique of patriarchal structures," or its "critique [of] notions of representation, gender, authority, and identity") always sounds slightly off to me. Killing is bad. Self-harm does damage. Bullying, up to and including violent dismemberment, appalls. Then what? Stick around, Madani says.

Unkillable

"Pity the meat!" Deleuze cried of the butchery in Bacon's paintings. In Madani's, there is plenty of meat, but less cause for pity. Her work pushes us instead toward grim mirth, sometimes approaching the LOL ("I really laugh when I paint"). Her animations take us past the initial shock of violence and into tragicomedies of humiliation, immolation, transmogrification. There is plenty of awfulness—that baby patting his cheeks with blood in the hospital is the stuff of nightmares—but there's also relief in watching an artist frolic so dauntlessly in the charnel house.

The animation *Mr. Time* (2018) zeroes in on the nearly insane indefatigability that radiates throughout Madani's work. Its hero, who is repetitively assaulted by a blind mob, will simply not stop going up and down that set of escalators, even after he has been sundered into bloody appendages that inch, wormlike, along his circular route. Why? Is he another glutton for punishment? A mindless bureaucrat devoted to his routine in

a strip mall–like setting destined to become, like so many other banal settings in contemporary life, a splatterfest?

When *Mr. Time* was first exhibited in 2018, its gory disarticulation brought to mind the murder by bone saw of Saudi dissident Jamal Khashoggi. Watching it in 2020, I think of the Proud Boys marauding through the streets of DC. As brutal, menacing squads reappear throughout history in differing guises, *Mr. Time* is likely to remain timeless. But its principal offering is not a blistering indictment of the mob mentality that leads to radical injury. Madani—who says she paints out of desire, including the desire to befriend her subjects—handles both victims and perpetrators with a certain equanimity and tenderness. A ruthless tenderness, if there is such a thing. She stands apart from her damaged and damaging men while also being her damaged and damaging men. "Every painting is me," she tells me in conversation. "The blue is me." We, in turn, get to wonder about our role in the alarming jubilee.

Mr. Time is a harrowing seven minutes, especially upon first viewing. But if endured, or watched enough times, or approached with the trust engendered by Madani's other work, an uncommon species of joy arises alongside the horror. This is the joy of the unkillable. The surreality of Madani's scenarios never fails to remind us that her figures are not flesh, but paint. Painting the impossible brings out repressed possibilities of flesh, allows us to feel them on our pulses. One such possibility is the tenacity of meat in the face of catastrophe. This tenacity does not suggest that violence or death can be avoided or voided. It suggests that we can visit with them anew, resee them as theaters of transubstantiation.

State of Play

What does it really mean for a work of art or a body of work to perform a critique? Can images provide—and do we really want them to provide— "critique" in the same way that, say, discursive prose does? Shouldn't there be a better word for the feeling we get when we sense that *something* is

being taken apart and savaged but that "something" remains intentionally imprecise or obscured? If satire is the art of "holding up human vices and follies to ridicule or scorn," as my dictionary has it, how do we describe paintings that showcase vices and follies with a spirit of hospitality as much as, or more than, condemnation?

Critique demands an object. When you take away the object but retain the mood, you are left with the feeling of being suspended within a problem. This suspension can feel painful and gratifying at the same time, even if—or especially if—one senses that the problem is unsolvable. Madani's paintings, taken individually and together, excel at conjuring this feeling. It is one of my favorite feelings, which is likely why Madani is one of my favorite painters. "Caricature is a *style*," she tells me. "It is not a de facto critique." Here she is speaking of the inspiration she's derived from Ralph Bakshi, famed animator of transgressive classics such as *Fritz the Cat* (1972) and *Coonskin* (1975). About his art, Bakshi once said, "The only reason for cartooning to exist is to be on the edge. If you only take apart what they allow you to take apart, you're Disney." Madani shares this appetite for taking apart what is not otherwise available for disassembly (echoing Bakshi, she says, "I tell my students sometimes that, if they're making work that their mothers will like, they're in trouble").

Another way of describing this appetite is a dedication to play, and not of the defanged variety. In Madani's world, men play by draping their huge, willowy penises over the edge of a crib, smeary brown moms play by contaminating blond children, babies play by committing homicide or matricide. "They're paintings," Madani sweetly reminds an audience member at the Moderna Museet, after he expresses a concern that "in some of your pictures, it goes very bad for the man." "I think it's a good thing about art that it can get quite bad for whoever and it's still okay," she says, then adds, "I hope."

Madani often cites Vladimir Nabokov as an influence—in particular, the kinship Nabokov felt between making art and devising problems for

chess. "Problems are the poetry of chess," Nabokov said. "They demand from the composer the same virtues that characterize all worthwhile art: originality, invention, conciseness, harmony, complexity, and splendid insincerity." Madani's paintings are rich with such virtues. In an art world wary of emphasizing artistic power, perhaps in fear of reifying unfashionable notions of genius or authority, I find it refreshing to hear Madani say that she thinks of her art as emanating from a podium, that it is not a conversation. The painter invents a problem to pitch to the canvas; the painting pitches the problem to the viewer. The viewer gets to behold the state of play, and contemplate her next move.

Shit Mom > No Mom

Madani is an artist in the middle of a thrilling, detonative career. She is also a mother of young children. Our mediums differ, but we have faced a related choice (even if, like most artists, we don't always experience subject matter as a choice in any simple fashion). In one direction lies buying into the notion of childbearing and mothering as unserious subjects, internalizing the powerful—and sometimes ethically prudent—norms about what "good mothers" should spend their time doing or rendering public, and continuing to play with the Big Boys, who—let's face it—can be a lot of fun, as well as, for some of us (or for some of us some of the time), the figurative, intellectual, or literal company we want to keep. Another involves embracing the novel, hazard-laden terrain of motherhood with the full, fearless force of our intelligence, wit, and ability, come what may.

In beholding her *Shit Moms* paintings (2019), I feel eternally grateful that Madani chose the latter route, even if only for a spell. It's not that I think the babies on the canvas are her babies, or that she is the shit mother here figured. I know she's the babies, she's the mother, she's the men, she's the curtains, she's the blue, she's the light. But as Madani herself tells it, this particular body of work began when she returned to the studio eight months after the birth of her second child: she tried to paint a mother and child, felt disgusted with the results, and became interested only when

she smeared the mother figure into something that resembled shit. The shit mom—as the antithesis of the unsoiled virgin that dominates art history—pleased her, and offered a way into the material.

It's one thing to understand intellectually, as Madani does, that mothers are doomed to fail (to be "shit moms," at least at some point along their journey), that they are unfairly judged and scapegoated, that their imperfections, perversities, risk taking, and humanity will always be received differently than that of men or of fathers. It's another thing to live it, to go around the world haunted by the ever-present whisper, "What will the children think?" (a whisper that can emanate from inside as well as out). Indeed, what will our children think—of our art, our public selves, our studio time, our grand ambitions, our urge to transgress, our splendid insincerity? What will they think of all the violence, the kink, the darkness, the vulgarity? What will they feel when they realize not only that mothers house the very things they are expected to protect against, but also that some of them—some of *us*—go around *broadcasting* these things, making a spectacle of them and ourselves, sometimes for reward?

We don't know. We proceed as we do not because we know or not because the answer will please us, but because we know that the alternative—a world in which artist-mothers repress, or are forced to repress, their curiosities and capacities—is not one we want to live in, or one we want our children to live in. If maternal failure is indeed built into the job, then it is a fool's errand to think that, if we played our cards right, we might be spared our children's pain and grievances. We will not. The intergenerational mayhem in Madani's work underscores this point, just as its triumphant liberations remind us of its value.

Pearl

In some of Madani's pictures, yes, it goes very bad for the man. But it can go very bad for the shit mom, too. Which brings us to another node in Madani's universe: Nathaniel Hawthorne's *Scarlet Letter* (1850), which features a shit mom for the ages, Hester Prynne. (Lest we forget, Hester

is also an artist: using her unrivaled sewing prowess, she embroiders her *A* into "a specimen of her delicate and imaginative skill, of which the dames of a court might gladly have availed themselves, to add the richer and more spiritual adornment of human ingenuity to their fabrics of silk and gold." Her badge of shame thus doubles as a shimmering advertisement for her embroidery services, which are legendary throughout the land, and which provide support for her and her wily bastard daughter, Pearl.)

Madani is interested in Pearl. I can see why: like Madani's babies, Pearl emerges into the world seemingly shorn of innocence, and tinged with malice and mystery. Pearl's shamelessness, furtiveness, and anarchy unnerve Hester, who once lunged for New World liberation (by means of copulating with the Reverend Arthur Dimmesdale) but ended up branded and bogged down in Old World punishment. (Madani, who was born in Tehran and immigrated to the United States as a teenager, is also interested in D. H. Lawrence's proposition that Pearl, with her checkered heritage and faux innocence, signifies America.)

A connoisseur of tales about the primordial, sometimes murderous conflicts between parents and children, Madani likes to point out that Western myths often entail the slaying of one's parents (e.g., Oedipus), whereas "Persians . . . have a very different filial idea. For example, in the tragedy of Rustam and Sohrab, the father kills the son." (As someone who has recently spent a lot of time reading Greek myths to her son, I would note that there's actually a fair amount of back-and-forth on this account—in early Greek mythology, Cronos castrates and overthrows his father, Uranus, but then eats his own six children in an attempt to keep them from overpowering him.) In the *Shit Moms*, it's the mother who is vanquished, consumed, humiliated, done and undone, created and destroyed. In *Shit Mom (Quads)*, babies celebrate over her decimated ruins; in *Shit Mom (Disco Babies)*, babies mess around with her orifices as she kneels on all fours under magenta and white spotlights; in *Shit Mom (Dream Riders)*, one baby rides her like a horse while another unspools a white scarf from her mouth; in *Shit Mom (The Streakers)*, her corpus has apparently melted into excrement, with which the babies streak a white

wall, bringing to mind everything from the symbolic dismantling of the
Sumerian goddess Inanna to the unthinkable fate of Sharon Tate.

However disseminated, the shit mom remains everywhere, unkillable in
her own way. Like Inanna, she seems capable of being left for dead on
a meat hook, then magically revived and returned to the arena. In this
way she remains a good-enough mom, à la D. W. Winnicott—a mother
who can withstand the child's desire to destroy, consume, punish, rage.
("A shit mom is better than no mom," Madani says she realized as she
painted.) Winnicott believed that children benefit profoundly from being
able to express disturbing thoughts and feelings, including hatred of their
parents, while beholding their caretakers' survival; the experience teaches
them that their destructive emotions do not necessarily obliterate others
or the external world. (Winnicott knew that such feelings ran both ways:
"The mother hates the baby before the baby hates the mother, and before
the baby can know his mother hates him.") The benefit children get from
this process is, as Winnicott had it, nothing less than the development of
a "true self"—a creative, authentic self that does not develop around the
need to censor or repress its true feelings in order to win the love of oth-
ers. "Only the True Self can be creative and only the True Self can feel
real," he wrote.

I've heard Madani say that our truest oppressor is our frontal lobe, that
our salvation lies in behaving like children. Given the antics of some of
her babies, and the fact that uninhibited aggression or sadism isn't exactly
known for creating a more just and peaceful world, I've often wondered
what kind of salvation she has in mind. Yet, when I think about this true
self, and the ways in which Madani's *Shit Moms* both depict and enact
the conditions necessary for its development, I begin to understand. For
the alternative to developing a true self, as Winnicott saw it, is the devel-
opment of a false one—that is, a self that hides internal feelings of rejec-
tion, self-condemnation, deadness, or emptiness behind a defensive and
compliant facade, a self that loses touch with spontaneity while harboring
"a growing sense . . . of futility and despair." Winnicott believed that the
capacity to engage in free and spontaneous play can reverse this drift, for

children and adults alike: "It is in playing and only in playing that the individual child or adult is able to be creative and to use the whole personality, and it is only in being creative that the individual discovers the self."

It is for this reason—along with their stunning, at times supernatural beauty—that the *Shit Moms* paintings feel almost holy to me. They impart the sense that *the paintings themselves* are the holding containers for whatever rage, anguish, curiosity, fear, or sorrow might pass through us, from infancy through adulthood. *Not only can I withstand such things,* they say, *but I can teach you to withstand them also, and to enjoy the ride.*

The End of Innocence

Another child who recurs in Madani's work is the boilerplate, prepubescent girl of the animation *Sex Ed by God* (2017) and the *Pussy* paintings (2013). Bow in hair, pleated skirt hiked up, knees tipped open, this girl is a sort of megachild who looms over the tiny men looking for ways (3-D glasses, cameras, abstract painting) to behold, represent, or offer instructions to her unsheathed pussy. She evokes many other girls found in pervy situations throughout art and literary history, from Alice Liddell to Balthus's model Thérèse Blanchard to Lolita, with the difference being that, in *Sex Ed by God*, the girl serves as both model and maker-destroyer. Beginning as a projection watched by spectators in the foreground, the girl of *Sex Ed* appears sanguine, buoyant, more Annie Sprinkle's *Public Cervix Announcement* than violated child. A little gumlike mouth floats in the air (the mouth of God?) giving an idiosyncratic lecture as to how to pleasure her ("grow dicks on your fingertips," "find her clit and *never let it go*"), while she reclines and smiles, occasionally primping her bow or gazing down at her vulva in languid admiration. Eventually, whether out of curiosity, boredom, or spite, she reaches out of her screen, grabs the little gum mouth and spectators, squeezes them like King Kong in her giant hand, and neatly inserts them into her vagina. She goes on to erase the landscape with a painterly hand, eventually crumpling everything up into a little black ball, which she also stuffs up her vagina, before crawling away like the baby she is not.

I first saw *Sex Ed by God* in the summer of 2017, at the Whitney Biennial, and loved it. I stayed to watch its two minutes and eleven seconds several times, knowing that, however many times I watched, it wouldn't be enough. I thought of it later that year, when, in November, controversy bubbled up over *Thérèse Dreaming* (1938) at the Metropolitan Museum of Art, in the form of a petition signed by more than ten thousand people arguing that Balthus's painting nefariously "romanticizes the sexualization of a child" and requesting that the painting either be removed or be presented with "more context." Believing, as I do, that the best response to art that bothers us is often to make or call attention to art we love, I kept imagining how fantastic it would be if *Sex Ed by God* could just be installed in the same gallery as *Thérèse Dreaming*—not unlike the intervention, also in 2017, of the rude sculptures of Sarah Lucas in the Auguste Rodin galleries at the Legion of Honor in San Francisco.

For if and when art actually does perform a critique—and I'm willing to say that *Sex Ed by God* does—it does so not by erasing, chaperoning, or acting as tribunal, but by being in conversation with previous works and impulses, and offering another turn of the screw. Those hoping to eliminate the sexuality or sexualization of children will find no safe harbor in Madani; the preservation or restoration of innocence, for either her subjects or her viewers, is not on the menu. If you've had enough of the creepy gawkers, Madani's megachild suggests, try inhaling them into your ample vagina, quite possibly pleasuring yourself—and transforming the world—in the bargain.

Children of This New Magic

When Pearl asks her mother for more information about the scarlet letter (which is also an attempt, whether Pearl knows it or not, to learn more about her own origins), Hester rebukes her: "Hold thy tongue, naughty child! . . . Do not tease me; else I shall shut thee into the dark closet!" Madani's work sets up shop in dark closets, which are punctuated, striated, and spooked by various species of light.

As in *The Scarlet Letter*, this light is complicated. In the novel's famous "walk in the forest" scene, in which Hester almost manages to exchange her grim life for one of freedom, the sunlight acts as a tease:

> Pearl set forth, at a great pace, and, as Hester smiled to perceive, did actually catch the sunshine, and stood laughing in the midst of it, all brightened by its splendor, and scintillating with the vivacity excited by rapid motion. The light lingered about the lonely child, as if glad of such a playmate, until her mother had drawn almost nigh enough to step into the magic circle too.
>
> "It will go now!" said Pearl, shaking her head.
>
> "See!" answered Hester, smiling. "Now I can stretch out my hand, and grasp some of it."

But no, Hester cannot—Pearl makes sure of that. After Hester flings off the scarlet letter and makes her impassioned pitch to the reverend about running off together to where there is "no vestige of the white man's tread," Pearl makes it clear that the plan is a no-go. She throws a tantrum and commands her mother, "Come thou and take [the letter] up!," thus reattaching Hester to her burden.

The light in Madani's paintings teases us similarly, dangling the possibility of an escape hatch, an outside of an oppressive scene (*Curtains #3*, 2019; *Manual Man*, 2019). At times it too creates a magic circle, a diffuse miasma coagulating at a figure's feet (*Fan*, 2020); at others its source is patently disturbing (as in the *Oven* paintings, which explicitly reference suicide). Then there are the many spotlights and overhead projectors, which layer up the interior space with dynamics of exposure and control, multiplying the worlds within worlds.

No matter how beautiful the light conjured—and often it is very beautiful—Madani is too devoted a satirist to lead us to believe that there are good forms of light (that of God, natural sunlight, our own radiant

purity) and bad ones (artificial light, celluloid light, light designed to expose, damage, or humiliate rather than illuminate or cleanse). We may root for Hester to step into the magic circle and start over fresh and free, but there is always a Pearl standing by to remind us that this, too, is a fantasy—that hygienic notions of illumination and freedom can have their own forms of violence embedded within them (as the nonwhite inhabitants of Hawthorne's wilderness knew all too well). Rather than shepherding us through moral dilemma, Madani uses the visceral splendor of light and color to direct us toward magic, wherever it may be found, and whatever its nature. "I sort of became obsessed with the idea of the cinematic light and how there is something quite magical in this celluloid, in the film and the light through that. I think obviously we are sort of the children of this new magic, from 150 years ago," she says. We cannot know in advance what being children of this new magic might mean; as with Pearl's brazen queries about her heritage, we can only inquire and discover.

Rue de la Vieille-Lanterne

In speaking about the role of light in her work, Madani has mentioned Julia Kristeva's *Black Sun*, a book in which Kristeva describes depression and melancholia as "invisible, lethargic rays" that pin her down and give her another life that is "unlivable, heavy with daily sorrows, tears held back or shed, a total despair, scorching at times, then wan and empty." Kristeva describes this "devitalized existence" as "unbearable, save for those moments when I pull myself together and face up to the disaster." Kristeva takes her black sun metaphor from a poem by Gérard de Nerval, a famous depressive who eventually hanged himself from a cellar window on rue de la Vieille-Lanterne. (Baudelaire's description of Nerval having "delivered his soul in the darkest street that he could find" brings to mind Madani animations such as *Eye Stabber* [2013], in which a man scissors himself into a spurting mess in a dark alley.)

There are, of course, other black suns: the black sun of Nazism and neo-Nazis, the black sun of Satanism, the black sun of alchemy, the black sun

of Mesoamerican myth, the black sun of the solar anus (as conjured in Madani's *Shitty Disco* series [2016]). But I like thinking about Kristeva's *Black Sun*—and Nerval—in relation to Madani's work, as it reminds me that if her work summons unbearable despair or sorrow, it doesn't mean that we've simply failed to take its joke.

This despair and sorrow feel particularly acute in the three-and-a-half-minute animation *The Womb* (2019), in which a fetus grows while a highlight reel of hominin/human history plays against the pink uterine wall. It's a selective history, heavy on atrocity, with fugues on fossil fuels, drugs, and technology, starring everyone from the Buddha to Abraham and Isaac to Adolf Hitler to Angela Davis. For a time, the baby tumbles around blind, futzing with its umbilical cord. Then, slowly, it grows more aware of the projection. Around the invention of agriculture, the fetus conjures a remote and powers down the show, buying itself a little more time to cartwheel. Before long, however, the movie is back; by the twentieth century, the fetus has surrendered, and sits down to watch in earnest. By Mao's Cultural Revolution and the moon landing, it appears discouraged, kneeling with shrunken shoulders in front of the screen as if in a prayer of despair. Not long after smartphones and Abu Ghraib, the fetus produces a black handgun from the pink surround and fires six shots into the uterine wall, creating six shafts of light. The animation fades as the baby approaches the bullet holes.

The Womb sets off multiple maternal anxieties with which I have ample familiarity. The first is the worry, first activated during pregnancy (or while trying to conceive), that everything you choose to imbibe (or cannot help but imbibe) will affect your unborn child. As researchers learn more about the physiological effects of stress and the biological repercussions of intergenerational trauma, gestating mothers get even more to worry about. Any adrenaline-raising interlude, any distressing images created or consumed, any inherited pain or defect, any stress—including the stress caused by trying not to be stressed—can provide occasion for what will soon become a common self-reproach: *No matter how hard you try, you're not going to do it right, and your errors might be ruinous. The*

Womb offers an allegory of this conundrum, in that the mother's body literally serves as the delivery device through which the baby gets exposed to the world's horrors.

Another anxiety has to do with the role we play in teaching our children about these horrors once they've been born—how we are to mete out the bad facts of history at an "age-appropriate" rate. (I am aware that the ability to mete them out is itself a form of privilege, distributed inequitably.) As I write, it's still pandemic time, which means that I've been with my son nearly twenty-four hours a day every day since March 13, 2020. Partly due to the nature of the times, partly due to his age (he's eight), and partly due to all the intense togetherness with a mom who can't stop talking, he's gone from being a fairly sheltered third grader to taking a luge through Black Death, the 1918 influenza, the Holocaust, and 9/11. He's been to Black Lives Matter protests, has learned about slavery, Jim Crow, Selma, mass incarceration, police brutality, and the death penalty. He's heard a white guy in Orange County call his mother a pussy for asking him to wear a mask, lived through the choking smoke of wildfires, learned about global warming and our daily complicity in it, witnessed two impeachments and an attempted coup. This concentrated parade—and my ambivalence about having served as its docent—has reminded me many times of *The Womb*, especially as our children, at least the younger ones, have been under near-total house arrest, forced to see the world through our prism.

The last anxiety I'll mention has to do with guns. Though it's hard to recall at present, since schools have been shuttered for so long, many of us used to worry about (and protest) mass shootings of children, sometimes by children. Having been raised by a very gun-phobic mother who was traumatized by her sister's murder by gunshot (and having myself attended the murderer's trial, which laid heavy visual emphasis on the bodily effects of those gunshots), I am gun-phobic as well, especially when children are involved—a phobia so intense it can extend to my capacity to take in certain images in art. But if there's anybody I trust to put a gun in the hand of a baby, it's Madani. Part of that trust has to do with

the fact that I know she isn't going to be satisfied with any easy breaking of taboos. If you're going to make art that won't please your mother, you've got to do more than offend. You have to make sure you destroy the cliché, and remain stringently inventive about what comes next.

I admit that it came as a shock to me to hear Madani describe *The Womb* as ending with the fetus's suicide, an act it chooses after seeing how bad the world has been and likely will continue to be. I had read the ending in the opposite fashion—as an allegory of birth, a sign of the fetus's impatience to get to life. I saw those six shots as the baby's way of saying, *Okay, okay, enough warnings, now get out of the fucking way and let me have my turn.*

The more I think about it, the more important this multivalence becomes. Each day, however fallow or overt the struggle, we all face the question of whether to choose life or death. Even if we aren't particularly prone to suicidal tendencies or depressive states, some of the problems we face—relentless mass shootings, a global climate crisis threatening human futurity—have led even the most buoyant among us to parry with nihilism. As we each must contend with such burdens, so must our children. A Green New Deal and stricter gun laws will help, but nothing will ever put an end to the fact that, at least on some days, life can feel "unlivable, heavy with daily sorrows, tears held back or shed, a total despair, scorching at times, then wan and empty." That's where Madani's art comes in. On its dare, I pull myself together, and face up to the disaster.

(2022)

MY BRILLIANT FRIEND

On Lhasa de Sela

The news of Lhasa's death on New Year's Day, 2010, sent me to the couch to howl like an animal. I curled up with my face against the fabric wall, needing the privacy one needs when stricken. I hadn't even known she was sick. How could I not have known.

Breast cancer, age 37, said the *New York Times.*

The days passed, and I found I had questions. Lots of questions. With no one to direct them to, they festered. After a year, I took the risk of sending them to one of her sisters, whom I'd known lightly in high school. She kindly promised to answer when she had time, but I never heard back. Who could blame her?

So I turned, instead, to YouTube. There I could find montages of still photos of Lhasa set to her music: Lhasa leaping over railroad tracks in an overcoat, Lhasa dunking under seawater in slinky silk, Lhasa performing in a black spaghetti strap dress surrounded by fancy-looking bassists and harpists. I read the comments in English, French, and Spanish, most of which offered some variation on *Puto cáncer. No te olvidaré jamás, dulce ser.* Mostly I watched her last recorded performance, shot by filmmaker Vincent Moon on April 11, 2009, at what appears to be a house party in

Montreal. I scoured Lhasa's face for signs of foreknowledge, acceptance, fatigue, anger, resolve. I tried to discern if she'd had a mastectomy. Her hair was short, her skin tone changed—signs of chemo? Or illness, or age? I watched and watched, but mostly I saw nothing but Lhasa, pretty much as she always was: bearing down on each word, lost and found in song.

And then, out of the blue, a few days before the tenth anniversary of her death, I got an email from a music journalist named Fred Goodman, who said he had recently published a book titled *Why Lhasa de Sela Matters*, and would I like a copy. I sensed—correctly—that many of my questions were about to be answered.

I last saw Lhasa in the winter of 2004. I was living in an industrial loft in Williamsburg, the kind where snow wafts in through the walls. It was a trapeze loft, managed by a friend in circus/performance art/cabaret. I had fallen into living there after a breakup that had caused my status in New York City real estate to plummet—I'd gone from living in my own one-bedroom, rent-controlled apartment in Boerum Hill for $790 a month to occupying a fifty-square-foot corner of a leaky, loud loft occupied by multiple others for $850 a month. Squatters and strangers abounded; one queen who spent the night with someone moving out the next morning just stayed on, burrowing in atop a plywood platform. For weeks, before any of us got up the gumption to ask him to leave, he cooked in our kitchen wearing a turban and apron printed with strawberries, as if our den mother. It was my first year out of graduate school, and my first working as a "professor," which meant trying to live on $3,500 a semester and struggling to correct papers to the sound of trapeze rehearsals and rowdy sex at random hours of the day and night. "You're really *living the life*," Lhasa said over tea in the loft's communal kitchen, which housed a clawfoot bathtub full of dirt and dozens of large plants hanging from the rafters. This was high praise, from Lhasa. I was glad, as always, for her approval.

Lhasa knew many amazing people in her childhood and adulthood, and I'm not writing this to insert myself into that canon. What Lhasa meant

to me is hugely outsized compared to what I meant to her. I accept that, and suspect it is true for many others. That happens commonly with re-nowned people—old friends and acquaintances try to stake their claim. I liked Elena Ferrante's *My Brilliant Friend* but had a hard time mak-ing it through once I realized that I was more Lenù than Lila—Lenù being the plainer, more obedient, less magical friend who grows up to be-come a writer, Lila being the truly brilliant friend who suffers more griev-ously, has her genius go unrecognized, and eventually disappears. Lila burns her writing, while Lenù's stories—about Lila, of course—become the book we are now holding in our hands, the homage paid by the high-functioning mediocre to the fast-burning extraordinary.

None of this is really the case with Lhasa. The world came to know her genius, and her music lives on, is beloved. But she did disappear. I still do not understand how this is possible.

We had met fifteen years earlier in high school, at the Urban School of San Francisco. Before showing up at Urban, Lhasa had been living in a school bus with her family in Mexico; after her parents split, she moved with her mother and a constellation of siblings into a railroad apartment on Harrison Street in the Mission. I didn't know it then, but her mother had just come off kicking dope, birthing six daughters in quick succes-sion (two of whom she no longer had custody of), surviving a near-fatal car crash, and fleeing a string of rough relations, the last of whom was Lhasa's father, a nomadic Mexican philosopher-mystic. (From Goodman I learned that Lhasa's mother retained a connection to money through her own mother, a volatile actress who had starred in Elia Kazan's *America America*, and was unhappily married to a corporate titan of New York City. But proximity to money doesn't guarantee money, or stability; cer-tainly that was the case here.)

I, on the other hand, was the second child of rule-following, ambitious, voted "most likely to succeed" white midwesterners who had moved to San Francisco in 1969 not for the afterglow of the Summer of Love, but for my father's job in labor law. By the time I got to high school,

however, things had taken a bit of a turn. When I was eight, my parents split; when I was ten, my father died, abruptly. The suddenness and mystery of the loss had filled me with dread, and my older sister had begun to slide, bringing drugs, older boys, and troubled friends into our shared basement life. Before long she would become a runaway, spending time in juvenile hall and reform schools; I would stay at home with my mother and stepfather, struggling to distance myself from the more frightening of her woes while trying not becoming a total nerd or goody two-shoes. (The latter felt a distinct possibility, as, almost despite myself, I cared deeply about my studies. I was also fearful that, were I to misstep, a 250-pound bald guy in a car with child-lock doors might come for me as well.) In eighth grade, I read *I Never Promised You a Rose Garden* repeatedly, and experimented with splitting myself into two: Maggie, who got good grades and gravitated toward light and life, and Margaret, who was sick with grief and anxiety and actively wanted to die. By high school, this struggle had become visible in my fashion: ankle-length, flower-printed hippie dresses with tassels, Renaissance Faire amulets, China flats, a mop of bleached blond hair and heavy eye makeup modeled after Anne Carlisle's character in *Liquid Sky* (whose name was, of course, Margaret).

Lhasa showed up dressed like a gypsy with a dash of Alice in Wonderland—headband holding back straight, waist-length hair, floor-length pleated skirt with a cinched waist, leotard top with a ballet sweater or scarf to cover her ample chest. More rarely, she wore jeans—low-slung faded Levi's—with a black rayon shirt, boat-neck. Her face in high school looked exactly as it looked later, so if you Google her, you'll see. People with strong faces like Lhasa's tend to have them their whole lives. Lhasa knew her face—its high cheekbones, almost clownishly wide smile—very well. In printmaking class, in ceramics, in painting, she reproduced it over and over again, like Richard Dreyfuss sculpting that butte in *Close Encounters of the Third Kind*. It's a mythic face, but it's also just a family face, her family face. Sometimes it seemed like the only face she could draw. (I was unsurprised to see it show up on the cover of her first album, 1997's *La Llorona*.)

I wish I could convey the magic of Lhasa and her sisters, two of whom were also enrolled at Urban. They were stunningly beautiful; surely that was part of it. Ironically, as a teenager (was Lhasa ever a teenager?), she wasn't considered the most beautiful of them. Her eyes were narrower, like her father's, whereas some of her sisters had wider eyes, like their mother's, which made for a more classic movie star look. This may have worked in Lhasa's favor in the long run (or at least, for as long a run as she got): "Beauty without imperfection is just . . . 'pretty,'" she later told an interviewer with disgust. I knew the feeling: my older sister was also known as a great beauty; on more than one occasion, I found out that guys I had crushes on were actually enamored with her, and using me to get closer to her legendary beauty and badness.

For Lhasa, who'd been homeschooled on poetry, fairy tales, and mythology, enrolling at Urban was an unsteady compromise with normativity. For me, it was my best shot at ditching it. I wanted to get as far away from the BMWs and aging Deadheads of Marin County, and as close to the movie *Fame*, as possible. Urban was housed in an old firehouse on Page Street between Ashbury and Masonic, in a purple and gold Victorian, the word GUMPTION carved on the double wooden firehouse doors. Inside was a two-story space organized around a hole where the firehouse pole used to be, wherein an enormous ficus now sprouted. At breaks we sat around the pit and let our feet dangle. There was no shortage of yuppie kids—it was a private school, after all—but it wasn't yet the cleaned-up college pipeline it later became. We had to do a lot of community service, which is how I found myself, at thirteen, taking care of a retired Irish priest in a Tenderloin hotel every afternoon. "Bless you, my child," Father Andrew would say as I helped him in and out of his ripped easy chair, two purple, zipper-like scars running down his knees. The Haight of the 1980s was also in a fashion crisis reflecting spiritual unrest: young skinheads in suspenders and Doc Martens roamed the streets, kicking hippies slumped under Mexican blankets, some of whom had been there for the past twenty years, surely wondering when a Gap had sprouted up on the neighborhood's most famous corner. At recess you could buy speed in the back room of Double Rainbow, patchouli oil from the tarot shop,

or wall-size silk flags of the *Dark Side of the Moon* album cover at the head shop. Lunchtime brought warm sesame bagels with scallion cream cheese from Holy Bagel; avocado, alfalfa sprout, and jack cheese sandwiches on coarse whole wheat from the health food store by the free clinic; or massive, perfect burritos at Chabela's, near the entrance to Golden Gate Park. Incredibly, we were allowed to smoke, albeit not right in front of the school (we smoked around the corner, on Ashbury, where several stand-up ashtrays had been installed for that purpose).

Lhasa's itinerant, iconoclastic, and occasionally indigent past distinguished her from many of the kids at school. At the same time, I can think of few friends from that time, rich or not, who had what one might consider a "normal," functioning household. Barely anyone's parents were together; most were hardly ever seen. There were kids already living on their own, kids involved in Survival Research Laboratories, kids enmeshed with the Pickle Family Circus. The circus thread lacing the school—circus being an available class option—would prove life-changing for several of Lhasa's sisters, as well as for Lhasa herself. At some point Lhasa and I absorbed into our friendship a delightful transfer student who seemed closer to sixty than sixteen, with arcane intellectual interests and utterly absent investment banker parents. Like Lhasa, he was a man out of his time, enraptured by ancient literature and lore; he introduced us to the Marquis de Sade and whippets (later, he became a historical archeologist). Our art history teacher was a wry, willowy visionary who taught us about Jung's anima and animus, converted us into docents for an exhibit of New Guinea totems at the de Young, and had us read Joseph Campbell's *The Power of Myth* before scouring our lives for "peak moments." Our Spanish teacher was a demanding force of nature whose extravagant passions rivaled those of Lhasa's family; when she died in 2005, her obituary read: "Born in Barcelona, Spain, she survived the Spanish Civil War, her father fighting for the Republic, her mother haranguing Fascist soldiers. In 1970, she became a teacher at the Urban School of San Francisco, and spent the next thirty-four years teaching Spanish and Latin American literature to adoring (and sometimes slightly frightened) students." RIP, Joana.

There might have been someone at our high school romantically interested in Lhasa, but generally speaking, she seemed untouchable. Some people—even in cool, progressive high schools—are simply above it all, not because they're arrogant, but because they levitate above the gross vicissitudes of adolescence, their soul having already ascended to the next level. Lhasa was like that. Even her figure was mature. She had a great sense of mirth and laughed often, but she was also deadly serious, which led to many clashes with the stoner dudes who aggressively instructed us smart and serious girls to relax. (I will never forget the ratty-haired surfer who popped several of my birth control pills "just to see what happens" during a class hike in an old-growth redwood forest, all the while telling me to *chill the fuck out*.) But some of Lhasa's untouchability was also literal, and had to do with her decision to remain a virgin, a situation we discussed at length.

It was exotic, to be a virgin in that environment. Lhasa said she was waiting for a "real man," not a silly high school boy—a Prince Charming she imagined was out there, waiting for her, too. I, on the other hand, had taken the *Little Darlings* route: convinced that everyone around me was fucking like crazy (my sister had already had an abortion by ninth grade), I felt mortified by my virginity, and by fifteen, had taken active measures to remedy it.

Lhasa's Prince Charming stuff made me nervous. I worried she thought too highly of men, even the good ones. Certainly she was impatient with creeps and sexists, but there was a certain reverence when she talked about men—especially *handsome* men—that I didn't share. She revered powerful women—indeed, she was one, and would become even more so. But she could also be brutal about women she considered weak, complainy, or insufficiently serious. (Years later, after touring with Lilith Fair, she would tell an interviewer that she had no more time for "whiny" female singer-songwriters who only wanted to "pick at the wound and see how much it hurts.") I had a few friends who tilted that way, and I could feel the burn of Lhasa's disapproval when I palled around with them.

Lhasa's apartment on Harrison felt unchaperoned and sexual. Languid young bodies in shiny leotards stretched on mats and practiced circus tricks in the rooms off the railroad hallway (her three sisters were training to become a tightwire walker, a contortionist, and a trapezist). Then there was the mystery of Lhasa's mother, who emanated sensuality and children (in addition to Lhasa and her three sisters, there were two adult half sisters who showed up from time to time, as well as, inexplicably, a pixie boy toddler). While most in the house slept on messy mattresses on the floor, Lhasa's bed was a loft, a bastion. We lay there chastely side by side, discussing the pros and cons of unrestrained passion—save for one night, when Lhasa's mother was away, when I spent a particularly lustful night with my high school boyfriend in Lhasa's mother's bed. What was Lhasa thinking that night, up in her loft? Should I have been up there with her, taking turns reading aloud from Lawrence Durrell's *Justine*? Was sailing through pack after pack of birth control pills the right path, or did Lhasa's romantic withholding put her in touch with a more mystical, transcendent realm to which I pitifully lacked access?

As with sex, so it was with politics: Lhasa and I were adamant about our convictions, perhaps Lhasa even more so. But whereas she was big on passionate, outraged speeches, I wanted to be in the nitty-gritty action. So, after my time with the priest, I started working at CISPES, the Committee in Solidarity with the People of El Salvador, headquarted in the Castro. It pains me now to imagine myself, a sixteen-year-old blond from Mill Valley waltzing into the CISPES office, full of righteous anger at death squads and imperialist injustice, ready to cold call and Xerox. But I was utterly convinced of the cause, and enjoyed working somewhere the FBI cared enough about to raid, overturning our empty cardboard boxes of printer paper and Cafix.

What were Lhasa and I into, together? The soundtrack from the movie *Time of the Gypsies*, composed by Goran Bregović. The Kronos Quartet's recording of Terry Riley's *Cadenza on the Night Plain*. Heavily steeped black currant tea with milk, and the spidery plants that reached up her living room walls. Billie Holiday (of course). Fyodor Dostoyevsky and

Paul Celan. Stevie Ray Vaughan's version of "Voodoo Chile," to which we danced our fucking guts out at a concert of his we attended together a few months before he died (helicopter crash, age thirty-five). The I Ching— O Lord, the I Ching. (I still have the I Ching I procured with Lhasa, introduction by Jung, leavened by a black-and-blue embroidered pouch holding pesetas from our 1989 trip to Spain.) My 1976 silver VW bug, in which I could take us places blasting *Electric Ladyland*, stuffing the car ashtray with Camels and Ducados. My reversible Korea jacket, blue velvet with embroidered tigers on one side, faded red-and-white silk stripes on the other, which Lhasa and I took turns wearing (and which I tragically left behind on an airplane in 1994, end of an era). Lhasa taught me that it was important to have one nearly perfect version of every necessary item: one good knife, one good teapot, one good coat. This is but one of the many lessons from her I have carried with me all my life.

In high school I knew plenty of kids who wore woven socks with leather soles and listened to Led Zeppelin and baked pot brownies while gearing up for the Harmonic Convergence (this also describes me at times). I also knew plenty of goths who wore motorcycle jackets, dabbled in dope, and pledged undying love to Nick Cave. But Lhasa was my first and only bohemian friend—someone for whom being an intellectual was the essence of cool. She was completely unafraid of dorkiness or hokeyness so long as it was in pursuit of wisdom, truth, or beauty. She later told an interviewer that awkwardness, being uncomfortable with ourselves, is how we retain our dignity. Somehow she knew and lived by this principle in high school, a time when awkwardness feels to most of us not like dignity but like dying.

Our junior year, we studied together in Spain, at la Universidad de Zamora, chaperoned by our ferocious antifascist Spanish teacher, who taught us to say *Me cago en Déu*. Our daily instructor in Zamora turned out to be a shockingly sexist teacher named Ángel, who wore crisp white button-downs and a leather jacket draped around his shoulders like a cape. He smoked through class while lecturing to us about why women shouldn't hold positions of power. *Es simplemente a-n-t-i-n-a-t-u-r-a-l*. I

can still hear Lhasa huffing in outrage. Angel was forced into pedagogical camaraderie with the most disaffected kid in our class, a guy who was treated with wariness and caution back at home, but who in Spain found a home and outlet for his closet machismo. It was frightening to behold, his first red-pill high. Every night Lhasa and I talked and smoked, smoked and talked, at a whitewashed bar decorated with broken cobalt tiles situated near a crossroads with a sign pointing to Portugal. Stands of cottonwoods rained fluff on us as we stumbled home, though I never saw Lhasa truly lost in liquor. If you told me this place was a dream, I would have believed you, except that I just found it on the internet: Trabanca.

When Lhasa began to sing, it was thrilling and agonizing. Thrilling because there, all of a sudden, was her voice, booming in the church gymnasium we rented for our Friday All School Meetings. Lhasa wasn't showcasing just her voice, but also the profundity of her investment in both the song at hand and life itself. To stand up in an auditorium full of teenagers, even sophisticated, arty teenagers, in your floor-length skirt and headband, and showcase this investment via an unhurried, a cappella version of "Good Morning Heartache," demands true bravery. The first few meetings at which she sang, she kept her back turned to us. When she started turning around, she had all the tics I behold now in her YouTube videos, repurposed, as happens, into star power—the repetitive tucking of her hair behind her ears, her side-to-side rocking, her breathy introductions, her giggling apologies when she erred. She was good, so good, but she wasn't perfect, and the combination of all that intensity with occasional swerves could be excruciating. No one knew where all this was going. But everyone knew something big was happening. On weekends we looked for cafés where she might be able to sing, her doggedness in the face of her stage fright challenging me to equal bravery, though I didn't yet know what to be brave about.

After graduation, Lhasa invited me to visit her in Mexico, where she would be spending the summer with her father. I don't think I've ever felt as free in my life as I did then, at age seventeen, boarding a plane for Mexico to find my brilliant friend in her legendary habitat, with a hand-

written note in my pocket as to how to find her. The house was more like a shelter—half-exposed to the elements, dirt patios between kitchen, bathroom, and sleeping areas. We slept on mats in an elevated area under a thatched roof, around which we sprayed circles of poison to repel scorpions. By day we'd pile in Lhasa's father's van and drive to resort hotels, where he would instruct us how to pretend we were guests in order to use their pools. At sunset, Lhasa's trapezist sister would perform on a hilltop to an audience of neighborhood kids, disseminating the family magic.

I saw more of Lhasa's body on that trip, spent more time with her at dawn and dusk, than ever before. I even snapped a nude photo of her in the shower—a true transgression, as she was so modest. She smiles at me in it with half-feigned outrage, covering her breasts, strong tan lines arcing at the tops of her thighs. I also have a photo of her in a sleeveless pink nightgown, smoking a morning pipe, and another of her over drinks, holding two cigarettes (one mine, so I could take the picture). One indolent afternoon, her trapezist sister drew me naked, lying on my side; I took a photo of the charcoal drawing, which remains the only evidence of what my naked body looked like at seventeen.

In the fall I went east to college. Coming on the heels of Mexico, the Haight, CISPES, and Lhasa, my liberal arts school in a depressed New England town felt alien and paltry. I had chosen a place that people told me was maximally nonconformist and politically active; once there, I felt surrounded by jocks, legacy kids, bad diner food, and stodgy East Coast traditions and architecture that meant nothing to me. There were even fraternities! Why hadn't anyone told me? Politics meant sobby Take Back the Night marches on the library steps, holding candles. Lhasa would have been appalled. I tried to impress my "frosh" dormmates by playing them my beat-up cassette of Lhasa singing "Willow, Weep for Me." *That's my friend from home. Isn't she amazing?*

The first creative essay I wrote in college was about my summer in Mexico, as I felt sure that Lhasa and her family were the most interesting things that had happened to me. I wrote about the day her father took us to an

abandoned glass factory littered with piles of broken blue glass, a place
that gave me the inspiration, on the spot, to write a book in fragments
about the color blue. Twenty years later, I wrote it. I always aimed to send
it to Lhasa—I thought it might be the first book of mine she might really
like, as it was an unabashed ode to beauty flush with heterosexual pathos.
But somehow we ran out of time.

Who taught you to write like this? my professor wrote on the back of my
essay. I thought she meant it in a bad way, until I realized that she didn't.
At that moment, something inside me began.

Lhasa went off to college as well—St. John's, in New Mexico. I think
she liked the idea of "studying the works of history's greatest thinkers,"
as its website now advertises; less imaginable is that she would take part
in "established traditions that date back decades or longer, from signing
the college register . . . to taking part in senior prank days before gradu-
ation." Within months she had dropped out, and moved to Montreal to
be near her sisters.

By the time I visited her there in 1991, things out east had looked up for
me. I'd fallen in love with a woman, the first woman I'd ever fallen in love
with (if you don't count Lhasa), and managed to escape the banality of
dorm living by moving into her off-campus home. This woman was deep
into a totally other mythology—one based in the East Village, involving
Patti Smith and Cowboy Mouth and the Poetry Project and Eileen Myles
and Lydia Lunch and David Wojnarowicz. It was the age of AIDS, and
New York was alive with post-punk, ACT UP, Lesbian Nation, kiss-ins
and die-ins. I was taken.

In Montreal I found Lhasa with a shaved head, experimenting with the
occasional mosh pit. Over black currant tea in her kitchen, where spidery
plants grew up the walls just as they had on Harrison, I told her about
my female lover, and my newfound revelations about bisexuality, the plas-
ticity and fungibility of organs and desire. I could be misremembering

through the lens of my own phobias, but I don't recall her having a particularly warm reaction. Who knows what she really thought—sometimes I suspected that Lhasa reacted with snootiness or disgust when she hadn't yet determined what she thought or felt about something. (She would, after all, later come to worship Chavela Vargas.) But I remember leaving Montreal with the feeling that our friendship had suffered a blow from which I wasn't entirely sure it would recover.

In reading Goodman's book, I learned that Lhasa's struggle with messy, everyday engagements with messy, everyday people—her difficulty in accepting them as something other than comedowns from the exalted world of myth, allegory, or fairy tale—extended well into her adulthood, even after she began to have full-fledged relationships. "Lhasa said that when you're in love and in a relationship and things are working, it's actually really a series of disappointments," one of her friends told Goodman. Worldly success offered no relief: as another friend said of her post-fame life, "She had turned herself into this great singer and, in her mind, into the princess. And still no prince appeared. And, in fact, some of the men in her life held her status and grandness against her. They would punish her in little ways here and there." Reading this made me angry; I also recognized the urge. Whether out of jealousy or self-protectiveness or some combination thereof, often I felt myself flickering between defending my importance to her and keeping my distance. "I've seen her flush people," a longtime collaborator, Patrick Watson, told Goodman. "She flushed me." Not staying too close was one way to avoid the drain.

And the drain was always a possibility, especially given our differences. In addition to my retaining the stink of the Marin County bourgeoisie (a stink that, I eventually realized, only intensifies with denial), the truth was that, no matter how many hours we spent throwing the I Ching, I harbored a deep distrust of archetypes and omens, Lhasa's principal nourishment. (One of her ex-boyfriends later told Goodman that Lhasa deeply believed "that she was being guided, that the universe cares. There were people in her life pushing her in that direction. I tried to get her to read

existentialists because I believe in the absurd and that the universe doesn't give a damn about any of us. . . . And that would piss her off so much that she would throw me out of the house and not speak to me for a while.") A lot of the art—perhaps most of it—that I felt compelled by, Lhasa would probably have considered trash. She valued beauty and craftsmanship more than I did, and had a much higher threshold for melodrama and whimsy. A little of the circus aesthetic went a long way for me; at times I found her relentless sincerity exhausting, at times bordering on the comedic. A painter friend of hers told Goodman, "We used to argue about art a lot. *A lot* . . . she went all the way! It drove me crazy. And one day when we were having this conversation, I just walked away. But that was us. Two days later, we're right back—it's love again, no problem." Lhasa and I never had such fights; whenever I saw her again after a long interval, it was always love again, no problem. But the intervals grew longer.

After college, I moved to the Lower East Side, where I got very into postmodern dance, especially of the contact improv variety. I took classes at Movement Research, religiously attended dance performances at the Judson Church, no matter how god-awful, and took part in weekly contact jams at PS 122 that my boyfriend at the time disparagingly referred to as "touch club." I was becoming increasingly dedicated, in dance and in writing, to immanence rather than transcendence—to specific bodies rather than "the body," to mantras such as "after the ecstasy, the laundry." Yet in my personal life, I remained drawn to charismatic people who knocked themselves out to have mystical, dramatic experiences. Often, this meant substances. One of my first boyfriends in New York—the guy who made fun of touch club—was a distinctly Lhasa-esque figure—larger than life, full of magic: the way we sat around drinking heavily steeped tea in his drafty Victorian at water's edge, talking about Kierkegaard and listening to early Dionne Warwick, the way he kept house (he too knew the rule about having one perfect iteration of each object), all reminded me of her. We even threw the I Ching. But his eyes were pinned, and his magic was dark. You can't always have one type of magic without the other, I know now. But you can learn to lean.

Another guy I hung around with for a while was a Montreal-based dancer with whom I had begun a lackluster threesome affair at a summer dance festival where he had been my teacher. After the festival, he maintained an interest in me, which was kind of flattering, and also kind of not; given our age differential, it was all a little typical. Not having anything better to do, and wanting to see Lhasa, I accepted his invitation to visit him in Montreal. I think I thought, since this guy was kind of a clown—literally—she might be impressed. We went to see her sing at a café, and it was my first time watching her perform with a musician, fully engaged with her audience. Not long later, she put out *La Llorona*, which promptly made her a star.

The attention was what she'd been angling for all along, but once it came, it freaked her out. A short time later, she left Montreal for France, to be, once again, with her sisters.

While she was in France, we exchanged letters. Someday I'll find them. They're no doubt sitting in a little white shed on my mother's property, along with the rest of my correspondence and diaries from age sixteen to thirty-three. I used to be someone who kept meticulous diaries, made collages and mixed tapes, wrote friends and lovers long letters, took Polaroids, and made poetry out of cut-up newspapers. Now I sit here in front of my Mac like everyone else, and hope that my thinking hasn't become as homogenized as my technology. If I were to bust out the rubber cement now, it would be performative nostalgia. I don't know if those modes of expression are unique to one's teens and twenties, or if magic has simply seeped from me. The older I get, the less open I feel to magic, or the less compelled I feel to make it or seek it. I don't know if this is has to do with sobriety, or depression, or happiness, or age.

I think I know what our letters were like, anyway. I know she told me all about the city of Marseille, the performances she was doing with her sisters' circus, and a failing love. I know they were written in her meticulous, upright printing in blue ink, with sketches of the city, and that face, in the margins.

By the time Lhasa visited me at the trapeze loft, she was done with France, and was touring her second album, *The Living Road*. She had performed in Park Slope a few nights earlier, and I had brought a writer friend to the show. This writer friend was unusually alive to magic, and I had wanted him to see and feel everything in her that I felt and saw, as if sharing the magic might make it grow. On stage that night Lhasa was generous, beatific, stunning. She knew it; I'd never seen her know it. I wouldn't have been shocked if she'd emerged from the green room afterward in furs.

After our tea at the loft, we walked around Williamsburg. It was freezing, so we had to hustle up and down Bedford to keep warm. I told her all about the book I had just finished, about the 1969 murder of my mother's sister. She told me all about a dress she had recently purchased for a music awards ceremony. It was clear that Lhasa's fame had exceeded, had perhaps even vaulted over, New York City, a place that was my everything, but that now seemed provincial in her presence. (This may be because New York City—and the United States in general—never received Lhasa as she was received elsewhere, perhaps due to our national tendency to dump all non-English singing into "world music." Someone even told me the other day that Apple Music had her listed under "soft rock.") I had never seen Lhasa excited about fashion before. It moved me, to hear her describe her dress. It was *so beautiful*, she said, her breath puffing white in the cold. *Like I wouldn't believe.*

And that was it. That was the last time I saw her.

I've been reading a lot of Thomas Bernhard lately, whose novels often feature a masculinized version of the Ferrante plot. There's often a genius figure—a dead man—around whom the narrator rotates: the narrator has to go through the dead man's papers, account for his last days, reckon with the friend's unfinished opus. Like Wittgenstein—an intimate player in Bernhard's universe—Bernhard acts as a kind of magician: by writing in and around inexpressible, unfinished genius, and by allowing his narrator to be a kind of doofus—someone who parses and perseverates—

Bernhard creates his own work of genius, that is, the novel we hold in our hands. I used to think, if I were a novelist, I might try for something of the same. I would write about someone like Lhasa, letting my narrator exhibit her own paucity of magic, her spiritual shallowness, her lack of charisma, her comparative cowardice, her defensive recourse to irony. The narrator would be the Freudian to her Jungian, the Beckett to her Joyce, the unbeliever to her faith, the average-looking to her beauty. Yet somehow the reader would come to appreciate the narrator as well. Neither would triumph. They could just be themselves.

For ten years I had imagined that, when her *New York Times* obituary said she'd battled cancer for two years, it meant that Lhasa had sought any and all means possible to stay alive. I had imagined that, all options finally exhausted, her huge family had rallied around her, with siblings and relatives flying in from all over the globe to be by her side. But Goodman's book told a different story. As Goodman tells it, after her diagnosis, Lhasa basically froze. "I need some time to think," she told people. For months and months, she took that time. No mastectomy. No chemo. No treatment, save special diets, and a visit to a Brazilian healer. "Lhasa remained guarded about her condition," Goodman writes. "She gave out very little information about her condition, even to her family. There were a few months when she wasn't even sharing her status with them." After a lifetime of seeking and embodying wisdom, Lhasa seemed lost. Those who advocated for treatment got shut out. Her friend Watson told Goodman: "We were not allowed to say goodbye. It leaves it raw."

Of course, Stage 3–4 is Stage 3–4; there's no telling what treatment would have mattered. But many people who loved her were angry. "I was mad at her," Watson told Goodman. "This vitamin C bullshit. I can respect romance and the bubble. But there's a time to call a spade a spade. Smarten up and go get chemo." Her last boyfriend put it a little differently: "I don't know if I would qualify it as denial. That wasn't the quality of it. She didn't quite spurn treatment—she reasonably approached Cancer Inc. the way she did everything, not taking it on gospel. And she definitely sought

alternative treatments. I think it was closer to being a personal and private struggle for her."

Upon learning all this, the shame I had felt about falling out of touch, and the anger I had felt about not having known she was sick, evaporated. In their place, I felt more tenderness for my friend than I ever thought possible.

The *Mahabharata* says: "Of all the world's wonders, which is the most wonderful? —That no man, though he sees others dying all around him, believes that he himself will die." To write about a dead person risks showcasing this error. It has a certain smugness to it, the smugness of the still-living. I wish I could stamp out this smugness as I write. But then I might also stamp out the wonder.

In one of my favorites of Lhasa's songs, "Is Anything Wrong?," she asks if time will make us wise. For the past few years, I've been literally praying for it to do so. I don't want to grow old, or older, with the same, festering neuroses that have tortured me, if not made me, this far. I want to abandon my habitual churning, the confines of my own bubble. For my own sake—and also for that of my son—I want to model a certain form of acceptance, a willingness to take life on life's terms. If time itself makes us wise, then I wouldn't have to *do* anything to achieve this acceptance. But that's not what the song says. The song asks a question.

Near the end of Goodman's book, I found the answer to what I somehow most needed to know. And that is that Lhasa's dying was hard. Very hard. Goodman describes her as being, at the end, blind, unable to walk, restless, unaware of what she was doing. He doesn't give any more details, and he never mentions pain. He just quotes her sister Gabby, one of the handful of people who was there to witness Lhasa's final decline: "I wish *like hell* that she had decided to end her life by her own choice several months earlier than go through what she went through. . . . I don't know if there is value in watching someone that you love suffer so horribly. I don't think there's value in it. And that's my takeaway."

I read these words in my dark office in the early morning hours, before the sun comes up, before anyone else is awake. As if it might evacuate their pain, I flip back to YouTube and mindlessly scroll the comments below her videos: "Now she twinkles high in the heavens like the star we already knew her to be," "She's in Heaven now, a welcome addition to a choir of angels," "R.I.P., my goddess." They say what I always wanted everyone to say, yet today I find them enraging. Lhasa *was* a star, an angel, a goddess, if there are such things. But she was also a goofy, struggling, often lonely human who, near the end, had apparently become fed up with certain of her stories, her bubble, and was looking for new ways. "I don't think she ever wanted to let go of the castles in the sky. And she was starting to," a friend told Goodman. Her last boyfriend echoed this assessment: "She was done with churning in her own solitary romantic sufferings. She was really done with that."

Was she done by April 2009, at that house party in Montreal, memorialized in the video by Vincent Moon? By June of that year she would start to get headaches, which would soon become seizures. The video pans over the hipsters lined up against the wall, squatting on the floor, all intently watching her body, and I think of all the eyes fixed on her during our All School Meetings. I want to break into the frame and protect her from all the prying eyes, all these voyeurs to her swan song. But I know by then she was a star, and could handle any crowd.

Awake again before dawn, I find that Goodman has sent me a new video, also from April 2009—it's another Vincent Moon piece, produced for the tenth anniversary of her death, containing rehearsal footage for a tour she would never take (for her last record, the self-titled *Lhasa*), along with snippets of an interview with her no one has ever seen. The video is dark, dark light in the dark of my office. Her face looks like it's struggling to emerge from the shadows; it unnerves me. At the video's end, she gives a long description of her song "Going In," in which two unborn souls— *deux amis*—are sitting on a ledge, discussing the pros and cons of jumping off a cliff, into life. The jump would be the moment of conception, of choosing to be born, no matter what's to come.

That story is familiar enough. But Lhasa's "going in" isn't just about choosing life despite its inevitable suffering. Her song's narrator—who, she makes clear, is also her—is going for "intentional blindness." "It's like I am choosing to dive into life and to lose my lucidity, to lose my wisdom, to be blinded by life. It's as if life were a sort of loss of vision. . . . That's somehow what it is." The narrator-friend tells the listening-friend that it's worth it to walk *away* from God, *away* from Truth, in exchange for a life spent seeking such things. "Just for the trip!," Lhasa laughs, impressed by her character's valiant idiocy.

(2022)

THE CALL

In Honor of Judith Butler

Let's face it. We're undone by each other. And if we're not,
we're missing something.
 —Judith Butler, *Precarious Life: The Powers of Mourning and Violence* (2004)

It starts with a call, a summons to common sense. We know the call is important because it gets its own paragraph. The subject is serious, but the call is casual. Like, *C'mon guys, just admit it. We're undone by each other—there's no use pretending otherwise.* It's also an invitation, in which case one might respond, *Yes, let's.* Is there a party waiting on the other side? (Kind of.)

And, so invited, we face the proposition. The essay in which the proposition nests ("Violence, Mourning, Politics") suggests that we treat the proposition itself as a face, in the Levinasian sense of the phrase ("The Levinasian face is not precisely or exclusively a human face, although it communicates what is human, what is precarious, what is injurable.") If the reader brings enough of her openness, her permeability, to the words and thoughts of others, she might be undone by what she faces.

I've turned toward and over "Let's face it. We're undone by each other. And if we're not, we're missing something" for over a decade now. Like a

289

shard of a beloved song, its fifteen words have, over time, become a part of me. At one point, I wrote that these lines were my own personal *Lasciate ogne speranza, voi ch'intrate* ("Abandon all hope, ye who enter here"), but then I took it back: it was too hard to explain what I meant. I didn't mean that "We're undone by each other" was a hopeless fact, welcoming us to hell. I meant what I think Butler meant, via "Let's," which is something like: I invite you to abandon the hope that we will *not* be undone by each other; I invite you to consider being undone by each other as neither a good thing nor a bad thing nor a static thing, but simply as something that happens; I invite you to consider that that undoneness can be devastating as well as exhilarating, and that neither sentiment means we have to chase after it or chase it away; I invite you to become one *who enters here*, wherein "here" means life, not hell, even if it can feel like hell (as grief and desire, Butler's two primary players, can).

So we've passed through the gates, we've accepted the invitation. We're facing it. But what, exactly, are we facing? What does "undone" mean?

There can be great pleasure in feeling "done." I know this pleasure well: I like to brush and part and tie my hair tight; I'm partial to top buttons. There can also be great pleasure in being, or beholding, an individuated, contained, self-sufficient unit coming apart upon contact with another; the physical undoneness is the (shaming, thrilling) mark of the encounter. ("That top button isn't fooling anyone," a friend tells Chelsea Hodson in her essay collection *Tonight I'm Someone Else*.)

And yet, as the specter of shame suggests, coming undone is not always desired or desirable. I brush and part and tie my hair tight because most of the time I *want* to appear—indeed, to feel—coherent, competent: nothing in my teeth, zipper up, well-chosen words coming easily out of my mouth, the marks of my despair or disrepair not involuntarily communicated. During the pandemic, I wore shoes and lipstick to every Zoom meeting, as a matter of preserving sanity and dignity; I desperately wanted—needed—what I presume many others wanted and needed, which was to keep the strewn Legos and dirty dishes and sociopathic dog

out of the frame. It didn't really help if a kind boss said, "It's okay, we like children!" I like children, too, and I like my own child very much. What I do not like is the impossible task of trying to parent and enact a professional, focused self at the same time, a task that can torment.

All of which is to say: it's easy to give lip service to the virtues of undoneness, and harder to accept its actual eruption in, and disruption of, our lives. This is especially so when it results from conditions that displease, surprise, or devastate us. This devastation is the primary subject of Butler's "Violence, Mourning, Politics"; its main exhibits are the violent wound of 9/11 and the speculative loss of a beloved.

In thinking about this unwanted devastation, I cannot help but think of my friend Christina Crosby, who repurposed Butler's phrase in the title of her 2016 book *A Body, Undone: Living On After Great Pain*, which deals with the ravages of spinal cord injury. As it happens, *Precarious Life* came out just months after Crosby broke her neck; as one of Crosby's stunned caregivers, I took Butler's examination of injury and injurability personally. (So did Crosby.) As a New Yorker who had also been stunned by 9/11 and its aftermath, I deeply needed Butler's meditation, as the vulnerability, loss, unmastery, and anxiety unloosed by that event were not theoretical, but agonizing and engulfing.

And there was more. By the time *Precarious Life* arrived, I had been thinking hard about injurability for some time, via writing a book (which would eventually become two books) about the murder of my aunt. Even (or especially) after years of thinking and writing about her death, I had become unsure as to what, if anything, remained to be known or said or gained from focusing so intently on sexualized female injury and injurability. Who needed the news, delivered, in this case, by two shots to the head and strangulation by pantyhose, of a woman's vulnerability to a man's murderous rage? It all felt so redundant, so "done." *Precarious Life* taught me otherwise. It provided a wider psychoanalytical, political, and even spiritual framework for absorbing and contemplating the various injuries before me, be they my aunt's, Crosby's, or my city's. No matter

how much I thought I knew—about wounding, about aggression, about justice, about mourning—Butler asked me, asked us, to know more, to think harder.

And so, as I headed off, in the summer of 2005, to the trial of the man accused of murdering my aunt, I kept *Precarious Life* close by my side. Its observations about grief and storytelling—"I tell a story about the relations I choose, only to expose, somewhere along the way, the way I am gripped and undone by those very relations. My narrative falters, as it must"—offered me not only insight and comfort, but also formal inspiration as to how one might allow narrative faltering to act as a powerful presence while one is trying to relay a story. (The working title of my courtroom book was *The End of the Story*, which eventually morphed into *The Red Parts*, a kind of in-joke with myself about my— and Christianity's—penchant for circling wounds.)

Crosby's *A Body, Undone* did not appear for another decade, but I still consider it a direct response to *Precarious Life*, especially to Butler's call to use the experience of being injured as an opportunity to think widely and generously about injurability. (Notably, Crosby's working title for *A Body, Undone* was *An Account of Myself*, echoing Butler's 2005 *Giving an Account of Oneself*.) The word "undone" appears three times in Crosby's book; each appearance tells us something about the phrase. Here is the first:

> Spinal cord injury has undone my body, bewildering me and thwarting my understanding. Yet I am certain about one thing—whatever chance I have at a good life, in all senses of that phrase, depends on my openness to the undoing wrought by spinal cord injury, because there is no return to an earlier life. I know that the life I live now depends on my day-by-day relations with others, as it did before, but to an incalculably greater extent. Now I need you to know from the inside, as it were, how it feels to be so radically changed. If I can show you, perhaps I'll be able to see, too.

The undoneness of Crosby's body is, as she makes clear in the passage prior to this one, a horror. This horror is not to be celebrated or overcome, Crosby insists, only borne, with great difficulty and sorrow. And yet Crosby also knows—indeed, she insists—that a livable life (another of Butler's important, abiding phrases) depends upon Crosby's openness to that undoing. It depends upon it because Crosby knows—as does Butler—that denial, disavowal, or fantasizing about the restoration of that which is irrevocably changed or gone are dead-end strategies that do not, in the long run, ameliorate pain. More often, they exacerbate it; they can also make one more likely to cause it for others. As Crosby's "If I can show you, perhaps I'll be able to see, too" suggests, writing (and reading)—if undertaken with requisite degrees of honesty and rigor— can counter this disavowal and denial. They can be a way of facing things.

Crosby's second use of the word arrives via a paraphrase of Elaine Scarry's *The Body in Pain* (1985), in which Crosby writes: "Crying, and screaming, and raging against pain are the sign of language undone." Language undone is, for Scarry, a hallmark of torture; Crosby, too, knows the threat of annihilation that great pain poses to language. Yet she perseveres, because she must: "I need you to know from the inside." To convey to another, in language, however imperfectly, the feeling of being undone, of having been undone, of falling into and out of the undone, is an act of survival. It insists on the possibility of communication and connection in the face of that which individuates, isolates, shatters. Butler shares in this project in "Violence, Mourning, Politics," albeit in a more philosophical idiom: the essay names no personal wound per se, but its anguished ambience, along with its copious, intimate deployment of "we" and "I," suggest that its author, too, has been brought up against the shoals: "Who am 'I,' without you? When we lose some of these ties by which we are constituted, we do not know who we are or what to do. On one level, I think I have lost 'you' only to discover that 'I' have gone missing as well."

Crosby's third and final use of the word arrives in a passage about the political activism of her youth: "I reserved my conviction that patriarchy could only be undone by radical feminists." This use is more pedestrian,

but it matters. It matters because it reminds us that "undoing"—for Crosby, for Butler, and for so many others—bears a relation to dismantling unjust systems that decrease the possibility of livable lives. That we're undone by injury; that we're undone by great pain; that we're undone in love; that we're undone in grief: these are the pains wrought by impermanence, which is a precondition for change. If we can't learn how to be open to undoneness—or if we are willing to be open to it only when we feel sure that the coming changes will lead to what we want, or away from pain—we risk not being open to any change at all. We may also miss out on the opportunity to train in "agreeing to undergo a transformation (perhaps one should say *submitting* to a transformation) the full result of which one cannot know in advance," which is how Butler describes mourning, but which could just as easily describe political and social upheaval of many kinds.

Undoing entrenched systems that we are deeply accustomed to—indeed, *abolishing* them—can create tremendous anxiety and destabilization, even for those who feel sure those systems need to go. Taking the leap toward a future undisciplined by a gender binary, or unstructured by carceral punishment, or independent of fossil fuels (to take but a few examples) requires, and will continue to require, courage from us all. Yes, we need plans and analyses, but we also need to be able to bear *not knowing* in advance the full result of our actions and desires, and we need to learn how to support each other through this not knowing, which will be—let's face it—unending. Butler's wise and compassionate mapping of this challenge struck me then, and strikes me now, as supremely important—certainly as important as the more combative rallying cries that come in at higher volume.

So those are a few aspects of undoing. But questions remain. If this undoing is so inevitable—if it's something that simply *is*, whether we like it or not—what can/does Butler mean by "And if we're not [undone by each other], we're missing something"? This is a tricky turn, as it reintroduces the possibility (and power) of denial, of disavowal. It allows for the possibility of *not* being undone by one another—the self staying brushed and tight and tied, dismissive of or insensate to its various dependencies and

enmeshments, unable or unwilling to accept life's motley penetrations and precarities. What's more, Butler casts these phenomena as something that can be missed: missed, as in not apprehended, but also missed, as in occasioning a new form of loss or lack. It would seem that, even if our undoing by one another simply *is*, there still exists the possibility of missing it. If we don't want to miss it, or miss out on it, we might have to do something. As is the case in most spiritual traditions, that something involves a paradox by which one is asked to accept, or surrender to, or open oneself up to, that which is already upon us or surrounds us or even *is* us (call it what you wish).

I love this line of thinking. And yet I must admit: the recovering codependent in me has awoken. Certain twelve-step knowledge systems encourage a practice and philosophy of not allowing the behaviors, struggles, thoughts, and feelings of others (alcoholics in one's life, most pointedly, but the teachings apply broadly) to undo you. For those of us accustomed to feeling undone by others on the regular, learning the arts of individuation, detachment, and boundaries can be absolutely key to the development of more livable lives. As Al-Anon literature has it: "Detachment is essential to any healthy relationship between people. . . . Simply put, detachment means to separate ourselves emotionally and spiritually from other people. . . . [Detachment] does not mean detaching ourselves, and our love and compassion. . . . [It means realizing that] we are individuals . . . not bound morally to shoulder the alcoholic's responsibilities."

Realizing that we are individuals? Not bound to shoulder the responsibilities of others? This doesn't sound very Levinasian, nor does it sound exactly simpatico with the imbrication Butler lays out in "I think I have lost 'you' only to discover that 'I' have gone missing as well."

My ears may be pricked, but, upon close reading and rereading, I can see that Butler knows that our enmeshment with one another isn't all one thing or another, that our capacity to undo each other, to feel unsure of our borders, doesn't wash away the need for independence or autonomy. Far from it. "We are something other than 'autonomous' in such a condition, but that does not mean that we are merged or without boundaries,"

Butler writes in *Precarious Life* (phew!). And so, as we bear down on "Let's face it. We're undone by each other. And if we're not, we're missing something," I hear a new question. What if, when we're undone by each other, we are also missing something—a necessary boundary, a healthy (if wavering) distinction between self and other that isn't ontologically precise or total per se, but that makes possible certain forms of self-protection, self-knowledge, and self-care, all of which can play a crucial role in our flourishing? If we're missing something both when we're undone by each other and when we're not, might we be better off accepting a certain rocking in between, a flickering that characterizes both love and mourning? A detachment that connects, that makes relation possible, even as it distinguishes and (superficially) separates?

I suspect Butler would have some choice things to say about the "self" here conjured (see, for example, the analysis of self-defense in 2020's *The Force of Nonviolence*: "to understand [the claim of self-defense], we would need to know who the 'self' is—its territorial limits and boundaries, its constitutive ties"). Nonetheless, despite the decisiveness of "And if we're not, we're missing something," these lines unsettle and open as much as they assert and resolve. They wouldn't have stayed with me all these years if they didn't weave, or accompany me, in and out of clarity and bewilderment.

Butler is unafraid of that weave, as the opening pages of *Precarious Life* make clear. After speaking lucidly in somewhat familiar academic terms about the hope that our "inevitable interdependency" might become "a basis for global political community," Butler swerves: "I confess to not knowing how to theorize that interdependency." This charming admission underscores the value Butler finds not just in not knowing, but also in publicly confessing to not knowing. We know some things, or we think we know some things, and then we are humbled, and we realize how little we knew. We push into our thought and find its limit, then leave it by the side of the road for another to pick up and take for a ride. We come together, we fall apart. We merge, we separate. We attach, we detach. We produce and present ourselves, we lose ourselves. We button and unbutton, various facets of our lives veering in and out of the frame.

Again and again, we set out to relate to others—indeed, to love them—even as we remain bewildered much of the time as to who or what they are, who and what we are to them, who or what we are together. As Butler writes with some measure of tragicomedy in *The Force of Nonviolence*:

> I love you, but you are already me, carrying the burden of my unrepaired past, my deprivation and my destructiveness. And I am doubtless that for you, taking the brunt of punishment for what you never received; we are for one another already faulty substitutions for irreversible pasts, neither one of us ever really getting past the desire to repair what cannot be repaired. And yet here we are, hopefully sharing a decent glass of wine.

This last line is a fun affective change from the solemnity of *Precarious Life*; maybe it's even the party that was promised! It's like—or I'm like—okay, I took you up on your 2004 invitation to face it; now it's 2022, and I've been facing it, yet everything remains a mess. I tried to figure out who you are, who I am, who we are to each other, who is responsible for what, where we begin and end, how to repair what can be repaired (and live with all that cannot), how not to punish each other or project onto each other (unduly), how to handle all the aggression and disappointment our interrelation arouses, how to mourn you. And I still haven't figured it out! And now you're retiring! And even if I wanted to share that decent glass of wine with you, I don't drink! What on earth are we—what am I—going to do now?

I confess to not knowing, and stand before you with imaginary glass raised, grateful to be one of the many who have answered the call, to be where we are.

(2022)

THE INOCULATION

On Dani and Sheilah ReStack's *Feral Domestic* Trilogy

Dani and Sheilah talk about "calling people in" so that they don't feel so alone, so that they feel buoyed by the bravery of others; they talk about wanting, needing to feel understood, guided, seen. They didn't say all this to me, or not exactly—these are my words. They called me in for my words. I didn't know them, but I answered anyway. Sometimes people call and you find a drooling bear at the door. Other times you open the door and find that the caller's already out in the field, beckoning—Hey, we've crossed this river, do you want to see what we've found? Yeah, I do.

I'm writing this in clumps because their writing came to me in clumps, and I think of their images as coming in clumps too. A clump isn't a stack because it's not vertical. The way I think of a clump, all the parts are touching. And clumps are messy, related to body and earth. Clumps of hair, clumps of blood and mud. A clump has to stick together, otherwise it's no longer a clump.

When I think about clumps, I think about conception and gestation and abortion—you know, clumps of cells that some call a life. Dani and Sheilah made a video trilogy about, among other things, what it means to call something into life, what it means to attend to the lives we're already in, how to respond to the elements we're made of and in which we find

ourselves. Sheilah says the trilogy was supposed to end in a conception; instead, it bears witness to disagreement and disappointment, along with a lot of beauty and water and blood. She kicks that metal pot down the road like a big "fuck you" to a thing that won't hold. Its counterpoint is rock: rocks don't leak. Is a rock alive? And how does their camera change how we feel about that.

Dani and Sheilah wonder whether making art helps you to feel more, to go further into your feeling, or whether it staves off feeling, distances you from it. It seems clear that it can do both. It all depends on whose feelings, and what feelings, we're talking about. Making an image can distance the maker from a feeling she's having in the moment in order to give a feeling to a viewer later, or for the maker to contemplate later. The maker may feel fascinated, but the viewer feels repulsed. The maker may feel high seriousness, but the image gives off camp. Or vice versa. In the case of Dani and Sheilah, there isn't only one maker (and there's never only one viewer), so there are a lot of feelings to go around. We know that they agreed on the images they included, but we aren't always sure they *mean* them in the same way. That tension is exciting, like a Neapolitan sandwich in which the viewer gets a stripe.

Often they stage something like an argument, whether it's via avatars on the phone debating whether to have a kid, or in interviews in which they say things like "I disagree" or "I gotta jump in," or on camera, when they pummel each other to the *Kill Bill* soundtrack. Sheilah has said the videos were a chance to see who had the better argument about bringing another kid into a damaged world. But the viewer isn't tracking arguments. The viewer is feeling. The viewer is feeling the overlapping but distinct orientations toward the world that the artists seem to want very much to convey to each other and to us. It feels like they get so much about each other that the things they don't get threaten to become chasms. This is not uncommon. One of these orientations might be "Some of us stay busy with the work of ordinary devotion/resilience/triage/sustenance while others luxuriate in despair"; another might be "If you don't feel despair you're not facing reality." The first prioritizes amelioration; the second hopes

to obviate pain by confronting it. "You can't get around hurting people," says one of their avatars, a line that, in its context, is part of an argument as to why its speaker doesn't want to have a child. Freed from its context, however, it offers no obvious prescription for our choices or behavior. It could just as well be followed up by something like "and since that's an inevitable part of our being in relation, we must accept it and develop robust practices of accountability and repair." The trilogy plucks both strings to make a chord.

"Use artifice to strip artifice of artifice" is a phrase Eileen Myles taught me (I know now that it comes from filmmaker Carl Dreyer). I don't know if Dani and Sheilah know this phrase but their work knows it. They bevel "honesty" with artifice—going so far as to discuss the term and its relation to art on camera—but they never wink at it. In *Future From Inside*, they sit up in bed together, entwined, and Dani says, "You were bringing up something important: that you're not going to blame me forever about it," and Sheilah, distracted by her phone—which is filming them that very moment—responds, "I'm just looking at our video." They know that anything they have to tell us about honesty and grievance and aggression and forgiveness in a piece of art will already be thick with artifice, so they go headlong into that sluice.

Dani and Sheilah have said that their trilogy was supposed to be about healing, but it didn't end up that way. Something different happened. This seems right—in the making, the plan never holds, but rather reveals itself to have been a pretext for opening up to things we could not foresee. Opening up is different from healing. It's not better or worse. It's just different. And here we might note that each of the videos features a foundational opening, or penetration. In *Strangely Ordinary, This Devotion*, it's the slicing of Dani's head; in *Come Coyote*, it's the insemination; in *Future From Inside*, it's the eye-drop ritual. These scenes have the power to evoke (at least in this viewer) some ugly memories, from head stitches to various misadventures in gynecology. But they also evoke many not-so-ugly, even joyful things, like making a baby, having sex, waking up, making art, giving birth, practicing magic. And so we find ourselves in a bumpy

symphony of opening and leaking and wounding and inserting and in-corporating and stitching and holding—activities revealed by the film-makers to be *a family affair.*

And a bloody one. In addition to a mosaic of head wounds, from the slit in Dani's head to the bloody bandages around the head of the father in *Purple Rain* (a film sampled in *Strangely Ordinary*) to the blood pooling under Dani's head after Sheilah smashes it against a rock, there's period blood, vomiting blood, blood swirling in water, and that damn cat with a bloody twig in lieu of an ear. Some of this bloodletting is "natural" (men-struation, illness), some is the result of injury (self-inflicted, ritualized, and/or inflicted by others); some "real," some overtly artificial. Of all the dangers here conjured, however, there is one threat that never makes it onscreen: that posed by the misogynists and patriarchs and homophobes who stand, as they have long stood, ready to punish, hurt, and prohibit the lesbian world-making to which Dani and Sheilah here pay homage, and enact. I'm glad these forces get no presence in the work—really, why bother?—but given the moment we're in, I find it hard to banish them from my mind entirely. Just this morning I heard a well-known white su-premacist in Idaho extolling (in what is now approaching a mainstream program) what he feels sure will follow the overturning of *Roe v. Wade*: "They're gonna ban sodomy! They're gonna ban gay marriage! They're gonna throw gays off roofs! Women lose, God wins. Christ wins. We shall have our theocracy soon."

Which brings us to the inoculation.

In March 2021, I wept with gratitude as I hung my left arm out my car window and a young man in army fatigues said, "Hello ma'am, my name is Harvey, and I'll be vaccinating you against COVID-19 today." Lots of people were understandably like, "What's the big deal? It's just a little prick. Just go get the fucking shot"—but to me it felt like a big deal, to drive to this megasite and trust young Harvey to inject me with a novel vaccine for a novel virus, especially a shot that would, twelve hours later, render me unable to bear light or walk across the room. In the weeks and

months that followed, my partner and I joked from time to time about how funny it would be if, ten years down the line, we discovered that we HAD been microchipped. Don't worry, we know we weren't—but our joke spoke to the kernel of anxiety and awe we felt about the fact that we'd chosen to trust, despite all our related distrusts (of government, of Big Pharma, of young men in army fatigues). Our trust may have been à la carte and well-reasoned (*we want to live!*), but it still felt extraordinary to join with hundreds of other trusting bodies, our arms hanging out of our windows, all of us prepared to take an unknown substance into our muscle mass in service of our conjoined survival. This felt markedly different from showing up at a protest, organizing in a basement, donating money, or writing books. It felt different because it pierced us.

I don't know when *Future From Inside* was made, in relation to the pandemic—I know Dani and Sheilah were working on it in 2020, and the video is dated 2022, so it's possible they had all this in mind when they conceived its drops-of-glacier-water-into-eyes finale. Or maybe it was just prescient. Either way, it has felt meaningful to me to watch it during this time. It's as if they created this parallel theater of inoculation in which we get to contemplate what it means, or what it could mean, to be penetrated together, and in service of what. Within the narrative of the video, the volunteers are becoming people who can live in a world without water (I think!). But mostly it looks like a bunch of women having a good time, participating in a ritual of waking each other up. Drop after drop, waking each other up. We presume it's just water, that no harm is being done, but it's still hard to watch, since the eye is so vulnerable, and we feel kinesthetic sympathy with the open eyes anticipating the drop, and then with the wincing, blinking, absorbing. Is this a hazing? The creation of a new species? An alteration of the code?

I'm writing this at the start of a new era in the United States, an era we will call "post-*Roe*." Among the many things this new era will make excruciatingly clear is that you can't have everything. If you choose to prioritize clumps of cells and embryos and fetuses over the bodies and lives of the people who house them, you're choosing to wage war against pregnant

people. This war will be waged—is already being waged—through neighbors turned against each other, courtrooms, jail cells, terror, and bloodshed. Some actively want that war ("Women lose, God wins"); others buy into the fantasy that it can be made gentle. Perhaps they think that it can be made gentle because we will eventually be tamed and drained and put back in our place —that, by choice or by force, we will relinquish our autonomy and submit to their regime. They are wrong. We will echolocate and inoculate, we will build worlds that hold. We will nourish each other with our devotion, invention, and friendship, even as we know we can't get around hurting others and being hurt. We will animate the network of fungal glitter under our feet, communicating our warnings and our bravery. I will listen closely for transmissions from Dani and Sheilah. I will watch what they choose to show me, laugh with them at a dog chewing on a strap-on, stand up for our queer families, search with them for that sliver of moon in a smeary daytime sky. I will follow their bear across the river.

(2022)

FOR WHO KNOWS HOW LONG

On Ari Marcopoulos's *Zines*

In the early days of the pandemic, some of the European philosophers I'd been reading all my adult life suddenly revealed themselves to be sublunary humans quarrelling in online forums. Giorgio Agamben raged against governmental restrictions in Italy, comparing them to Nazi Germany, asking, "What do human relationships become in a country that habituates itself to live in this way for who knows how long? And what is a society that has no value other than survival?"; Jean-Luc Nancy replied with a tender, cutting, and surprisingly personal anecdote: "Giorgio is an old friend. . . . Almost thirty years ago doctors decided that I needed a heart transplant. Giorgio was one of the very few who advised me not to listen to them. If I had followed his advice I would have probably died soon enough. It is possible to make a mistake"; Slavoj Žižek made the point that stances such as Agamben's, which treat solidarity as dependent upon physical intimacy and full-faced encounters, were missing the paradox of the moment, which was that "not to shake hands and to go into isolation when needed IS today's form of solidarity." Reading these back-and-forths was distressing, but also invigorating: it reminded me that philosophers do not come down from on high to offer measured, insightful takes on our chaotic situation, but rather are flesh and blood humans dropped into their lives and times, grappling with their own bodies and mortality, rich with their

own reactivities to questions of solidarity, sociality, governmentality, and freedom.

Looking at Ari Marcopoulos's zines from 2015 to 2021 brought me back to that moment—that feeling that a wide cast of characters, some well known, some less so, some not at all—have been plunged, are now together plunging, in and through this riotous time, flush with a shared bewilderment and humanity. Marcopoulos is here, his partner Kara Walker is here, his neighbors are here, various friends and strangers and family members are here, celebrities are here, pop culture is here, art is here. The news is here, trees are here, history is here. Doctor Vitt is here, June Leaf is here, the mailman is here, Jay-Z is here. (As others have noted, in Marcopoulos's photos, the famous often feel less so; the not-famous, exceptional.) So here we all are, trying to find ways to be together, to transform Agamben's question "What do human relationships become in a country that habituates itself to live in this way for who knows how long?" from rhetorical protest to vital challenge.

In such a context, Marcopoulos's signature date stamp—a digital readout on each photo memorializing the date it was taken—gains new meaning. Rather than signaling happenstance or a conceptual tradition, the stamps offer a collective accounting of certain shared stations of the cross (namely, though not exclusively: June 2015, Trump declares his candidacy; November 2016, Trump is elected president; March 2020, COVID-19 hits; May 2020, George Floyd is murdered; summer 2020, the people rise up; November 2020, Biden is elected; December 2020, mass vaccination begins; January 2021, the US Capitol is attacked; and so on). At times this accounting becomes meta, as in the photographs of *Remains Board*, a gigantic red digital clock installed on the waterfront of Matthew Barney's studio in Long Island City that counted down the days, hours, and minutes remaining in Trump's term, or in the photographs of the *New York Times* announcing milestones such as "U.S. Deaths Near 100,000, An Incalculable Loss," or "Officer Charged with Murder as Minneapolis Calls for Calm." The date stamps help us to make sense of why the subjects are

or are not wearing masks, why it's a makeshift bandanna or an N95; they let us know whether we need worry about the size of the gathering or the intimacy of the embrace depicted, whether Robert E. Lee is still mounted atop his marble base, whether Breonna Taylor has yet to be murdered in her home.

As befits the times, the mood is often dark. Even a great picture of Hilton Als getting a haircut feels foreboding: its stamp reads 2.17.20—we know what's coming; he does not. Attempts at cheer and care, such as the "This Too Shall Pass/Stay Healthy" sign posted outside Sandy's Fine Food Emporium—pineapple logo and "Since 1952" included—have that sad aura of dashed optimism we've all come to know well. And yet, taken in aggregate, the photos testify to the abiding, sustaining power of relationships of all kinds, and our inventiveness in forging them. We watch people set up folding chairs to visit with one another on the street; we watch them visiting each other's studios with their faces variously swaddled; we see masked kids celebrating a graduation ("Straight Outta 8th Grade"); we see a variety of masked folks smiling at Marcopoulos's camera, their beam still miraculously detectible.

We also get to witness the developing relationship between Marcopoulos and Walker, which began when this series began, in 2015. In addition to goofy and often lovely photos of Walker in intimate settings (joking around on the couch with her daughter, eating from a bowl in bed while draped in a blanket), there are also many, many photos of Walker at work. And by "at work," I don't just mean perched on a ladder with paintbrush in hand, though there are plenty of those too. I mean photos that bear witness to Walker bearing witness to the news, places, objects, people. Whether she is contemplating an image of Yoda on a box of *Star Wars* cereal in a store, posing next to a real estate sign offering the proverbial forty acres, or attending a family reunion in Stone Mountain, Georgia, we sense that everything she is touching and seeing will feed, somehow, into her formidable body of work. The photos thus gift us a record of someone known for making art about history inhabiting history in real

time. Meanwhile, the photos also serve as a portrait of Marcopoulos at work, as each image becomes a part of his decades-long practice of immersing, observing, capturing, and presenting.

Walker's sculptural works—such as *A Subtlety, or the Marvelous Sugar Baby* (2014) or *Fons Americanus* (2019)—construct megamonuments that talk back to monuments of (racist) history. In contrast, Marcopoulos attends—in form and content—to detritus, ephemera, the faded, degraded, and embodied inheritances of history, racist and otherwise. (His 2016 zine *Rome* fittingly opens with ruins—or, more accurately, with photos of photos of ruins—juxtaposed with photos of blue tarps and construction buckets, tree roots cracking through asphalt.) Marcopoulos captures peeling relics of racist pasts—leftover marquees for *Gone with the Wind*, old signs from South Africa announcing WHITE AREA/ BLANKE GEBEID—as well as mundane signifiers from the present, such as a GMC truck with Confederate flag plates parked at a lube shop. At times, the story he's telling feels carried—literally worn—by T-shirts: *Keep Your Eyes Open*; *Black Lives Matter*; *The Free Black Women's Library*; *It's a Southern Thing/Some People Don't Understand*.

Most of what we learn about Marcopoulos comes via the rhythm of his attention, but a few of the photos—namely, the ones that pair superficially disparate cultural objects—seem to speak more directly, even if their message remains open-ended. I'm thinking in particular of the photo of two monographs placed side by side—one on Théodore Géricault's *The Raft of the Medusa*, the other on Edward Kienholz's *Five Car Stud*. The combination gestures toward Walker's work, in that both *The Raft of the Medusa* and *Five Car Stud* depict complex structures of white and Black bodies engaged in suffering and violence (in *The Raft*, starvation, cannibalism, murder; in *Five Car Stud*, the violent castration of a Black man by a group of white racists). Marcopoulos doesn't go in for grotesquerie or spectacle, however—he gives us only the covers. It's as if he's saying, "Here are a couple of things I found together, or put together; I hereby present them to you, unopened, for you to ponder." And ponder I did. I thought about Géricault's and Kienholz's relationship, as white artists,

to Black figures, to historical violence, to antiracist protest, to abolition-
ist politics (and, by extension, about Marcopoulos's relationship to the
same). I thought about what it's like to live intimately with another artist,
wherein their concerns and obsessions (and libraries) flow into yours with-
out ever becoming synonymous—there is always that gap, that differ-
ence. I think about the chasm—and the connections—between 1818–19
(the year of *The Raft*) and 1969 (the year of *Five Car Stud*), about how
traditions as distinct as "French Romanticism" and "1960s installation
art" are linked by legacies of imperialism and racism, how the two works
offer distinct but related treatments of age-old questions about composi-
tion and the representation of atrocity. (I had similar thoughts when mus-
ing on Marcopoulos's photo of the books *Vietnam and Black America:
An Anthology of Protest and Resistance* and Fernando Pessoa's *The Book of
Disquiet*, propped up side by side in a dusty window.)

Such combinations feel portentous and provisional, and give me a great
deal of pleasure. Part of that pleasure comes from the sense, underscored
by the informal quality of Marcopoulos's work, that art, literature, ideas,
and politics all issue from—indeed, are often indistinguishable from—
sleeping, dancing, stoop sitting, lounging, eating, playing the guitar,
talking, or just sitting at one's desk in a purple flowered shirt, putting a
few marks on paper. I also take pleasure in the handful of appearances
that Marcopoulos himself makes in his photos—my favorite of these is
the one dated 7.12.20, in which Marcopoulos's pale face and torso shim-
mer into view through a window, his form dappled by the reflection of
branches and leaves, bearing an uncanny resemblance to any number of
white-bearded men painted by Rembrandt. Such an evocation is not, I
don't think, accidental: though he works—or because he works—so in-
sistently in the low-fi medium of photography and zines, Marcopoulos
creates a space from which we can contemplate what aggressively casual
forms of contemporary art might have in common with more august me-
diums from the past.

When Agamben asked what becomes of human relationships "in a coun-
try that habituates itself to live in this way for who knows how long," he

was talking about Italy, and about COVID. But it's worth asking the same question of the United States—not about COVID per se, but about the racial injustice and violence we have lived with and suffered from, for who knows how long. There are many depressing answers to this question, especially when it comes to interracial relationships. Marcopoulos's photos from the past six years tell a different story. They depict moving scenes of intergenerational and interracial love and support, including between parents and children, employees and customers, the living and the dead, artists, neighbors, friends, and lovers, including Marcopoulos and Walker themselves. They conjure a world in which Black sociality and culture feel primary, while wagering that others are welcome to contribute, witness, and play. If one answer to "what becomes of human relationships" during this deeply painful, deeply disruptive time can be found in this patient, democratized, often joyous record—well, that's the best news I've heard in some time.

(2023)

AND WITH TREES

Conversation with Eileen Myles

MAGGIE NELSON: I was so happy to see the article in the *New York Times* the other day.

EILEEN MYLES: Oh, yeah.

MN: What did you think?

EM: I mean I'm so sick of the public account of who I am. It's not like I think I'm a household name, but those same details have been trotted out so many times—it's like sitting through a boring introduction of yourself at a reading.

MN: Did you want it to be more about the issue at hand? Because I felt mixed, like, I see that they're running the same career narrative of you that they've run before, but now they're running it through the question of why Eileen cares so much about the trees. I liked reading it, but I get why it might have seemed boring to you.

This conversation with poet, novelist, and art journalist Eileen Myles was conducted over Zoom, then transcribed and edited for publication in an issue of *Women's Studies* devoted to Myles's work. The "caring about the trees" referenced here has to do with the activist campaign in which Myles has been involved to save Manhattan's East River Park—along with its 991 trees—from demolition.

EM: Instead of Why Eileen cares about the trees why doesn't the *New York Times* care about the trees? I mean *in New York*. Because you waited a fucking year for most of the trees to be cut down before you covered this.

MN: Did they approach you about the piece?

EM: Alex, the writer, started showing up at our events and he was nice and immediately was very excited about profiling me *through* this. I felt a little embarrassed is all, because *this*, the fact of the city's total demolition of our green space, is the thing that's really important.

MN: Well, I get all that, I can see all that. Then, of course, as your friend, I was just like, Yay, what a beautiful picture of Eileen hugging a tree for us to immediately put on our refrigerator.

EM: Oh, sweet. I like being on your refrigerator.

MN: To talk to you today, I reread *For Now*, which I really love. And it was interesting because you told me that for this conversation you wanted to talk about time—and then in the *New York Times* piece you talk about how one needs time if one's going to get arrested, time to waste. And in *For Now* you say that you don't consider literature a moral project, save in its capacity to waste time. I love that.

EM: Yeah.

MN: But also, I would just say that, again, while I understand the badness of the *New York Times* approach to the trees, since I've known you for a long time, it was interesting to me to hear this new, updated recitation of your life—like, when I met you, you were like, "I've lived in this neighborhood for twenty years." And now you're like, "I've lived in this neighborhood for forty-four years." It gives me this feeling of tumbling through time with you, and getting to see you tumble through time.

EM: Right, right.

MN: Writing about time through time. And I thought, wow, what an honor for me to have heard you thinking about time for the past thirty years. You know what I'm saying.

EM: Yeah. A thing that's weird about time is there's this inclination to be making a judgment about it, like is it a good thing? Whether it's living in a space for twenty years, then forty years, then fifty years. Is that good or is that bad? How do you feel about it? How do you feel about me? How do *you* feel about time? The thing that's so great is it doesn't matter what we think or say, it's just constant movement. I think probably the thing that was so disturbing about what happened in the park was the trees are that too. They're this incredibly beautiful collective austere rendition of time that we live among and around. And a park is one of the many studios of the writer. For me that's always been one of the puzzles about what we are and what we do, Where is that place? It does and it doesn't exist, because it's language, but it camps out in the world in all these various places, and there are some places that are more conducive to that camping out than others. In some parts of your life, it's a bar, in some parts of your life, it's a lover's apartment, and in some parts of your life, it's a mountain, a beach, a park. But all these places, they're holy, because that's what held you while you did some part of the work.

MN: In *For Now*, at the very start, you talk about the way you've amassed various philosophies, but the point is to be here in the present. And then you talk about writing as a technology for that. And I wonder . . . like, I believe in that, philosophically . . .

EM: Uh-huh. [*laughs*] I'm very excited by this hesitance.

MN: I guess in my lived experience of writing, writing has become much weirder, maybe less "present," over time. When I was younger, it felt like I was really inhabiting the present by scribing—scribing felt like a way of being there, being here, more thoroughly. I don't feel so sure about that anymore. I think a lot of us begin writing as a way of getting privacy, and feeling free, and feeling alone. And then, the more books you write, the

more intense the struggle becomes to play dumb that you're not writing this for public consumption in the future. There's something about that playing dumb process that takes me out of time, because there's always this other time, the postpublication time, the other-people's-eyes-on-it time, that you're spending energy keeping at bay in order to be present with the writing in the now. This could just be a parable for the difficulty of being in the present in general. But I find it all deepening in challenge and complexity as I go along.

EM: Yeah, I feel like success is like a shitty edifice. It really becomes such a place that's so antithetical. I love what you were saying about playing dumb, you kind of have to do that. Like here, in the situation I'm in, which is a residency, where a number of people applied to work with me and be mentored by me. I hate that language, because I feel like I came from such a kind of a casual place where, you know, you and I are friends. We came from friendship. I would never say, Oh Maggie, I mentored Maggie. You know, it's like, no. But, nonetheless, here in this residency we do this collective writing, which is my favorite thing. We occupy these spaces here and we agree on silence. I think you went to the Radar retreat. Did you do that?

MN: Yes, that was the best part, the silent hours of writing in the morning.

EM: That's where I got the idea. I was like, oh, we don't need to be apart, we need to be in agreement. And that agreement is so sweet. For me, its roots have to do with being in church, and then, later in life, in Buddhist meditation, where something makes us sit together silently, and to get to a place where writing does that is such a gift. But, nonetheless, they are all making new work. I realize that continually what *I'm* doing is rewriting something. Something that didn't go here and should go there is getting tweaked, or oh, I have to look at that again. A novel that I wrote in the '90s (that I didn't publish) is hopefully being installed into a larger novel structure that I'm working on now, so that I'm having to look at my back-pages. I probably haven't reread it enough so I haven't crossed over into understanding it *is* my writing. It feels other. I just want to run and

screech into the present and future dark and write something new. I do do that once in a while, but it feels perfunctory because the larger structures are shaking and calling to me. Even the larger structure of time—meaning that I keep wanting to be vague about my age now. Not because I'm shy about being seventy-two, but I just would rather be saying something like, "well I've been here for a while." Like a stray dog that came into the shelter. Well we think it's about six but we don't know. I like that because the specific fact of time means that I probably only get to work on so much, and so I feel quietly crushed by some of those structures.

MN: And do you feel like the rewriting, instead of the writing off into the new, is it because it feels like there are agitating problems that are asking you to figure them out, that have to do with larger structures?

EM: I think there's probably midpoints in making books, right? Where you feel like there's a part where you're just writing. Definitely, a couple of years ago, I was writing a lot. And, here and there, I'm writing. In fact, I was writing something this week that's part of it. I guess with working with earlier material that I'm fitting into something larger for a long while I might be working with a bad idea. That's very uncomfortable. Sometimes it's not even writing. It's waiting. So it's not that I don't like editing, I think I'm just super aware of the pleasure that these guys [at the residency] are having, of not knowing where this is going but doing it. Writing over time does become more conceptual. You're in the distance. I think that part of the struggle when you have a career is that that is the open space you're trying to find, on some level.

MN: I feel like the small amounts of writing that I've done in the past several months, I can only do them by opening the file and then saving it and shutting it and never looking at it again. It's like I'm taking private turds and then burying them, and I actually feel phobic about ever looking at the pile. I used to get really excited, when I was younger, to write at night and behold all I'd written the next morning. But at the moment, it's like I need to keep it so dumb that it's actually literally dumb, it's not speaking, it's entombed or something. Maybe this is just a normal feeling you get

after the public exposure of a book—you're tired of dealing with what the world, from intimate to not intimate people, have to say, you're struggling to recreate this private space, even if you know it's kind of a ruse.

EM: Well, it's interesting because you think about those writers who used to seem inexplicable, like J. D. Salinger. Maybe he stopped writing, but he definitely stopped being J. D. Salinger. There's a way in which that's appealing. I definitely think that, because I'm trying to write something big now, which I feel like only strikes fear in the hearts of editors and agents.

MN: Whatever it is it's going to be huge—

EM: —and problematic, and too expensive. And what if it sucks? There's so many questions about it, and yet for some reason that's what I've decided to do with this moment in time.

MN: That sounds great.

EM: It is when I'm deep in the pleasure of being lost in it. But, actually, the most fun part lately was being with these younger writers, I managed to create feigned dumbness. There was a book I was kind of obsessed with that I read a year ago, a nonfiction book that I wanted to use for this book. I underlined like crazy, and all year it was propped out waiting to be done, I was going to have to type up those underlines and see what this all added up to. Normally if I'm writing a piece that would be my process. So, though it is my book, it's the same deal. So, I finally got around to that but I was doing it around these other writers. And I was transcribing by hand, so I was sitting there with legal pads, writing in a scrivener-like way. Again very excited about wasting time. I just was trying to drag it out and make it as bodily as possible, that was the only way. I was pretending to write to be with them. Kinda. But the thing that started to happen was that I started to go off in journalistic, diaristic ways about what was going on in the room and out the window and in my head and in my other reading. And I thought oh my god, I think it's becoming a

piece. That was not the plan at all, but something started to happen. I feel like the present sort of stole me in a way. And that was exciting. I finished typing it last night, and of course I go in and out of thinking this sucks, this is not anything but no it is something. Because the real wants you, in some way. And what's funny is that the real has come to mean the real fact of actually nakedly writing.

MN: This is a different subject, but I've been thinking a lot during the pandemic about the everyday and magic. I was rereading Joseph Cornell's diaries, and he would go out around New York hunting for what he called the "spark." The spark was in a poster of a starlet or something he saw in the garbage or whatever. When I came to New York, your poetry and your teachings all seemed to be about how to go out hunting for the spark. This sounds clichéd, but after the everydayness of being mostly in the house for eighteen months of pandemic time, the spark became pretty hard to find. To find magic, do you need to go outside? Was it in other people? Was it in contingency? Thoreau said it's not what you look at, it's whether you see. If I looked long enough at a piece of bamboo in my backyard, would magic come back? Maybe what I'm describing is just depression, I don't know. But I started to think maybe I just wasn't playing dumb enough with my life. Maybe I need to play even dumber.

EM: It totally makes sense. It's like the pandemic created a problematic new studio for all of us.

MN: Right.

EM: I mean Thoreau would have gotten out a tape measure and measured the house.

MN: Totally.

EM: And even today's work—today, we're going to go on a field trip to, among other things, the bar that Aileen Wuornos was arrested in. It's called the Last Resort.

MN: Oh my god.

EM: [*laughs*] Apparently it's a real scene. It's like the West End Bar, people hang out there all day long. So we're going to go there and write, which is really funny.

MN: That is definitely not any field trip that I could have had in mind, but it's so good.

EM: And there is some great tree. This was not my initiatory desire, but there are some great old trees in Florida that are really beautiful. So we went to one last week and we're going to go to another one today. So, with the tree and Aileen . . . but I'm also going to be looking at this Thoreau piece—I had this topsy-turvy publishing experience writing it. In the nineties, I read Thoreau's *Cape Cod* and I loved the book and thought I'll write a similar piece. So I asked everybody on the planet if I could write about [*Cape Cod*] basically redoing Thoreau's walk and nobody wanted it. So I did the walk, I didn't write the piece, but I wrote a handful of poems. And recently I thought I'll write it now. I started pitching it around and this one editor said he wouldn't commission it, but "if you do it, I'll look at it." Then when the park started heating up, I was pouncing on everybody, saying let me write about it. And just like *Cape Cod*, nobody would let me write about the park. Finally *Artforum* did. But in the midst of that, this same journal goes we'd like that *Cape Cod* piece now. It was sort of weird, it wasn't the right time, and I'd hurt my ankle, so we put it off until this spring. I went down there in April, and I did the Thoreau walk and it was amazing. It was many things, including that I still had an injured ankle, so my foot was part of the story. Thoreau had never been to Cape Cod when he began, whereas I have many friends there. Instead of the Wellfleet Oysterman, I'm going to talk to Larry Collins and Michael Carroll and Helen Wilson. I wrote the piece, and because he did the walk several times with different surges, so he didn't end it all at once, I quasi-ended it and then I got back to New York, and that's when I got arrested with the trees. And that was the end of the piece. And I gave it to this magazine, and they killed it.

MN: [*gasps*] They did?

EM: I should read you the [rejection]. I'll read it to you, it's so amazing. It was really one of those rejections where it's a beautiful description of what you do, and they were like, but we don't do that. You got us very close to the experience of doing the walk in a poetic way. And we like an arc and freestanding narrative pieces. We don't know how to edit this. And they killed the piece.

MN: Well now you have the piece, I guess.

EM: It's like now I have this time frozen and this kind of voyage. And of course it'll go into a book. And yeah somebody else is going to publish it. And they are great. What's amazing about this whole saga is that the original journal's kill fee is better than most other places' fees.

MN: I was going to ask. Great, that's fantastic.

EM: It's probably going to turn into its own little book. I'm going to keep doing the walk. I wrote too much. I wrote fifty pages. So, I'll take it to one hundred. But I learned so much, I think this is what triggered me—I learned so much about Thoreau on the way. He's queer, he's absolutely queer, and I suspect that was part of what they didn't like me talking about. Not because they are homophobic. But because it's not a fact. It's speculative. It *feels* right. And that's what it feels like to be in a queer world. It's its own place. And so many of the men who have done that kind of work, so many of them are gay. Alexander von Humboldt, he's the guy that first discovered plate tectonics and the relationship between heat and climate change and trees. Stuff we know today, but he was the first guy to say it. He was totally gay, you know, it's just funny. But that otherness is a research tool. If you're all buttoned up about sexuality can you really think about climate.

MN: Yeah.

EM: I learned that Thoreau was a surveyor, I didn't know that. He actually made his money surveying farms. The new biography of him is actually pretty great. But he was just out there with his measuring tape. That's who he was, and that's what he did. And his joke about himself was I've traveled a great deal, in Concord.

MN: Right.

EM: Back to the pandemic and staying still, he kind of did. He went out at night, listened to the birds. It's a conceptual thought.

MN: When I took classes with Annie Dillard, who, before you, was the only person I had ever taken a writing class with, that was her whole thing, you go out, and it doesn't matter if you're looking at trash and beer cans, just stick around for a while and just keep writing about what you see in front of you, you just keep doing it, you keep scribing. And then I met you and it was a similar ethos, but you took us to Times Square. But I also have this part of me that works with a lot of abstract ideas. There's a scriber in me, and then there's this other part of me that feels ideas as concrete things that I'm moving around in my head, but it's very internal labor and doesn't really involve that kind of journalistic or even poetic attention. It involves a different part of my brain.

EM: Which part? I think I almost understand, you mean write about things or the abstract?

MN: I just feel like with all writing the easiest way to make it better is to make it more specific. But you have this funny line in *For Now*, when you say something like, "I'm really abstract." [*laughs*] And I feel like there's a part of me, the "really abstract" part, and it reads a lot of philosophy and stuff, then starts imagining these blocks of ideas, like things that I start moving around as furniture. And then I'm arranging ideas, the same way you might be looking at an assemblage of shit in the gutter, but they're all in my head, pulled from my reading. I'm doing this other kind of organization, to which there's not a "well, just say it how you saw it" kind of an answer.

EM: Right, right.

MN: I have to invent a scaffolding—it's just it's a different process, and it has different solutions for how to make it feel alive, I guess.

EM: I just think we're so different in that way, because I feel you are so much more comfortable with those abstract ideas than I am. So I also think that when you come back to the real, you get so much bang for your buck.

MN: [*laughs*] Yeah, right.

EM: You're very comfortable in that place, but you still have that poet's need to get the fuck out of there too.

MN: For sure. I feel like each book I write is a kind of refuge from whatever mental space the last one had me in, like I can't stand that space anymore and now I want to fly away and do something very different. But it's hard because I know, as a reader and as a teacher, how much purchase the "real" has. So, when people might say, "oh, why doesn't Maggie get back to talking about her body, that felt so much more real?," I get very bristly, because I feel like I get that, I know that, maybe I've even given that advice to someone else. But while I know I could write an essay on my toes this morning, and it would have a lot of purchase in some way, that's not the only thing in me at all.

EM: Yeah. Though I think the interesting way you subverted that in *On Freedom* is how you got to the planet as your body.

MN: Right.

EM: I mean you use your son—I don't mean you *use* him—but there *he* was. And then there *it* was. And then it just kept becoming a bigger and bigger disaster film.

MN: [*laughing*] Yeah.

EM: It was very scandalous and prescient in the way that it just kept getting worse.

MN: You mean writing about climate change?

EM: Yeah, I mean some of the stuff you had there was the most scary stuff I've heard anywhere. The guy who said we have thirty years.

MN: Guy McPherson.

EM: I've been using that, that was one of my constant takeaways from your book. It's a very loaded nugget.

MN: I think I kind of move off him and that attitude in the chapter. Maybe the link to what we've been talking about, about attentiveness, is that I think some people have the idea that the moment "now" is to take that attentiveness and turn it into a kind of death doula practice. You know, attentiveness to the earth dying. I don't know that we know what we're doing as much as that. I think for some people that orients them toward a feeling of possibility and purpose. It doesn't do that for me. So, I can't make that turn at present.

EM: Yeah. Though I like dying a little.

MN: I can get into it if it's a kind of Buddhist thing where attending to living is attending to dying, attending to dying is attending to living, but I don't like thinking of it as a kind of switch from one to the other because life is bigger than that, I think.

EM: For me, the urgency of that thought, that we could be that close to the edge, ultimately just flips me back into the present, because I just have nowhere to go.

MN: I know, right, where is there to go?

EM: Though any knowledge I have about the larger crisis is in relationship to the specific little plot of fifty-seven acres [of East River Park] that I've been so obsessed with for a few years. To understand this park's relationship to this larger struggle became really, really interesting to me. You know, this is not just my problem.

MN: I was going to ask you how it felt. Was there any conflict, or did it feel like it was the right thing to narrow down on this fifty-seven acres as where you could make your mark or make your stand?

EM: It was so literal. It was like being a Palestinian. Like, oh my god, the settlers seem to think that my house is their house. I just think it was that close. But again, it did throw me onto all these things, including how much I realize that trees have been in my work since—

MN: I've noticed that too! I was just thinking about that. Obviously way before *Sorry, Tree*, but I was thinking about so many encounters, specifically where you're talking to trees.

EM: Right!

MN: Or even saying, "Can I come out to a tree?" A lot of companionship.

EM: I mean they are so interesting; they're sculptural, they're vertical. When you're the last man standing, you're not, because there's a tree. It's sort of like they're always this echo. Because we are. Somebody lately—I don't know the science—said we're actually 50 percent tree. I don't know what that even means, but it seems right. There's that wonderful book by that Irishwoman about speaking to trees [Diana Beresford-Kroeger's *To Speak for the Trees*], and she's way steeped in Celtic lore and is a scientist as well. She is so good at explaining how trees just absolutely created the condition for us to live. There actually could be no oxygen. The planet was dominated by plant things before there were ever human things, and it's like they adjusted the atmosphere to an extent that we could become. So, it's so literal what their destruction means, just how insane that is.

MN: Do you feel like loneliness is assuaged by trees, or do you feel like it's not that kind of enmeshment?

EM: No, I think that's completely, literally, and absolutely true. There's no words besides yes because I feel like they've just been such a presence. What's better generally means trees. And it's always anecdotal too; when I was a kid, there was a chestnut tree out my window of my house. We just had a shitty backyard, a little gravel backyard between two family houses, but there was this tree, and it was the conversation, the syntax, the seasons, the everything of my growing up, watching the tree change. My mother loved plants and growing things, and she was particularly aware of the tree and we had so many rituals involved with the tree. When she remarried, my stepfather came in and cut down the tree.

MN: Oh god. Did he not know the cliché that he was living, of cutting down all that was prior to him coming into your family?

EM: I mean I think that was a piece of who he was. He was probably cutting down both of their families. He was really a nice guy, a great guy in many ways. We didn't really get along. [*laughs*] But I think that was part of his mission, perhaps. To end things.

MN: You were saying that reading the *New York Times* piece was like sitting through a boring introduction of you. And you write in *For Now*, "I'm sick of my history." Then you have a bunch of stuff in there that I really love and really relate to, when you're railing against this proprietary, self-important concept we have of "MY WRITING," you know, the big deal *it* of it. You talk about how we get bored and want things to change and we're tired of the same old thing, but we're also having these thoughts while tying our running shoes against this same old tree, and we can only tell it's a new thought because it's happening against the old tree. Have you thought about how those things move together? The boredom and the restlessness, alongside that which stays or bears witness?

EM: I was just getting really lost at what you were saying in the beginning because it's so absolutely beautiful that you go through all these phases of your life in discontent with it and fixation with it and discarding it, and there just keeps being this rhythm of this other thing—that is not other, that is really such a part of us. I do feel it's part of what we began talking about in the beginning, this kind of playing dumb and all that has to do with wanting some parts of the particularity of whatever our journey is to be gone. To make space. My therapist is always talking about sanding off the details and getting past the particular and getting into the larger principle because that's what's driving me and that's what's happening, and how do we affect that. Before we talked, all I could think of was time because I just wanted to get big as hell, and as far away as I can from the particular horizon of tiny details that I've been identified with as a writer, or I have been used to being comfortable with. To get beyond that. Of course, the scary thing is: What is beyond that? I don't know, I don't know. And yet I can't help feeling like it's this backdrop, not just for me but for everybody, something about how and where we live, and how we live with it, and coexistence in some way. We don't know where the world is going. Whether that means something that happens in my writing or something that happens in my life is something that I know I care about. Much more than I care about the particular pieces—the thing about being a lesbian or no, I'm trans now. Or life in this place, not that. That's only interesting as it becomes vaguer and vaguer to me. I think with life, what happens isn't that it becomes vaguer, but it does become more general, because it starts to be about movement itself, and how am I in sync with that or not. And how I find ways to hold it. Because that's the only difference between me and death.

And a tree is always there. A tree is always there, you know.

MN: When you say what is beyond that, you mean what's beyond the shedding of signifying details that have clustered around a life, rendered it legible?

EM: Yeah, and make it feel so known that you're sick of working there. Because I am, I know I am. And sometimes just by stating that, I start to come up in a different relationship to it all. But it's true, I just find myself longing for something beyond. I've had passions and interests that have cropped up in my life that feel like they're beyond, and I love standing there and finding people to stand there with, to stand there with other people. But I can't help but keep continuing to say "and with trees."

MN: Yeah, and with trees. I gave my students this semester your essay on flossing [from *The Importance of Being Iceland*]. And I was thinking about it when I was reading *For Now*, in which you talk about your, or someone's, *Selected Poems* as being like a good full scan of the corpse. And then you're talking about an ex and what she thinks about being in your papers in the archive and you say she was already imagining her future in the crypt. In the flossing piece, there's a lot about the skull, about death in life, which has always been in your work. But I guess what's interesting to me is that most people, even if they're as young as John Keats, when they start writing, they immediately sense that something about writing is about death, or at least about death in life. I remember reading Cynthia Carr's book on Wojnarowicz and she was saying—and I'm paraphrasing here, and maybe I've projected this read into the book— that Wojnarowicz's early writing had always been about death in life, in a kind of romantic way, and then when HIV came along, it gave this prior impulse its content. Anyway I was just thinking about the way that all writing has that good full scan of the corpse aspect, and how, if you get to keep living, your writing records changes in the scan, because you're in a different relationship to mortality at different moments in your life. I wonder how you feel now when you look back at earlier writing of yours that may have felt at the time like it's writing from the future crypt—like, do you look back and go, "oh, I didn't know anything then," or do you feel like, "oh, I was feeling the same continuum of death and life that I feel now"?

EM: I think when I began I thought that was subject matter. I just thought that you went to the heaviest, deepest, darkest stuff. Trauma was the ter-

ritory. And I thought my relationship to that was what I had that was interesting.

MN: Did you do that consciously? Would you have said that then?

EM: I said it in my poems for sure. And then really got educated away from that by my particular avant-garde writing school, until I gained permission by proving that I was any good, to then figure out how to bring it back in. Of course, it returns always. It's interesting, there's so much trauma bashing right now as well as trauma promoting. Because I think we're in a multitude of global states of panic. But, of course, trauma is always with us, which is death and dreams, and what your particular relation is to that—where you sat when you first discovered that, and where you're sitting now, and then mapping that for the rest of your writing life. I think that part of what I'm struggling with and what I feel like we've been talking about in this conversation is what I don't want death to be is a pile of little tchotchke things about me. I don't want that in the room. And I'm trying to figure out what the room is without that sitting here, while really being attendant to the wily magical place that death always holds.

MN: A few years ago I asked some students in a questionnaire what they would most like to take a future class on, and over half said "trauma studies." I was like, "What do you think we just read together?" [laughs] It seems to me it's not so much that the literature differs—so much literature always circulates around trauma—but rather the psychologized or medicalized ways we talk about life, which change era by era. The literary question, it seems to me, is How do we make our writing address things in such a way that it moves beyond, or will last beyond, the diagnostics of any given moment.

EM: Right. Because it seems crucial that you do make your own map. Beyond is a rendering.

MN: Yeah. And the literary seems like a place where you have to allow the narrative to surprise you—it can't just reinforce a predetermined map.

EM: In part because I think there are other people, and they're all talking stories, you know. All I have to do is visit somebody that I haven't seen for a long time who I've had a past relationship from this place, and they're someplace so different now, and you wind up either talking them off the cliff, or seeing that their extreme experience is like an amazing demonstration that something else is possible. I feel like other lives totally knock me out of orbit. I feel like there always are all these planets that are affecting my orbit, and I don't know what or where they are until I find them.

MN: You've said you're interested in the question of how something becomes a book. Can we talk about that a little? What do you think a book is? It strikes me now that I was probably very influenced, early on, by your sense of what a book is. The book as container. It's become difficult for me to write something that's not book length, besides individual poems, or art catalog essays. My mental holder is always "this will be a book." I never think, "this will be an essay." I'm trying to change that a little, because I get moored up in books for years, and end up saying no to everything else in the meantime because I'm like, the book, the book, the book. I can't do anything else but the book.

EM: That's great, and I envy that. At this point in time I feel like I'm trying to conceptualize a book that will be a cabinet that will hold all these other parts. Because it's the book, and it's not the book. And it's like, what would these speedy little boats do if they come into the book, you know. What would the book become. I like these problems, otherwise I'm bored by the book when I'm writing it. Plus I enjoy being outside it, writing other things.

MN: The thing is, being in a book is really great and also really boring. And here we are, back to the pandemic studio—you have to keep hunting for the spark. I think a lot about how writing is just like life in general. You complain endlessly about "oh, this is dragging me off the main thing," and it's like, no, all of it is the main thing. You never really know what's the main thing and what's a digression. We just have the pretend idea that the real work is somewhere, and it never is. There's no *there* there.

EM: Yeah, the great mistake is thinking, "oh, I wish that would stop so I could stay here" when that was the thing that was making here.

MN: But is that part of the game? Do we have to keep thinking, "oh I wish that would stop" to somehow manage our being, or is that way of thinking just unnecessary suffering?

EM: I don't know. I think my burden of time is that I always want things to be over, and then something distracts me and then I'm in it.

MN: Often when I've agreed to take on a writing assignment, I resent that I've taken the job, and when I finish it I think, "god, that was such a distraction." But (a) from what? and (b) before I started it, I probably felt like everything else in my life was a distraction keeping me from the assignment. When I see this pattern from afar, I just think, wow, this is all a really elaborate mind game about where value is, where things are happening. You know, I'm hot, better turn up the AC, I'm cold, better turn on the heat. So you're spending a lot of time just jiggering the thermostat.

EM: Right, and almost like anything else you can do with your body brings you back to it in this completely other way.

MN: I think about it a lot as a parent. I think parents are really annoying to kids because they always want their kid to be doing something other than what they're doing. When you go up to your kid and you're like, "oh, are you hungry?" and they're like, "no, I'm fuckin' reading a comic book, I don't want to think about 'am I hungry?'" But you're always trying to service them, and be like, "are you cold? do you need a sweatshirt?" And they're like, can you just get away from me. You're trying to care for them, but you're also making a bid for connection, but you fail a lot because you don't know how to do it. And in part you don't know how to do it because you're this adult and it's no longer natural to you to connect by just sitting down on a beanbag. Often I'm like, I'm fifty, I don't want to sit down on a beanbag in the middle of my day, that's not where I'm at. But I do want to connect, you know?

EM: Just the fact of that must make you think all the time that you need to do something about that, and you don't.

MN: You're right, I don't. But also, sometimes I will sit down and just try to be there, and my son will be like, "why are you just sitting there?!" and I'm like, "oh, I'm just trying to be." Sometimes nothing feels right, including not trying! It's hard, to let nothing be quite right.

EM: Uh-huh, and there's always an unhappy little author in the house.

MN: Exactly! Is it him or is it me?

EM: That is the question. Alright, I love you, I have to go to Aileen's.

(2023)

ACKNOWLEDGMENTS

Thank you: PJ Mark; Ethan Nosowsky, Katie Dublinski, Anni Liu, and all the good people of Graywolf Press; Cyrus Dunham and Frances Lazare; Harry Dodge, for making my days rich with art, conversation, and love; Iggy, for the title, and the real thing; and Mary Ann Caws, for her example, and for enjoining me, so long ago, to bring pencil and paper to the museum.

Thanks also to the many editors and curators who occasioned or otherwise supported these pieces, including: Kiera Blakey, Rosa Campbell, Arne De Boever, Louise Dunnigan, Shannon Ebner, Tyler Foggatt, David Frankel, Massimiliano Gioni, Sinéad Gleeson, Kim Gordon, Aaron Hicklin, Karen Jacobsen, Jamillah James, Jenny Jaskey, Evan Kindley, Hannah Lack, Mia Locks, Tom Lutz, Adam Marnie, Rebecca Matalon, Camille Meder, Maggie Millner, Helen Molesworth, Susan Morrison, Margot Norton, Arthur Ou, Lauren O'Neill-Butler, Meghan O'Rourke, Rosie Pearce, Annie Philbin, David Remnick, Frances Richard, Emily Stokes, Margaret Sundell, Lanka Tattersall, Mario Telò, Mamie Tinkler, Joshua Marie Wilkinson, and Diana Wise. Special thanks to Fred Goodman and Sky Sela for their support of "My Brilliant Friend."

Grateful acknowledgment to the following venues, in which many of these pieces—in slightly different forms, sometimes under different titles—first appeared:

4Columns, 2017: "By Sociality, To Sociality: On Fred Moten's *Black and Blur.*"

"Alette in Oakland: A Symposium on the Work of Alice Notley," held at the Bay Area Public School, Oakland, CA, October 24–26, 2014: "Changing the Forms in Dreams: On Alice Notley's *The Descent of Alette.*"

AnOther Magazine, 2019: "A Continuity, Imagined: Conversation with Björk."

Ari Marcopoulos: Zines, Aperture, 2023: "For Who Knows How Long."

Artforum, 2017: "A Life, A Face, A Gaze: Conversation with Moyra Davey."

Carolee's, Artist's Institute and Koenig Books, 2016: "The Reenchantment of Carolee Schneemann." Abridged version reprinted in *New Yorker* online, 2019.

Evening Will Come: A Monthly Journal of Poetics, 2012: "From Importunate to Meretricious, With Love: Conversation with Brian Blanchfield."

File Note 143: Dani and Sheilah ReStack, Camden Art Centre, 2022: "The Inoculation."

Grand Journal, 2021: "The Longest Road: Conversation with Jacqueline Rose."

Hammer Museum at UCLA, Los Angeles. 15th Annual Gala in the Garden, honorees Hilton Als and Ava DuVernay, October 14, 2014: "Like Love: A Tribute to Hilton Als."

I Stand in My Place with My Own Day Here: Site-Specific Art at The New School, Duke University Press, 2019: "The Understory: On Kara Walker's *Event Horizon*."

JOAN gallery, Los Angeles. Introduction to *The Deadman*, screened as part of the *Sylvia Bataille* exhibition curated by Adam Marnie and Rebecca Matalon, December 11, 2015: "A Girl Walks Into a Bar . . .: On Peggy Ahwesh and Keith Sanborn's *The Deadman*."

Los Angeles Review of Books, 2012: "Almost There: On Eve Sedgwick's *The Weather in Proust*."

Los Angeles Review of Books, 2014: "Beyond All Change: On Ben Lerner's *10:04*."

Matthew Barney: OTTO Trilogy, Gladstone Gallery, 2016: "Porousness, Perversity, Pharmacopornographia: On Matthew Barney's *OTTO* Trilogy."

New Yorker, 2016: "The Grind: On Prince."

New Yorker, 2020: "At Girò's: On rereading Natalia Ginzburg's 'Winter in the Abruzzi' at the start of a pandemic."

Poetry Project Newsletter, February/March 2006: "Say After Me: Conversation with Wayne Koestenbaum." Reprinted in *What Is Poetry? (Just kidding, I know you know): Interviews from the Poetry Project Newsletter (1983–2009)*, Wave Books, 2017.

Rachel Harrison: Life Hack. Whitney Museum of Art, 2019: "Eighteen Theses on Rachel Harrison."

Relationship, by Zackary Drucker and Rhys Ernst, Prestel Publishing, 2016: "If I Didn't Tell It: On Zackary Drucker and Rhys Ernst's *Relationship*."

Representations, Special Issue: *"Proximities: Reading with Judith Butler,"* University of California Press, 2022: "The Call: In Honor of Judith Butler."

Sarah Lucas, Au Naturel, Phaidon Press, 2018: "No Excuses: The Art of Sarah Lucas."

The Seas, by Samantha Hunt, reissue by Tin House Books, 2017: "O That Wave: On Samantha Hunt's *The Seas*" (preface).

Suicide Blonde, by Darcey Steinke, 25th anniversary reissue by Grove Press, 2017: "*Suicide Blonde* at 25: On Darcey Steinke" (preface).

Tala Madani: Biscuits. MACK Publishing, 2022: "The Dare of Tala Madani."

This Woman's Work: Essays on Music, Hachette Books, 2022: "My Brilliant Friend: On Lhasa de Sela."

To the Friend Who Did Not Save My Life, by Hervé Guibert, re-issue by Profile Books, 2021: "This Living Hand, or, My Hervé Guibert" (preface).

Women's Studies: An Inter-Disciplinary Journal, Special Issue: "*Eileen Myles Now*," 2023: "And With Trees: Conversation with Eileen Myles."

Yale Review, 2022: "I Just Want to Know What Else Might Be Available: Conversation with Simone White."

MAGGIE NELSON is the author of several books of poetry and prose, includ-ing the national best seller *On Freedom: Four Songs of Care and Constraint* (2021), *New York Times* best seller and National Book Critics Circle Award winner *The Argonauts* (2015), *The Art of Cruelty: A Reckoning* (2011; a *New York Times* Notable Book of the Year), *Bluets* (2009; named by *Bookforum* one of the top ten best books of the past twenty years), *The Red Parts* (2007; reissued 2016), and *Women, the New York School, and Other True Abstractions* (2007). Her poetry titles include *Something Bright, Then Holes* (2007) and *Jane: A Murder* (2005; finalist for the PEN/Martha Albrand Award for the Art of the Memoir). She has been the recipient of a MacArthur "Genius" Fellowship, a Guggenheim Fellowship, an NEA Fellowship, an Innovative Literature Fellowship from Creative Capital, and an Arts Writers Grant from the Andy Warhol Foundation. She is currently a professor of English at the University of Southern California and lives in Los Angeles.

The text of *Like Love* is set in Adobe Garamond Pro.
Book design by Rachel Holscher.
Composition by Bookmobile Design & Digital
Publisher Services, Minneapolis, Minnesota.
Manufactured by Friesens on acid-free,
100 percent postconsumer wastepaper.